† MONASTERIES OF GREECE

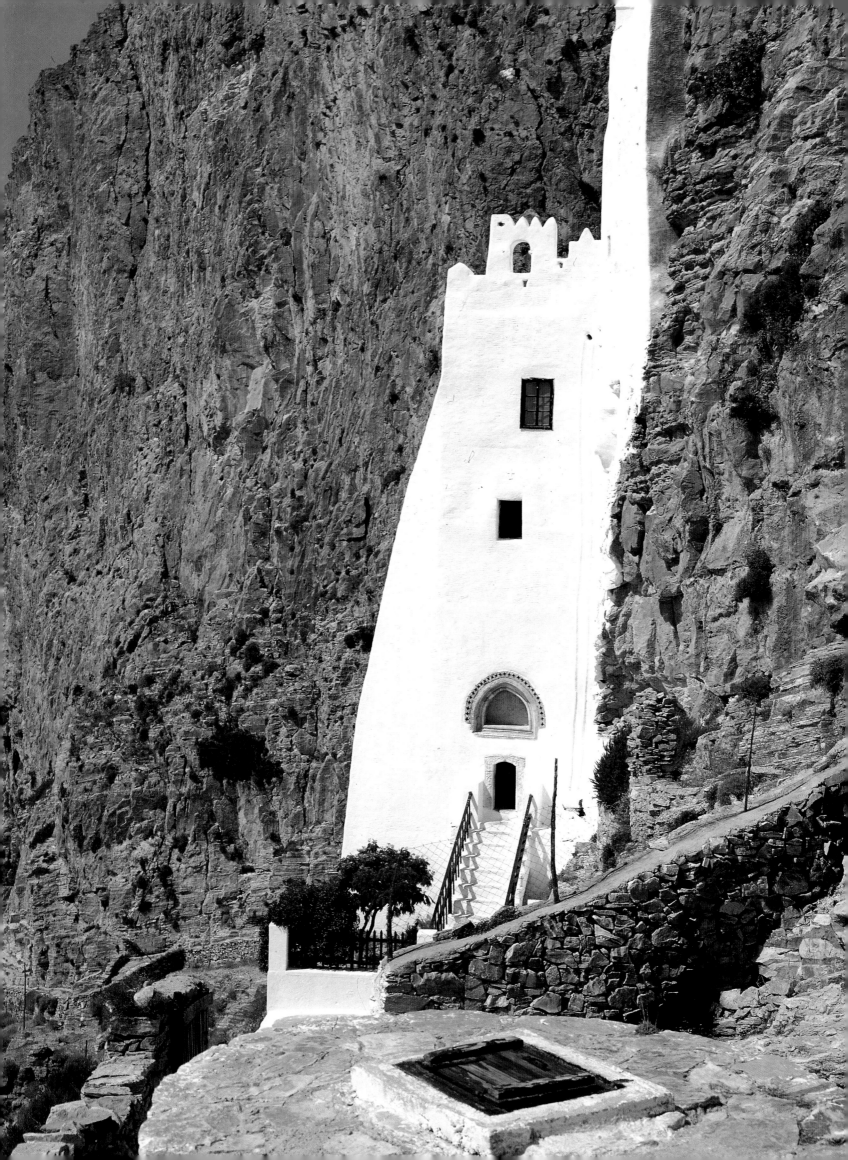

✝

MONASTERIES OF GREECE

CHRIS HELLIER

Tauris Parke Books, London

To my parents, Margaret and Lyndon, with love and thanks

Published by Tauris Parke Books
An imprint of I.B.Tauris & Co. Ltd., London

In the United States of America & Canada distributed
by St Martin's Press, New York, NY 10010

Text and captions © 1996 Chris Hellier
Photographs © 1996 Chris Hellier except Peter Wilson:
Jacket; 178–179; 188–189; 201; 202. Kostas Kontos Agency, Athens:
Back jacket; 2; 8; 10; 18; 20; 23; 28; 31; 34; 39; 42; 47; 52 top
and bottom; 53 top and bottom; 73; 74 left and right; 75; 76 top
and bottom; 77 top and bottom; 78 bottom; 79; 80; 81; 86; 87; 101;
105 top; 106–107; 109; 116–117; 126; 129 top left and right; 129
bottom left and right; 130; 131; 134 top; 142; 143 bottom; 146; 152
top and bottom; 154; 155 top; 156 top and bottom; 157; 166; 167;
184 right and left; 185; 193 top and bottom; 204; 208; 209; 214 top
left. Zbigniew Kosc: 132–133; 160–161; 159 left

Designed by Barbara Mercer
Picture Research by Francesco Venturi
Edited by Judy Spours, Betty Palmer and Elizabeth Harcourt
Maps by Andras Bereznay

The Cataloguing in Publication data for this book is available
from the British Library.

ISBN 1–85043–264–3

Photosetting by August Filmsetting, St. Helens
Colour origination by Amilcare Pizzi, Milan, Italy
Printed by Amilcare Pizzi, Milan, Italy

FRONT JACKET: *The
Roussanou Monastery in Meteora.*

BACK JACKET: *A painting from
St. Nicholas' Monastery depicting St.
James the Persian.*

FRONTISPIECE: *The monastery
of the Presentation of the Virgin on
the island of Amorgos.*

Acknowledgements

I am indebted to many people for their assistance and hospital-
ity during the preparation of this book. Firstly, I would like to
thank the monks themselves, particularly Monk Iakovos, the
polyglot gatekeeper at Iviron Monastery, Mount Athos, and the
jovial hermit, Father Alexandros, who both introduced me to
life on the Holy Mountain today. Thanks also to numerous
public officials, government architects, historians and adminis-
trators who helped me during my visits to monastery museums.
A special thanks, too, to Nikos Kostopoulos and Vassilus
Tseghis.

Much of the research for the book was undertaken in the
libraries of the British School of Archaeology and the École
Française d'Archéologie in Athens, both venerable institutions,
as well as my more usual hunting ground, the British Library,
London. In Athens, I am particularly grateful for the efficiency
of Penelope Wilson, the British School librarian, who even
recalled an important book from the binders so that I could
consult it before leaving the city.

I would like to thank all the staff at KEA: my editor, Judy
Spours, for her valuable comments on the text; Elizabeth Har-
court who keeps the office running smoothly; and Francesco
Venturi, photographer and publisher. It was a pleasure to work
with them once again. Thanks also to Wendy Thompson who
read through several of the early chapters. And, as always, a
special thank you to my wife, Joëlle, for her continual support
and for reading numerous drafts of the text as it progressed; and
to Naomi, my daughter, who, sometimes reluctantly, accepted
my extended absences from home during visits to Greece and
London.

Chris Hellier
Aix-en-Provence
1995

Contents

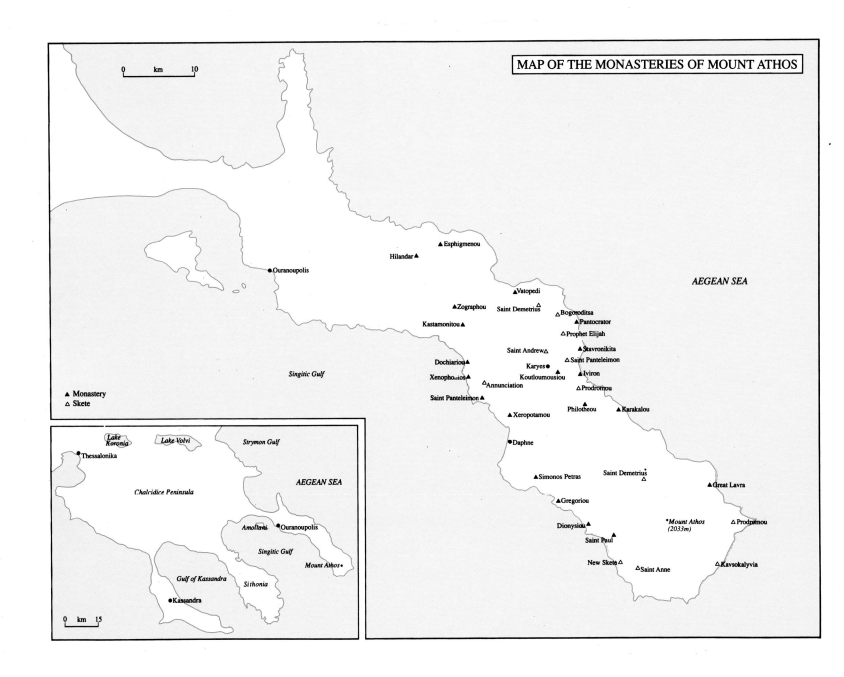

MAP OF THE MONASTERIES OF MOUNT ATHOS

AEGEAN SEA

▲ Esphigmenou

Hilandar ▲

Ouranoupolis

▲ Vatopedi

▲ Zographou Saint Demetrius △

Bogoroditsa △

Kastamonitou ▲ ▲ Pantocrator

△ Prophet Elijah

Saint Andrew △ ▲ Stavronikita

Singitic Gulf

△ Saint Panteleimon

Dochiariou ▲ Karyes ● ▲ Iviron

Xenophontos ▲ Koutloumousiou ▲

△ Annunciation △ Prodromou

Saint Panteleimon ▲

▲ Xeropotamou Philotheou ▲ ▲ Karakalou

● Daphne

▲ Monastery
△ Skete

▲ Simonos Petras Saint Demetrius
 △ ▲ Great Lavra

● Gregoriou

Mount Athos · △ Prodromou
(2033m)

Dionysiou ▲

Saint Paul ▲ ▲ Kavsokalyvia

New Skete △
△ Saint Anne

Lake
Koronia Lake Volvi Strymon Gulf

● Thessalonika

AEGEAN SEA

Chalcidice Peninsula

Amoliani ● Ouranoupolis

Singitic Gulf

Mount Athos ·

Gulf of Kassandra Sithonia

● Kassandra

0 km 15

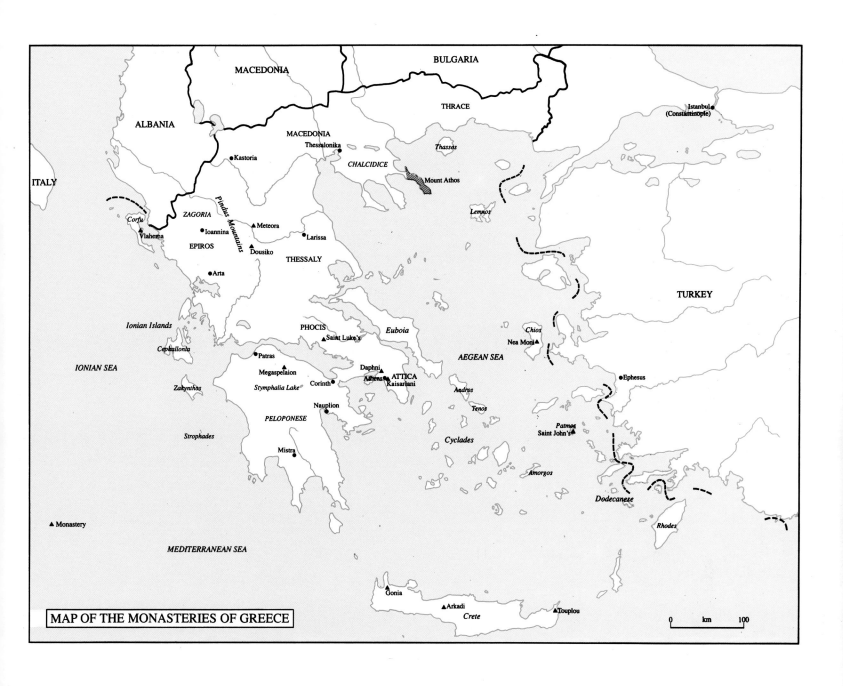

ITALY

ALBANIA

MACEDONIA

BULGARIA

THRACE

Istanbul
(Constantinople)

MACEDONIA

Kastoria

Thessalonika

CHALCIDICE

Thassos

Mount Athos

Lemnos

ZAGORIA

Pindus Mountains

Corfu

Meteora

Ioannina

Larissa

Vlaherna

EPIROS

Dousiko

THESSALY

Arta

TURKEY

Ionian Islands

PHOCIS

Euboia

Cephallonia

Saint Luke's

AEGEAN SEA

Chios

Nea Moni

IONIAN SEA

Patras

Megaspelaion

Daphni

Athens

ATTICA

Ephesus

Zakynthos

Stymphalia Lake

Corinth

Kaisariani

Andros

Nauplion

Tenos

PELOPONESE

Strophades

Cyclades

Patmos
Saint John's

Mistra

Amorgos

Dodecanese

Monastery

Rhodes

MEDITERRANEAN SEA

Gonia

Arkadi

Touplou

Crete

0 km 100

MAP OF THE MONASTERIES OF GREECE

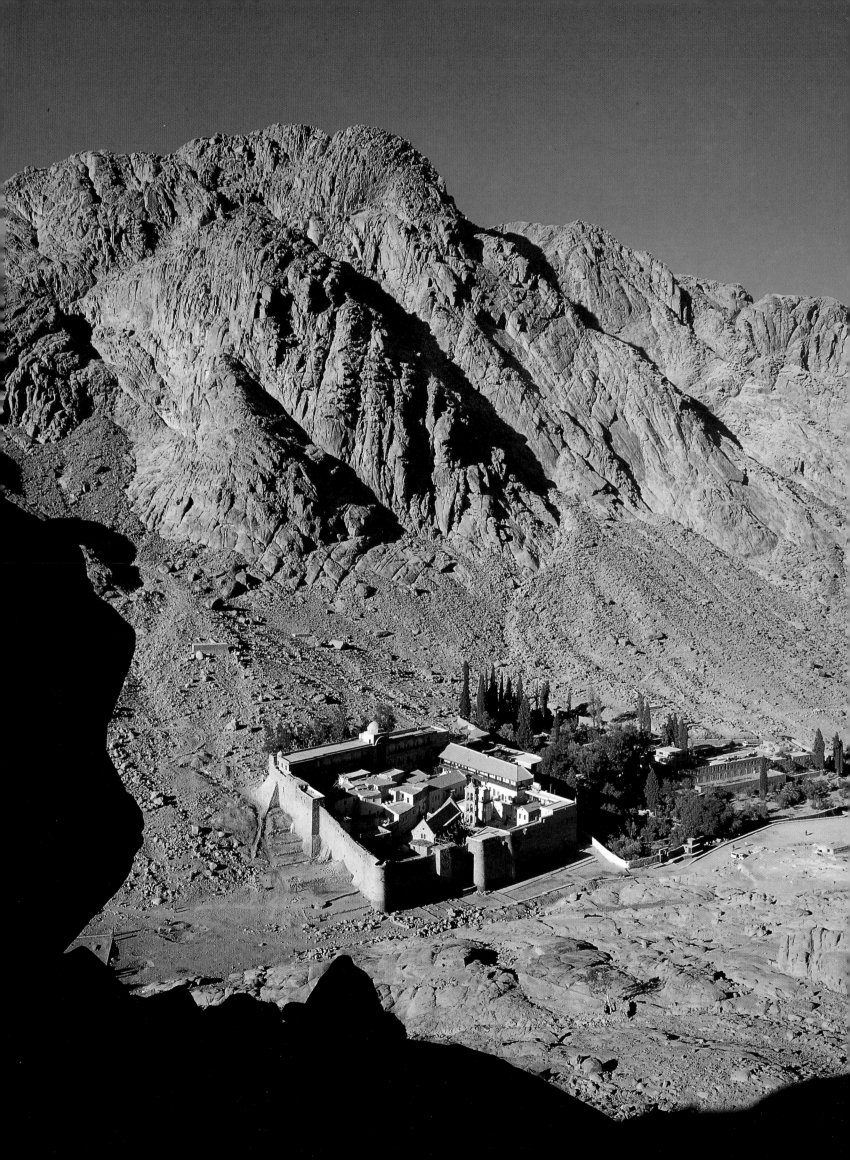

·I·

Out of the Desert

An ecstatic calm, smoother than pearls, overspread the water, broken by the black figure of a shrimping monk, gown tucked above his knees. Behind, above a broad field scattered park-like with occasional trees, reared the monastery, topped here and there with little leaded domes and resembling a great country house.

Robert Byron on Iviron Monastery, August 1927

Almost seventy years after Robert Byron's sojourn at Iviron Monastery, one of twenty ruling monasteries scattered along the narrow, finger-like peninsula of Mount Athos in northern Greece, I sat by the monastery's jetty one June morning listening to silence. The sea was calm and two black-clad figures waited for the early morning boat. Since Byron's time the park-like field had been converted to a vegetable garden and urgent repairs were under way on the monks' living quarters. But overall there seemed to have been little change. I met one old monk, a wizened ninety-year-old with a long sorcerer's beard, who had moved into the monastery the year before Byron's visit and had not left it since. The three score years and ten had passed in prayer and meditation. Yet he seemed bewildered, lost in his own thoughts. He ran bony fingers through the long beard and muttered: 'A lifetime is not long, not long.'

After brandishing my 'pilgrim's pass', issued by the religious authorities for visits to Athos, I had been welcomed at Iviron, although the monks made it immediately clear that I was expected to attend regular services and to follow the rhythm of monastic life. At five-thirty on the first morning I was woken by a rapping on the cell door, the call to morning prayer, and, not yet fully awake, I hurried down to the sixteenth-century Church of the Dormition of the Blessed Virgin Mary. As a non-Orthodox guest I was forbidden entry to the main church, so I stood in the painted narthex, the porch reserved for catechumen and, in non-monastic churches, for women and children, following the numinous service from the rear stalls.

In dribs and drabs monks and Orthodox pilgrims, their footsteps echoing across the stone floors, straggled into church. They paused on the threshold, crossed themselves from head to navel, left to right, and then knelt beneath a garish representation of Christ and the Virgin Mary and gently kissed them both, before disappearing silently into the inner naos. Within, lighted candles flickered in the

OPPOSITE: *St. Catherine's Monastery at Mount Sinai, built in the sixth century by the Byzantine Emperor Justinian I, still houses a handful of Greek monks. The monastery, built on the site of the Burning Bush, has always been an important destination for pilgrims and is dominated by the craggy peaks of Mount Sinai where God delivered the Tablets to Moses.*

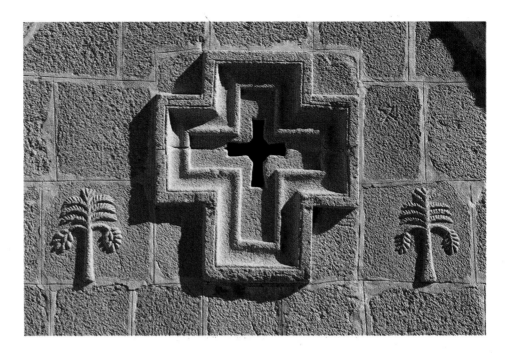

A Greek orthodox cross and palm trees carved in a wall of St. Catherine's Monastery.

gloom and the air was heavy with the scent of burning wax. A priest, dressed in a voluminous cloak and ceremonial sash, began to chant the litany, a haunting eight-tone cadence that has changed little since the days of Byzantium. After an hour the service reached its climax as the priest, with an air of divine purpose, marched round the church, his cloak swirling, swinging an incense burner to cleanse the air.

Even before the service came to an end, monks had begun leaving the church and as the priest swung the censer for the last time I was ushered out of the narthex, back up the stairs of the guest wing, into a plain, whitewashed refectory. The first meal of the day consisted of stale bread, wrinkled olives and weak luke-warm coffee. I had difficulty swallowing the dry offering, but the monks thanked God for their modest fare. Afterwards, I and other pilgrims, were given small passport-size pictures of the monastery's most treasured possession, a tenth-century icon of the Virgin Portaitissa, the Mother of God of the Gate, housed in a small chapel in the main courtyard.

I was to get a closer look at the real icon later that morning when the jovial gatekeeper and guest-master, Monk Iakovos, took the visiting foreigner under his wing. He stooped as we entered the chapel, for he was a big man with bottle-thick spectacles and outsized boots. We stood before the venerated Portaitissa.

'Look,' he said, 'how the eyes follow you around the chapel.'

I tried the moving eyes test and had to agree that they did indeed seem to look at you wherever you were. The chapel, however, was only small, no more than four metres square, and a trick of the light or cunning perspective could easily explain the moving eyes. For the faithful, however, the icon harbours miraculous powers. A copy of it is believed to have cured an ailing daughter of the seventeenth-century Russian Tsar Alexis of Russia and generations of pilgrims have left small gifts, mainly watches, pressed medallions and gold coins, at the base of the gilt-covered painting as a token of their belief. Monk Iakovos was explaining the icon's supposed provenance in Constantinople when a young priest monk, Father Jeremiah, entered the chapel and whispered to his fellow ascetic.

'The chapel is to be cleaned now,' said Iakovos simply. 'And I must return to my cell.'

I took the interruption as a sign that I should now leave the monks to

themselves and, with my copy of the Portaitissa icon in my breast pocket, I shouldered my rucksack and headed north, along a narrow mule track shaded by scrub oak and chestnut trees, to the larger monastery at Vatopedi further up the coast.

In Greece, every district once had a monastery of its own like Iviron or Vatopedi, and it was often the most imposing and dramatically sited building in the area. Today, only a fraction of the monasteries remain from the heyday of monastic power in the Middle Ages. But there are still around 200 scattered about the countryside from the central Peloponnese to the narrow peninsulas of southern Macedonia, from the heights of Thessaly to the remotest Greek island. They are still, as Robert Curzon described them in the 1830s, 'the most ancient specimens extant of domestic (Greek) architecture.' Many are small, picturesque, abandoned; others hang on to their monastic traditions by a slender thread. Some of the larger centres have seen their fortunes take a turn for the better in recent years; while others have been overrun by a new breed of vacationing 'pilgrim'.

The monasteries' former wealth, and their central importance to the Greek-Byzantine spirit, are still hinted at in their rich treasuries, invaluable archives, and heavily painted walls. Today's monks, the young as well as the elderly, continue to be drawn by a tradition as old as Christianity itself. But what leads men and women to adopt this curious lifestyle, to retreat from the world in their search for God? And what was the origin of a monastic movement that has had such a profound effect on the Greek national psyche?

The word monastery is derived from the Greek word *monachos*, 'living alone', and dates from the time that Greek was the language of the Christian church. The earliest communities of Christian hermits settled in remote parts of Egypt and, to a lesser extent, in Syria, from the third century onwards. They followed the teachings of the 'Desert Fathers' whose devotion and manner of living were instrumental to the growth and development of monasticism throughout the Levant and, subsequently, the rest of the Christian world. The strictest of the founding fathers was probably Saint Antony, a Coptic Christian, whose 'visio Dei' distinguished his movement from the church of the day. As a young man, following the death of his parents in the 270s, Antony decided to become an ascetic. After fifteen years as a novice, he later shut himself away from the outside world for another two decades in an abandoned fort, and in doing so established a tradition that was to become central to the eremitic way.

Antony's reputation soon spread, other ascetics gathered around him, and about 305 he organized the first semi-eremitic community. Under Antony's direction, or that of one of his disciples such as Macarius, hermits learned the way of 'askesis', the training necessary to live life as solitaries, before branching out on their own to spread knowledge of the discipline. Antony's teachings allowed for differing degrees of seclusion. In the desert margins of Lower Egypt his followers gathered in twos and threes, lived entirely alone in dingy caves, or formed groups of hermits' cells known as *laura* or *lavra*, adapted from the Greek word meaning a lane or passage way. In their *lavrai* monks had their own cells or caves, drew water from a shared well, baked bread in the common bakery and assembled once or twice a week for prayer.

Saint Antony's near contemporary Saint Pachomius (c.290–346) founded a more communal form of monasticism known as the coenobitic. In his teens Pachomius lived as a pagan recluse of the god Serapis in the Thebaid, but soon converted to the new religion of Christianity. He later served in the Byzantine army,

OVERLEAF: *The eleventh-century Hallaç Monastery, one of many monasteries carved out of soft volcanic rock in Cappadocia, a former Byzantine province now in central Turkey. During the Middle Ages, Cappadocia housed a large monastic community and was an important centre of provincial art.*

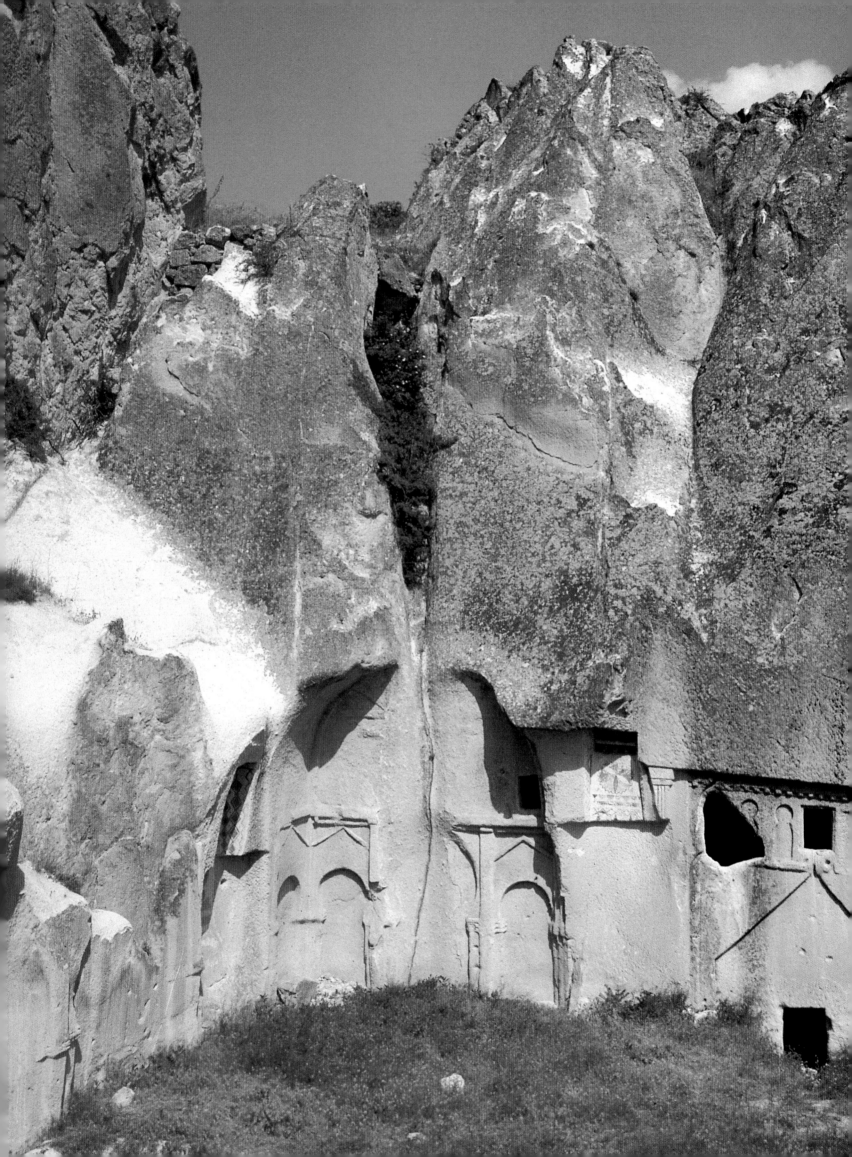

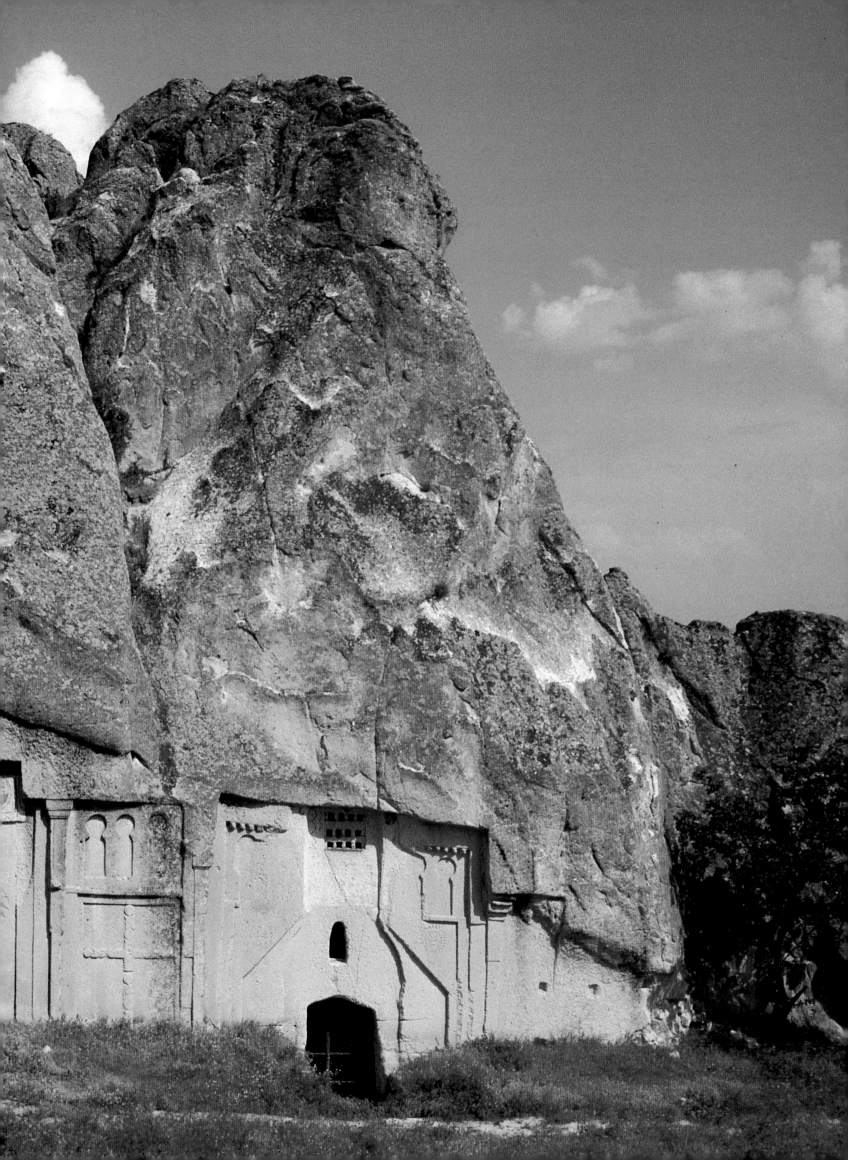

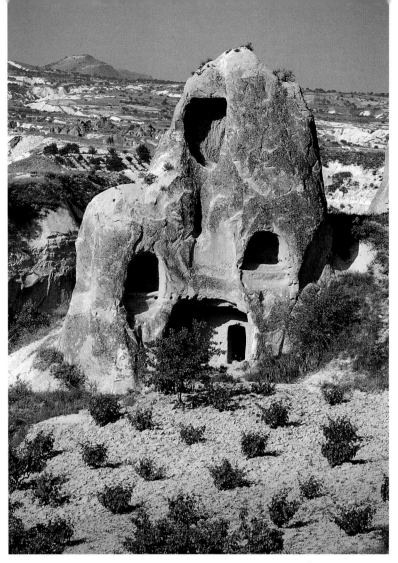

An isolated hermit's cell, carved from a rock cone in Cappadocia, gives some idea of the early recluse's curious lifestyle.

Among the rocky outcrops at Meteora, the remains of hermits' cells, little more than precarious wooden ledges strapped to the rock face, stand as a reminder of the centre's ascetic heyday.

giving him experience of organization and group discipline which perhaps influenced his approach to the solitary life. In 320, inspired by the example of Antony, he established the first real monastery in the Christian world, at Tabennisi on the River Nile. Other communities, subject to formal rules, soon developed in upper Egypt where the monks shared common kitchens and refectories, and divided their day into a strict routine based on prayer, Bible reading, and necessary work. This new way of life, in many ways simply a different expression of the ascetic spirit that had existed since the time of Christ, appealed to women as well as men. Monasticism was never an exclusive male preserve. Indeed, when Antony opted for the reclusive life he sent his younger sister to live in a convent of virgins which had existed even before he and Pachomius had founded their own communities.

The monastic movement spread quickly in Egypt and elsewhere so that by the fourth century, according to a contemporary chronicler, there was 'no town or village in Egypt or the Thebaid that is not surrounded by hermitages … and the people depend on their prayers as if on God himself…' In Syria, Christian practices fused with Asiatic ascetic rites as monks and hermits mortified their bodies by self-torture. These included the pillar saints, notably Saint Simeon the Stylite (395–461), who passed their lives perched atop the columns of ruined pagan temples. Other hermits grazed like domestic cattle or loaded themselves with hefty weights. Some went as far as to repudiate everything human as sinful, the wealthy were damned and the married excluded for ever from eternal salvation. The so-called 'saloi' served God, or so they believed, by acting as fools. Strangest of all, perhaps, were the Dendrites who chained themselves for decades in the branches of trees.

These essentially oriental practices particularly appealed to Levantine communities. But there were other, more external factors which encouraged the growth of early monasticism. Above all, it represented a flight from the evil world. Monks rejected public and private sin, and a decadent, unjust society governed through oppression and burdened by heavy taxation. Only by retreating from the normal duties of life, many believed, could the pious follow the true path of Christ and achieve salvation.

Monasticism proved a powerful lure and the growing number of monks soon began to create political problems for the authorities. By the end of the fourth century there were 7000 Pachomian monks in Egypt alone, and another 5000 Antonian hermits in Nitria. The Arian emperor Valens, who reigned from 364 to 378, not only disapproved of the monks' religion but was uneasy about their influence over the people and considered their way of life a waste of human resources. In an effort to curb their activities and convert them back to paganism he conscripted young and able-bodied ascetics at Nitria for the army. But his actions had little overall effect on the growing strength of the monastic movement.

Not all monks were as fanatical or as extreme as the Egyptian pioneers or Syrian hermits. In Asia Minor coenobitic monasticism developed rapidly under the teachings of Saint Basil the Great (329–79), Bishop of Caesarea, today's Kayseri in central Anatolia. Around 360, though barely into his thirties, he retired to Annesi in the Pontus Mountains where he drew up strict rules, based on Pachomius' regulations, for his form of communal monasticism. Under the Basilian model monks lived together, ate together, worked side by side, and assembled six times every day to pray in the church. For Basil, hermits were no more holy than monks. Life in a coenobitic community was no compromise with the Antonian ideal. It was a higher and preferable form of the monastic way. In Basilian communities ascetic practices took second place to work, mainly agricultural, which became an important element

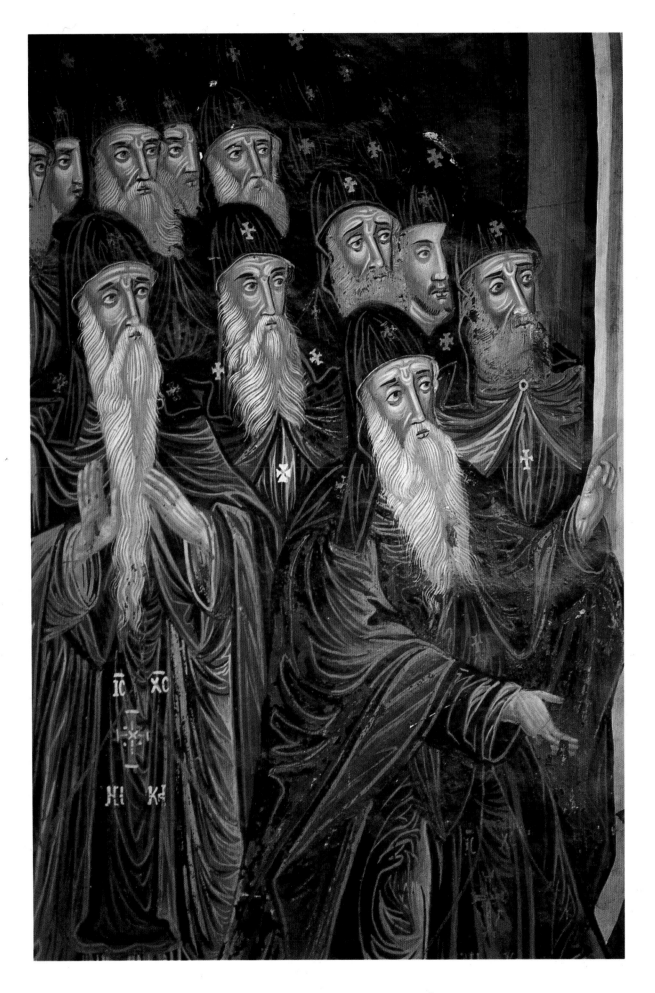

in daily schedules. The education of boys and running orphanages became monastic responsibilities. And monasteries were governed and organized by abbots to whom the monks pledged strict obedience.

Saint Basil did not form or propose an order of monks in the western sense. To the Byzantine a man was either a monk or a man of the world. Basil's 55 Longer Rules and 313 Lesser Rules did, however, establish a basis for monasticism and were conceived as answers to questions posed by novices who planned to adopt the coenobitic way as Basil conceived it. His concept of the monastic life seems a long way from the anchorite practices advocated by Saint Antony barely half a century earlier; but it was Basil's rules that were to become the basis of Greek and Slav monasticism, and his ideas that were to become so important an aspect of the Byzantine monastic tradition.

OPPOSITE: At the Great Lavra, the leading monastery at Mount Athos, nineteenth-century paintings of monks decorate the narthex of the catholicon.

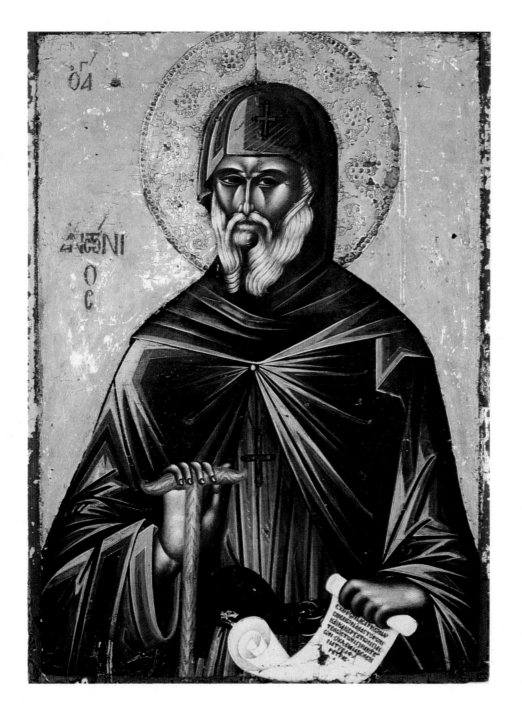

A seventeenth-century icon of St. Antony, one of the founding fathers of monasticism, from the Monastery of Dionysiou on Mount Athos. The Egyptian hermit attracted an enormous following after living for years in an abandoned fort. His 'Life', based on the Coptic original, is attributed to Athanasius of Alexandria.

· 2 ·

In the Shadow of Byzantium

> . . . breast the flood of mortal cares and strife.
> This is the one care of the monkish life,
> To find a harbour on that quiet shore
> Where toil is done, and hardship is no more,
> Where men can sing hymns to their God in peace,
> Where all constraints and persecutions cease.
>
> Saint Theodore of Studium (759–826)

The early history of Greek monasteries is, essentially, the history of Byzantine monasticism. For 1100 years, from the foundation of the Byzantine Empire by Constantine the Great in 330 to the fall of Constantinople to the Turks in 1453, all roads in the Near East led to New Rome, to the emperor's palace and the residence of the city's Orthodox patriarch. In Constantine's new city monasticism developed quickly following the establishment of the city's first ascetic community, Dalmatou. This bastion of orthodoxy, built just outside the land walls in 382, soon became the seat of the archimandrite or exarch who supervised other monasteries in the capital. Within 150 years another seventy monasteries had been founded in the city so that Byzantine monasticism, unlike early Egyptian monasticism, developed a strong urban base.

Lesser centres grew up in the provinces. Several holy mountains developed, notably on Mount Athos and Bithynian Olympus, and remote communities flourished in Thessaly and in the volcanic valleys of Cappadocia in Asia Minor. Greek monasticism founded houses as far afield as Palestine, the Syrian desert, southern Italy and Mount Sinai, where at the famed Saint Catherine's Monastery a handful of Greek monks still tend an altar on the site of the Burning Bush.

In the empire's early days, whether on the streets, in the churches or at established schools of learning, Christianity became a national obsession; and it was one in which the monks played a leading role. Monks represented the radical wing of the Church. They were the rabble-rousers whose outspoken, unorthodox ways ensured them wide popular support, particularly in the provinces where the laity

OPPOSITE: *The eleventh-century catholicon of Nea Moni Monastery, Chios, one of the most important buildings of the Byzantine period. The monastery was founded by Constantine IX Monomachus (1042–55) on the spot where a miraculous icon of the Virgin was found hanging from a myrtle bush.*

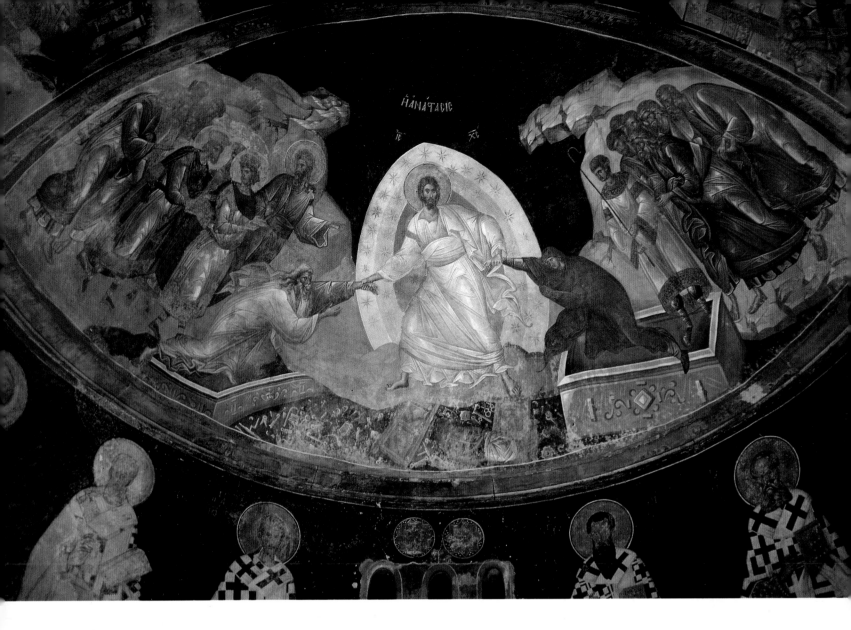

The remarkably well-preserved
Anastasis, or Resurrection, painted in
the early fourteenth century in the
sanctuary conch, St. Saviour in
Chora Church, Istanbul. Christ, with
John the Baptist to the left and Abel
to the right, breaks the gates of hell
and releases Adam and Eve from
their tombs.

was more easily influenced by holy men and monks than they were by the hierarchy. The monks' supposed powers, to heal the diseased, to drive evil from people's souls, or to foretell the future, only added to their aura. And during the fourth and fifth centuries they played a major part in the ecumenical councils which dealt with Church organization and established the basis of the Orthodox faith in the Nicene Creed.

The monks' success at the councils, however, was sometimes achieved by questionable means. At the third General Council, held in Ephesus in 431, delegates met to debate the nature of Christ. Nestorius, Bishop of Constantinople, proclaimed that Christ had two natures, one human, the other divine, and that Mary was the mother of the man Jesus but not of God. He was staunchly opposed by Saint Cyril of Alexandria who emphasized the unity of Christ's person and insisted that Mary most definitely was the mother of God. Cyril won the argument, aided by bribes and a band of monk supporters who intimidated the court and citizens of Ephesus, and in doing so brought about Nestorius' downfall.

Intimidation appears to have been a common strategy of the early monks. Most of them were uneducated peasants, easily influenced by unscrupulous ring-leaders who often used them for their own ends. But as monasticism developed and the intake broadened monks lost their rough, radical edge, although there would always be a place for extreme ascetics. Later Byzantine monasteries were more varied than the early retreats, attracting men and women from all walks of life, from peasants to patricians, from ex-teachers to emperors. More than one Byzantine ruler surrendered his purple robes for a black habit, though this was often by force rather

than choice. Two deposed eighth-century emperors, Anastasius II and Theodosius III, were sent, respectively, to monasteries in Thessalonika and Ephesus. Leading functionaries, too, were known to turn their backs on the questions of state in search of inner peace. If monasteries were convenient places of exile for politicians or patriarchs who had fallen from grace, it was a respectable enough confinement. The Byzantines attached such huge importance to the monastic life that between the seventh and fifteenth centuries, out of ninety persons canonized, seventy-five were monks.

The importance attached to monasteries extended to the gilded corridors of the imperial court. Many emperors were generous benefactors, although a few, notably the eighth-century iconoclast Constantine V, saw little benefit in the monastic life and persecuted ascetic communities relentlessly. The fortunes of the monasteries waxed and waned as the empire grew and contracted. During periods of prosperity new communities were founded by wealthy patrons while existing houses received substantial gifts, expanded their holdings, and commissioned the empire's greatest painters to embellish their walls.

In periods of crisis it was a different story: libraries and treasuries were plundered, land lost, whole monasteries abandoned to the elements. Yet in spite of such shifting fortunes, in spite of a history of wars and rebellions and a decline in the monastic calling, a significant number of important monasteries have managed to survive.

Originally the church of a former monastery, the Church of St. Saviour in Chora, Istanbul, contains some of the finest mosaics and wall paintings of the Byzantine world.

† The Stairway to Heaven

During the days of monastic adolescence, when most initiates came from the peasantry, monks were men of the people whose wild fanaticism affected the masses and generated intense theological controversy. There was no control over recruitment, and among the genuine holy men was a growing band of impostors who profited from their austerities and their mask of holiness. Worried by their potential influence on the basic tenets of Christianity the Church took steps to oust the false monks from their ranks. In 451 the Council of Chalcedon forbade the establishment of any new monastic communities without the consent of the bishops of the diocese, and canons were passed calling for episcopal supervision over existing houses. Although the true ascetic still had little time for the established church and its hierarchy, the days of monastic experimentation were quickly drawing to an end.

Increased control of the monasteries, by both Church and State, soon led to the first 'golden age' of Byzantine monasticism. The era overlapped with the reign of Justinian I, the most successful emperor since Constantine himself, who ruled for thirty-eight years during the mid-sixth century. Justinian was an autocratic ruler, unloved by his people and often guilty of excess, but he was committed to strong, efficient government and enlarging Byzantine territory. He also reinforced monastic regulations, strengthening the canons drawn up at the Council of Chalcedon in 451. Laws were passed compelling religious communities to follow the Basilian model. Henceforth, all monasteries were to be communal, with shared dormitories and refectories. Individual cells were forbidden, unless used for punishment; so was private property, which was to be disposed of before the monk took his final vows. Monks could, nevertheless, continue to inherit property, if previous arrangements had been made for its disposal, and become the guardians of minors.

With the exception of escaped slaves and serving government officials, monastic vows were open to all. Women had equal rights to men although double monasteries, with male and female quarters, were now forbidden. Henceforth monks and nuns were to live in separate communities with their own abbots and abbesses. Under the new legislation each monastery was controlled by an abbot, known as the 'hegoumenos', leader, or the 'archimandrite', head of the flock. It was usual for abbots to live in the monastery permanently though there were examples of absentee abbots. One, Apollo, was in charge of a monastery of 500 monks which he visited only once a week. Another abbot, Theoctist, was responsible for the day-to-day running of a community, but left important spiritual matters to Euthymius the Great, who only came on Sundays.

Beneath each abbot was the 'economus', roughly equivalent to an accountant, the 'bibliophylax', who looked after the library, and a 'chartophylax', the clerk and registrar. Then came the ordinary monks, few of whom were priests, although each community included several ordained monks to perform church services. Candidates followed a three-year probationary period as novices when they decided whether or not the life of a monk was really for them. If so, and with the novitiate complete, they took their vows of poverty, obedience and chastity before the abbot. The new monks adopted monastic names, their heads were tonsured and they received their black robes, the 'angelic habits', for the first time.

In many ways monasteries were extremely democratic places and, at least in theory, great social levellers. There were no comparable institutions where peasants rubbed shoulders with lords. The monks also elected their abbots, chosen for their wisdom and spiritual experience, who were then blessed and presented with the

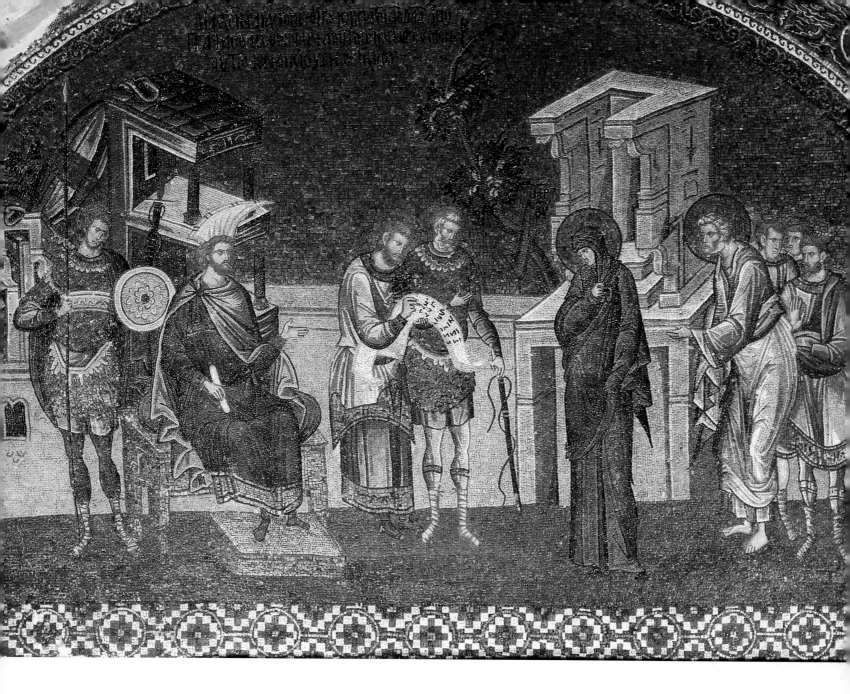

pastoral staff by the bishop of the diocese. Bishops also supervised the foundation of new monasteries, blessed chosen sites where symbolic crosses were planted, and presided over an appeal court which met to judge inter-monastic disputes. Increasingly it became the custom to recruit bishops from the monasteries. Unlike the secular clergy, celibate monks were eligible for the highest offices of the church and after Justinian most of the empire's bishops and patriarchs were recruited from the leading monasteries. The Great Lavra on Mount Athos alone produced twenty-six patriarchs and almost 150 bishops.

While imperial laws provided overall guidance there was room for individual communities to adopt different emphases in their daily timetables. Each monastery was a separate entity with its own rules defined in two foundation deeds. The 'typicon' specified the monks' rights and duties and, in particular, carried the important provision that the monks should pray for the founder and, after his death, should intercede on behalf of his soul. The supposed effectiveness of monks' prayers was often the main reason that benefactors founded new monasteries or supported existing ones. The second document, the 'brevion', stated the founder's wishes regarding the litany and listed all endowments. Subject to the limitations of the brevion, the abbot had control over all other matters.

A monk's day was long and his tasks repetitive. Each day began early with an hour of prayer before dawn. This was followed by sunrise mass, psalmody during the

Joseph and Mary enrol for the census. A fourteenth-century mosaic in the eastern wall of the exonarthex, the Church of St. Savior in Chora.

· 23 ·

Seven Canonical Hours, and all-night services for special feasts and on the eve of important saints' days. Discipline, invariably strict during peaks of monastic power, was the responsibility of the abbot. Patriarchs issued punishment codes, but the abbot was ultimately responsible for interpretation and implementation. Insolent monks who broke community rules were subject to enforced fasts or excluded from the litany. More serious offenders could expect to end up in solitary confinement – an unusual punishment, it would seem, for those who sought solitude.

As well as clarifying monastic organization, Justinian legislation granted monasteries special economic privileges. They were allowed to rent monastic lands on preferential terms and the state was forbidden to confiscate their properties. The emperor also allowed bequests from private citizens for the first time, ensuing that monasteries now had a sound financial base. When Justinian died in 565 they were wealthier and better organized than ever before.

In the religious sphere, however, Justinian's reign had mixed results. Justinian strongly desired unity between East and West, which had begun to drift apart since the reign of Constantine, but his policies only contributed to greater division. Mutual antagonism grew further as Constantinople became entirely Hellenized under his successors. In 641, Greek, the language of the Church and the people, was declared the official language of the empire. Latin West and Greek East were beginning to follow different paths which, ultimately, would end in the Great Schism of 1054.

Orthodox monks contributed to this growing rivalry as they gained a foothold in the ecclesiastical hierarchy. The first monk to be appointed patriarch was John the Faster, who in 588 raised the wrath of Rome when he adopted the title 'Ecumenical', implying supremacy over other prelates including the Pope himself. Thereafter, monks frequently sought the patriarchal seat. Between 705 and 1204, when Constantinople fell to the Latins, forty-five out of fifty-seven patriarchs had been monks, and they were often the most outspoken opponents of union.

While monks were becoming increasingly influential, the hierarchy still sought greater control over their activities. The monastic reforms initiated by Justinian were confirmed and partially extended over a century later, during the first reign of Justinian II 'Rhinometus', or 'Cut-Nose'. The Quinisextum Council, summoned by the emperor in 691, forbade the secularization of monastic property, added a year to the novitiate, and fixed a minimum age of ten for novices. The Council also tried, unsuccessfully, to control the activities of hermits and to abolish their loosely organized lavrai. According to Canon 42, 'those hermits who dress in black, wear their hair long and go about the towns visiting laymen and women' must cut their hair and enter a monastery. If they refused they were to be chased away to remote places, which probably suited some of them very well.

While monasteries were becoming formally organized, Greek spiritual writers were more concerned with the concept and practice of prayer than with their material surroundings. In the mid-fifth century, Diadochus of Photice recommended the constant repetition of the name 'Jesus' as the 'sole occupation' in a cathartic, Christocentric doctrine. Even more influential was Saint John Climacus (579?–649?), abbot of Saint Catherine's monastery on Mount Sinai, who also promoted the 'Jesus Prayer' as the simplest invocation of the name of God.

All Byzantine monks were familiar with Climacus' *Scala Paradisi*, or *Ladder of Divine Ascent*, a guide to contemplation which described Christian life with thirty rungs, the age of Christ at his baptism. A remarkable icon in Saint Catherine's Monastery depicts a ladder reaching up to heaven. Rank and file monks are climbing

The Ladder of Divine Ascent or Scala Paradisi, *as portrayed in the catholicon of the Great Lavra on Mount Athos. Devised by St. John Climacus in the seventh century, this guide to contemplation described life as a thirty-runged ladder leading to Heaven.*

up slowly, headed by John Climacus, their hands clasped in prayer. As they rise winged demons prey on their weaknesses. Evil spirits pull several monks off the ladder with ropes resembling lassos, others fire volleys of arrows. But angels are at hand to help them on their way. Only if they reach the top of the ladder unscathed are they admitted to Heaven.

† Theodore of Sykeon

One of the many hagiographies written at this time concerns the career of Theodore of Sykeon, a monk and holy man who came from a small village on the main road from Constantinople heading east. The 'Life', written by Georgios, a later abbot of the same monastery, cannot be taken as accurate or serious history but, like other lives of the saints, it provides an evocative description of the religious calling and of the importance of miraculous intervention to the average Byzantine. According to

Georgios, Theodore was born during the reign of Justinian I. His mother, Mary, was a prostitute who worked with her mother and sister at a wayside inn at Sykeon. Theodore's father, an imperial messenger, was one of Mary's clients.

On the night that Mary slept with the messenger she dreamt that a star descended from heaven and entered her womb. The bishop of Anastasioupolis and a local holy man duly interpreted this as a divine message; the baby was surely endowed with holy virtues and baptized Theodore – 'gift of God'. Major events in his life were also determined by heavenly intervention. At the age of twelve Theodore caught bubonic plague which was sweeping through the empire at the time. Near to death, he was taken to the village church of Saint John the Baptist. Above him hung an icon of Christ which, as he lay suffering, began to drip dew on the boy's frail body. Predictably the dew was a life-saving potion and Theodore made a quick and miraculous recovery.

Cured and healthy again, Theodore turned increasingly to religion. He attended church at dawn, hid himself between Epiphany and Palm Sunday, gave away worldly belongings, and learned the psalms off by heart. He stumbled over the psalms, but the difficulties soon evaporated after he addressed himself to another icon. By the age of fourteen Theodore had decided to become a monk and began by digging himself a cave beneath the church of Saint George. Even at this young age his miraculous abilities as a healer soon rose to the fore: Theodore cured a boy possessed by demons by taking oil from a lamp and anointing the boy's head in the sign of a cross.

Theodore then chose to retire from the world for two years. He hid himself away in a mountain cave and was kept nourished by a deacon who alone knew the whereabouts of his secret den. At the end of his internment Theodore was in a pitiful state, covered in sores and boils and lice. But he was soon well again and one Bishop Theodosius ordained him as a reader, the first step towards holy orders, then sub-deacon, then priest. His ordination also anticipated his subsequent acceptance as a monk. Before entering the monastery, however, Theodore went on a lengthy pilgrimage to the Holy Land where he visited biblical sites, ascetics' cells and monasteries near Jerusalem and Bethlehem.

Theodore was clearly impressed by the ascetic practices of the Palestinian monks and, although Saint Basil had sought to discourage extreme acts of self-mortification 200 years earlier, he planned his own scheme of human endurance. One winter, from Christmas until Palm Sunday, he stood in a wooden crate in the church of Saint John the Baptist. Much of the next three years he spent in an iron cage suspended in the mountains where he bound himself with shackles and carried a heavy iron cross. On the coldest winter days his feet froze to the floor of the cage. With these dramatic acts, and numerous attendant miracles, Theodore's reputation as a healer and holy man spread far and wide. Sykeon Monastery, where he was now abbot, expanded rapidly to accommodate increasing numbers of pilgrims and sick people seeking a cure.

As the monastery prospered, the trappings of a religious community were constantly improved. Marble altar vessels used for the eucharist were replaced by new silver ones, a chalice for communion wine and a paten for bread, all produced in the workshops of Constantinople. Theodore was dissatisfied with the new silverware, so he returned the first objects delivered back to the capital, declaring that they were made from recycled metal. The silversmiths admitted as much, and more – the silver had come from a prostitute's chamber-pot – so they agreed to produce a replacement set for the monastery.

With increasing demands on his time Theodore resigned his position as abbot in favour of a fellow monk named Philoumenos, so that he could travel more widely to heal the sick. On a third visit to Jerusalem his reputation was reinforced when it rained, thanks to Theodore's intervention, thus ending a long period of drought. Although travelling a great deal Theodore was still based at Sykeon and while in residence he was visited by the future emperor Maurice then on his way back to Constantinople after a successful military campaign in the east. Theodore predicted his rise to the throne and his status grew in the eyes of the imperial court. When Maurice did ascend the throne in 582 he offered Sykeon Monastery another chalice and paten and an annual subsidy of corn. The monastery church was enlarged and decorated. Sometime later Theodore is said to have obtained relics of Saint George from the city of Germia; and he was presented with a gold cross by another powerful devotee, General Domentziolus, the nephew of emperor Phocas and army commander during the Persian war.

The racy narrative of the 'Life' catalogues a remarkable number of miracles. On a brief visit to Constantinople, Theodore healed people from all walks of life including one of the emperor's sons who was suffering from a supposedly fatal disease. On a second visit during the reign of Phocas he cured the pain in the emperor's hands and feet, but also censured him for committing innumerable murders. Icons often played an important role in Theodore's cures; in one, the saint's presence miraculously affected the icon itself.

Even on his deathbed Theodore continued to prophesy and cure. When near to death he blessed the Emperor Heraclius who stopped at the monastery while heading east to fight in the Persian wars. Theodore died on 22 April 613 and when the news reached the capital the patriarch Sergius I celebrated a special service in Saint Sophia, Justinian's great church, and decreed an annual commemoration. Another saint had been canonized.

✝ Forbidden Images

The reforms of Justinian and the Quinisextum Council did much to encourage the foundation of new monasteries, but during the eighth century there was a lull in building activity. Much of this slowdown was due to the antagonism of emperors who opposed the veneration of icons and tried to curtail growing monastic influence. As is illustrated by the life of Theodore, images of Christ, the Mother of God, and the veneration of early saints, had become an essential characteristic of Orthodoxy. As an aid to worship, icons adorned churches and monasteries, wayside shrines and private homes, but during the eighth and ninth centuries the iconoclasts, or icon-smashers, demanded that art representing God or the human form should be destroyed. They argued that icons had become little more than talismans or magic charms which produced a paganistic idolatry rather than leading worshippers to God. The reformers had influential supporters and from 726 until 780, icon veneration was officially suppressed.

The first attacks started under Emperor Leo III, who ordered palace workmen to pull down the vast golden mosaic of Christ, Constantinople's most prominent icon, on the principal Chalke gateway of the Imperial Palace. It was a rash decision and rioting ensued. A group of enraged women set upon the workmen demolishing the image and killed their foreman on the spot. Leo retaliated by having the women executed. Demonstrations spread beyond the capital as the iconodules got wind of

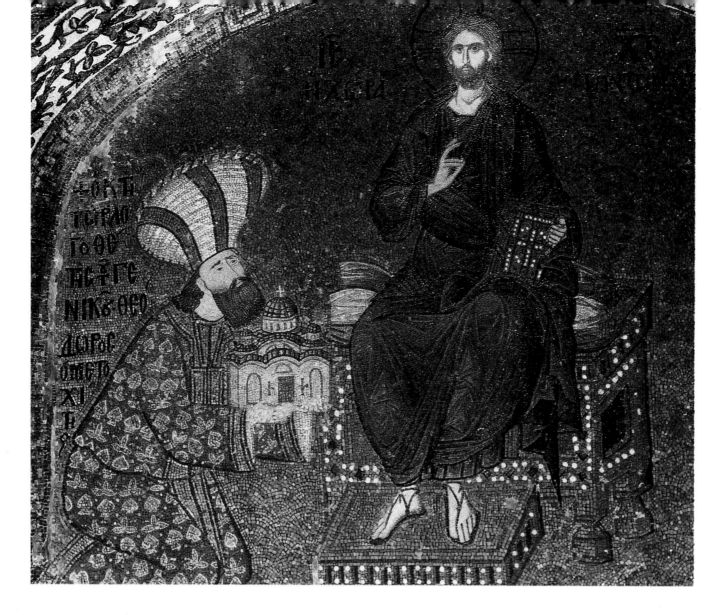

Christ on the throne with Theodore Metochites, a Byzantine minister and founder of the Chora Monastery in Constantinople.

Leo's deeds. There were mutinies in the Aegean fleet and among the army in Thrace. The people vented their anger in a time-honoured way by taking to the streets but Leo remained unbowed. Holy pictures continued to be smashed. The iconodule Patriarch Germanus was replaced by an acquiescent cleric called Anastasius, and those who continued to cherish their icons lived in constant fear of arrest and punishment.

The biggest burden fell on the monasteries, whose splendid collections of icons and holy relics were an obvious target for the emperor's vandals. Hundreds of monks left the capital for the Greek provinces concealing as many icons as they could beneath their robes. Others fled as far as Italy or sought refuge in the volcanic valleys of Cappadocia which had already become a refuge for eastern Christians fleeing Saracen raids. Meanwhile the emperor was carefully nurturing his son Constantine in his iconoclastic ways and when Leo died in 741 there seemed little hope that chastisement and persecution would cease. A year later, however, Constantine's brother-in-law, Artabasdus, briefly seized the throne while the emperor was marching east to fight the Saracens. He immediately ordered the icons to be re-instated and thousands of images that had been hidden from the emperor's officials, or which many thought had been destroyed, appeared to grace the city's churches and public buildings once again.

For the iconodules it was a false and short-lived hope. Constantine V, nick-named 'Copronymus' following an unfortunate accident of the bowels during his baptism, was back on the throne within sixteen months and he soon proved himself a more militant icon-smasher than his father. Artabasdus' coup had only deepened Constantine's hatred of holy images. Earlier orders for their destruction were simply

reconfirmed and leaders of the pro-icon party, including the deposed Patriarch Germanus, were excommunicated. Iconodules could do little but wait and pray, though they felt God was on their side. When plague struck the city they interpreted it as divine admonition. Its effects were later recorded by another Saint Theodore, abbot of the influential Studium Monastery, in a memoir to his uncle Plato: 'There suddenly appeared on each man's garments the sign of the living Cross, drawn in bold strokes as if by an accomplished hand. No such thing; it was formed by the finger of God. A man so taken was greatly disturbed in his mind, for death followed shortly thereafter.'

The monasteries were again one of the emperor's principal targets. But whereas Leo had railed against them for their icons and holy relics, Constantine became firmly anti-monk and persecuted them for their own sake. In Constantine's view they were 'the unmentionables', corrupt institutions which had sunk to the lowest levels of human greed and debauchery. Opponents trying to make their voices heard above this relentless diatribe were silenced or ridiculed. One leading monk, Stephen, abbot of Saint Auxentius' Monastery in Bithynia, was arrested on charges of coercing people into adopting the monastic life. In the aftermath of a Council of 754 condemning holy images, monks flocked to Stephen for advice. The monastery became a focus of dissent and when Stephen and his monks refused to accept the rulings of the Council they were held under house arrest. Still they refused to acquiesce. So Constantine burned the monastery to the ground and forced Stephen to live in another monastery near Constantinople. He remained a thorn in the emperor's side, however, and was exiled to an island in the Sea of Marmara where he was soon joined by other monks from Saint Auxentius.

Later, Stephen was recalled from exile and hauled before the emperor but he had still not changed his mind. A theological dispute ensued which resulted in Stephen being imprisoned along with 342 other monks. For eleven months he survived on a meagre diet of bread and water brought to him by a sympathizer, the wife of one of the prison guards. Reports then reached the emperor that Stephen was transforming the prison into a monastery. Enraged palace officials were sent to drag him from his would-be retreat. A crowd gathered, a scuffle ensued and, in circumstances that remain unclear, a mob stoned him to death on the streets.

Elsewhere the stories, albeit invariably recounted by iconodules, were similar. Odious and brutal officials had a field-day persecuting the monks in their midst. In Thracesion, a province comprising much of the central Ionian coast and its hinterland, the local governor, Michael Lachanodrakon, ordered all monks and nuns to marry or to face deportation to Cyprus. Monks who opposed him, it was said, had their beards oiled and waxed, and then, if they continued to refuse his commands, set on fire. The empty monasteries were ransacked, their libraries burned, and treasures looted. The most valuable gold and silver vessels were sold and the proceeds sent to the emperor.

Constantine was delighted with his distant official; monk baiting was proving a profitable business. That and the continuing persecution of the iconophiles became principal features of his long and brutal reign. There were practical reasons, however, for Constantine's efforts to empty the monasteries. He urgently needed manpower, particularly in Asia Minor, to help secure the empire's borders and to till the land. By discouraging his citizens from taking holy vows he hoped to channel them into more constructive occupations. But it was a battle he simply could not hope to win; he was tampering with the Byzantine soul, which accepted monasticism as the ultimate sacrifice in the name of God the Father. Even members of his court

and senior army officers continued to opt for the cloistered life in retirement. In the second half of his reign the numbers of serving monks plummeted, but within a few years of his death in 775 the monasteries were full and flourishing again.

Constantine's son and successor, Leo IV, could well have turned out to be an iconoclast like his father, but under the influence of his wife Irene, a much stronger character and an icon sympathizer, his natural inclinations were kept firmly in check. Some persecutions continued, Leo had a group of senior officials imprisoned for icon worship, but they were minimal compared with earlier years. Largely due to Irene, the monasteries were also left to their own devices and desires, and exiled monks returned to their former homes. And it was under Irene, who became the effective Byzantine ruler following her husband's death in 780, that the first bitter era of the iconoclastic controversy finally came to an end.

A second attack on icons began in 815. This time, Theodore of Studium and other monks emerged as key defenders. In a series of rhetorical dialogues Theodore replied to the iconoclasts' arguments point by point. But writing and impassioned speeches were also accompanied by action. One Palm Sunday a parade of monks, headed by Theodore, marched through the streets of Constantinople clutching icons. It was a remarkable gesture of defiance but the authorities were unyielding. Theodore was arrested, imprisoned and flogged.

Under a new emperor, Michael II, the pressure against icons continued in Constantinople. It was, however, relaxed in the provinces and Theodore, wishing to remain true to his version of the faith, left the Studium with some of its monks for the countryside. But even here Theodore was not free of the emperor's grip. Michael feared that Theodore and his fellow exiles would support Thomas the Slav, a pretender to the throne, so he ordered them back to the capital where they remained within the Studium walls. The dispute continued to rage, outliving Theodore by seventeen years, but the monks were to get their way in the end. Following the Council of 843, the icons were reinstated by Empress Theodora and their role in Orthodoxy was never significantly challenged again. This, the final victory of the iconodules over the iconoclasts, came to be known as 'the Triumph of Orthodoxy', and is still celebrated each year on the first Sunday of Lent.

† Saint Theodore and the Studium

It is somewhat paradoxical that the most influential of all Byzantine monasteries, probably the greatest spiritual centre in Constantinople, underwent a remarkable renaissance in the early ninth century when iconoclasm and monastic persecution still raged. Known as the Studium, and located near the Golden Gate on the Marmara coast, the monastery is associated with Saint Theodore, the reforming abbot whose name is so closely linked with the most controversial religious questions of the day. Born in Constantinople in 759, in the middle of the first iconoclastic purge, Theodore came from a distinguished family. His father, Photinus, worked at the imperial treasury. His fanatically religious mother, Theoctista, was a society lady who believed in good works and bringing her son up as a well-bred Christian. And it was her pious attitudes which were to have the greatest influence on her son's life. After studying in the libraries of Constantinople, Theodore followed in his uncle's footsteps beginning his monastic career in the famous centre of Bithynian Olympus. He later returned to the capital where, under his direction, the Studium Monastery was reinvigorated and its rules revised to create a more ordered and active establishment.

The Nea Moni Monastery on Chios, together with Daphni and Saint Luke's (see Chapter 4), contains one of the most important series of eleventh-century Byzantine mosaics in Greece. The brightly coloured scenes, characterised by austere figures with expressive features, include (OPPOSITE) Peter cutting Malchus' ear, (PAGE 34) a winged cherub, and (PAGE 39) the washing of the feet.

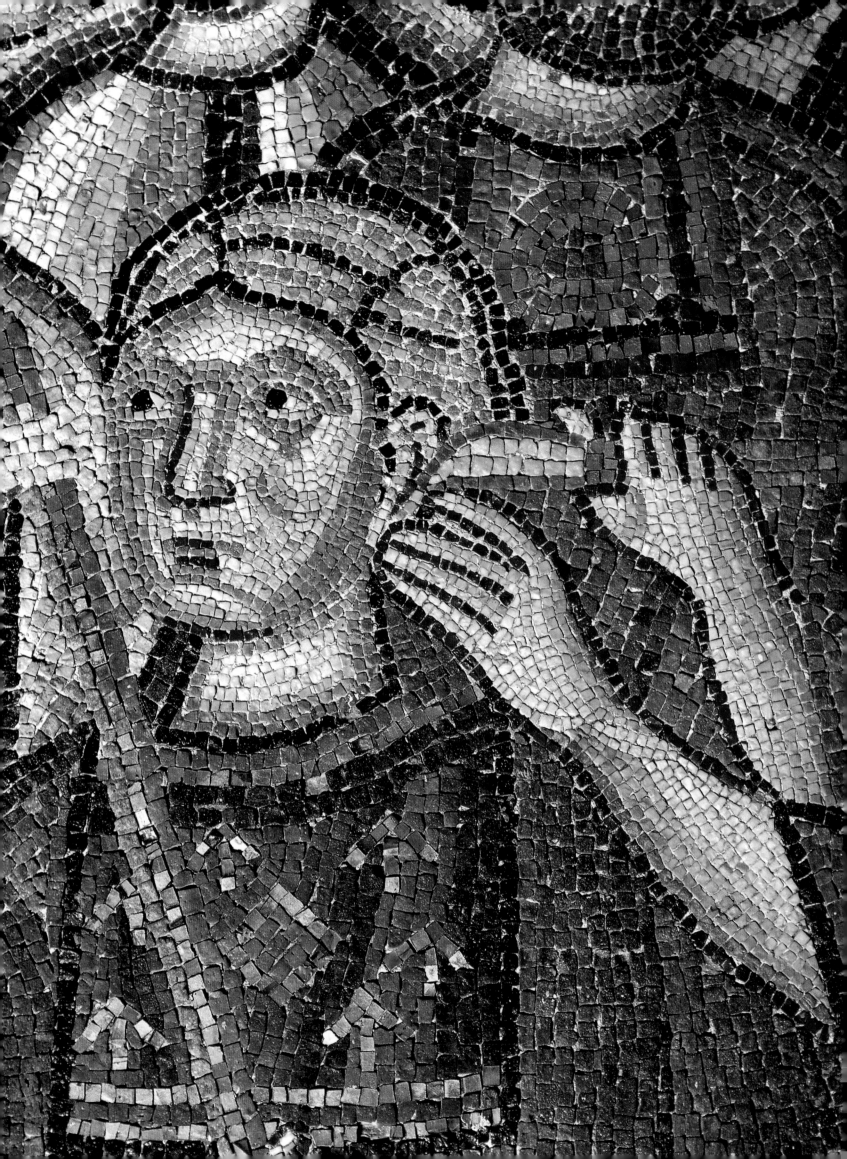

Development of the site had begun more than 300 years earlier when an expatriate Roman called Studius founded the Church of Saint John of Studium in 463. His benevolence soon spread to include a monastic community hitherto based on the River Euphrates. Known as the 'sleepless ones', the brethren divided their day into shifts to hold perpetual vigils and constant prayer, actions which soon had them talked about throughout the city. Studius, attracted by their strict doctrine, offered them financial support and they became the first monks of the Studium foundation. Continuous vigils had been abandoned by the time Theodore became abbot, but he quickly set about establishing his own rules for a highly disciplined community.

In addition to the leading functionaries, the abbot himself, the economus and the bibliophylax, the Studium included numerous minor officials to ensure the smooth functioning of the monastery. There was a supervisor of church music; the 'epistemonarchoi', who arbitrated between disputing monks; and the 'taxiarch' who organized processions and other church rituals. Strict discipline was maintained under the watchful eyes of the 'epitaktoi' who reported any breaches in house rules to the abbot. Theodore was moved to verse to describe this form of monastic neighbourhood watch:

'You are my eyes among the brothers. See
All that they do, and note it carefully,
By dark of night or under noonday sun.
Restrain loose laughter. Angry words repress,
For these will turn our thoughts from godliness.'

The monastic day began with a morning call on the 'semantron', a wooden clapper said to symbolize the timber used in the building of Noah's ark. Like the epitaktoi, wakers-up had strict instructions to 'Search through all the drowsy cells and look in every bed. Sleep's done. It's time for morning prayers instead.' One of the toughest jobs was that of the cook, who slaved over open fires and in primitive kitchens thick with smoke. Theodore recognized the cook's thankless task. But if the monks were unable to appreciate his cooking the drudgery would take him straight to God: 'You scour the pots, but scrub your sins as well. Better the kitchen fires than the fires of Hell.'

Despite such strict discipline the Studium attracted eager new recruits, many of whom were soon busy copying manuscripts in the monastery's scriptorium. Seated before solid wooden easels, the monks produced new copies of early religious texts enhanced with fresh illustrations. On their palettes shells held coloured inks; wooden rules held down the script; and a small knife was at hand to sharpen the reed pens. Byzantine scriptoria were invariably poorly lit and unheated, so the older monks suffered from poor eyesight and arthritic hands. At the Studium, Theodore took a particular interest in his monks' skills. He was an expert calligrapher himself and may well have influenced the form of later Byzantine scripts. Other important monasteries in the city, such as the Hodegon, fulfilled similar functions to the Studium so that by the eleventh century half the empire's scribes were monks.

✝ The Second Golden Age

During the tenth century, with the iconoclastic controversy firmly behind them, monasteries began to acquire substantial landholdings beyond their own walls. They became increasingly wealthy as donations from pious benefactors and successive

emperors flooded in. Rent and other income from their distant fields, workshops and urban properties swelled the coffers and they benefited, too, from generous tax concessions; their fixed and liquid assets were zero-rated. Not all, however, welcomed the growing prosperity of the monasteries. Emperor Nicephorus II Phocas, who reigned from 963 until 969 and planned to retire to a monastery on Mount Athos, endorsed the stricter concept of 'poor monasticism'. His ascetic nature was affronted by the enormous wealth accumulated by the monasteries and in 964, in an effort to curb the continuing growth of monastic estates, he issued an edict restricting further land acquisition. Would-be benefactors could restore ruined or derelict monasteries, but no new foundations could be established. The edict, however, was short lived. Nicephorus' successor, John I Tzimisces, revoked the order and monasteries continued, as before, to expand their holdings.

It has been estimated that by the year 1000 there were more than 7000 monasteries within the borders of the empire. About one per cent of the population was probably monastic and each monastery had an average of twenty-one and a half monks. (It seems modern statistics decapitate monks as easily as their early suppressors.) During the twelfth century there were 175 monasteries in Constantinople and its suburbs alone. The smaller establishments had no more than ten members; the largest, such as the Studium, comprised several hundred monks. One source claims a thousand monks lived at the Studium but this is probably an exaggeration. Monasteries and convents were dotted all over the countryside and an important provincial city, such as Thessalonika, had twenty establishments at least.

Monasteries varied enormously in size, influence and collective intellect. New retreats were founded by holy men or rich laymen; by emperors, patriarchs or priests. Patriarchal foundations, however near or distant from the capital, were controlled by the 'sacellarius' from the patriarchal court. Imperial monasteries were directed by the emperor's officials, without recourse to the church, and some were decreed to be 'autodespotae', free of all ecclesiastical and civil jurisdiction. Sometimes monasteries overextended themselves. Legislation had proved ineffective in curbing monastic growth, but the huge properties and pious endowments began to create problems for the monks themselves who could no longer manage their vast estates. Self-control became inevitable. Some monasteries appointed stewards to look after distant holdings; others employed the costly services of a property manager.

The latter foundations became known as 'charisticum' monasteries. Their manager or protector, the 'charisticarius', administered the monastic holdings, distributing the income on a needs basis to the monastery and retaining any profit. The authorities supported the idea since it meant estates could be efficiently organized and well managed. Many founders, however, were wary of the system. It was open to abuse, unreasonable profits could be made, so they stipulated that their foundation should never be converted to a charisticum. The introduction of what, in effect, amounted to commercially-run establishments was so far removed from the Basilian ideal that they challenged the whole monastic movement. But they never gained widespread acceptance and most monasteries remained true to their faith in personal frugality.

Attitudes to learning changed from place to place, and from one generation of monks to another. Since the early days monastic leaders had emphasized the necessity of reading. Pachomius ruled that any illiterates entering a monastery must first learn to read by studying three times a day. An ability to read, however, did not make a monk learned and it seems likely that many monks, particularly in monastic

backwaters, remained illiterate. All monasteries, of course, had a library of sorts. Some were rudimentary and poorly kept; others, including the leading monasteries at Athos and Saint John's Monastery on Patmos, maintained important collections of books and documents which are largely intact today. The monasteries of Bithynian Olympus promoted religious studies; while the monks and hermits hidden away in the hills of Cappadocia were more interested in contemplation than books.

The urban monasteries, more usually than their provincial counterparts, encouraged intellectual discussion and until the last centuries of Byzantine rule were important centres of learning. Theodore of Studium stressed the importance of monastic libraries and established rules for their use: 'It should be known that on days when we perform no physical labour the librarian strikes a gong once, the brothers gather at the place where the books are kept, and each takes one, reading it until late. Before the bell is rung for evening service the librarian strikes again, and all come to return their books according to the list.' If any monk was late in returning his books he was subject to an unspecified penalty. Theodore gives the impression of a well organized and learned community, but outside the main towns and monastic centres monasteries were often unworthy institutions. Some were little more than

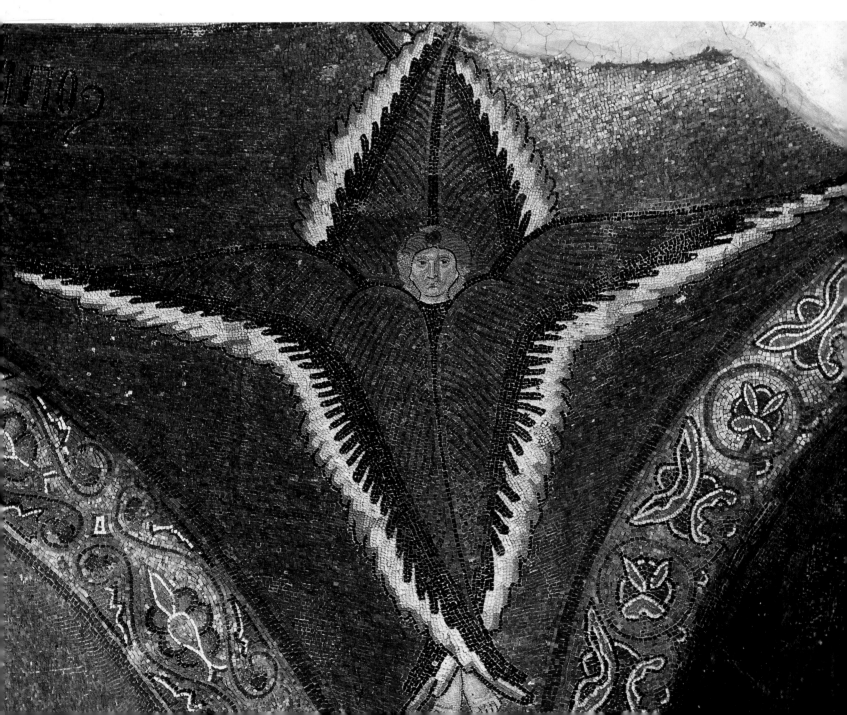

residential clubs, and, the worst of all were full of the lazy, ignorant and dishonest who plundered the monasteries' treasures, and sold invaluable books from the libraries.

By the tenth century, although most monasteries were coenobitic and several emperors had attempted to abolish the lavrai, a significant minority of monks still craved a more solitary life. Allowance was made for them within the coenobitic system itself. With his abbot's permission a monk could elect to live in a separate cell within the monastery, an affiliated lavra nearby, or an isolated cave in the country-side. Each monastery was allowed a maximum of five solitaries, or 'kelliots'. Today, the system has virtually disappeared except on Mount Athos where most variants of the reclusive life still exist side by side.

During the middle Byzantine period the true hermit, the original stylite or dendrite, became increasingly rare. The last recorded stylites, two men called Luke, both lived during the tenth century. The younger of the two became renowned for his prophetic powers and had some influence over local administrators. Governors used to consult him in his isolated retreat in Styris. When he successfully prophesized that the Byzantines would retake Crete from the Saracens in 961 his fame reached the royal court. So impressed was the emperor that when Luke died his hermitage was converted into a monastery by imperial decree.

If mystics sought solitude, the church encouraged them to adapt to the coenobitic life until they were sure of their calling. Symeon the New Theologian (949–1022), the greatest of the Byzantine mystics, spent most of his career in a coenobitic monastery in Constantinople before retiring to the countryside. It was in the great city that he attempted to describe the mystical experience, the search for the Light which was actively followed by the monks on Mount Athos. 'I know', he wrote, 'that the Invisible appears to me.' Symeon believed that all baptized Christians could have direct experience of the Holy Spirit. He described the culmination of the mystical experience as a vision of the divine and uncreated light, the Light of God himself.

✝ The Cistercians and the Fourth Crusade

While monasticism was enjoying its second golden age trouble was beginning to brew in the West. The Crusades had initially been launched to help the Byzantines repulse the Muslims from the Holy Land, but the Venetians and Franks soon showed that they had broader interests than the liberation of Palestine. Some were more interested in commerce and territory than religious ideology; others were more concerned with uniting the two Churches than with stopping Islam. In 1204 the Fourth Crusade was directed at Constantinople itself, ostensibly to help settle the disputed succession to the throne. It was an inadequate excuse. The city was sacked on 13 April, its churches desecrated, its monasteries pillaged and ruined. Elsewhere, in the Peloponnese, Boeotia and Crete and other territories conquered by the Latins, monastic life was also disturbed. Athonite monasteries lost the bulk of their mainland estates, though they were recovered when the Nicaean emperors, who, following the Fourth Crusade, had managed to retain control over some Byzantine lands around Nicea, recaptured Macedonia in 1224.

Monasteries were not only disturbed. Some were even occupied by Latin monks after the Orthodox had been ousted. Daphni, near Athens, for example, housed Cistercian monks for over two hundred years. The Cistercian order, which

had been founded in 1098 as a strict offshoot of the Benedictines, played a crucial role in the organization of the Fourth Crusade and in the establishment of the French in Greece. Once territories had been allotted to the Latin knights, the foreign monks began to found their own houses or take over existing monasteries. As well as Daphni, they occupied Ossios Loukas and Orchomenos monasteries in Boeotia, the monastery of Vlacherna on the Kyllene peninsula, and Zaraka Abbey on Lake Stymphalia.

The Cistercians' main task, following the behest of Pope Innocent III, was to work towards ecumenism, the union between eastern and western churches. It was a thankless task, working among an antagonistic population that their countrymen had conquered, although they did have the support of the Knights Templars, later replaced by the Knights of Saint John, and of the Franciscans and Dominicans, who had their own monasteries on the mainland and several islands. Their efforts, ultimately, were to fail but they have left their mark in a number of curious double churches built with two naves, one for the Orthodox, the second for the Catholics, such as the twin church at Ossios Loukas Monastery.

✝ The Palaiologos Renaissance

Constantinople was in Latin hands for little more than fifty years, but in that time the invaders had a marked effect on monastic life. Michael VIII Palaiologus reconquered the city in 1261 to find its monasteries impoverished and in an advanced state of decay. Some had disappeared altogether; most had lost endowments. Michael offered monasteries the means to rebuild. Few new ones were founded, but Michael amalgamated and repaired existing houses to form larger, more efficient units. The emperor had the Monastery of Saint Demetrius rebuilt and renamed. His daughter Maria, the widow of a Mongol khan, enlarged and repaired the monastery which became known as Mary of the Mongols. Its church, which still stands in the Fener district of the city, was the only Byzantine church to remain in Greek hands after the fall of the city to the Turks.

Monasteries were sometimes founded on the basis of self-aggrandizement rather than theological piety. Two fourteenth-century ministers, Theodore Metochites and Nicephorus Choumnos, endowed new monasteries and then joined them in retirement. Choumnos changed his name to Nathaniel and died a monk in 1327 in his Monastery of the Saviour Philanthropenos, one of the city's few double monasteries which, despite earlier legislation, continued to accept women as well as men. Metochites, renamed Father Theoleptos, died five years later in his Monastery of the Saviour in Chora, whose splendid church, decorated with some of the finest mosaics of the period, still stands a stone's-throw from the Theodosian land walls.

In the provinces monasteries were generally fewer and poorer, but new establishments continued to be founded and existing houses recovered many of the holdings they had lost during the Latin occupation. From the thirteenth to the fifteenth century, monastic records show continued acquisitions in southern Macedonia by the monasteries on Mount Athos, on the Aegean islands, and near Trebizond, now in north-east Turkey but then the capital of the Greek Pontic kingdom. Several foundations were established at Mistra, the capital of the Principality of Morea; at Kastoria, near the Albanian border; and at Megaspelaion, the 'great cave', in the Peloponnese. In Thessaly, the curious pinnacled landscape of the Meteora, long the home of hermits, attracted the attention of Serbian kings who funded several new houses there.

Monks also began to play a greater role in influencing church policy. They had made their views known during the days of the iconoclastic controversy when they had strongly opposed imperial views. Since then they had had little say in church politics, but from the thirteenth century onwards they had their own party which disapproved of the upper hierarchy and the royal court. Deeply conservative, yet democratic, the monastic party staunchly opposed granting concessions to achieve union with Rome. The party criticized court luxuries and the autocracy of the emperor. It was suspicious of philosophers in lay establishments who might pry into theological matters. But they were willing to form alliances when it suited them, particularly with the landed nobility who had similar economic interests to their own.

The first party to emerge as a distinct force of opposition were the Arsenites who supported Patriarch Arsenius Autorianus of Apollonia, an erudite monk who was head of the church when Michael VIII Palaiologus recaptured Constantinople from the Franks. Even before Michael retook the city, Arsenius was suspicious of his intentions. The new emperor had usurped the throne from the child Emperor John IV and, despite initial assurances that the boy would not be harmed, he deposed and blinded him in 1262. Arsenius, horrified, promptly excommunicated Michael and relations between emperor and patriarch steadily worsened.

Michael sought his revenge. But it was three years before his protests and plottings against Arsenius succeeded. Having bought off a number of patriarchal officials, the emperor called for a Synod at which Arsenius was accused of omitting Michael's name from church services and of allowing a Turkish emir to participate in communion. Arsenius considered the Synod illegal and refused to appear before it. For this he was condemned, deposed and finally exiled to an island monastery where he died seven years later. With Arsenius out of the way, Michael now sought absolution for his treatment of John IV. Under a later patriarch, Joseph of Galesia, Michael was finally absolved of guilt but only at a price. A law was passed giving patriarchal decrees equal validity to imperial decrees; blind John was granted a hefty pension; and a humiliated Michael, dressed in penitential clothes, confessed his crimes on his knees before the patriarch.

Michael's confession, however, did little to placate the Arsenites. The monasteries, always suspicious of the imperial court and church leaders, adopted Arsenius as a martyr who had courageously opposed the emperor on a matter of principle. They were joined by others in the hierarchy who were also uneasy about imperial influence over the Church. The Arsenites refused to recognize Joseph's pardon: to them the emperor remained excommunicate, his hierarchy illegitimate, and his officials no more than a usurper's lackeys. The hierarchy tried to oust dissidents from the monasteries, but many simply went to ground. Those that were dismissed wandered around in coarse rags preaching resistance among the people. In the provinces Arsenites flourished, although they were successfully suppressed in the capital where Michael continued to enjoy the support of leading churchmen.

Michael Palaiologus had other reasons for suppressing dissident monks. He sought, as much for political as religious reasons, a union with Rome, a policy which divided the church and was widely condemned by priests, monks and laity alike. He subscribed to the 1274 Union of Lyons held by Pope Gregory X in the presence of the discredited ex-Patriarch Germanus. But before successfully forging a union, Michael was dead. His son and successor, Andronicus II, following mass popular protests, reversed his father's policy and demoted the advocates of union. With the merger scrapped and Michael dead, the Arsenites were gradually reconciled, and

even joined the hierarchy. They nevertheless left behind a body of rump dissent, the Religious Zealots, who advocated the ascetic life and contemplation and remained averse to the court and its intellectuals.

Within the Church the Religious Zealots were opposed by the Political Zealots. They believed in co-operation with the state and supported the monk Barlaam, an opponent of the mystical 'hesychasts' who tried to attain divine peace and tranquillity in their search for God. In the heady atmosphere of the time the two groups inevitably became embroiled in the dynastic struggles which weakened the already diminished empire during the mid-fourteenth century. Generally speaking, the monks, villagers, the landed aristocracy and Church Zealots supported John VI Cantacuzene, the usurper, who had declared himself emperor in 1341 at Didymoteichon in Thrace. The legitimate Palaiologan dynasty, however, gained most of their support from the capital, from the intellectuals and the upper hierarchy.

Things turned out differently in Thessalonika. Here, in 1345, power was seized by the Political Zealots, who supported Palaiologus rather than Cantacuzene. After lynching the co-governor, they declared an independent city-state and confiscated episcopal and monastic property. They professed to be acting on behalf of lower-paid clergy and railed against the disparity of church endowments. But they soon lost the support of the monks and priests whom they claimed to represent. In 1349, John Cantacuzene marched on the city, suppressed the uprising and arrested leading zealots. The revolt was over, Cantacuzene had consolidated his power, but it was the Palaiologan dynasty that would ultimately triumph.

The zealot question was intimately linked with another equally contentious issue, the so-called hesychast controversy which proved as divisive as the iconoclastic disputes had been 500 years earlier. In the fourteenth century monks became increasingly concerned about the exact nature of the divine light and the Vision of the Father. None doubted that it existed, but could it be apprehended by mere mortals? And how could a pure mystical experience be described with the restricted concepts of language?

The hesychast approach to contemplation gained a new momentum under the teachings of Gregory of Sinai who left his monastery on Mount Sinai in the early fourteenth century to travel through Greek lands. After receiving instruction in contemplation from a Cretan ascetic he took his knowledge to Mount Athos where he soon attracted a group of disciples, among them the future Patriarch Kallistos I. In the privacy of their cells, Gregory and his hesychast followers claimed to receive the light of the divine vision by adopting particular exercises and postures. Monks sat in silence with their chins on their chest and their eyes fixed on their navel. Simultaneously they repeated the Jesus prayer: 'Jesus Christ Son of God have mercy upon me'. In this way they claimed to experience the uncreated light, the same divine light that had transfigured Christ on Mount Tabor and had blinded the apostles.

Not all accepted the hesychasts' claims. The first to challenge their doctrine was Barlaam, a Greek monk from Calabria in southern Italy. In 1330 he went to Constantinople where he attacked the leading theologians of the capital before turning his wrath on the monks at Athos. Supported by the Political Zealots, Barlaam denounced the hesychasts to the Patriarch John Calecas for heresy. And the monks were dismissed as unworthy 'omphalopsychi', those who keep their souls in their navels. Hesychast supporters, however, were quick to jump to their defence. Chief among them was Gregory Palamas, a solitary at the Saint Sabas hermitage on Athos, who drew up a hesychast manifesto approved by his colleagues. In 1341, at a Council

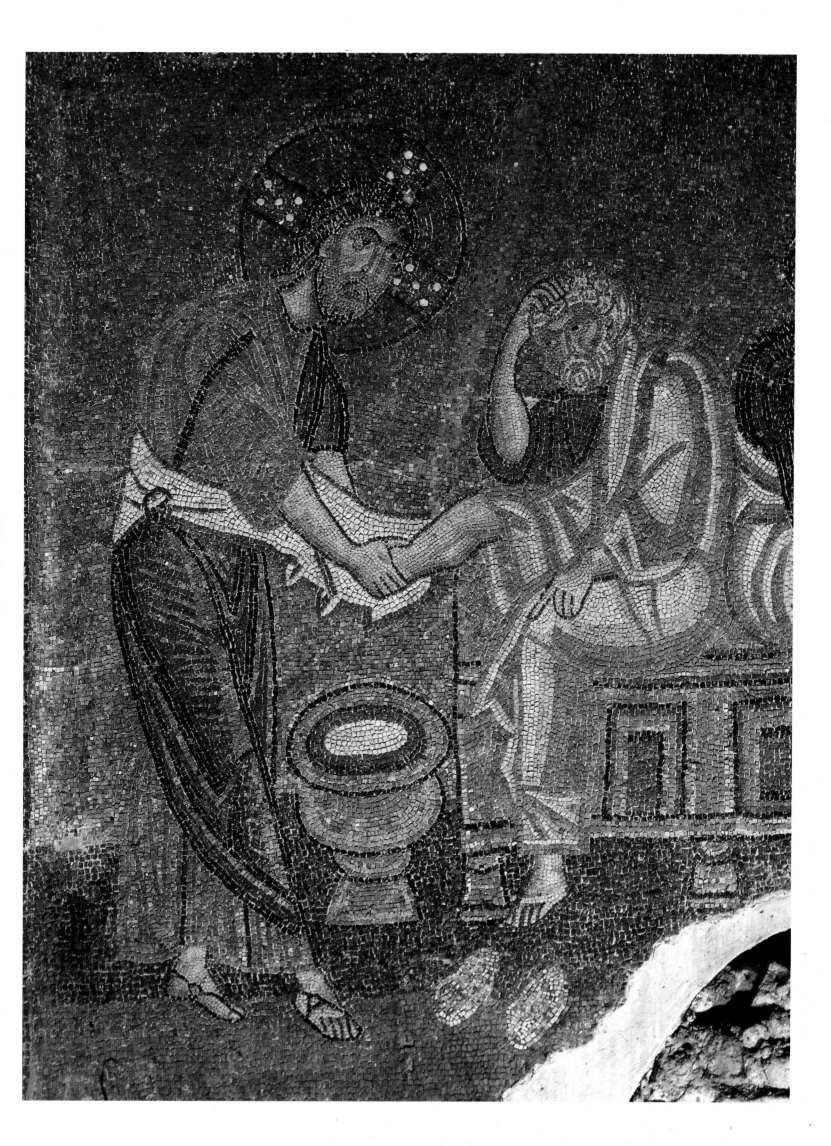

summoned in Constantinople, the hesychast doctrine was vindicated and the slighted Barlaam sailed back to Italy.

The issues raised in Constantinople, however, took a long time to settle. Barlaam's all-embracing attack on hesychasm was soon forgotten as the arguments became more subtle. There were wider theological implications to hesychast claims to see God. Palamas distinguished between the essence and the energies of God. In his essence God was imperceptible to the human senses, but through his divine energies he could make his presence known to man. To Palamas, the light of the Transfiguration experienced by practiced hesychasts was one of the manifestations of these energies. Some leading theologians, however, disagreed. By distinguishing between God's energies and essence Palamas drew accusations of dualism. His claims verged on heresy.

Palamas' leading opponent this time was Nicephorus Gregoras, a conservative scholar who was convinced that the conception of God implicit in hesychasm was heretical. He had some influential support among the clergy and the capital's intelligentsia. Most importantly the Empress Anna and the Patriarch Calecas believed Palamas' teachings were heterodox. The decisions of the Palamite Council were thus reversed, hesychasm condemned, and Palamas was thrown into jail. The empress's rough handling of the matter ensured that the vast majority of monks, even though few understood the theological arguments, zealously supported the imprisoned Palamas. Their chance came in 1347 when, as the usurper John VI Cantacuzene marched towards the city, Palamas was released and his friend Isidore appointed as patriarch. At another Council in 1351 the practice of hesychasm with all its implications was finally accepted by the Byzantine Church.

✝ Excess in Excelsior

While theological controversies raged in Constantinople, in the provinces there was an underlying popular unease about the excesses of monastic wealth. Monasteries had shown a remarkable ability in assembling vast holdings and had successfully resisted any slippage back into lay or imperial hands. The unease had been highlighted by the unsuccessful Zealot revolt, but the feeling had been growing for some time. In the late twelfth century the Byzantine chronicler Archbishop Eustathios of Thessalonika described how monks threatened the poor and charmed the rich into parting with their property, and then forgot them when they had what they sought. The life of a Byzantine peasant was probably little different whether working on monastic, private or state lands, but resentment was growing against institutions which professed poverty while accumulating wealth.

How much land was owned by monasteries is impossible to determine; though one scholar has suggested that half the empire was controlled by monks during the last centuries of Byzantine rule. It was certainly a huge proportion and at some point monasteries would have to be brought to heel. Emperors were finally jolted into action by the worsening state of the economy. In November 1367, John V Palaiologus distributed tracts of monastic lands to his increasingly disgruntled soldiers. A synod replied to the effect that even the ecumenical patriarch had no right to give away church property but, 'if the holy emperor wishes to take them by his own power, to do with them what he has in mind, let him do so ... We ourselves will in no way do this, by our own will.'

But there were some pious advocates of redistribution. The ascetic

Patriarch Athanasius I, who held office from 1289 until 1293 and again between 1303 and 1309, advocated the donation of church lands to charity and monastic holdings to the state. The fourteenth century humanist mystic Nicholas Cabasilas shared his views: '...is it not better if with (monastic) money we arm soldiers who will die for these churches, for these laws, for these walls, than if these same sums were spent in vain by monks and priests whose table and other needs are slight, for they stay at home, live in shelter and expose themselves to no danger?' And a fourteenth-century bishop of Philadelphia, Theoleptos, condemned what he saw as the negative effects of capitalism on late Byzantine monasticism.

Theoleptos and Cabasilas, however, represented a minority view. Most monasteries still aimed to follow the coenobitic ideal and enjoyed the support of the people. And their voices, anyway, were swamped by the heated debates of the hesychasts and Religious Zealots which were far removed from the economic and political realities of the day. So absorbed were the monasteries in religious controversy that they failed to recognize, or at least remained uninterested in, the dire straits of the empire. Byzantium was being threatened by enemies on all sides and while monks debated the nature of divine revelation the Turks swept in from the east, taking Macedonia and with it the Holy Mountain, and then finally Constantinople, the illustrious and incomparable capital, in 1453.

Byzantium was no more. The capital of eastern Orthodoxy had been usurped by Islam. The former monastic centres in Asia Minor, in Cappadocia and Bithynian Olympus, rapidly declined. But in the Greek provinces monasticism managed to survive. It was a shadow of its former self, but throughout the Turkish period monasticism would continue to nurture the Byzantine spirit and the soul of the Greek people.

·3·

The Guardians of Hellenismos

There is nothing improbable in the supposition, that in Greece the least corrupted part of the population may be the monks, and that the virtue which oppression has contributed to expel from the higher classes may have found some sort of refuge among them; for the policy of the Turks has always protected them more, or rather persecuted them less, than the other orders of the community.

Revd George Waddington, writing from the Monastery of the Strophades, May 1820

After the fall of Constantinople in 1453, the organization and spirit of the Orthodox church and its monasteries would never be the same again. Much of mainland Greece had been conquered by the Turks long before, but it was the capture of the Great City, the centre of the Byzantine world, that finally put an end to the empire. Under the Turks the Greeks continued to enjoy freedom of worship, but they were now captive to a foreign power, second-class citizens in their own homeland. Although the Greek spirit managed to live on, largely guarded by the Church and its monasteries, the light of Orthodoxy dimmed. In many churches the candles were extinguished for ever. These long dark centuries, which the Greeks call the Turcokratia, lasted until the end of the Greek War of Independence in 1827, although much of Macedonia, including the monasteries on Mount Athos, and western Thrace, would remain in Turkish hands until 1912. Crete had to wait even longer for independence but was finally ceded to Greece in 1913.

Relations between Turks and Greeks, particularly among the ordinary people, were often genial enough. There were also wise and conciliatory sultans as well as the brutal and unscrupulous. After sacking Constantinople, Sultan Mehmet, 'the conqueror', sought the friendship of the Greeks. Without their co-operation there was little hope for the economy – Turks had little interest in business and few were good sailors – and the sultan needed a supportive Church. The previous

OPPOSITE: *The Turkish occupation of mainland Greece had little stylistic effect on Greek architecture. But on Crete, which was controlled by Venice for four hundred years, Italian influence is clear in the church of Arkadi Monastery. The façade, remodelled in 1587, combines a touch of the baroque in the curving of the pediments with Renaissance conventions.*

patriarch, Gregory Mammas, had fled to Italy, so Mehmet sought out a new leader. An anti-unionist, anti-western patriarch, unlikely to delve into foreign intrigues, was essential.

The sultan found his man, the monk Gennadius, living as a slave in Adrianople. Gennadius, the former George Scolarius, one of the most gifted scholars in Constantinople at the time of the conquest, was released by his new master and escorted back to the city. Six months later, on 6 January 1454, he was enthroned. Mehmet himself invested the new patriarch with the words: 'Be patriarch, with good fortune, and be assured of our friendship, keeping all the privileges that the patriarchs before you enjoyed.'

Once the horrors of the conquest had passed, Gennadius' reign began on an optimistic note. He and the sultan frequently met in the side-chapel of the patriarchal church to discuss religion and politics. But conservative opposition within the church and worsening Christian-Muslim relations were to cut short his tenure. Gennadius was particularly criticized for marrying boys under twelve, so that they could escape conscription and conversion to Islam, and for confirming or annulling marriages contracted in captivity. Tired of such opposition he resigned his post in 1457 and moved to Mount Athos, then to the monastery of Saint John at Serres, though he would later be called back to the patriarchal throne.

† Beggar Monks

The extent to which learned Greeks fled Constantinople after 1453 has often been overstated. Greek scholars had been leaving the city since the beginning of the Latin occupation and continued to do so during the last centuries of Byzantine decline. The fall, however, did lead to a further exodus. Some scholars chose, like Gennadius, the obscurity of a monastic cell; others headed for Crete, Italy and the West. Within the capital, churches and monasteries were soon converted into mosques. The once illustrious monastery of the Studium survived the fall and continued to function for almost half a century, celebrating its millennium in 1462. Then, around 1500, the Church of Saint John was converted into a mosque and the few monks still in residence were forced to find shelter elsewhere. In the provinces the story was usually the same. Wherever Turks settled churches and associated property were annexed in the name of Allah.

Eye witness reports from Thessalonika, which had fallen to the Turks in 1430, described with horror the fate of the city's churches and monasteries. According to John Anagnostes 'Diegesis' many 'were transformed into common houses ... to speak in the manner of the prophet, "They tore down the sanctuaries of God with pick and axe". Others retained only the corpses of their former beauty and their location; some, indeed the majority, completely collapsed, so that it is no longer possible to tell where they once were.'

Among the monks there were heroes and traitors. Fourteen monks from the Monastery of Saint Basil 'under the walls' were led off in chains, a ransom of 1000 gold florins on their heads, for resisting the Turks. At least one monastery, the Vlatadon, survived the siege when their monks, according to one account, collaborated with Sultan Murat II. They informed him that he should sever the pipes bringing water to the city from Hortiates. A short while later the city was his and the monks were placed under imperial guard. Despite their help, the monks' Vlatadon holdings were confiscated, although in return the sultan granted them other lands

OPPOSITE: *The church of Kaisariani Monastery lies on the once verdant slopes of Mount Hymettos near Athens. Renowned since antiquity, when a philosophical school flourished among the hills, Hymettos is also the site of a sacred spring, the Ram's Head Fountain, celebrated by the Latin poet Ovid in his didactic poem* Ars Amatoria.

including vineyards, olive groves and gardens. They were also exempt from paying tithes and other taxes. The monastery subsequently made a modest recovery, still survives today, and is home to the important Institute of Patristic Studies.

In the post-Byzantine era the number of monasteries and monks dropped sharply. One scholar has estimated that the average rural monastery rarely contained more than three or four monks. Monastic populations fluctuated wildly for reasons that are often unclear. The Great Lavra on Athos probably had 700 monks in 1054. By 1623 there were just five or six, but by 1677, according to John Covel, their numbers had risen again to about 450. There was also a new if infrequent phenomenon of large nunneries. In 1669 the nunnery of Saint Theodora in Thessalonika housed a 150 sisters; the nunnery of the Virgin Mary in the same city contained eighty nuns; and a century later two nunneries on Chios had 250.

The nuns at Saint Theodora's, and the remains of their saint, were described by Robert de Dreux, chaplain to the French ambassador at the Sublime Porte in the late 1660s:

A sculptured niche and elaborate stone cross carved into the front façade of Kaisariani monastery church.

> Their clothes are a little like those of our grey sisters, having an additional large black veil on their heads. The abbess took us to the church, whose altar is decorated with a well gilded retable, and to a chapel to see the body of Saint Theodora, which is still whole and whose flesh is a little dark, but without any decomposition, even though many years have passed since this saint died.

Rural monasteries were far more likely to survive than urban communities, partly due to Turkish attitudes to conquest and their subsequent policy towards the Greeks. If a walled town refused to surrender it was pillaged and property titles went unrecognized. It was also in the towns that conversion of Christians to Islam was most apparent. That and their repopulation by Muslims from elsewhere meant that successive sultans controlled their empire through its towns. If a country monastery could hold on to its lands then it had a chance of survival; but if deprived of endowments, a monastery soon disappeared. In the conquered territories only Mount Athos and Saint John's Monastery on Patmos, exceptions to the general rule, secured favourable deals with the Turks which helped to ensure their survival to the present day.

Another exception to the general air of monastic despondency was on Crete which remained in Venetian hands long after the fall of Constantinople. Indeed, the island benefited from the Turkish conquest of the city. Many monks, scholars and artists from the capital settled on Crete, heralding an artistic renaissance, the renowned Cretan school of painting, which enriched the island's churches and monasteries with fresh paintings and icons. The school developed a distinct style of its own, in which Byzantine formality was softened by the island's Italian influence, and reached its apogee under two master painters. The first, Damaskinos, worked in Venice and the Ionian islands between 1574 and 1582 before returning to Crete. The second and greater of the two, Domenico Theotokopoulos, the icon painter better known as El Greco (1541–1614), emigrated to Venice, later moved to Rome, and finally settled in Spain. With the loss of its greatest exponent, the Cretan school also moved, re-establishing itself at the monastic centres of Meteora and Mount Athos.

Under Venetian control monastic life in Crete prospered. As late as 1632 the island contained 376 monasteries some of which, such as Arkadi Monastery with its Italianate façade built in 1587, were strongly influenced by the architectural conventions of the Renaissance. At this time there were 4000 monks in an island population of 200,000, probably a higher proportion than in any other region of Greece. But

Crete, too, following the capture of Heraklion in 1669, eventually succumbed to the Turks. The occupation was harsher than in many other parts of Greece. Some Cretans were forced to convert to Islam, others took to the mountains or fled the island, and the monasteries, as elsewhere, were soon emptied and ruined.

In Greece as a whole, monasteries that did survive were invariably impoverished, their lands much reduced, their immunities replaced by crippling taxes. During the Ottoman period, monasteries, as well as the Church, lived in almost perpetual debt. Monks became beggars. Holy men frequently toured the villages, armed with lists of previous contributors, seeking gifts to keep the monasteries afloat, at least until the next collection. One monk, Dapontes of Xeropotamou Monastery, left Athos in 1757 with the monastery's alleged relic of the True Cross; two forged papers attested its authenticity. The cross worked wonders. Eight years later Dapontes was back on the Holy Mountain with sufficient funds to rebuild the monastery.

Eighty years earlier, John Covel, the first Englishman to write about Athos, claimed that of 450 monks at the Great Lavra at least 150 were abroad to beg alms.

… they haue some all over the Greek church and as they come home others goe out as missioners… Many goe as far as Russia, Muscovy (I met two here that haue

Although Kaisariani Monastery was founded in the eleventh century, the murals, which include some of the best post-Byzantine paintings to be found anywhere, date from the seventeenth and eighteenth centuries. Over the entrance to the narthex is a colourful portrayal of the Tabernacle of the Witness, executed by a Peloponnesian artist, John Hypatos, in 1682.

been at Archangelo), Morea, Palestine, Stambol, Smyrna, etc., and they now tell me or pretend that most of the entrata comes in this way ... and those of yeares and standing, if they bring home good store of money, are undoubtedly made hegoumenoi the year following.

With poverty went a breakdown in discipline. In order partly to secure funding, 'idiorrhythmic' houses became increasingly acceptable. Such institutions allowed would-be monks to retain much of their private property. They omitted vows of poverty and there was less obedience to a superior. Idiorrhythmy had started on Athos in the 1390s, before the arrival of the Turks, but its growth was a logical response to pressing material needs and the triumph of idiorrhythmy occurred during the Turcokratia. Indeed, the idea of maintaining a true coenobitic community with populations of just three or four old monks was becoming untenable. Even for monks committed to Basilian principles, their lives increasingly began to resemble those of recluses living in loosely based lavrai. A handful of monks living in a monastery built for many times that number must have been a depressing existence, even if their true spirit was not in the material world.

† Behind Closed Doors

The poverty of Greek monasteries during the Turkish period should not, perhaps, be exaggerated. The fortunes of monasteries had varied enormously during the days

The parable of the Prodigal Son (1682). One of numerous framed panels in the narthex which include scenes from the parables and the Book of James. The strong use of colour and almost folksy elements is far removed from the earlier Byzantine traditions found in the Macedonian and Cretan schools.

of Byzantium. There was certainly a crisis, money was in short supply, but monasteries survived and those that did were still full of religious treasures. In the libraries monastic scribes continued to produce an astonishing number of documents. Three-quarters of the manuscripts in the Athos libraries, the richest source of material about Orthodox monasticism, date from after 1500. Athos monasteries also added to their collections by buying up other libraries such as that of the rich Greek merchant Michael Cantacuzene, who was executed by the Turks in 1578. If abbots were presented with such opportunities it seems that money could still be found.

In the realm of painting, old traditions also continued in remote corners of the former empire. Several monasteries at Ioannina are decorated with remarkable frescoes from the sixteenth and seventeenth centuries; while the almost complete murals at Kaisariani near Athens date from 1672. On Athos, under the influence of the Cretan School, the sixteenth century was the most copious period for wall painting, but many churches there were also repainted in later centuries.

Indeed, Athos remained an important spiritual centre throughout the Turcokratia and its role shifted as it replaced Constantinople as the bulwark of Greek monasticism. Constantinople was still the seat of the patriarchate and the centre of lay learning, but there were now few monks in the capital of the Turks. The Church was weak and servile and made little contribution to religious life and thought. The standard of education declined. In 1555, a German professor of Greek, Martin Crusius, was shocked when he heard about the lack of Greek education. A few poor schools still taught boys the Horologian, the Octoechon, the Psalter, and other

liturgical texts. 'But even among the priests and monks those who really understand these books are very few indeed.'

On Athos there were some efforts to keep learning alive. Maximus the Haghiorite, born in Arta in 1480, travelled widely as a young man, and studied in Paris and Italy. On his return to Greece he settled on the holy peninsula where, conscious of the inestimable value of libraries, he became renowned as the librarian at the monastery of Vatopedi. Damascenus the Studite, a well-known homily writer, probably studied at Athos. And scholars such as the Cretan Maximus Margunius, who died in 1602, continued to add to the Athos libraries. Most of his Latin books and a manuscript copy of the ancient Greek tragedians are still in the monastery of Iviron. But on Athos, as elsewhere, literacy declined during the eighteenth century. Libraries, with few exceptions, lay neglected. Manuscripts were used as wrappings, or sold to passing strangers, often bibliophiles from the West.

Outside a handful of main towns, provincial boys had few educational opportunities and it was the poorer classes, those who provided most of the monks and village priests, that fared worst. In local monasteries, boys hoping to be priests learned religious texts by heart, but it was no real education. Few monasteries were able to add to their libraries or to keep them up to date; and barring a few standard texts monks lost the habit of reading. They were still respected by their parishioners since only they could cite the litany. But higher education was beyond them and they were uninterested in it. The position of nuns was even worse. A few nunneries offered lessons to local girls, but when many nuns could barely read themselves, teaching could only be at a most basic level. In their growing ignorance monks tended to react against new learning and a gulf grew between them and the lay élite, the Greek Phanariots of Constantinople.

☦ Travellers' Tales

It was during the Turcokratia, particularly during the last two centuries, that significant numbers of western travellers began to visit Greek monasteries, and most were appalled by the low standards of the monks and clergy. Some writers, particularly western Catholics, swayed by their hostility to Orthodoxy, were openly biased. 'It's a deplorable thing to see the blind obedience of these so-called monks,' wrote Robert de Dreux, 'most of whom are so ignorant that they think they are learned when they know how to read, and several claim that they are not obliged to confess, because they have absolute power over others.'

Not all visitors, however, were so harsh in their judgements. The English aristocrat Robert Curzon, author of the classic *Visits to Monasteries in the Levant* published in 1849, had no obvious religious axe to grind. Curzon was attracted by the monasteries, particularly the libraries, but he began his journey with the notion that 'monks are a set of idle, dissolute drones, either fanatical hypocrites or sunk in ignorance and sloth.' After visiting numerous monasteries, including those at Meteora and Athos, Curzon was pleased to conclude that, in fact, most monks were actually the opposite of what he had supposed: quiet and simple, but they still lived in complete ignorance of the world.

Modern medicine, for instance, was almost unheard-of on the mountain so the monks had to resort to folk remedies. One of the more entertaining of nineteenth-century travellers, Athelstan Riley, had a curious brush with monastic medicine in 1883. While visiting Koutloumousiou Monastery on Athos his dragoman began complaining of earache. An old monk was summoned and peered into the

dragoman's ears; then left to search for medicines. He soon returned with a small bottle of thick yellow oil, a stout twig, and a lump of cotton wool. It transpired that the medication was 'rat oil' which, the guide claimed, was used elsewhere in Greece. According to the doctor: 'You take a young rat from the nest – when it is just born and pink, you know – and you put it in a bottle of oil and place it in the sun. At the end of a few weeks you will find the rat quite gone, dissolved in the oil. Then you cork up the bottle and keep the oil for use.' Apparently the oil was efficacious in treating other ailments as well.

 Another Englishman, the traveller and priest George Waddington, quoted at the head of this chapter, suggested that monks had remained virtuous and less corrupted than other Greeks. Perhaps so, but the monastery of the Strophades from where he wrote, once the island home of the Harpies, was one of the remotest communities imaginable. Waddington described an idyllic, almost self-sufficient community growing their own corn and vegetables. They sold their cattle to pay the rent 'and a slight addition to their revenue is made by the sale of turtle-doves, which resort hither in vast numbers during the two seasons of their passage, and are shot or taken by the monks; these also they send, in vinegar, to Zante; and this is the extent of their intercourse with man.'

 Waddington was well received at the Strophades. One morning, while on his way to breakfast with the abbot, he was surprised to be honoured with a salute of the cannon. Other foreigners were also warmly welcomed, notably Lord Byron, whose staunch support of Hellenism guaranteed him the red carpet treatment wherever he went. In August 1823 he visited Cephallonia, then part of the British protectorate of

In the lowest zone of the sanctuary apse in the Kessariani Monastery, eighteenth-century paintings depict the Church Fathers St. Athanasius, Patriarch of Alexandria, and St. John Chrysostom. The latter, a fifth-century Patriarch of Constantinople and one of the most venerated of the Greek fathers, initiated a Constantinopolitan school of thought in which priestly power prevailed over that of the State.

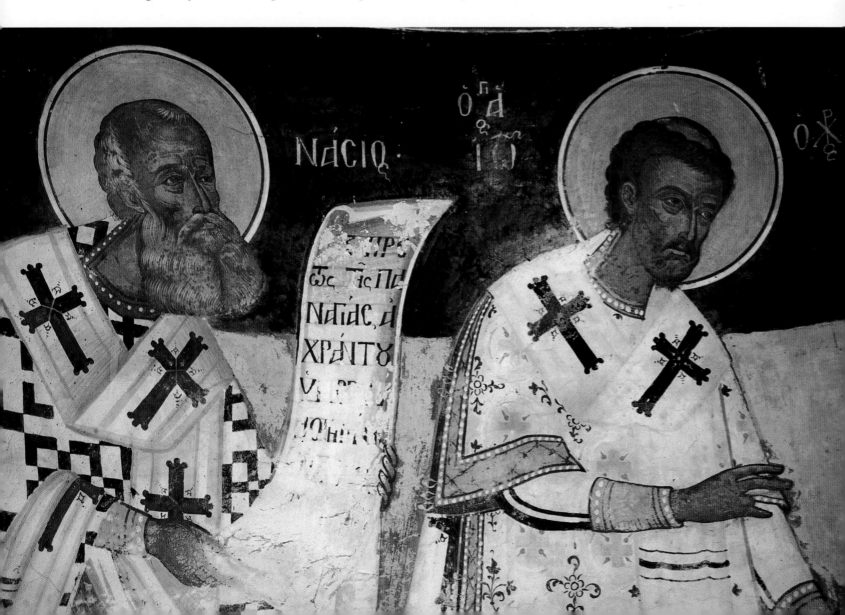

ABOVE: *The 'Great art Thou, O Lord' icon, dated 1770, illustrates Biblical scenes, including Christ and the Samaritan woman at the well, in naive detail. A masterpiece of Cretan art, by the Creto-Venetian artist Ioannis Kornaros, the painting is kept in Toplou Monastery, Crete.*

A narrative scene from the 1770 icon showing the Flight from Egypt and the parting of the waves.

A depiction of the Baptism of Christ from the 'Great art Thou, O Lord' icon.

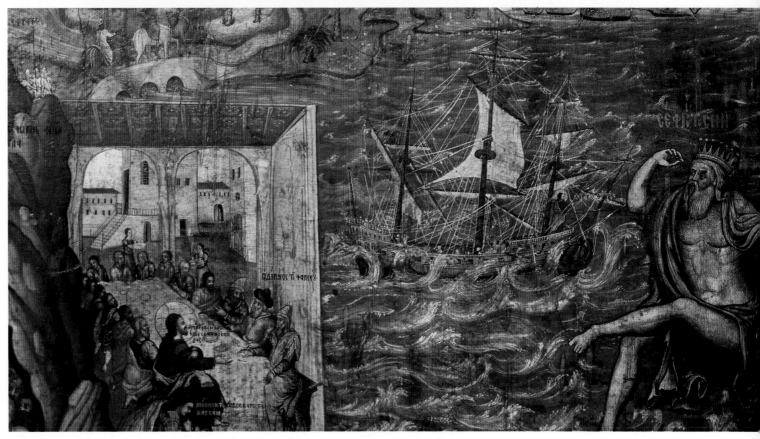

BELOW: *A maritime scene from an eighteenth-century icon in Toplou Monastery, Crete.*

the Ionian islands, as the London representative of the Committee for the Liberation of Greece. On the first day, he and his small party left the coast to spend the night at the white monastery of Saint Cosmas above Sami. Byron was in poor health, suffering from periodic attacks which soon would kill him, and climbing the hill exhausted the young poet. Near the monastery he stumbled across some open sarcophagi where, climbing into the deepest, and lying down full length, he began to recite 'Alas, poor Yorick'.

At this point a welcoming party of monks emerged from the monastery to greet the English philhellenes. The abbot, whom Byron described as a 'whining dotard', led the grey-gowned fathers, chanting and swinging their censers, in the preliminary ceremonies of the evening. As the chanting ceased, the abbot paused to deliver his *pièce de résistance,* a flowery and tedious speech which tried Byron's patience to the limit. He was seized with a spasmodic attack and yelled at the abbot: 'Will no one relieve me from the presence of this pestilential madman?' A stunned silence fell over the proceedings. The trembling abbot dolefully mopped his brow and simply uttered: 'Poor fellow, he is mad.'

Byron's seizure worsened inside the monastery. With wild eyes, a burning forehead, and violent stomach cramps, he ripped off his clothes, tore bedding to shreds and smashed up some of the furniture in the guest bedroom. It was all his companions could do to calm him down. One of them, James Hamilton Browne, finally got two pills down his throat and a relieved silence fell over Saint Cosmas. The next morning Byron, filled with remorse, was careful to pay his respects to the slighted abbot and at midday the party rode back to Sami.

✝ Raising the Flag

Byron may have made a poor impression on the unfortunate abbot, but his propagandizing and strong anti-Turkish sentiments helped to further the cause of Greek independence. A spirit of revolt had been growing among the Greeks since the 1789 French Revolution, encouraged by increasing intellectual contacts with the rest of Europe. Leading figures hatched their own plots for political freedom. Some, such as Adamantios Korais, rejected the Orthodox Church and the Byzantine past as a model for an independent Greece. Korais had little time for religion, looking instead to the ancient Greeks for inspiration. The poet Rhigas, who continuously reminded the Greeks of their illustrious past in his songs, drew up more elaborate schemes to liberate the whole of the Balkans from Turkish rule.

While the intellectuals schemed and talked, Greek peasants began to take action. Outlaws, known as 'klepts', took to the mountains and lived by raiding the properties of Turkish landowners, though they frequently robbed Christian merchants and foreign travellers as well. To ordinary villagers they became folk heroes, Robin Hood figures who stole from the rich, foreign oppressor. They could always count on popular support and find refuge in local monasteries. The monks at Megaspelaion Monastery even collected money to buy them arms.

The klepts soon became a menace to the Turkish authorities and during the reign of Sultan Selim III serious efforts were made to bring brigandage under control. Selim sought the support of the patriarch, who issued a decree threatening with excommunication any priest or monk who sheltered a klept, or refused to co-operate with the authorities to suppress them. The decree was issued in the Peloponnese where the outlaws were particularly active. Most of the higher clergy reluctantly

OPPOSITE: *The fourteenth-century monastery of Haghios Ilias at Zitsa, north of Ioannina, one of several monasteries visited by Lord Byron. A plaque to the left of the entrance commemorates his visit: 'Monastic Zitsa! From Thy Shady Brow Thou Small But Favoured Spot of Holy Ground'. Byron, 13 October 1809.*

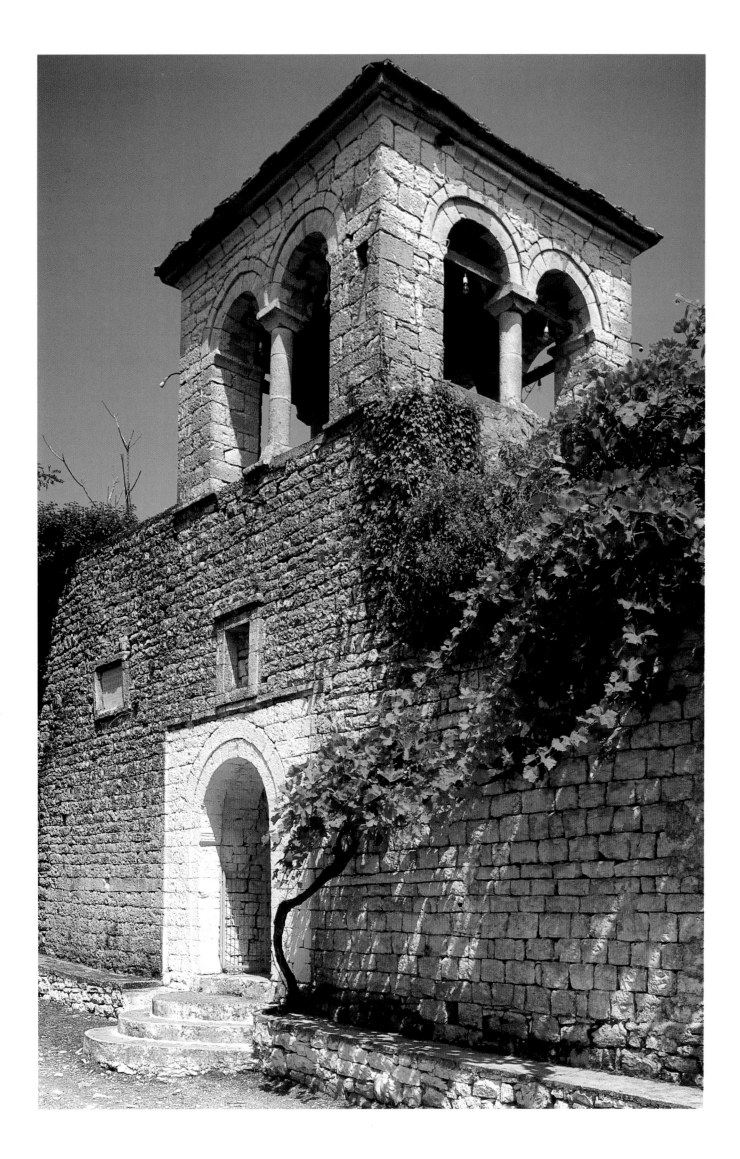

obeyed the order, but the villagers and monks were outraged. In the Greek provinces animosity against the established church simply grew, for the ordinary monk and peasant had little conception of the patriarch's difficult position in Constantinople.

Attitudes to the church hierarchy were reflected in a book entitled *The New Geography*, published in Vienna in 1791 and based on a manuscript smuggled out of Ottoman territory. The book, written by two Greek monks, George Constantas and Demetrius Philippides, accused the church hierarchy of serving the Turks and succumbing to bribes. The lower ranks, raged the monks, were simply obscurantist and ignorant. Charges were repeated in other works such as an anonymous book published in 1806 under the title *The Hellenic Nomarchy or a Word about Freedom*. Such attacks, however, simply increased patriarchal entrenchment. Some members of the patriarchal court even believed that a true religious life was better lived under Turkish rule than under the spirit of revolt.

The revolutionaries and planners of Greek independence could hardly expect a lead from the patriarchate. Neither did they get it. But in the provinces there were many supportive clergy and sympathetic monks. When the time finally came to start the War of Independence, which had been planned since 1814 by the secretive Society of Friends, the 'Hetairia ton Philikon', a monastery was chosen as the symbolic launching pad. On 25 March 1821, Germanus, Metropolitan of Patras, in open defiance of the patriarchate and Orthodox tradition, raised the standard of revolt at the Monastery of Agia Lavra near Kalavrita in the Peloponnese. The Greek War of Independence had begun.

The struggle for independence was a long, drawn-out war to which some monasteries made a significant contribution. After raising the flag at Agia Lavra, Bishop Germanus returned to Patras at the head of a thousand armed peasants. In front, marching monks and clergy sang psalms and promised a martyr's crown to anyone who died in the coming struggle against the Turks. In Patras crosses were raised above the Turkish mosques, a huge icon of Christ was erected in the main square and, at night, the monks from Megaspelaion led the army in prayer. The monks and churches of the Peloponnese were united in their support for the revolution and no single institution took a more active role than Megaspelaion. When aid was needed the monastery appointed two inmates to lead a band of seventy monks to relieve a besieged town nearby. Refugees subsequently poured into Megaspelaion and the monastery's copper objects and fittings, from spare utensils to door knobs, were melted down for ammunition.

Localized revolts began to erupt north of the Gulf of Corinth as news of the uprising in the Peloponnese spread. But on Athos, much to the disappointment of the revolutionary leaders, any monks prepared to fight were soon brought to heel by their cautious abbots. This was a great blow to the Hetairia which wanted to make use of the monasteries' musket and artillery stores which had always been at hand to fend off brigands and pirates. Some monks aided and abetted Greek civilians on the mainland, but most dithered and then retreated within the monasteries' walls when expected Russian aid failed to materialize.

News that some Athos monks had risen up against the Turks soon reached official ears. For their monks' treachery the abbots were fined 3000 purses and a Turkish garrison was stationed at Karyes, the capital of the Holy Mountain, where it remained until the end of the war. Any potential trouble from Athos was effectively neutralized, but over the next few years about half the monks fled the peninsula to serve the cause of the revolution elsewhere.

As the revolution grew and showed little sign of waning, Sultan Mahmut II

sought assistance from abroad. In 1825, Egyptian troops under Ibrahim Pasha landed on the Peloponnese coast intent on capturing Nauplion which had emerged as the national centre of the revolt. On the way to the capital Ibrahim Pasha passed near the Megaspelaion Monastery where he demanded the monks' surrender in return for unspecified gifts. The monks were having none of it and in a wordy and mocking reply the abbot informed Ibrahim: 'What wonderful thing would there be to conquer monks – but great would be the shame if conquered by them, for we are resolved to die upon this spot. We tell you then, go first and subdue Greece and then we shall surrender to you.' In the event the clash between Ibrahim and the monks ended in stalemate. The Egyptian soldiers were repulsed from the monastery walls, but they managed to make off with the monastery's flocks.

Few monasteries, however, fared as well as Megaspelaion during the revolution. In 1829 the French philosopher Edgar Quinet travelled through a Peloponnese badly ravaged by the war. During a brief stay at Mycenae he visited the sixteenth-century Voucarno Monastery nearby. Because of the monastery's isolated position Ibrahim Pasha had accommodated his harem there. The women had left by the time Quinet passed by but the monks had still not returned:

> The caloyers (monks) had fled to surrounding caves. The interior of the church dome was riddled with bullet holes; all the painted saints' heads on the wall had been almost entirely burnt. I searched in vain for the remains of the library. In the cells I found, in the place of books and manuscripts, only sabres and some belts fitted with pistols.

Many monasteries and churches were badly damaged during the revolution but, even more disappointing for ecclesiastical leaders, the Church began to lose its pre-revolutionary status and influence. Much of its wealth had been dissipated, some of its best men, bishops and abbots, had been killed or wounded, and its role as a leader of the revolution declined. Secular leaders, influenced by new ideologies from the West, increasingly gained the upper hand. In the new Greece to come the Church would lose its responsibilities for the educational and judicial systems. But even worse was to befall the monasteries.

✝ The Dispossessed

By 1832 independent Greece had been ravaged by more than ten years of warfare in which inter-factional fighting had often been as fierce as battles against the Turks. The country needed a unifying figure to help stem the anarchy. The choice was an unusual one: a seventeen-year-old Bavarian Catholic named Otto became Greece's first king. His regency government, too, was made up of foreigners. Among them was Georg von Maurer, a liberal Protestant, who was largely responsible for the legal and ecclesiastical foundation of the new Greek state. As head of the Ministry of Ecclesiastical Affairs, one of Maurer's first tasks was to help reorganize the Church and in March 1833 an ecclesiastical commission comprising three clergymen and three laymen was appointed 'to ascertain the condition of the Greek Church and of the monasteries'.

The commission's recommendations were radical and far-reaching. After eleven centuries of unity under the patriarchate of Constantinople the bishops of free Greece took the momentous step of splitting away from the Great Church to form the autocephalous Church of Greece. The newly constituted Holy Synod

became the governing body of the Church and the responsibilities of Church and State were divided as they never had been before. Under the influence of secularist intellectuals, the church became subordinate to the king, who exercised his authority through the Ministry of Religion and Education. The State also controlled the Church's temporal affairs, notably monastic regulations and the disposition of monastic property.

The government's new powers led almost immediately to the abolition of most of Greece's monasteries and the wide-scale confiscation of monastic properties. Few in the Church doubted that the monasteries needed reforming – after the war some were little more than ruins, others had been abandoned or contained only a handful of monks – but the severity of the regency's reforming zeal was unexpected and had no historical precedent. Even the iconoclastic purges a thousand years earlier had probably had less effect on monastic life. Although monks were relatively few in number, Greece's new western rulers sought to eliminate any possible source of dissent. The monks were the major opponents of church reform and there was strong suspicion that their sympathies now lay with the Tsar of Russia, the perceived protector of the patriarchate. Greek reformers and the country's western rulers were also contemptuous of a medieval lifestyle, the epitome of oriental obscurantism, that threatened to hold back the fledgling state on its path to modernity. The monasteries may have played an important symbolic role in launching the revolution, but their influence was soon to wither away.

Few aspects of the cloistered life were to remain unaffected by the commission's report which spoke of widespread abuses, immoral behaviour, neglect of holy offices, and the misappropriation of monastic property and funds. Criminal charges were even proposed for the more sinful monks. The number of pre-revolutionary monasteries is disputed, though most sources give a figure of over 500 in the liberated provinces. On this basis there was one monastery for every 100 square kilometres of territory and for every 1500 inhabitants. There was also a confusing array of different types of monasteries. Some still came under the direct authority of the patriarch in Constantinople while others, the parish monasteries, were administered locally by the nearest bishopric. A minority of monastic properties and holdings were dependencies of larger communities, including those outside the liberated provinces. And there were even private monasteries, held in trust by their donors or heirs.

This complex system meant administrative complications and conflicting claims over rights to monastic holdings. Even if the government was not concerned about the monks' potential influence on the life of the new nation, reform was clearly long overdue. In the event, the commission recommended that any monastery with fewer than three monks should be closed although the regency later raised the minimum to six. All badly damaged or destroyed monasteries, irrespective of the number of registered monks, were also dissolved. Government figures from the period, partly due to the difficulties of defining monasteries as well as the problems of collecting the data itself, are full of inconsistencies; but a Ministry of Finance report of 1843 is one of the most comprehensive extant documents. It lists 593 monasteries in free Greece before the dissolution. Of these 412, more than two-thirds, were dissolved and 151 retained. Others were recognized as foreign owned or as private holdings, or were converted to parish churches. A later report by the Holy Synod in 1858 listed 148 monasteries occupied by 1579 monks and four convents with 116 nuns, just below the required minimum of thirty sisters each.

Maurer argued that monastic funds had been wasted or siphoned off by

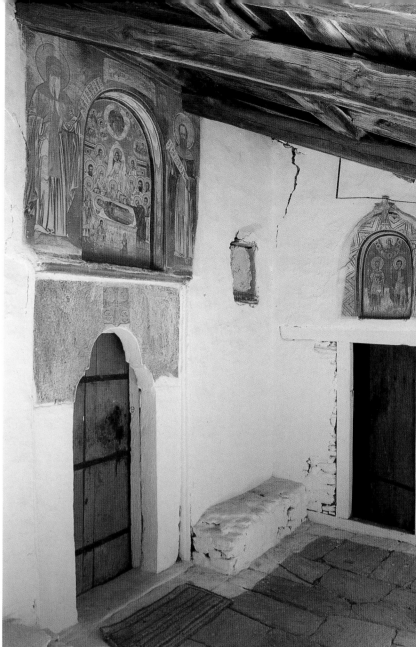

unscrupulous relatives. A tighter rein was now to be kept on monastic expenditure. Revenues from the confiscated estates were channelled into a new Ecclesiastical Fund to help support the larger monasteries, as well as the churches and public education. The surviving monasteries were also subject to taxation at both local and national level. At first taxes were collected by public contractors who competed for the right to make assessments. But private tax collection inevitably left the monks open to exploitation and in 1838 the government abandoned the scheme for a fixed sum paid directly to the treasury department.

As well as reducing the number of monasteries the regency, through the Holy Synod of Greece, increasingly controlled the lives of individual monks. In particular the journeys of monks outside their monasteries were strictly limited. Hitherto monks had been free to wander between towns and villages, carrying revered icons and holy relics and making collections for their monasteries or other unspecified causes. Now they were obliged to consult their abbot and ask the permission of the bishops in whose dioceses they hoped to preach.

Other decrees and regulations soon followed. Henceforth regular reports listing monastic property, daily income and expenditure, and personal details about the monks, their nationality and date of birth, were to be certified by local officials and then forwarded to the Ecclesiastical Ministry. Weddings and baptisms could no longer take place in monastery churches. And the regency government imposed new rules on the election of abbots.

ABOVE LEFT: *A staircase leads to the former monks' cells in the sixteenth-century Haghios Philanthropinos Monastery, one of four communities established on a small island on Ioannina Lake. Ali Pasha, the 'Lion of Ionnina', who enjoyed semi-independence under the Ottomans, was murdered by the Turks in one of the monasteries in 1822.*

ABOVE RIGHT: *An interior corner of the eighteenth-century Panagia Monastery on the narrow Pelion peninsula. During the Turkish occupation this isolated, heavily-wooded region became a haven for Greek culture and monastic life.*

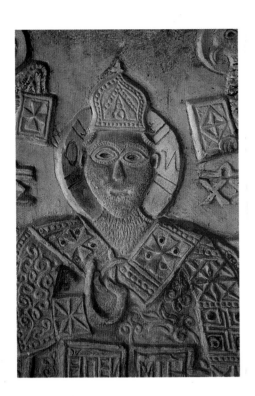

By the end of the eighteenth century much post-Byzantine art had degenerated into a form of folksy kitsch. This unusual, almost primitive, bas-relief of a cleric, sculptured in 1795, decorates the entrance to the church of the Panagia Monastery.

OPPOSITE: *On the flanks of Mount Olympus a single monk now lives at the Monastery of Haghios Dionissios. Destroyed by the Turks in 1828 and again by the Germans in 1943, the monastery and its catholicon are being restored in preparation for a new influx of monks.*

Greek convents did not escape Maurer's heavy-handed reformation. Figures for the number of convents in pre-reformation days vary from eighteen to forty, but following a government decree of 25 February 1834 there was to be no more uncertainty. All nuns were to be moved into just three institutions: one for Attica, another for the Peloponnese, and a third for the islands at Thira. The reformed convents had difficulty, however, fulfilling the regency's requirements. By the end of the year the Attica and Peloponnese convents were forced to close, although another opened at Aegina, because they did not have the minimum number of thirty sisters. The Holy Synod had been critical of the convents' 'bad practices' where more evil than good was done. The Synod demanded their moral improvement and, to this end, all nuns under forty were commanded to return to a secular life unless they could demonstrate their devotion to the nunnery and that their behaviour was beyond reproach. Like the monasteries convents were now closely supervised. The nuns could nominate candidates for the post of abbess but ultimately the choice was down to the Holy Synod.

The Maurer reforms inevitably only affected orthodox monasteries in independent Greece. Many Greek provinces, including Macedonia, western Thrace, and Crete, were still under the Turkish yoke and here, ironically, monastic organization was undisturbed. Monasteries in Turkish Greek territory continued, for the most part, to depend on the patriarch in Istanbul, though several had supported the revolution. After the Greek flag was first raised in the Peloponnese, Crete was soon up in arms in support of a Free Greece. But the rebellion was quickly subdued by the Ottomans, helped by fresh troops from Egypt.

Further uprisings, increasingly supported by the rich monasteries founded under Venetian rule, followed in 1841 and again in 1856. One of the bloodiest revolts occurred ten years later when Cretan insurgents, the 'palikares', forced the Turkish army to surrender on the Apokoronas plain. But it was a short-lived victory. The Pasha summoned reinforcements from Istanbul and in late 1866 the Turks attacked the fortified monastery of Arkadi, hitherto a guerrilla stronghold. Ferocious fighting ensued and two days later it fell to the stronger Turkish forces.

Rather than surrender, the Cretans lit the powder magazine, blowing up hundreds of women and children huddled inside, as well as Cretan defenders and some of the Turkish assailants. In all 830 people perished, including Father Gabriel, the monastery's abbot and leader of the resistance. News of the tragedy soon spread to the West, drawing support and sympathy for the Cretan cause. Yet despite the outcry and further rebellions, Turkey retained control of the island for another half-century. The formal union of Crete with Greece was only achieved in 1913.

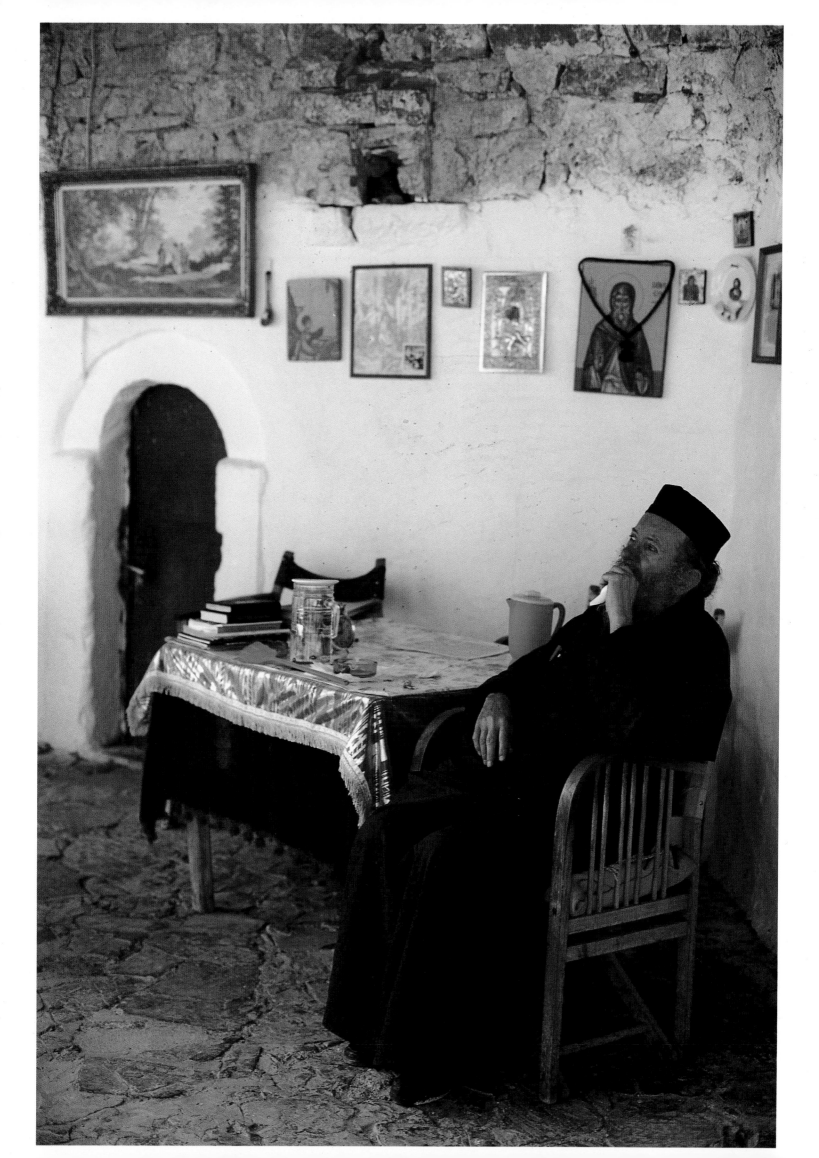

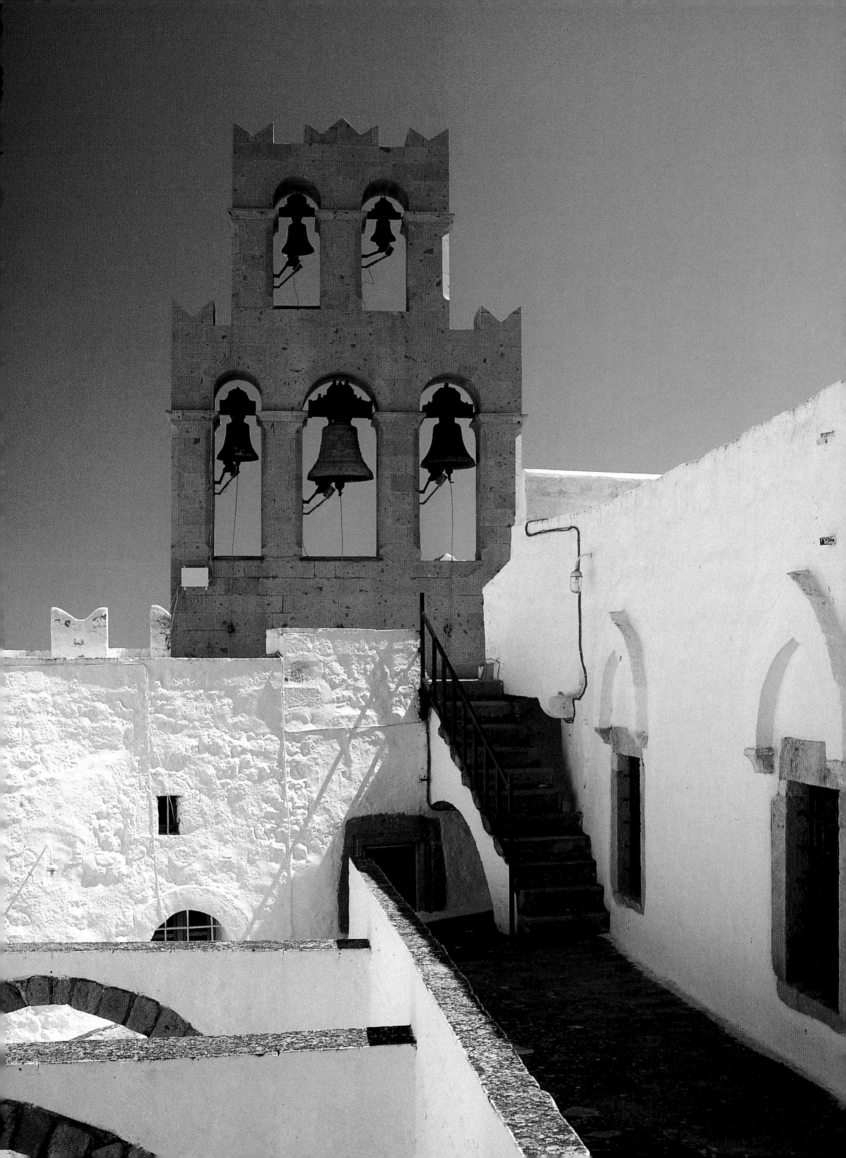

·4·
Remains of
the Way

The monastery of S. Luke is styled by its panegyrist the Glory of Hellas, and the queen of all monasteries, on account of its church, which for magnificence and the grandeur of its proportions is not equalled perhaps in all Greece.

Dr Richard Chandler, *Travels in Greece*, 1776

The Monastery of Saint Luke still stands today, one of the most complete and interesting of eleventh-century Byzantine buildings. Indeed, thanks to frequent restorations, it is probably now in a better state of repair than it was in Chandler's time. Saint Luke's, however, is an exception to the general rule; little now remains of the vast majority of medieval monasteries. Warfare and earthquakes, dispossession and decay, and the purges of the iconoclasts have all taken their toll, so that for most monasteries the only evidence for their existence is to be found in cluttered archives and libraries.

Many Byzantine monasteries had disappeared long before the Turkish conquest of Constantinople. Of ninety-two monasteries founded in the sixth century, only two survived until the fifteenth. Others were founded in intervening years but when Constantinople fell to the Turks there were only eighteen monasteries in the whole city. The destructive effects of iconoclastic emperors, in particular, means that little evidence of the early monasteries remains in Greece or in other central regions of the Byzantine Empire and that most Greek–Byzantine monasteries that still stand belong to the later centuries of Byzantine rule.

Among the remains, however, there are some magnificent survivors, most of which are discussed in this book. The major extant centres of monasticism, at Mount Athos and the Meteora, are treated in later chapters. There are several single monasteries, however, of such architectural, artistic or spiritual importance that they deserve more than a passing reference in the text. Four of them are described here. On Patmos stands the fortified Monastery of Saint John, once called the Mount Athos of the Aegean. On the Greek mainland the Monastery of Saint Luke or Ossios Loukas, on the borders of Boeotia and Phocis, and Daphni Monastery near Athens are both notable for the quality of their Byzantine mosaics. The monasteries at Mistra, once capital of the despotate of Morea, also deserve a special mention since they formed a part of the last centre of Byzantine culture.

OVERLEAF: *St. John's Monastery at Patmos, one of the most important shrines of the Orthodox Church. Founded in 1089 by the monk Christodoulos, it was subsequently expanded to include several chapels, a refectory, and the massive seventeenth-century buttressed walls.*

OPPOSITE: *The lower roof terrace offers a bird's eye view of the main courtyard, the pierced belfry, crenellated walls and the turquoise waters of the Aegean beyond.*

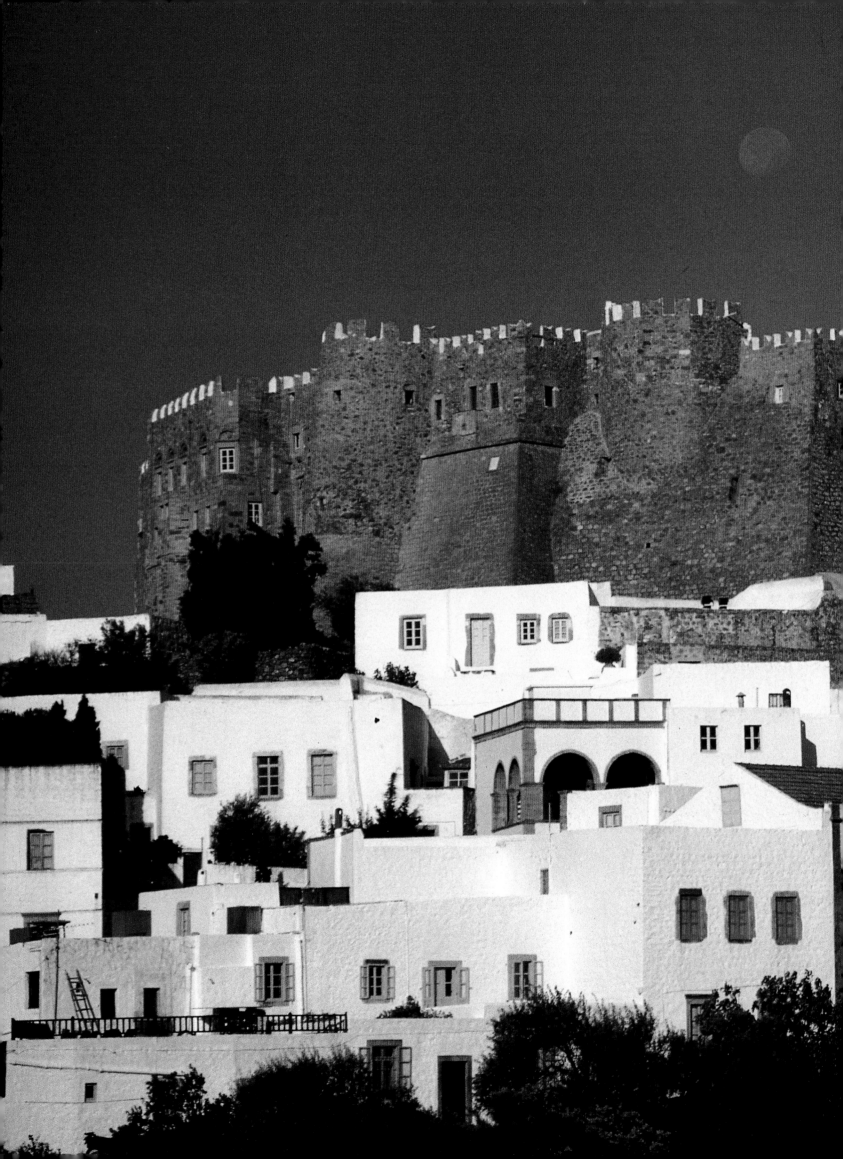

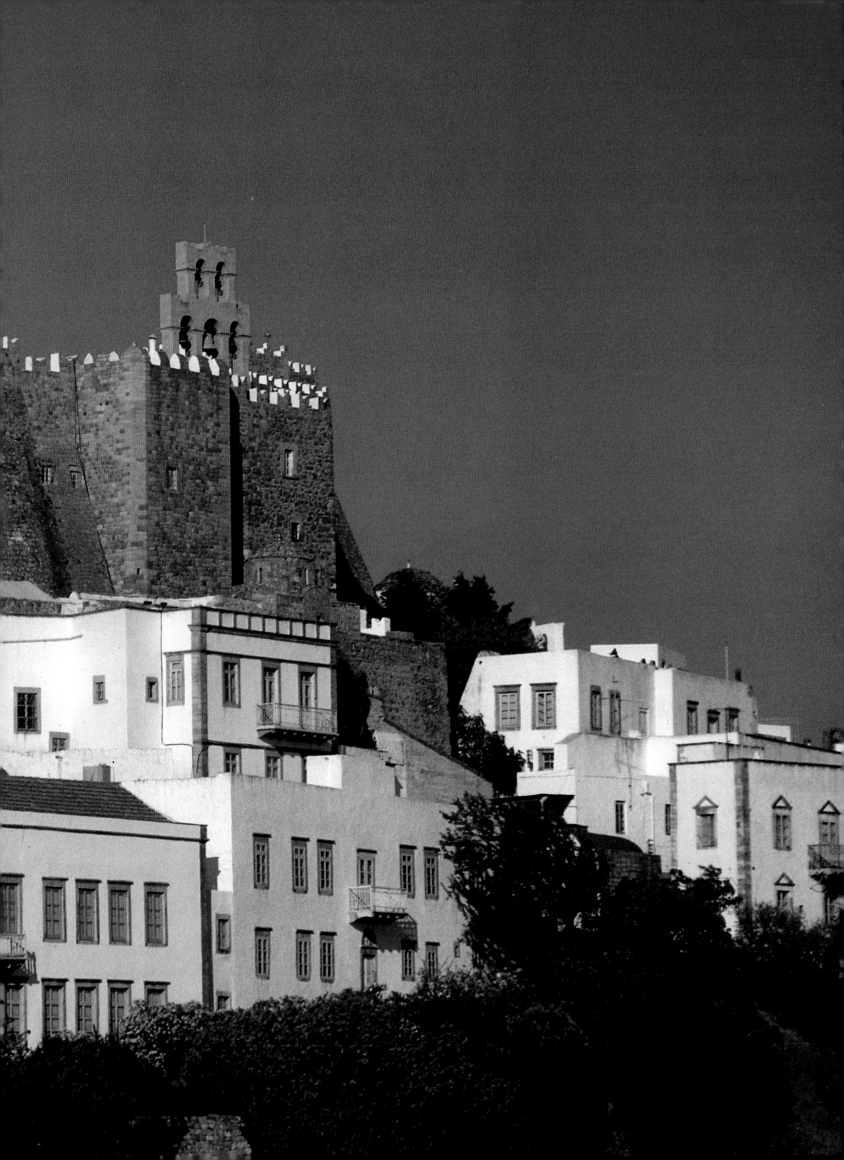

† Revelations on Patmos

Of all the dramatically sited monasteries in Greece none looks more like a medieval castle than Saint John's Monastery at Patmos. Its massive, crenellated bulk towers above the small town of Hora, whose dazzling white houses only seem to emphasize the solidity of the monastery and its buttressed walls. From without Saint John's does not even look like a monastery, though there are tell-tale signs: a bell tower that rises above the battlements and the small dome of the Chapel of the Holy Apostles which seems to cower beneath the western walls.

Other monastic complexes are also fortified, notably on Athos, but there the impression is one of walls raised to protect the monks within. Defence was clearly the aim at Patmos as well, but here the overall message is one of military might; one half-expects to find a row of canons piercing the crenellations. In the days when pirates and buccaneers roved the Aegean an impression of physical strength was an appropriate message although it had little effect in keeping foreign navies at bay; the Normans, the Turks and Crusaders all occupied the island at one time or another, though the monastery itself was never taken by force.

Only on entering the building, along a dark meandering alleyway, does the feeling of the place change from a fort to a friary. Within lies a labyrinth of pebbled courtyards, great arches and whitewashed domes. Vaulted passageways lead from the old refectory to the main church where Saint John the Theologian is portrayed dictating a passage of the Apocalypse in a seventeenth-century fresco. Saint John, traditionally regarded as the author of the book of Revelations, or Apocalypse, was banished to Patmos in the year 95 by the Roman emperor Domitian for preaching the gospel at Ephesus. It is possible that he wrote parts of his book, a series of moral admonitions in letters addressed to the seven Christian churches of Asia Minor, while living on Patmos. The circumstances in which the Apocalypse was produced, as well as its meaning, have sparked a vigorous theological and historical debate. But for true Patmos pilgrims there can be no doubt. On the rocky hillside halfway between Skala, Patmos' main port, and the Monastery of Saint John lies a dingy grotto, its rock walls cracked by the voice of God, where, according to local tradition, Saint John had his Apocalyptic vision.

After Domitian's death in 97, Saint John returned to Ephesus leaving Patmos deserted and soulless. Two and a half centuries later, when the Byzantine Empire finally embraced Christianity, a small basilica was built on the site of a pagan temple, where a group of Christians scraped a living from the stony-dry land. The islanders, however, fled Patmos during the sixth century following raids by Saracen pirates. For 500 years the island was all but deserted once again until, in 1088, Emperor Alexius I Comnenus, ceded it free of taxes to Saint Christodoulos, an abbot from Asia Minor, to found the monastery of Saint John the Theologian.

Work commenced on the monastery the following year when Christodoulos and his companions laid the foundations and raised the first part of the monastery walls. 'I started with a castle, I raised it as high as I could,' he wrote, but Christodoulos was unable to begin work on ancillary buildings before pirate raids forced him to flee to Euboia, where he died in 1093. (Other versions of the story say he squabbled with his monks or that he sought a more reclusive existence and that he lived until IIII.) Christodoulos' disciples subsequently returned to the island, following a lull in attacks, bringing with them his relics which are now kept in a small chapel in the monastery.

The tomb quickly became renowned for working miracles and the monas-

Above the central courtyard of St. John's Monastery three great arches help to support the side buildings, including the exo-narthex in front of the catholicon and the Chapel of Christodoulos.

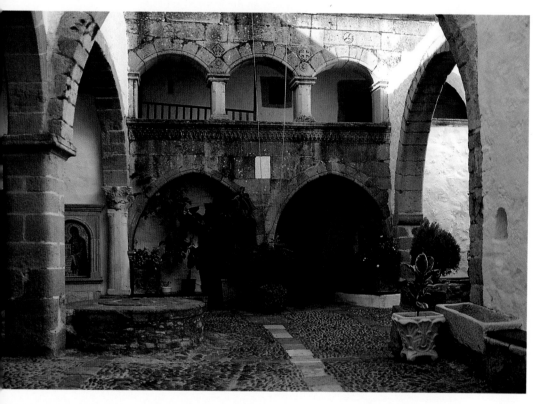

The two-storey portico, or tzaphara, on the south side of the main courtyard.

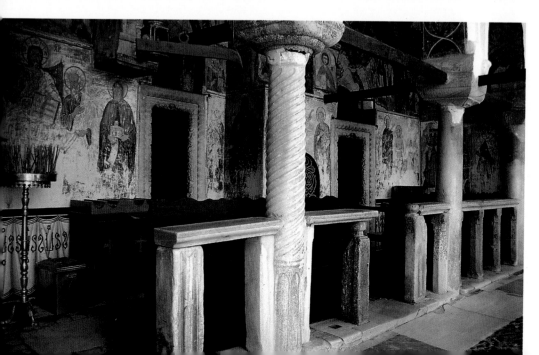

The seventeenth-century outer or exo-narthex incorporates columns and marble fragments from a fourth-century basilica. The walls are decorated with frescoes depicting the life of St. John.

tery began attracting groups of believers from the mainland and other islands. Pilgrims, crowded into gullets and fishing boats, thronged to Patmos, boosting its saintly reputation. It was soon known as the holiest island in Greece. Financial support came from emperors and patriarchs who donated arable land in Asia Minor and Crete, and Cretan workers arrived to complete and maintain the monastic buildings.

Alexius Comnenus' generosity to the monastery was not governed by religious concerns alone: he urgently needed a strategic Aegean base for the Byzantine fleet. The island's boatyards were soon a hive of activity, fully equipped to build new boats and undertake major repairs. Military funds poured into Patmos and the island basked in its own prosperity. But its relative wealth was a mixed blessing which encouraged further piratical raids. The monks sought stability and, as the Ottoman shadow fell over the Near East, they negotiated with the Turks who agreed to recognize the abbot's authority if the island surrendered peacefully.

The abbot readily agreed. As the Turks strengthened their hold on Asia Minor more monks and clergy fled to Patmos, helping to spread its influence in the monastic world. Few Turks chose to settle on the island and, under monastic direction, it became renowned as an intellectual centre. Education was generally poor throughout Greece during the Turcokratia and it grew progressively worse, but on Patmos the monks founded the celebrated Patmian School in 1713, where Latin, rhetoric and philology were taught as well as religious studies.

Like other monastic centres, Saint John's Monastery grew and developed in a rather *ad hoc* manner. Of the structures standing today, many of the walls, the catholicon, refectory and several cells in the southern wing were built between 1088 and 1093, before Christodoulos' death. The following century a narthex was added to the church, the refectory remodelled, and the Chapel of the Virgin built to the north of the catholicon. Individually they are unremarkable buildings but, consciously or otherwise, they broke a golden rule of monastic design. The catholicon, as well as being an unusual variant on the cross-in-square type of church, is not free-standing. From outside the church cannot be viewed as a whole; it is almost entirely enveloped by annexes and outbuildings. The dome, too, cannot be seen from outside. The roof is a flat terrace, commanding magnificent views of the harbour below, and seems only to confirm the idea that the building conceals from outside the religious nature of life within.

It is difficult to accept the opinion of one twelfth-century monk that the catholicon is 'a church of astonishing beauty' although easier to imagine it by candlelight 'lit up with the golden flashing of its holy icons'. To Byzantine monks church architecture was less important than the symbolism of its internal layout, the icons hung on the iconostasis, the elaborate silk embroideries, and, of course, the paintings on the walls. In the Monastery of Saint John two series of Byzantine paintings survive. The more complete of the two dates from the late twelfth century and was only discovered under later paintings after restoration work in the small Chapel of the Virgin in 1958.

The wall paintings in the chapel belong to the 'academic' or 'monumental' style of the time. The figures are static, symmetrical and usually full frontal. Elements, such as saints' beards, hair or ears, are reduced to separate volumes, and there is little or no background setting. Apart from the Presentation of the Virgin and Abraham's Hospitality, the sanctuary vault is decorated with Christ's miracles: the Healing of the Paralysed Man, the Woman of Samaria, and the Healing of the Blind Man. All share the common theme of water which cures and quenches thirst. Since

The northern entrance and porch to the small Chapel of the Virgin. The chapel contains important twelfth-century frescoes which were only discovered in the late 1950s beneath poorer quality eighteenth-century paintings.

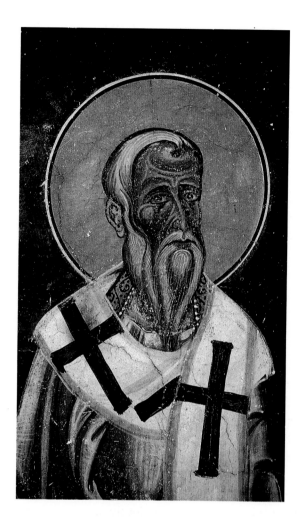

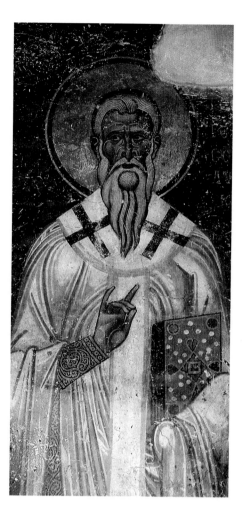

FAR LEFT: *St. Cyprianos, one of several hermit saints depicted on the west wall of the old refectory. The painting belongs to the earliest extant cycle of paintings in the monastery and has been dated to 1176–80.*

LEFT: *St. Macarius of Jerusalem, who 'discovered' the Holy Sepulchre and the site of Golgotha in 336, is one of a series of saints, painted between 1176 and 1180, in the Chapel of the Virgin. All the figures have a similar pose but are differentiated by the position of their hands and in their manner of carrying the Bible or a cross.*

BELOW: *A detail from the 'Healing of the Blind Man' (1176–80) in the sanctuary vault of the Chapel of the Virgin. Other scenes in the vault are also linked with water and have a symbolic association with this part of the church.*

the beginnings of Christianity water has symbolized the Word of God, which, following Christian belief, is expressed through the Sanctuary.

Elsewhere in the chapel, on the north and south walls, figures of saints, including seven Church Fathers and a series of patriarchs of Jerusalem, are depicted as busts or full-length figures. The patriarchs' portraits, as well as providing valuable historical information, help to date the paintings themselves. The latest figure portrayed is Leontius II, Patriarch of Jerusalem from 1176 until his death around 1190. Before becoming patriarch Leontius was the abbot of Saint John's Monastery and he probably held both posts simultaneously until 1180. It is thus supposed that Leontius donated the money and supervised the painting of the murals in his last four years as abbot.

Leontius and other abbots of the late twelfth and thirteenth centuries were educated men, as the chapel paintings and a second, though damaged, set of paintings in the refectory, help testify. They enjoyed close contacts with Constantinople and the skilled artists they employed probably trained in the same workshops in the capital. By contrast the later paintings, dating from around 1600, in the catholicon, the exonarthex and the Chapel of Saint Christodoulos, reflect the changing political jigsaw in the region. Constantinople had long since fallen to the Turks, and Patmos became culturally and artistically linked with Crete, though its economic links dated further back to the middle Byzantine period.

At this time Saint John's abbot was a Cretan humanist, Nicephorus Chartophylax, who taught Greek and philosophy and built several churches on the

island. It was probably Chartophylax who commissioned a Cretan artist, drawn from the circle of a celebrated painter known as Angelos, to paint a new series of frescoes. The style and feeling of the paintings differ enormously from those in the Chapel of the Virgin. They are difficult to make out in the gloom but, with the aid of a lighted candle, one can identify scenes from the Nativity set in a picturesque mountain landscape and a deeply disturbing depiction of the Slaughter of the Innocents. In the latter painting soldiers armed with swords and spears slash and pierce children while their mothers vainly try to protect them. A more peaceful scene in the narthex depicts the Parable of the Ten Virgins. Here, Christ is seated in the centre, with the five wise virgins to his left and the foolish ones, weeping, to his right.

In the post-Byzantine period, at least before the sacking of Heraklion by the Turks in 1669, Cretan artists were also engaged at Patmos to produce portable icons and sculpt an elaborate iconostasis, painted by a celebrated Cretan, Andreas Ritzos, of which only a sanctuary door now remains. The new paintings contributed to the monastery's already rich collection of icons, gold embroideries, church silver, and illuminated manuscripts. Many of the most important are now on display in the monastery museum. These include the most venerated icon of the monastery, a twelfth-century icon overpainted in the fifteenth of Saint John the Theologian; an icon of Saint James, the brother of Christ, painted around 1260–70; and an unusual eleventh-century mosaic icon of Saint Nicholas, probably brought from Asia Minor by Christodoulos himself.

Some of the oldest books and manuscripts in the library also date back to the eleventh century. Whether any of them were originally owned by Christodoulos is impossible to say, but he brought some books with him when he founded the monastery. The Patriarch of Constantinople also offered him a quarter of the books, those 'without decoration' only, which he had rescued from Seljuk raids in Asia Minor and taken back to the capital. One document that has certainly survived from that time, the most precious in the monastery, is the chrysobul of Emperor Alexius I Comnenus ceding Patmos to Christodoulos. Of the other manuscripts only fifty or so are illustrated, and of these only just over half contain anything more than decorated initials, but they include some extremely valuable pieces. One of the earliest illuminated manuscripts in the library is the Book of Job, which pre-dates the founding of the monastery and is written entirely in uncial letters, as was the norm in fourth- to eighth-century manuscripts. There are also thirty-three leaves of Saint Mark's Gospel, the Codex Purpureus from the sixth century, written in silver lettering on purple vellum; and several illuminated evangelistaries, codices containing miniatures, of the evangelists, from the twelfth to fourteenth centuries.

Like the library, the treasury was largely built up through bequests and donations. Most of the objects on display were gifts from priests and patriarchs who were born or studied on Patmos, though some donations came from further afield. Catherine II of Russia sent a silver cross and medallions. A seventeenth-century patriarch offered a gold crozier decorated with enamel and precious stones; while anonymous donors gave votive offerings of silver model boats and liturgical vestments embroidered in gold and silver thread.

Christodoulos may well have founded Saint John's Monastery, but its wealth and influence depended as much on the generations of pious donors who sought salvation. In the words of one patriarch: '... in the monastery we place our trust and take pride ... and each of us, readily and with faith, devotes and dedicates of his accord what he wants, in the belief that it will remain for ever and ever, inalienable and irremovable.'

OPPOSITE: *Central detail from the 'Parable of the Ten Virgins', a painting dated about 1600 on the narrow north wall of the narthex. The complete mural shows Christ flanked by the five wise and five foolish virgins.*

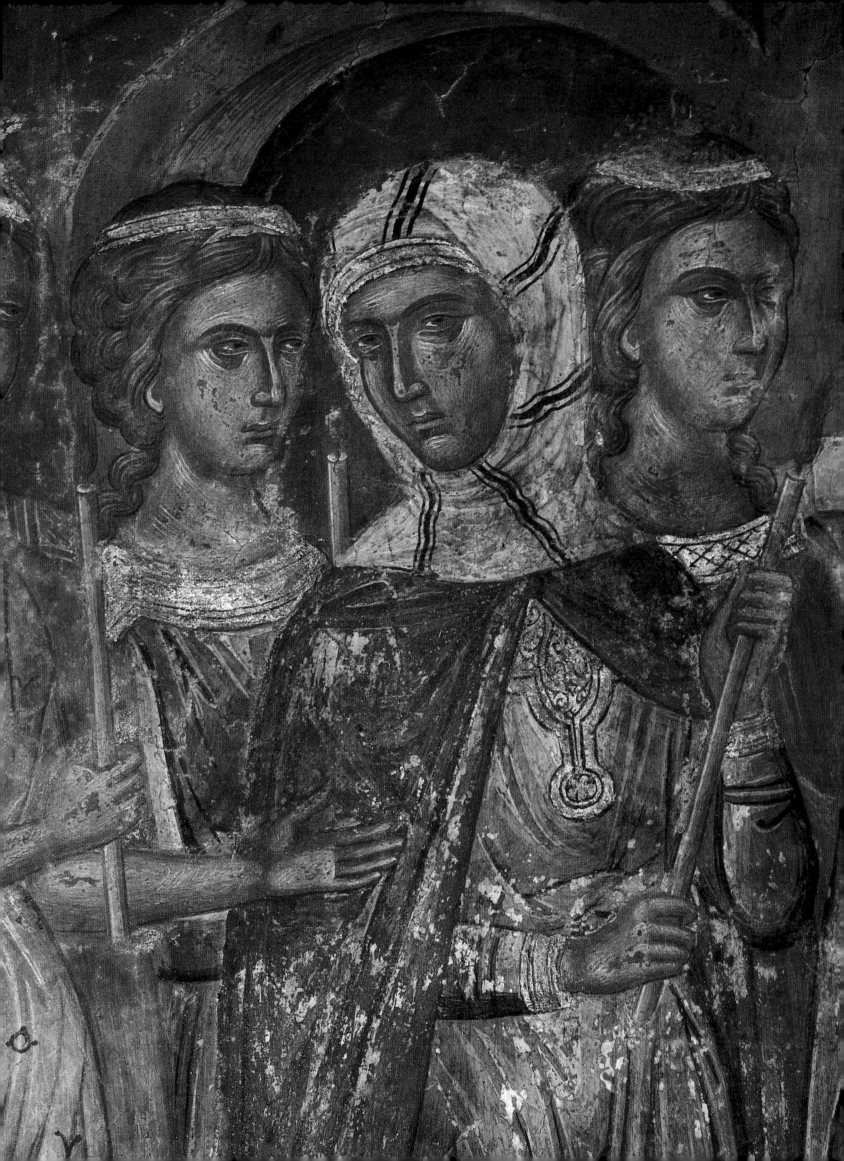

† Saint Luke and the Daphni Mosaics

Saint John's Monastery impresses by its sheer towering bulk, its intimate courtyards and narrow labyrinthine passageways; in short, its uniqueness. Two other monasteries, Ossios Loukas and Daphni, on the mainland, are more conventional in form. The church exteriors, though important examples of provincial Byzantine architecture, create little sense of awe like Justinian's Santa Sophia in Constantinople or the great cathedrals of the West. But if they disappoint on the outside, they more than make up for any shortcomings by the decoration of the walls within.

The monastery of Ossios Loukas was founded by a wandering hermit, Luke the Stylite, who died in 953, and whose tomb soon attracted pilgrims from near and far. It is perhaps some measure of Luke's sanctity that the community still houses a healthy number of monks today. In contrast, Daphni monastery has a far longer history, dating back to the fifth century, but it now stands empty and is no longer consecrated, its interior devoid of the liturgical trappings of a living church.

The first community at Daphni was ruined but later rebuilt, on a Greek cross plan, towards the end of the eleventh century, fifty years or so after Ossios Loukas. Both monasteries were subsequently endowed with liturgical treasures, venerated icons and glittering mosaics. They became, to borrow Richard Chandler's words, 'glories of Hellas', but during the thirteenth and fourteenth centuries, after the region fell to the Burgundian Dukes of Athens and Thebes, the Greek monks were ousted by Cistercian friars.

It is not, however, for their history that the monasteries are best known but for their astonishing cycles of eleventh-century mosaics. Beyond the threshold awesome, arresting figures spring from dazzling gold backgrounds. The walls and ceilings, pediments and pilasters, illustrate the Bible story with a brilliance that cannot be captured in wall paintings. Scenes and saints are invariably named and the Greek lettering, as in Byzantine painting, forms an integral part of the whole. It is a subliminal art, above all religious in nature, which sought to elevate the mind and spirit above the monotony of worldly affairs.

Though both churches were decorated in the eleventh century they are markedly different in style and provenance. Saint Luke's mosaics date from the early eleventh century, are particularly monastic in character, and relate to others in the Nea Moni on Chios. The pictures are provincial works, inspired and probably executed by the monks themselves. By contrast, the more sophisticated Daphni mosaics of the late eleventh century were undoubtedly the work of metropolitan artists from Constantinople. The cycle is not as complete as at Saint Luke's, and some scenes have been over-restored, but they still constitute the most perfect ensemble of the age. Indeed, outside Italy, the two monastery churches contain the only medieval mosaic cycles which allow the original ideas of the artists, in terms of space and colour, to be fully reconstructed.

The decoration of the two churches, perhaps more than any others, most clearly illustrates the iconographic importance of Byzantine art. Each panel is, in effect, an icon and the whole interior becomes a sort of extended iconostasis. Each has its place in the whole, and the whole represents Eastern Orthodoxy itself. Every scene is subordinated to the image of Christ, the Pantocrator, surrounded by his celestial court, in the dome. The original mosaic dome at Saint Luke's has, unfortunately, been lost and replaced by later paintings but the almost complete Pantocrator at Daphni is one of the finest and most alluring representations of Christ ever produced.

OPPOSITE: *Founded during the fifth century, Daphni Monastery was subsequently abandoned and fell into ruin. In the late eleventh century it was rebuilt and the interior decorated with remarkable frescoes. The delicately coloured scenes, set against a brilliant gold background, are masterpieces from the Second Golden Age of Byzantine art.*

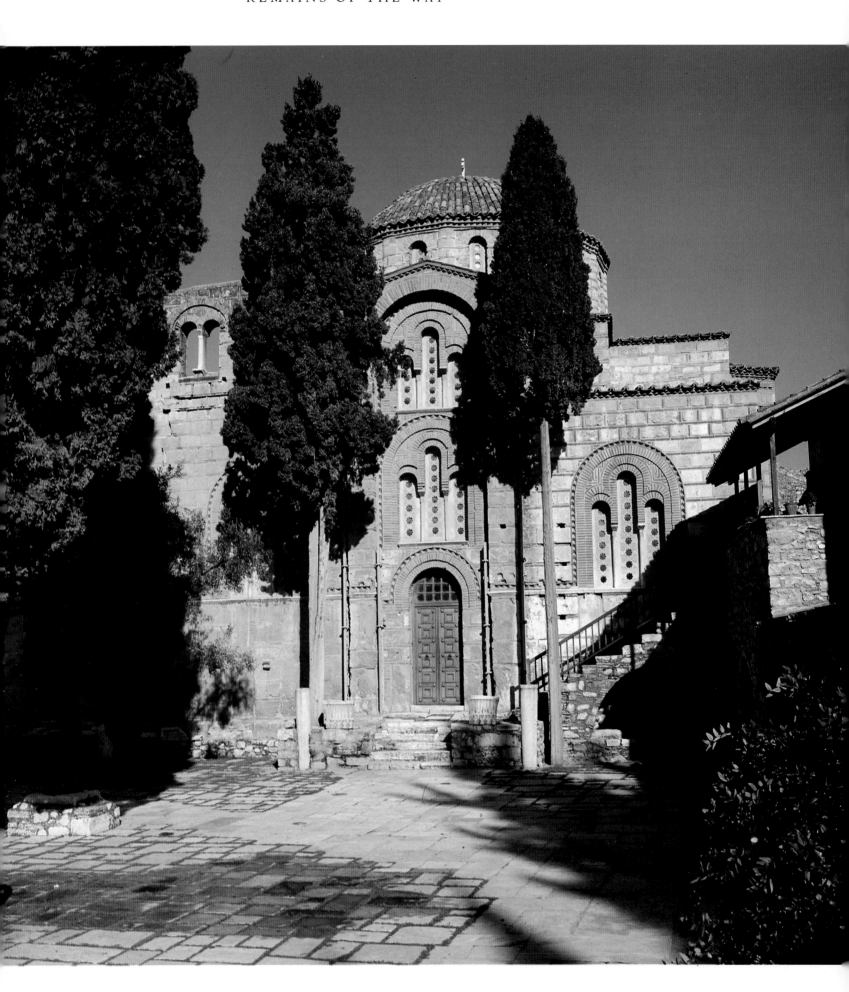

OPPOSITE: *Christ Pantocrator, 'the Almighty', a masterpiece of eleventh-century mosaic work, dominates the dome and is surrounded by the sixteen prophets.*

BELOW: *The Transfiguration of Christ, one of four key scenes in the squinches beneath the dome. Christ, shown between Moses and the Prophet Elias, stands on Mount Tabor transfigured by the Divine Light which dazzles Peter, James and John, who cower on the ground below.*

BELOW RIGHT: *The Betrayal of Judas in the narthex. Judas reaches up to kiss Christ while, to the right, Peter cuts the ear of young Malchus, the servant of the high priest who supervises Jesus' arrest. For his treachery Judas is portrayed in profile with a single eye. Artistic convention required figures to be depicted from the front with both eyes visible so that their presence could be felt in church.*

Much has been written about the Daphni Pantocrator. In 1931, Ernst Diez and Otto Demus, authors of a book about the Saint Luke and Daphni mosaics, considered that 'there is only one other figure in art, the Moses of Michelangelo, which can be compared to this picture in spiritual power, and it is remarkable how similar the tension of the hands in both appears, and how the hands were used by both artists as the most suitable means of expressing this quality.' The hands, with their somewhat awkward positioning, and elongated, perhaps arthritic, fingers dominate the lower half of the composition. The thumb of the right hand consciously touches the middle finger, a symbol of the blessing, while the left hand clasps an elaborate Bible, its cover inlaid with semi-precious stones.

But above all the tense severity of the mosaic is expressed in the face. A deeply frowning Christ captures attention by the sad expression in the dark, side-glancing eyes. The lined brow, the deep bags under the eyes, heavy shadow, and a down-turned mouth emphasized by the form of the beard, reinforce the sense of Christ's suffering for the salvation of the world.

All other figures are subordinate to the great Pantocrator. Each character and scene exists as a participant in, indeed an integral part of, the Divine Liturgy. They are not intended for instruction but to encourage a sense of veneration among the worshippers. Realism is rejected in favour of symbolic or sacramental representation; an approach which had direct effects on architecture and its decoration. In depicting people, for instance, a frontal position was preferable since a person was only deemed to be present if both eyes were visible. If two figures had to confront each other the rule was modified; a half profile was permitted but two eyes still had to be seen. The only biblical figure who is habitually portrayed in profile, with a single eye, is Judas Iscariot whose presence naturally was not required in church. A well-preserved scene showing Judas' betrayal, with Christ robed in blue and surrounded by soldiers and Pharisees, appears in the narthex at Daphni.

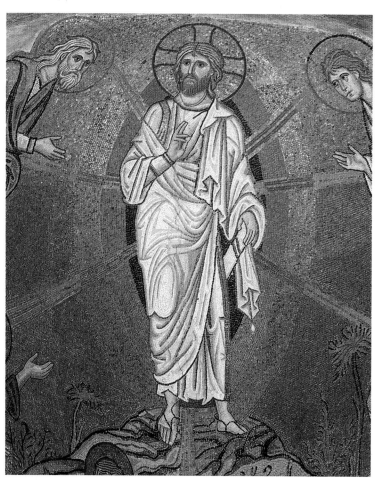

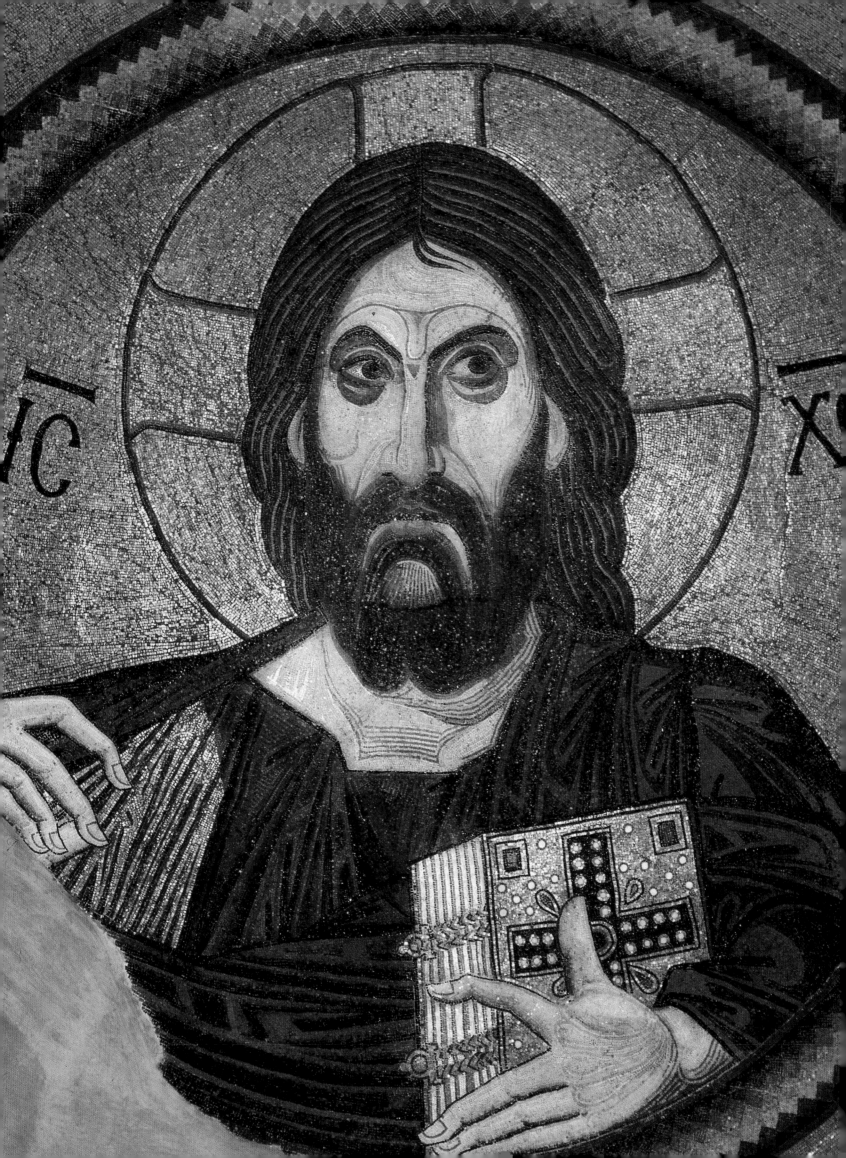

St. Sergius, according to tradition, was a Roman soldier martyred at Resapha in Syria for being absent when Emperor Maximian offered a sacrifice to Jupiter. His cultus spread far and wide. Sergiopolis, where he was buried, became a major pilgrimage centre and desert nomads adopted him as their patron saint.

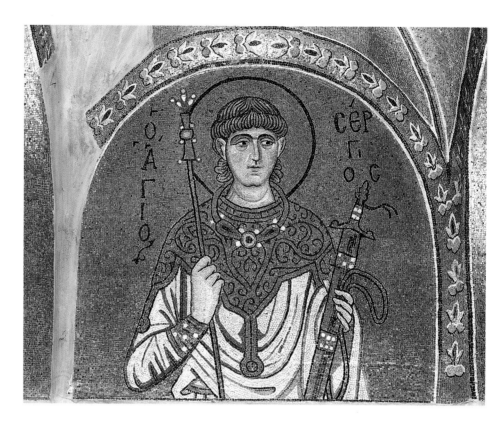

The Baptism in the south-west squinch. The hand of God reaches down from heaven; a dove symbolises the Holy Spirit. On the left stands John the Baptist while two angels, with blue and brown towels, wait to dry Christ after his immersion in the River Jordan.

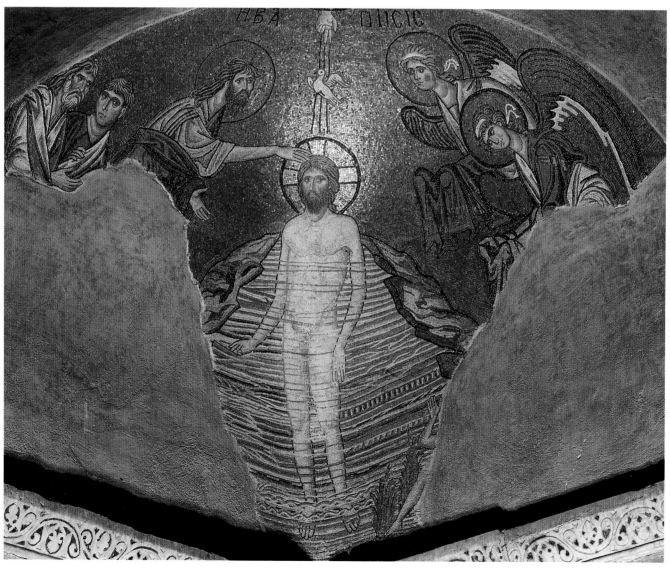

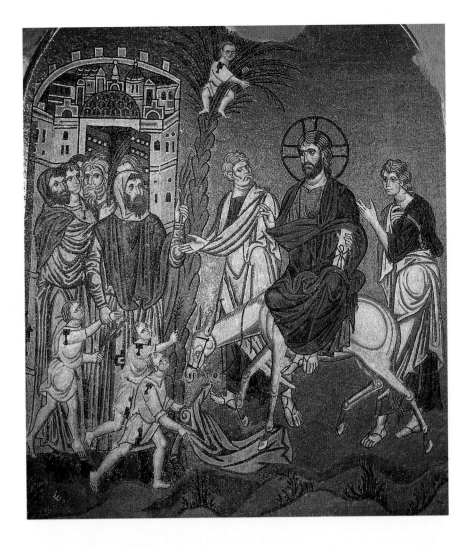

The Entry into Jerusalem. On what is now known as Palm Sunday, Christ is welcomed at the city gate by people offering palm branches. Boys cast their garments on the ground in veneration. One youngster has shinned up a palm tree for a better view of the procession.

Nativity scene in the south-east squinch. The infant Jesus in a manger attended by Joseph and Mary. Two shepherds and four angels look on.

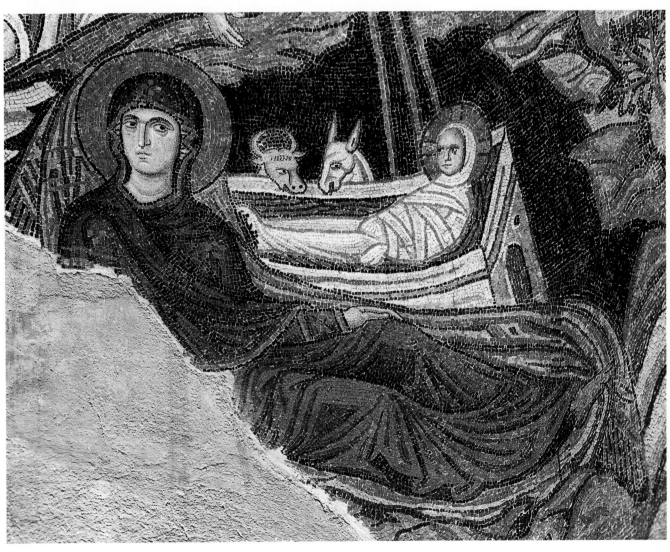

St. Pegasius in the narthex of the catholicon. The largest part of the mosaic decoration is devoted to portraits of the saints.

St. Luke the Styriot (896–953), founder of the monastery that bears his name, looks down from the western wall of the north transept.

OPPOSITE: *A detail from the Resurrection showing Christ wielding a cross as he breaks open the gates of Hades.*

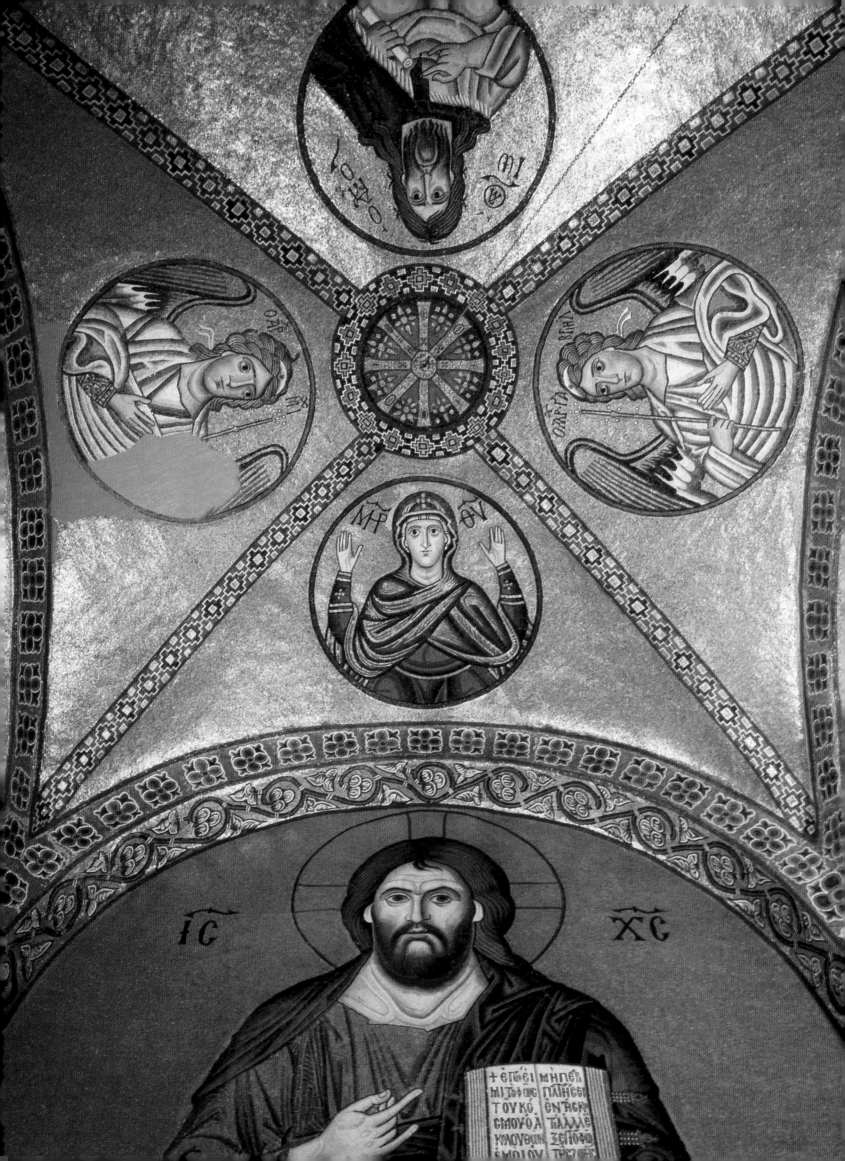

✝ Prayers Among the Ruins

The monasteries of Saint Luke and Daphni were well-established communities long before a series of new monasteries, glorious reminders of the last flourish of Byzantine power, were founded at Mistra in the central Peloponnese between 1295 and 1428. The monastery churches still stand, and one retreat is occupied by a handful of nuns, though the city itself, once known as the 'Florence of the East', is now little more than ruins.

The first significant building at Mistra, the famous fortress looking out over the Sparta plain, was built by William of Villehardouin, a Frenchman born in Greece and Prince of Morea, in 1249. At first Mistra was a Frankish city but, ten years later, following William's capture by soldiers of the Byzantine emperor, Michael VIII Palaiologus, it passed into the hands of the Greeks. After the Byzantines retook Constantinople in 1261, Mistra enjoyed a central role in the revival of Byzantine art before the capital fell again, this time to the Turks, two centuries later.

Byzantine officials arrived at Mistra in the spring of 1262 to take control of the castle and to oversee the start of a substantial building programme. New homes and churches soon dotted the steep, rocky site. A metropolitan church, or cathedral, was built in the lower town, and before long the growing city became known for the wealth of its monasteries and as a centre of Hellenic politics and culture.

At the end of the thirteenth century an energetic cleric, Pachomius, did more perhaps than anyone else to encourage religious life at Mistra. Pachomius oversaw the completion of the city's first important church, Saint Theodore's, in 1295. A few years later, having retired from public life, Pachomius incorporated the church into the Brontochion Monastery, of which he became abbot. The main monastery church, however, was not completed until 1310 when a more sophisticated edifice, decorated by painters from Constantinople, was dedicated to Our Lady Hodeghetria, 'she who shows the way'.

The new church reflected the city's growing influence. Between 1312 and 1322, Emperor Andronicus II issued a series of chrysobuls granting the monastery estates throughout the province, and giving the abbot authority over several smaller communities. Copies of the chrysobuls, stamped with the emperor's gold seal, decorate the walls of a Hodeghetria chapel. They give details of the Peloponnese estates, together with the names of the villages and the number of inhabitants in each. More importantly, at least in terms of status, Pachomius also persuaded the emperor to remove Brontochion from the jurisdiction of the local ecclesiastical authorities, so that it became virtually independent, but under the ultimate direction of the patriarchate in Constantinople.

Increasing prestige encouraged a local governor, Andronicus Palaiologus Asen (1316–21), to offer the monastery more land; and in 1375 leading citizens clubbed together to donate another large estate. The Brontochian, with its two churches and vast estates, was the wealthiest monastery in Mistra, and it was appropriate that Pachomius should be buried there. The abbot's tomb lies in the Hodeghetria's northern chapel, while above it, on the wall, a damaged fresco depicts Pachomius kneeling before the Virgin and offering her a model of the church. The chapel also contains the tomb of the Despot Theodore II Palaiologus (1407–43), who abandoned the secular life to become a monk. Above his tomb are two portraits; one depicts a regal Theodore in the rich, embroidered robes of a ruler, the second, an older Theodore in the simple habit of a monk.

After founding the Brontochion, Pachomius was assisted by a high-ranking

The holy spirit prepares the throne for Christ's return in the catholicon, St. Luke's Monastery.

OPPOSITE: *The catholicons of St. Luke's and Daphni monasteries are the two best preserved monuments of Greek mosaic art. Here, in the narthex of St. Luke's Church, Christ is portrayed above the Royal Door, leading from the narthex to the nave, while the Virgin Mary, John the Baptist and the Archangels Gabriel and Michael look down from the central vault.*

OVERLEAF: *The ruined city of Mistra, once known as 'The Florence of the Orient', was an important centre of late-Byzantine monasticism, Hellenic politics and culture. Mistra's monastery churches, several painted with remarkable murals, are among the best preserved buildings in the former capital of the despotate of Morea.*

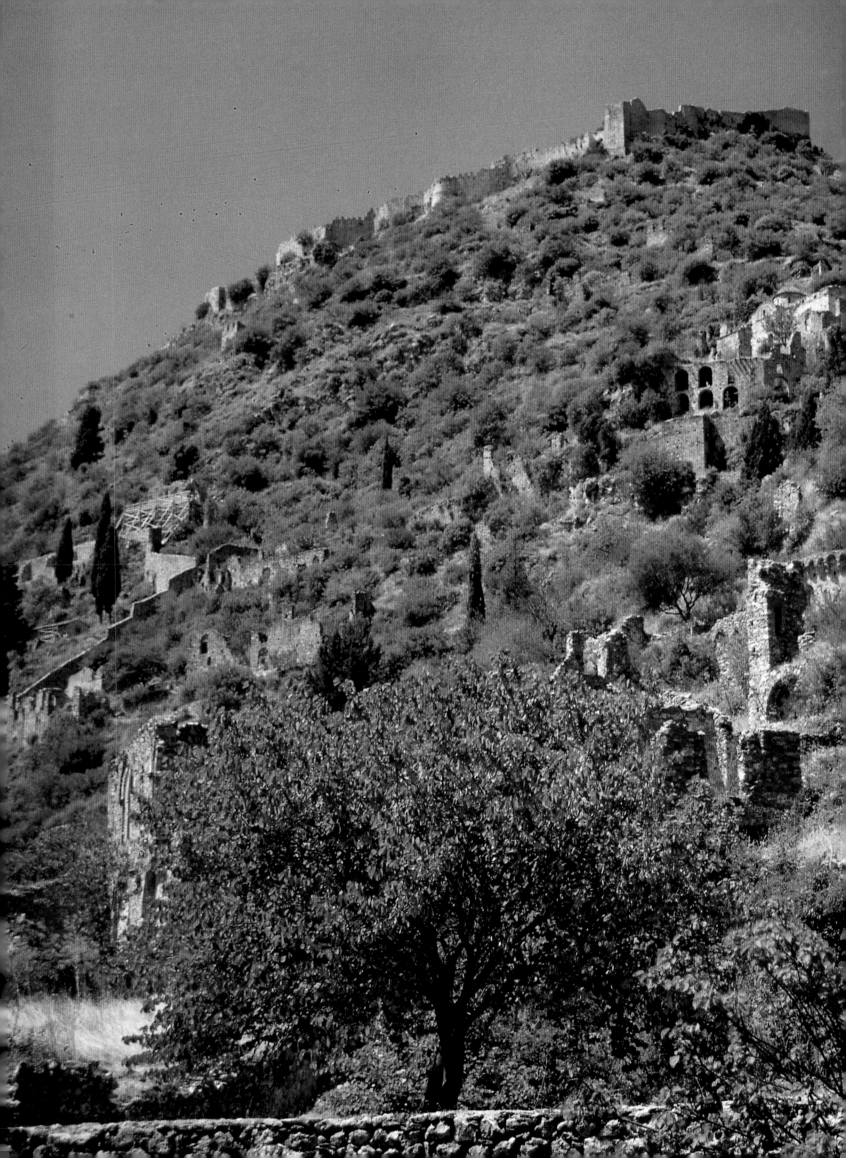

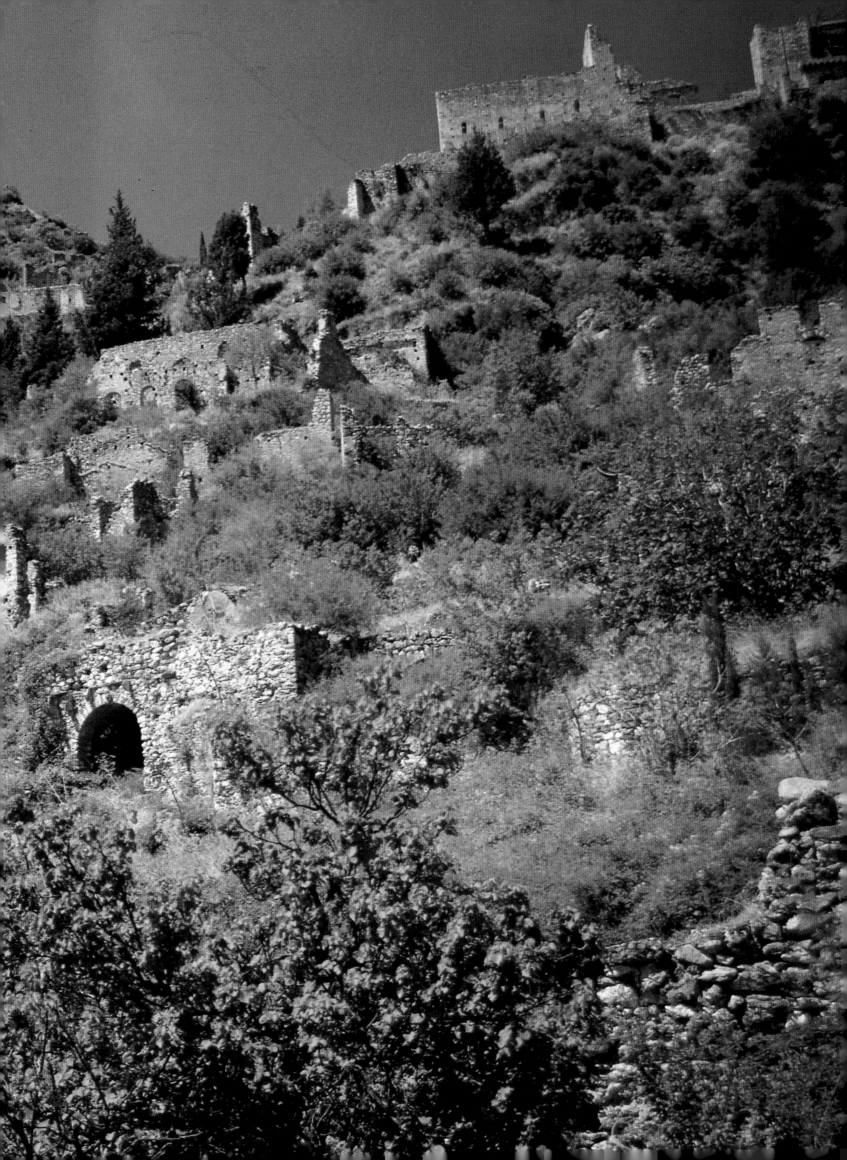

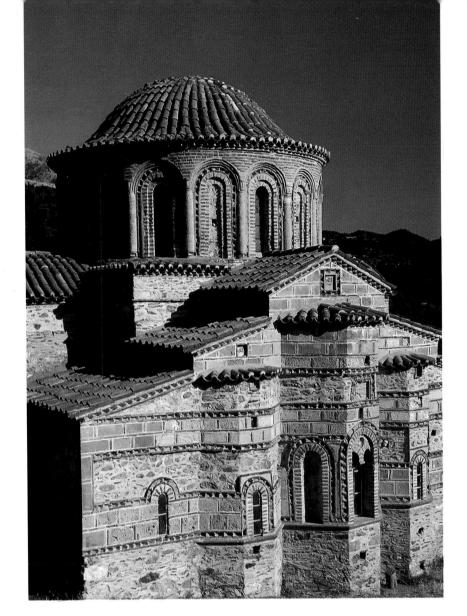

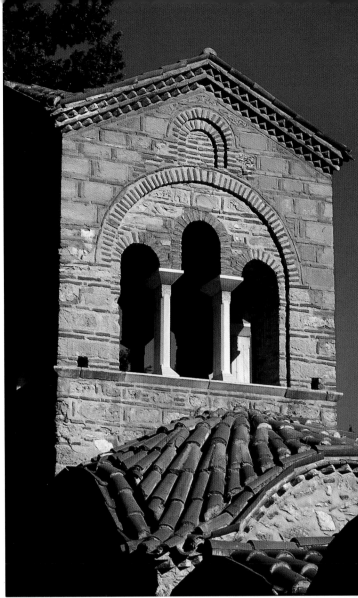

prelate, Nicephorus Moschopoulos, in turning the monastery into a centre of learning. Nicephorus had been appointed by the patriarch himself to administer the local see of Lacedemonia and, with the help of his wealthy brother Aaron, he completed the Metropolitan Church around 1309 or 1310. He also presented the Brontochion Monastery with an illustrated copy of the Gospels, now in the Synodal Library in Moscow.

Later governors and despots also proved themselves important patrons of the arts. The Despot Manuel Cantacuzene built a court church dedicated to Saint Sophia in the upper town, and founded a small monastery nearby. Another small monastery, the Peribleptos, was altered and painted with fine frescoes in the mid-fourteenth century. The larger Pantanassa Monastery, the only one still inhabited, was founded by a chief minister of the Despotate, John Phrangopoulos, and dedicated to the 'Queen of the Universe' in September 1428, just twenty-five years before the fall of Constantinople and the end of the Byzantine world. The church includes the last important series of Byzantine frescoes ever to be painted.

Though much of Mistra's secular architecture was strongly influenced by the West, a result of the Frankish occupation, the city's monasteries and churches continued to reflect Byzantine tradition. Western influence is evident in the belfry towers attached to the Pantanassa, Hodeghetria and Saint Sophia churches, in the refectory tower at Peribleptos Monastery, and in decorative trefoil designs and occasional pointed arches. But overall it is Byzantine conventions, including decorative brickwork, dog-tooth bands, blind arches and cloisonné walling, that predominate. And various conventions, indeed styles, were fused and adapted in the design of Mistra's churches.

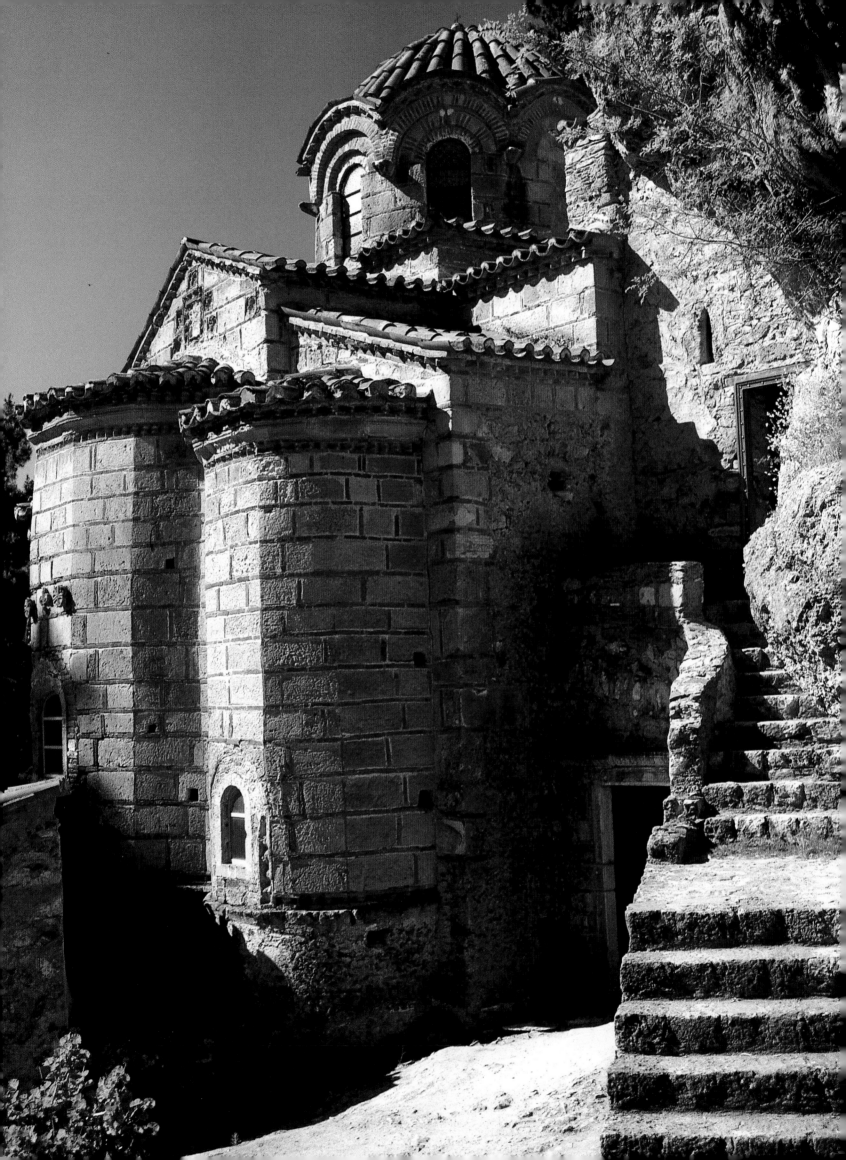

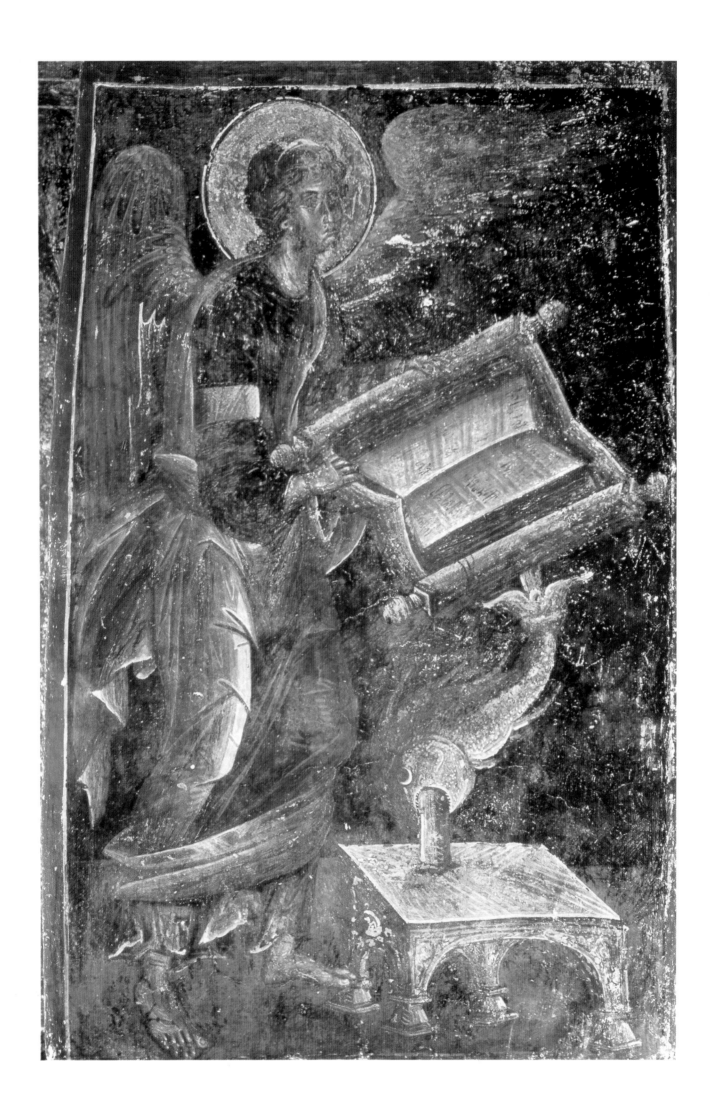

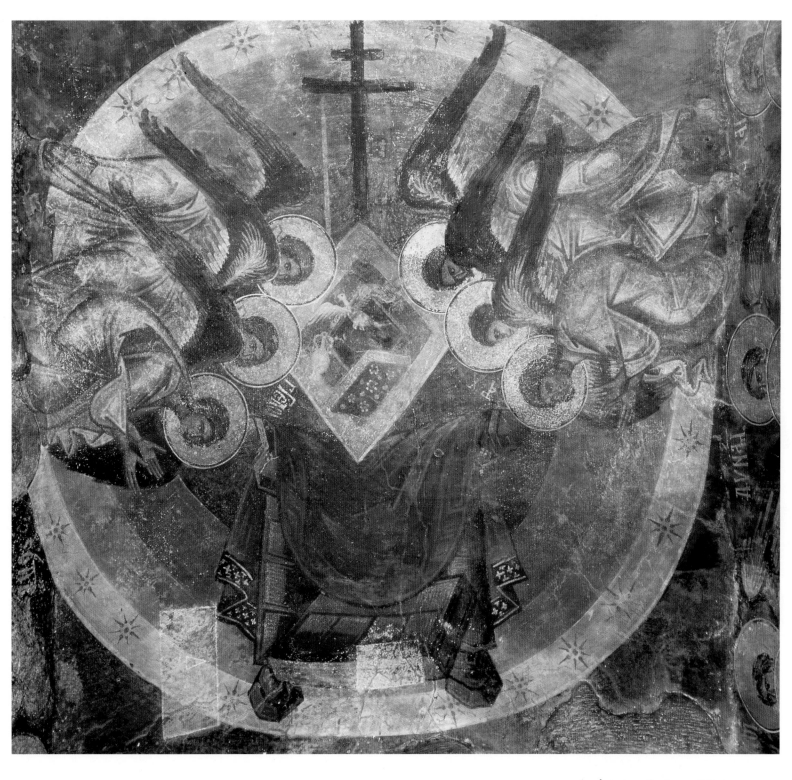

Angels prepare the throne of Christ for the 'Second Coming' in the Cathedral of St. Demetrius, Mistra. An empty throne, surmounted by a Byzantine cross, symbolises the expectation of the second coming of Christ.

OPPOSITE: *An unusual early fourteenth-century scene in the narthex of Mistra's St. Demetrius Cathedral. The painting, inspired by the Last Judgement in the Book of Revelation, includes a curious lectern with a base in the shape of a fish, a symbol of Jesus Christ the Saviour.*

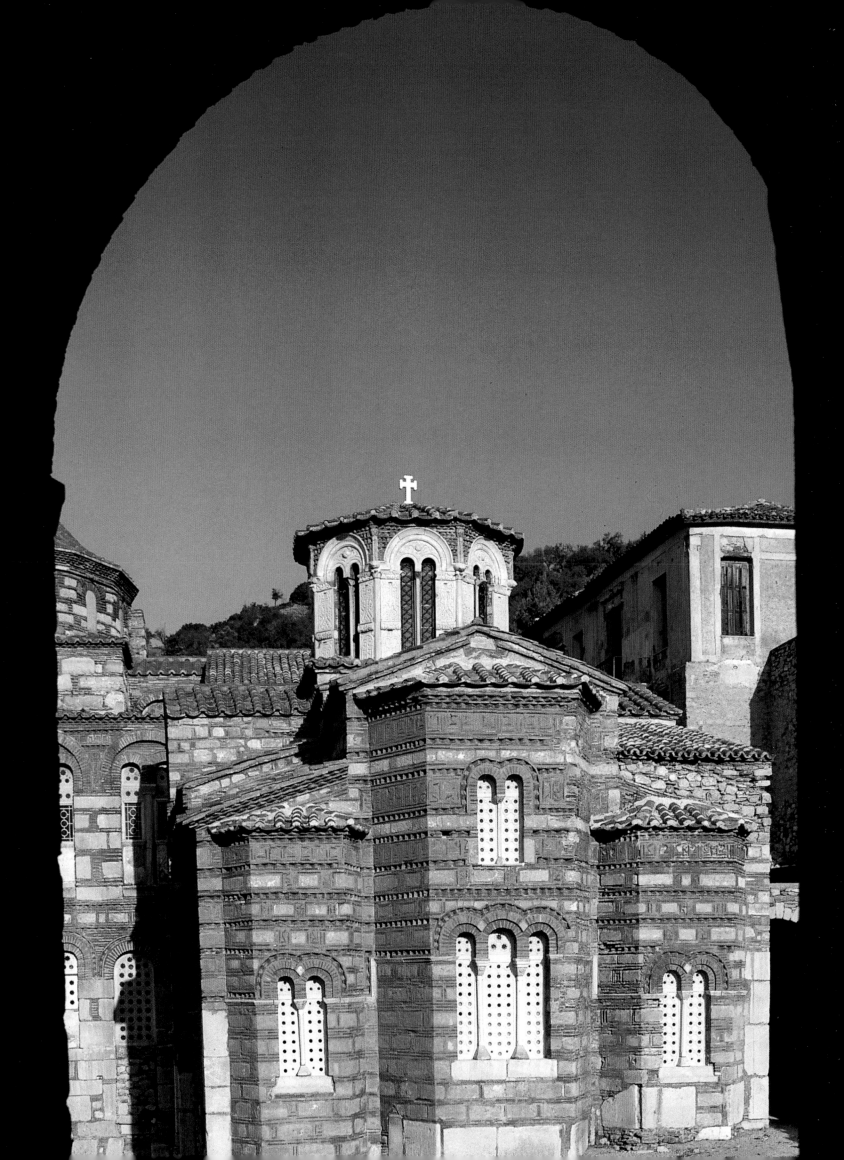

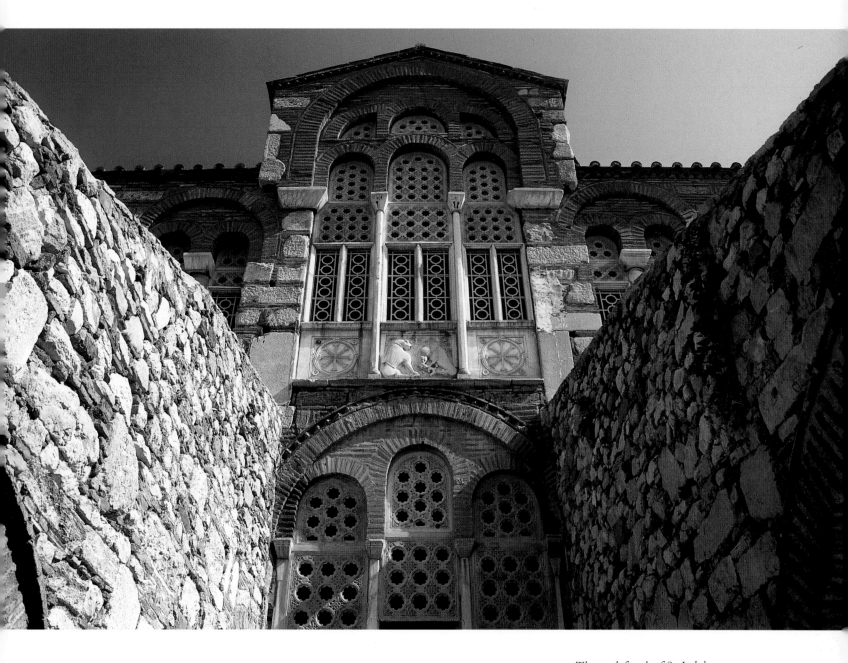

Abbot Pachomius's Hodeghetria – the catholicon of Brontochion Monastery – and the Metropolitan Church are essentially three-naved basilicas, smaller versions of the Church of Saint Irene, one of the earliest Christian churches in Byzantium. Each basilica is crowned by five cupolas, with, in the case of the Hodeghetria, a sixth over the narthex. The earlier Church of Saint Theodore, like the churches at Saint Luke's Monastery and Daphni, is a Greek cross-style church, or, more specifically, a cruciform octagonal naos, in which the dome is supported at eight points instead of the more usual four. Saint Theodore's Church represents the last example of this type, a model which was fashionable from the eleventh to thirteenth centuries. The important church of the Peribleptos lies halfway between a domed basilica and a Greek cross, a type common in the Palaiologan period and known as distyle, but here adapted to suit the rocky nature of the site. The last church built during the Despotate, the Pantanassa, is another basilica crowned by five domes.

The south façade of St. Luke's Church. According to monastic tradition the catholicon was built by Byzantine Emperor Romanus II (reigned 959–63) who arranged for himself and his wife to be buried near the tomb of St. Luke.
OPPOSITE: *The Church of the Virgin Mary at St. Luke's Monastery is markedly different in style to the main church or catholicon. It was probably built in the thirteenth century for the Cistercians when the region was held by Burgundian Dukes. Instead of the conventional Byzantine dome, the church is crowned by an octagonal lantern.*

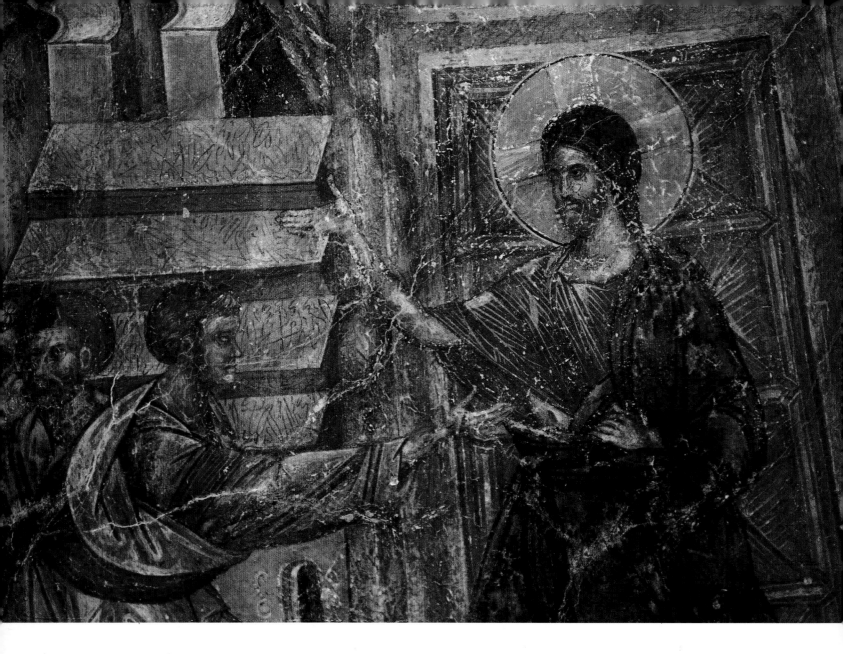

Mistra's churches are decorated with the finest surviving frescoes of the period outside Constantinople. The excellent workmanship in the Metropolitan and Hodeghetria churches suggests that the artists belonged to the same Constantinopolitan school that produced a great contemporary masterpiece of Byzantine painting, the Anastasis in the funerary chapel of the Church of Our Saviour in Chora in Constantinople. The paintings are comparatively small in scale but finely worked. The figures are well drawn and the colours rich but not overdone. Some of the best paintings decorate the narthex of the Hodeghetria. Here, Christ's miracles, including a notable Marriage at Cana, are painted with the harmony of colour and the fluid lines of a true master, the equal of the Florentine painter Giotto, or his contemporary Duccio.

The frescoes in the monastery church of Peribleptos were painted fifty years later, around 1350, and include some of the best preserved scenes in Mistra. They have a striking individuality, but whether they represent a native school or the work of artists from the capital is now impossible to say since no frescoes of this date have survived in Constantinople. The Peribleptos painters used a wider, usually livelier, palette than their predecessors at the Hodeghetria. Much use is made of ochre and a cheerful chestnut red. The drawing is still good, the figures a touch stiffer than before, and the outlines softened by subtle graduations of colour.

Quite the most unusual use of colour, however, is to be found on the walls of the Pantanassa, the last great Byzantine monument at Mistra. So striking are some of the scenes, so riotous the colour schemes, that the paintings have led to widely

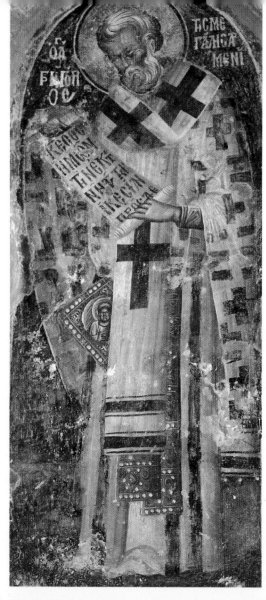

One of a series of bishops in the sanctuary of Hodegetria Church.

A fine and subtly coloured mural of the Wedding at Cana, when Christ turned water to wine, in the narthex of the Church of the Virgin Hodegetria, Brontocheion Monastery.

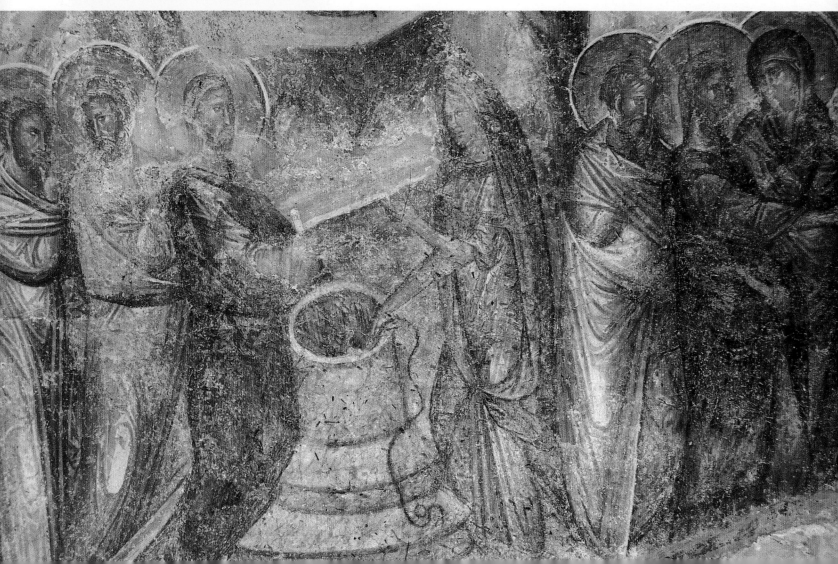

divergent opinions among leading Byzantinists. Steven Runciman feels the compositions, though charming, are cramped by too many figures. 'It is almost as if we were looking at the illustrations to a book of fairy tales. One feels that the artists were trying to transfer a style suited to book-illumination to larger spaces for which it was unsuitable.'

Robert Byron and David Talbot Rice would have had little time for this point of view. In their book *The Birth of Western Painting* (1930) they devote a lengthy passage to the striking portrayal of the Raising of Lazarus on the north vault. To the enthusiastic onlookers the painter's palette included bottled honey, slightly tinged with olive, crushed strawberry, pink-tinted brown, glowing amber, dark crocus, and a pearly opalescent yellow. Of the central scene they had this to say: 'A most beautiful moving humanism pervades these six persons … The anatomy is no longer hieratic, no longer the anatomy of physically abnormal ascetics. The weeping figure is perfectly proportioned; the mummy expresses a tragic resignation; while the man unwinding is fired with a frantic vigour.'

Moving humanism or fairy-tale illustration, the painting, sadly damaged by fissures in the ceiling, is among the most alluring murals to be produced in the last decades of Byzantine rule. There is far more movement, more emotion, in the Pantanassa painting, than the static, model-book figures of the earlier Macedonian school or, indeed, in the other murals at Mistra. Conventions, inevitably, have still been followed, but they have been adapted to such an extent as to create a unique work of art, the final artistic flourish in the twilight years of a once great empire.

OPPOSITE: *The recently restored monks' cells at St. Luke's Monastery form the north and west sides of the monastic enclosure. Monks are still in residence and efforts are currently underway to revitalise the community.*

·5·
Athos — The Holy Mountain

More blest the life of godly Eremite,
Such as on lonely Athos may be seen,
Watching at Eve upon the giant height,
Which looks o'er waves so blue, skies so
serene.

Byron, *Childe Harold's Pilgrimage*, Canto II, 1812

OPPOSITE: *The towering walls of Iviron monastery with its well-tended vegetable gardens below.*

During the late Byzantine and post-Byzantine periods Mount Athos came to represent the essence of Orthodox monasticism. In historical terms it was perhaps appropriate that this narrow peninsula should become a bastion of eastern Christianity. Thessalonika, to the north-west, had been visited twice by the Apostle Paul and it was there that one of the first Christian communities on mainland Europe grew and flourished. According to pious tradition, Athos itself was visited by the Virgin Mary and John the Evangelist who, in a tale that stretches the imagination, were said to have been shipwrecked on the eastern shore while on their way to Cyprus. Mary was so enchanted by the place that she asked for it as a gift from Jesus.

Legends apart, little is known of the early history of the peninsula. The first documentary evidence dates from the ninth century when monks from Athos are known to have attended the Council of 843 convened by Empress Theodora, which effectively brought to an end the iconoclastic controversy by reinstating holy icons as legitimate images of veneration in churches and private homes. While the controversy raged the monks lived as solitary hermits or in small groups adapting their way of life to the teachings of two influential fathers, the semi-legendary Peter the Athonite and Euthymius the Younger who arrived on Athos in 859.

The two preachers had both been strict solitaries. Peter spent fifty years in the forests battling against all manner of beasts, real and imaginary, before being discovered by a hunter. His successor, after rejecting the world at eighteen, moved on all fours and ate grass. He then retired to a vermin-ridden cell which he only left

OVERLEAF: *Iviron Monastery, third in the list of twenty ruling monasteries on Athos, from the south-east. Founded by Georgian monks at the end of the tenth century, it was handed over to Greeks in 1357 following a decree issued by Patriarch Kallistos. Iviron Monastery is dedicated to the Dormition of the Blessed Virgin Mary and, with its dependencies, houses almost eighty monks.*

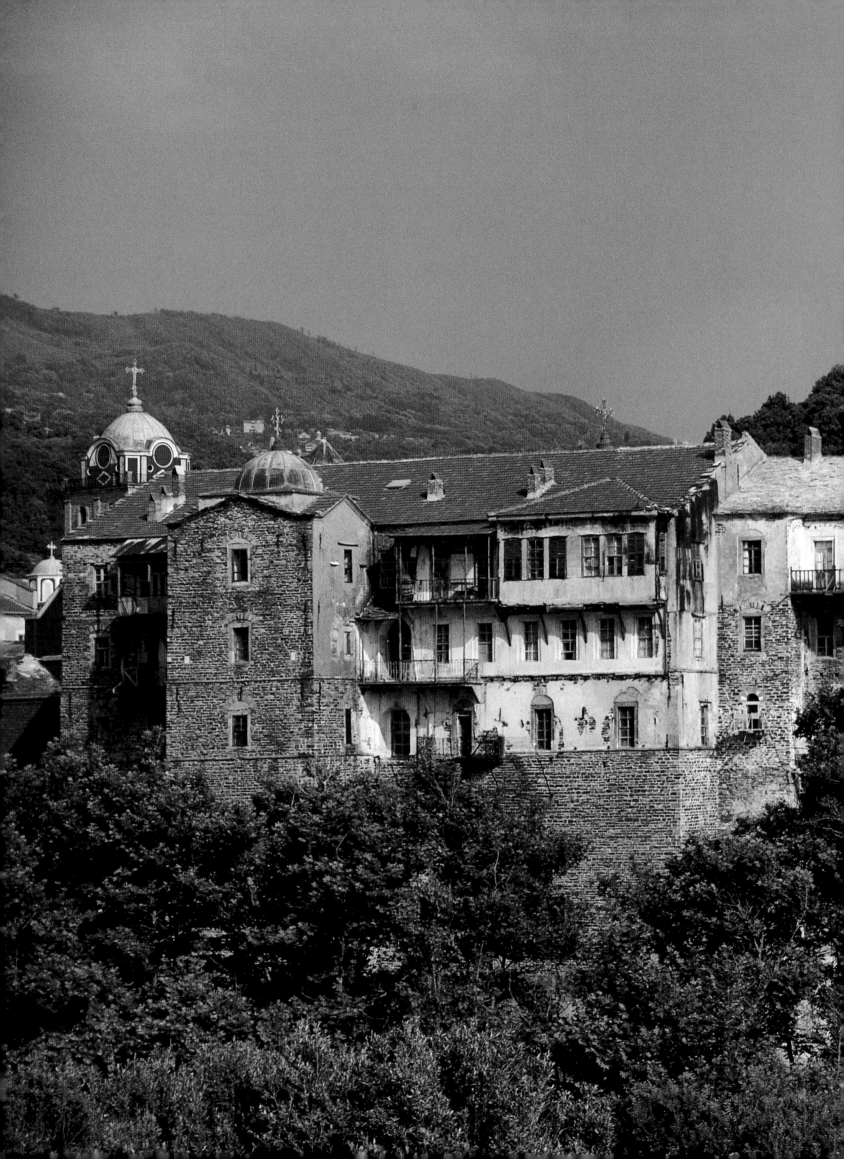

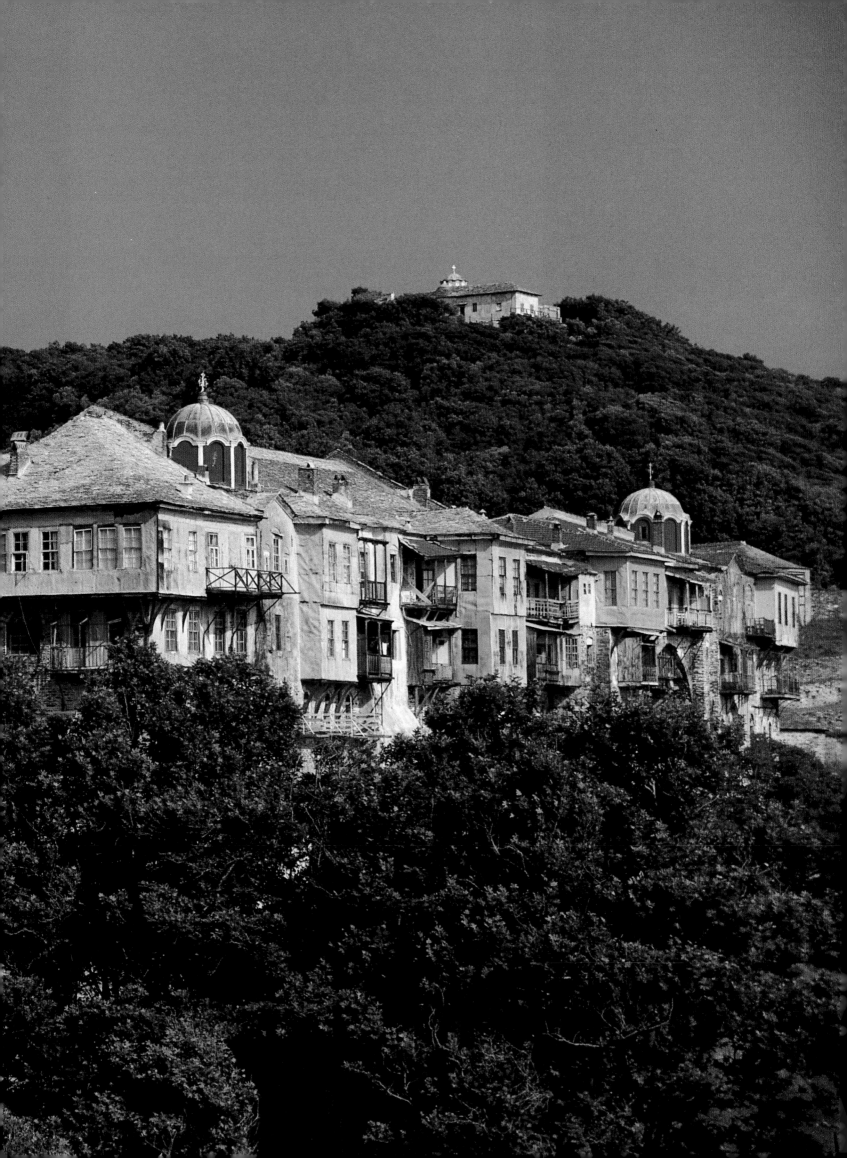

A small church, built on the shore next to a holy spring, belongs to Iviron. The monastery owns more than thirty dependencies on Athos as well as land beyond the Holy Mountain's borders in Samothrace.

A sculptured hand decorates a fountain in Iviron's outer walls.

Inside the main entrance to the monastery a double-headed Byzantine eagle atop a small wall fountain.

OPPOSITE: *The interior courtyard and* phiale, *or fountain, which was reconstructed in 1865. Within the monastery enclosure are sixteen small chapels including the nineteenth-century Chapel of the Archangels which contains the relics of a hundred and fifty saints and, it is claimed, a fragment of the True Cross.*

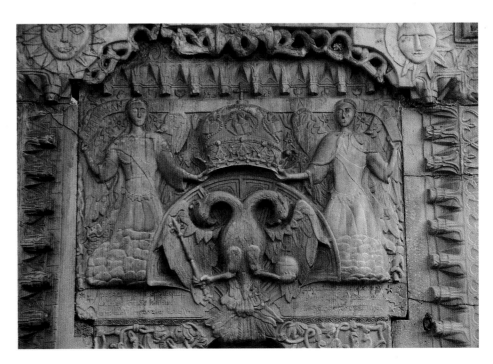

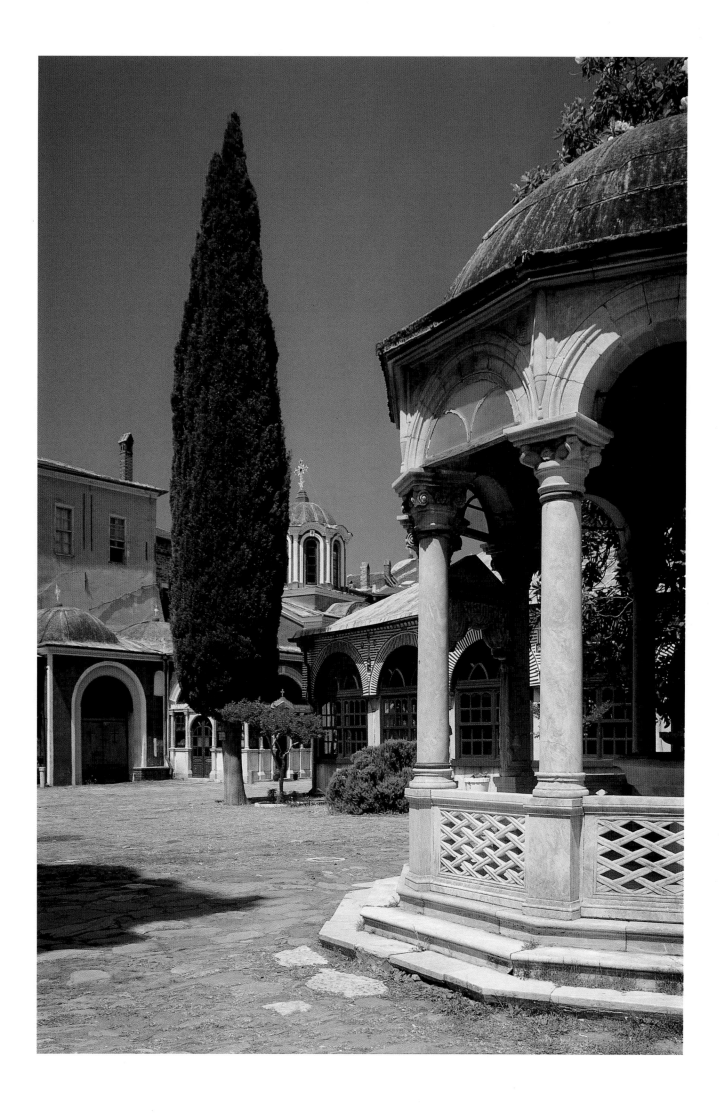

after three years to perch on a pillar. Despite, perhaps because of, their extremism both men attracted new recruits to the Holy Mountain.

Athos became an increasingly important community, modelled on those of the Byzantine capital or of others elsewhere in the Near East. Official recognition came in 883 when Emperor Basil I declared Athos to be a spiritual centre. In a decree issued that year the mountain was also established as an all-male preserve; henceforth, shepherds, women and all female animals were forbidden from entering the peninula, which was to be the exclusive domain of monks and hermits.

✝ Athanasius and the Hermits

As increasing numbers of monks sought spiritual refuge at Athos the nature of monasticism began to change and diversify: eremiticism overlapped with a more liberal semi-eremiticism which was later overshadowed by the communally organized coenobitic life. The coenobites first appeared on Athos during the ninth century, but it was only under Saint Athanasius, founder of the Great Lavra in 963, that the coenobitic life was firmly established.

Athanasius' arrival on Athos followed a teaching career in Constantinople and six years in the Bithynian monastery of Kyminas. In the capital he had been well connected with the aristocracy and private counsellor to the ruthless general and future Emperor Nicephorus II Phocas, a position which proved invaluable as he sought to effect radical changes in Athonite monasticism. With Nicephorus' support and adequate funds, including the general's share of the spoils from the liberation of Crete, he founded the first great monastery on Athos, the Lavra, near the southeastern tip of the peninsula.

Nicephorus, despite his barbarous reputation, was a deeply religious man and eager to retire to the monastery himself where, he told Athanasius, 'you and I can be alone with our brothers and together taste the joys of the Eucharist.' His desire for solitude, however, was thwarted when he fell in love with the widowed Empress Theophano, a stunning beauty less than half his age. Athanasius, naturally shaken by the turn of events, promptly wrote to Nicephorus accusing him of breaking his promises. According to the *Vita Athanasii*, building work at the Great Lavra was suspended and Athanasius returned to his former hermitage.

The monastery's typicon, on the other hand, states that Athanasius went straight to Constantinople and confronted the emperor, accusing him of betrayal. Athanasius had lost interest in the Holy Mountain and, he told Nicephorus, he would not be returning. Nicephorus was dismayed and reportedly fell to his knees, pleading with Athanasius to continue with the project. The emperor said he still dreamed of retiring to Athos and one day would join his friend on the Holy Mountain. He had not, he claimed, had carnal intercourse with Theophano, nor would he in future and he implored Athanasius to return to the mountain to complete the task in hand.

Athanasius, appeased though burdened with a heavy conscience, duly returned to Athos with the emperor's chrysobul declaring the Lavra to be an imperial monastery independent from the church authorities. Other decrees limited the number of monks to eighty and granted the monastery lands and a 'solemnion', or annual stipend, of grain and 244 gold pieces. The emperor also sent personal gifts: a splendid jewelled Bible and a golden reliquary containing a piece of the True Cross, both of which are among the Mountain's greatest treasures today, and a pair of huge

OPPOSITE: *Vatopedi Monastery, second in the Athos hierarchy, was founded by three monks from Adrianople towards the end of the tenth century. It has been the home of several eminent figures including the fourteenth-century hesychast theologian Gregory Palamas, Patriarch Gennadius Scholarius, following his abdication from the ecumenical throne, and Emperor John VI Cantacuzune, who retired here.*

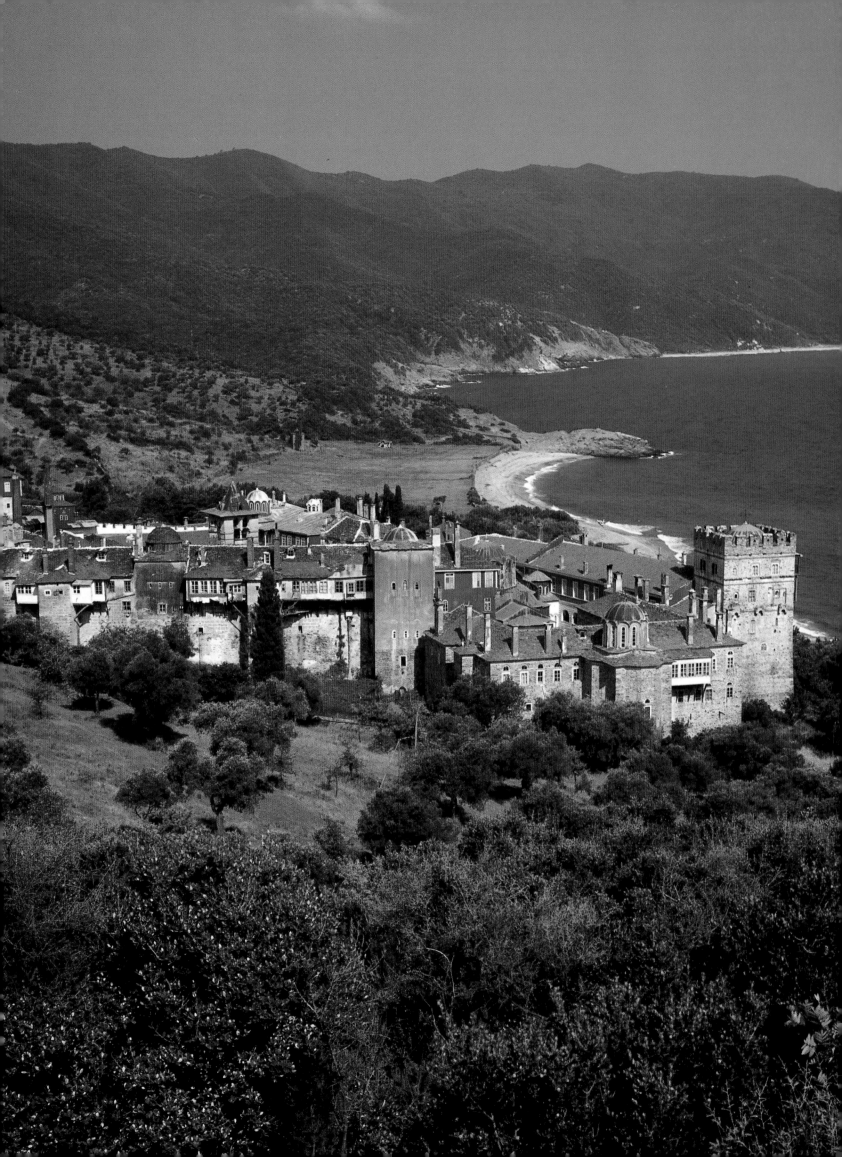

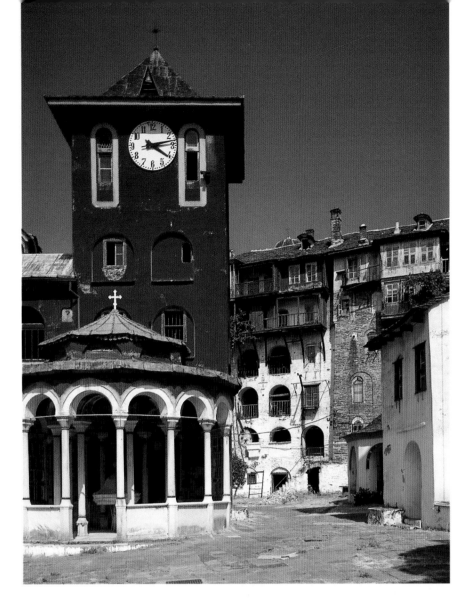

Vatopedi's inner courtyard with its fifteenth-century clock tower and phiale *abutting the catholicon.*

Colourful bay windows of the monks' cells.

bronze doors which are still in place. Nicephorus, however, was never to realize his professed dream. Six years after rising to the throne he was brutally murdered in the imperial palace, the victim of a plot between Theophano and her latest lover John Tzimisces.

Pagan sculpture of a ram and fool, probably rescued from the ruins of the ancient town of Thyssos, in the front wall of the catholicon.

While Nicephorus had provided financial security, it was Athanasius who supervised the construction of what became a large complex, including the Church of the Theotokos, the monks' cells, a refectory and kitchen, and a hostel for visitors. But, like Nicephorus, Athanasius would never see the completion of the Great Lavra. Around 1000, while supervising building work, his life was cut short by the collapse of the church's main dome. The unfortunate Athanasius was subsequently commemorated in portraits depicting him as an elderly, balding man, in a monk's habit and long two-pointed beard, in churches and manuscripts associated with Athos. One of the most dignified paintings is the huge Dormition of Father Athanasius in the refectory of the Great Lavra. Here, the saint lies in the centre of a hermit-dotted landscape, surrounded by the walls and inhabitants of the monastery. Above him appear the cell where he lived and the domes which killed him. For all his saintly aura, Athanasius was thwarted in his wish to escape earthly glory. According to two biographies, one of them by an Athonite monk and written soon after his death, he was unable to conceal his privileged background under the guise of a simple monk. Indeed, if he had succeeded in doing so perhaps he would not have achieved so much.

During Athanasius' lifetime his radical, communal ways did not always meet with unanimous approval. His main opponent, the anchorite leader Paul Xeropotaminos, supported a more austere interpretation of monasticism including a complete withdrawal from secular life, a solitary existence in the wilderness. So irate was Xeropotaminos that he left his isolated retreat and headed for Constantinople with other monks to protest at Athanasius' meddling to the new Emperor John I Tzimisces, Nicephorus' assassin and successor, who had ascended the throne in 969. Xeropotaminos claimed Athanasius was disrupting ancient Athonite tradition, bringing worldly ways and unacceptable luxury to the Holy Mountain. The

The exo-narthex of Vatopedi's main
church. Its sanctuary, one of the
richest on the peninsula, contains
important sacred artefacts including
the Cross of Constantine the Great,
the Girdle of the Virgin Mary,
allegedly made by Mary herself, and
the skulls of numerous saints in
silver reliquaries.

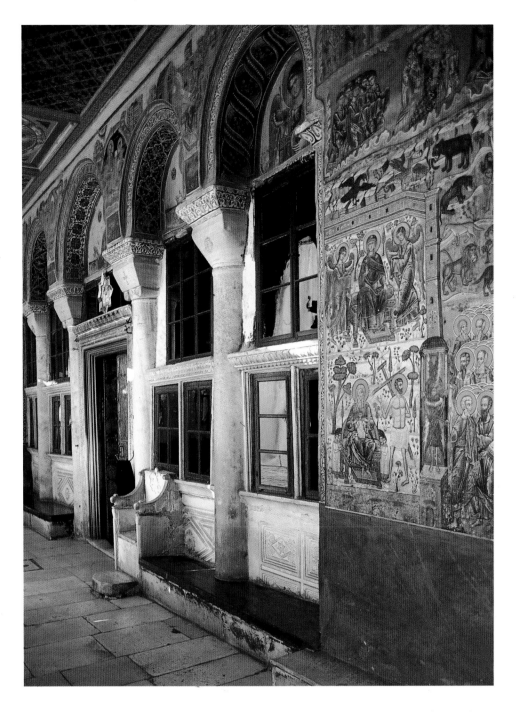

ON PAGES 106–107:
*The 'Great Lavra', the largest and
leading monastery on Athos, was
founded by St. Athanasius, a key
figure in the development of
monasticism on the Holy Mountain,
and funded by Emperor Nicephorus
II Phocas, who planned to retire here.*

emperor pacified Xeropotaminos by sending another monk, Euthymius the Studite,
to investigate the allegations.

Euthymius sympathized with Athanasius' coenobitic reforms and his visit to
Athos helped to confirm the rights of the large monasteries. John I Tzimisces, how-
ever, sought a compromise between the two groups and issued a typicon which
accepted the rights of anchorite leaders and lone hermits to attend assemblies in
Karyes, the Mountain's capital and administrative centre. Under the Athonite Con-
stitution, the head monk of each monastery composed the Holy Synod, which elec-
ted the Protos and acted as advisory body to him. Among his many duties, the Protos
confirmed the election of abbots and judged inter-monastic disputes.

Coenobitic monasteries soon became the norm on Athos as the lives of the
Athonite hermits became overwhelmed by a spurt of building activity. Within forty
years of the Lavra's foundation another five monasteries had been raised on the
narrow peninsula. Among them was Vatopedi, the monastery 'among the brambles';
Iviron, named after its Iberian founders; and Hilandar, the monastery of a thousand
men or a thousand mists. The position of the Great Lavra, however, was unchanged
and it remained, as it does today, the leading monastery in the Athonite hierarchy.

A post-Byzantine sun motif in the wall of the exo-narthex of the catholicon, Great Lavra.

BELOW: *The walls of the exonarthex at Vatopedi, re-painted in 1843, depict military saints and the Second Coming.*

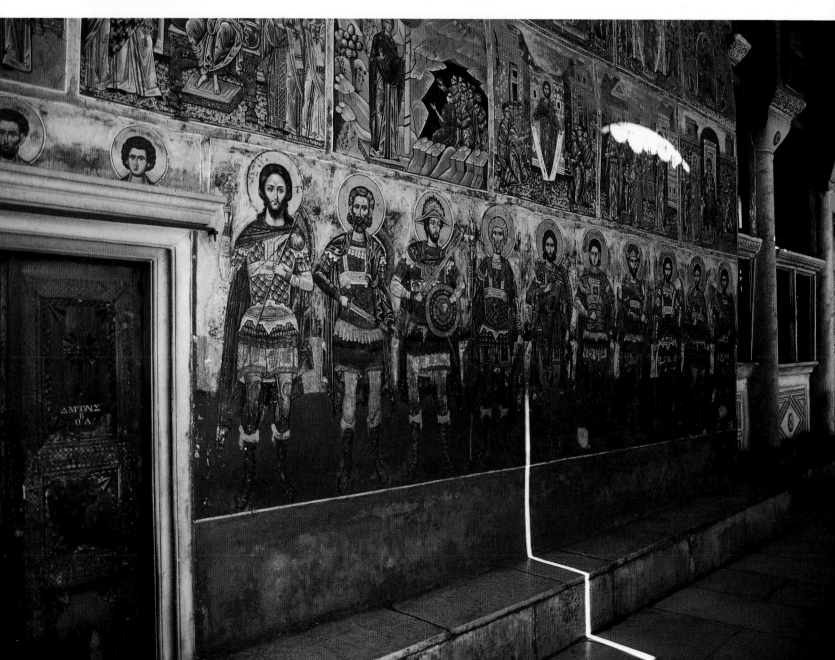

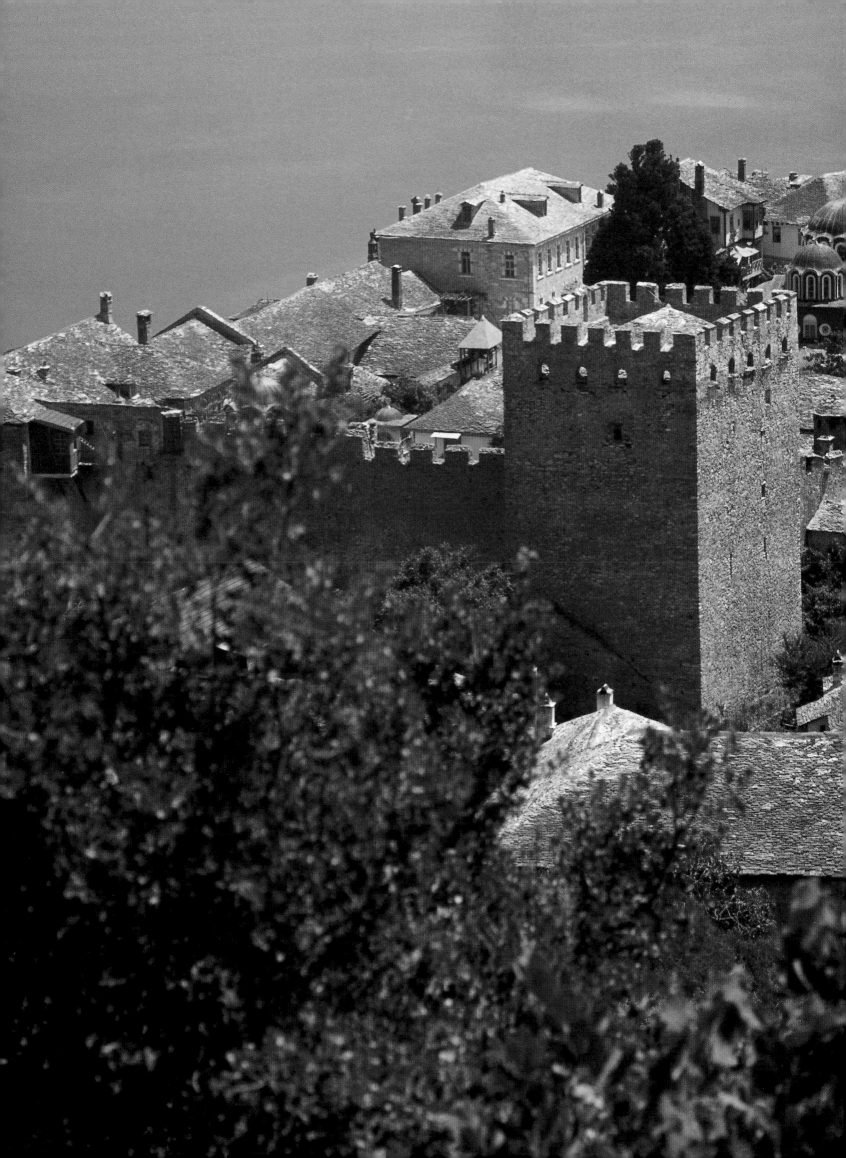

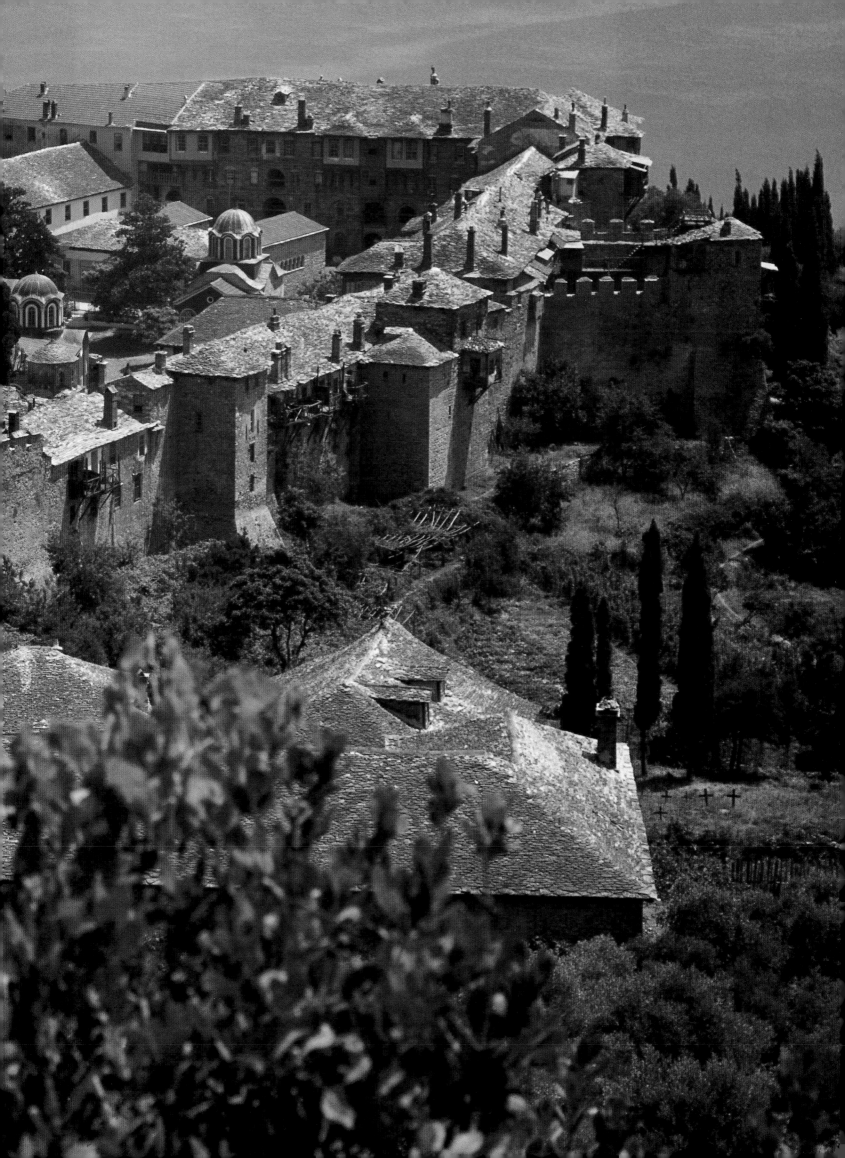

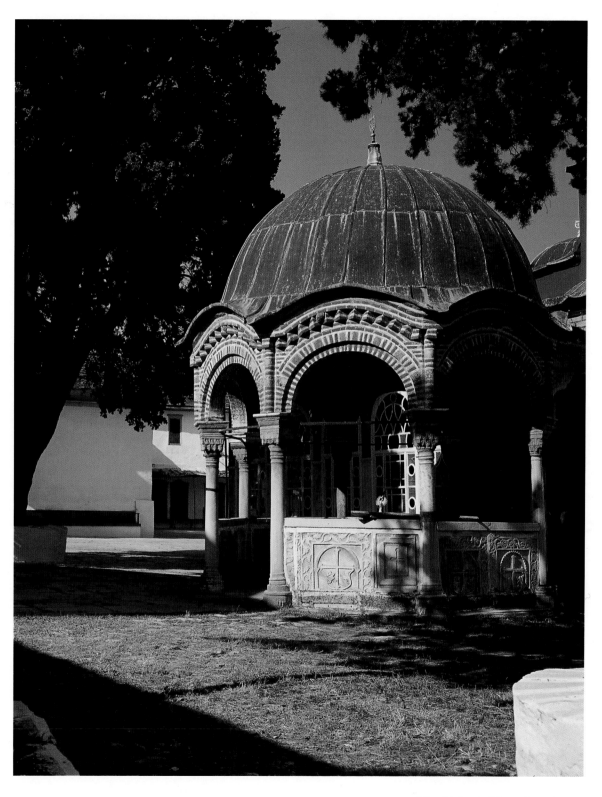

The phiale, *the biggest fountain on Athos, at the Great Lavra. At the beginning of each month and for the Festival of the Baptism of Christ, the ceremony of the blessing of the waters takes place here.*

OPPOSITE: *A bronze detail of the Virgin in the outer door of the catholicon. According to tradition the door came from the Church of the Holy Wisdom in Thessaloniki and was brought to Vatopedi after the city fell to the Turks in 1430.*

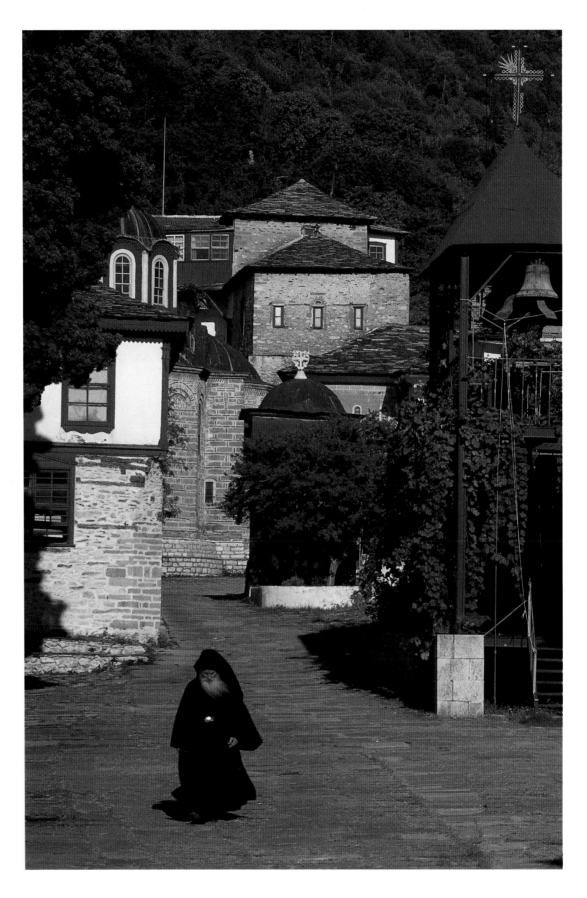

ABOVE:
The main courtyard
of the Great Lavra.

OPPOSITE: *At the Great Larva,*
the catholicon vestibule, gaily lit by
stained-glass windows, replaced an
earlier narthex in 1814. A pair of
magnificent baroque doors, carved
with the eagles of the Orthodox
Church, lead into the church to the
left.

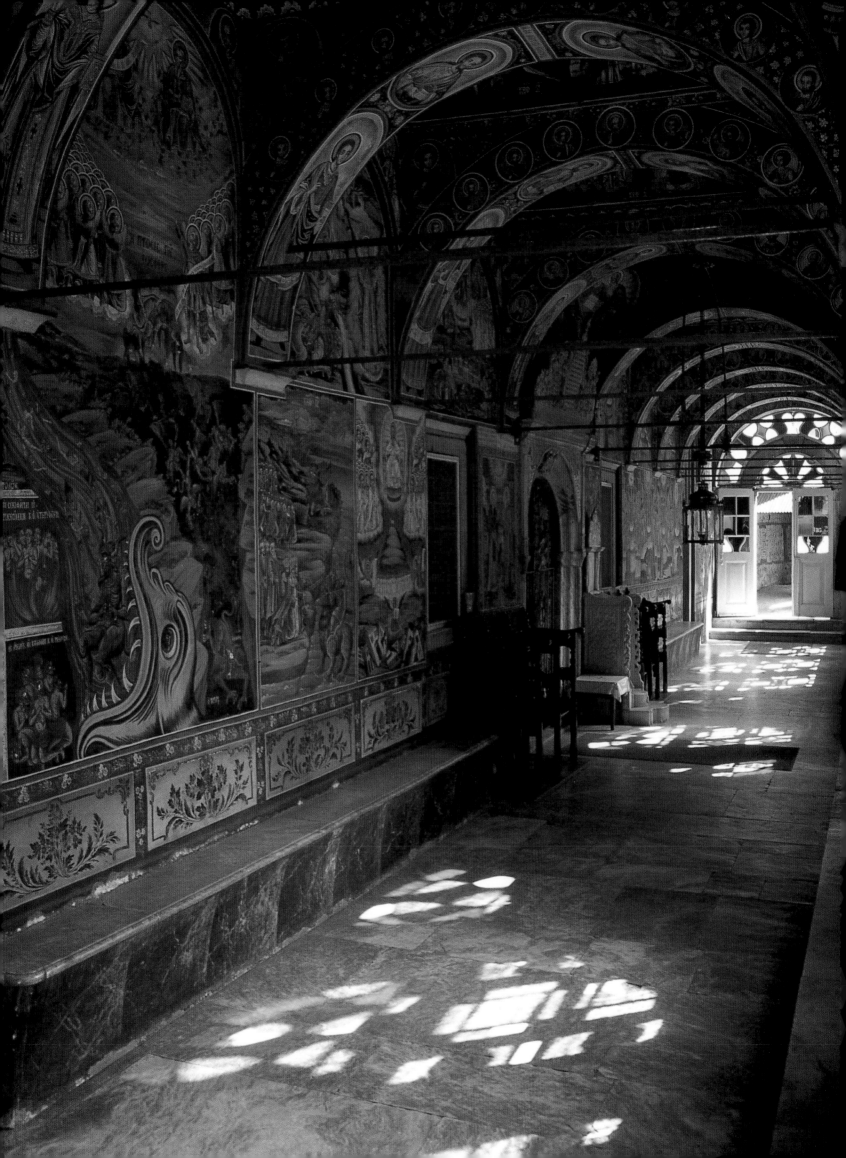

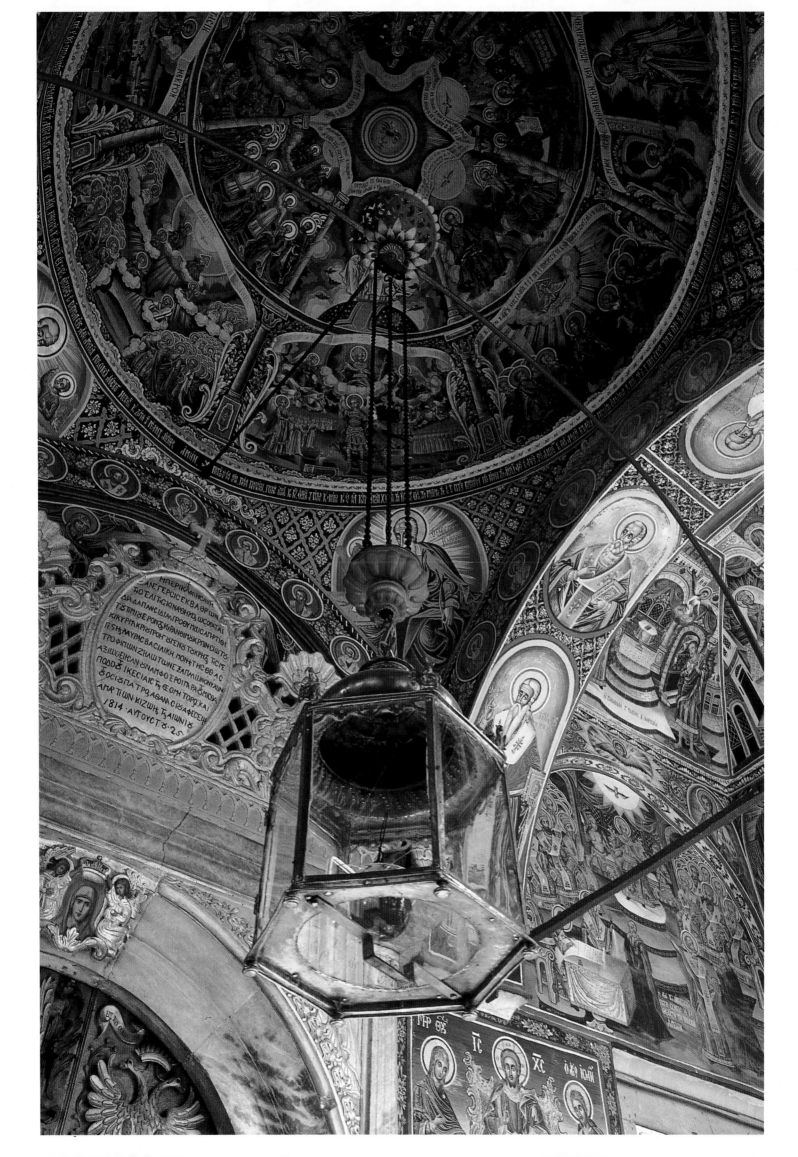

Ornate nineteenth-century frescoes decorate the roof in the narthex of the main church.

OPPOSITE: *A lamp hangs from the heavily frescoed central dome of the catholicon narthex.*

BELOW: *Delegates at one of the early ecumenical councils, which form the basis of Christian orthodoxy, in the narthex of the Great Lavra catholicon. Orthodox christians often refer to their religion as 'the Church of the Seven Councils' since they see the period of the councils, from 325 to 787, as the great age of theology. Council decisions still offer a guide to those seeking solutions to problems today.*

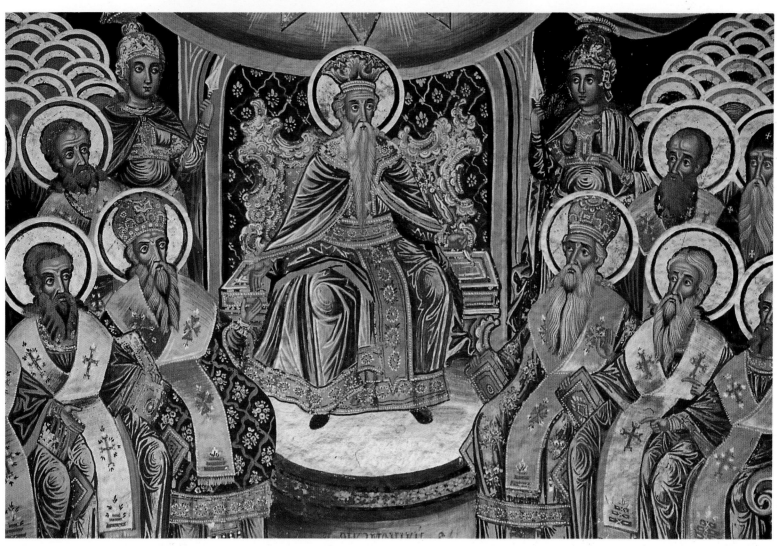

A winged seraph inside the enormous domed portico at the entrance to the Great Lavra Monastery.

ABOVE RIGHT: *A clerical figure in bas-relief from the white marble base of the narthex at the Great Lavra. The marble was carved with mystic symbols by an Armenian artist at the beginning of the nineteenth century.*

✝ Beyond the Frontier

If the numbers of monks and monasteries grew rapidly, Athos also took on a more cosmopolitan air. Orthodox monks from non-Greek lands began arriving on the Holy Mountain, so that it came to represent the centre of Eastern Orthodoxy and not just Greek Orthodoxy. In 979 Georgian monks founded the monastery of Iviron, while there were many Orthodox Armenians resident at Esphigmenou. During the twelfth century substantial numbers of Slavic monks arrived from the north. Hilandar monastery was restored by Serbs in 1197, Panteleimon became Russian, and, somewhat later, Bulgarian monks were in the majority at Zographou. There was even, briefly, a Latin rite monastery established by the Italian Amalfitans.

From the early eleventh century monastic leaders began to widen their horizons beyond the Holy Mountain. The emperors Nicephorus II Phocas and John I Tzimisces had envisaged Athos monasteries limiting their interest to the venerated peninsula. But under Basil II (976–1025) several of the more influential monasteries gradually transformed themselves into substantial landowners, expanding their possessions to include land in Macedonia, especially elsewhere on the Chalcidice peninsula, but also in Thrace, the nearby islands of Thassos and Lemnos, Serbia and Wallachia. Representatives were appointed to control distant properties; while the Great Lavra retained a special financial and diplomatic agent in Constantinople.

Within a generation the idea of 'poor monasticism' was replaced by a significant rural economy. If the earliest hermits had been self-sufficient, and the first

coenobites largely dependent on their annual stipend, monks of the eleventh and twelfth centuries rapidly expanded the economic activities of their semi-autonomous theocratic state. From Athos itself monks traded surplus crops of vegetables and fruit, wood was sold from the Athonite forests, and wine from the monastic vats. External revenues from urban rents in Thessalonika, and from distant fishponds, mills, and workshops, considerably swelled the monasteries' coffers. Indeed, the bulk of the Acts of Athos, by far the richest of Byzantine archives, concern these growing monastic estates.

During this prosperous period only one significant incident, the vexed 'Vlach question', caused much of a rumpus. Despite the prohibition of beardless youths, eunuchs, women and all female animals on the peninsula, substantial numbers of Vlach shepherds, some sources say 300 families, settled on Athos towards the end of the eleventh century to supply the monks with milk and cheese. But dairy products were not the only things Vlach settlers could provide to please the monkish palate. So many of the fathers fell for the pleasures of female company that many were excommunicated, seriously depleting the population of some of the monasteries. According to Robert Byron, 'half the monks deserted their monasteries in company with the shepherds'. The stricter monks, those who had not succumbed to temptation or at least had concealed their weakness, demanded the suppression of the beardless intruders and around 1100 Emperor Alexius I Comnenus expelled the herdsmen from Athos.

But far worse was to befall the monasteries a century later. After the capture of Constantinople by the Fourth Crusade in 1204, Athos came under the rule of the Frankish Kingdom of Thessalonika and remained so for the next twenty years. Under the Franks the monasteries lost holdings beyond the Holy Mountain and their revenues were considerably reduced. Some lands were only recovered after the Greeks reconquered Constantinople in 1261, but the reign of the newly crowned emperor, Michael VIII Palaiologus, proved a disaster for Athos. Michael was the moving force behind the Union of Lyons of 1274, the first important attempt to unite the Christian East and West. His motives, however, were as much political as religious – he needed papal support to fend off attacks from Charles of Anjou – and the union was strongly opposed by the majority of the Orthodox Church. On Athos, the monks suffered for their beliefs. Michael VIII despoiled their monasteries and churches. Athonite fathers who resisted union were executed in the Protaton, and at Zographou and Vatopedi monasteries. All this in the name of unity.

After the death of Michael, who was denied a Christian burial for his betrayal of Orthodoxy, the Union of Lyons was officially repudiated. Michael's son and successor, Andronicus II Palaiologus, opposed the adoption of Latin rites and placed the monasteries under the direct control of Patriarch Athanasius I, reputedly a strict disciplinarian. He also began to restore the Athos monasteries damaged by his father. But just as the buildings were completed anew another threat loomed on the horizon. Andronicus, with little forethought, dismissed an unruly group of mercenaries, operating as the Catalan Grand Company, whom he had originally hired to protect colonies in Asia Minor. Without a paymaster, and seeking a new base and lucrative returns, they settled on the westernmost promontory of the Chalcidice peninsula. For the next two years they plundered the Mountain, murdering monks, razing monasteries to the ground, and carting off invaluable treasures.

The Catalan raids were fortunately short-lived. Following the mercenaries' departure Athos was able to resume an air of normality again and for the next hundred years enjoyed one of the most peaceful periods in its history. Several new

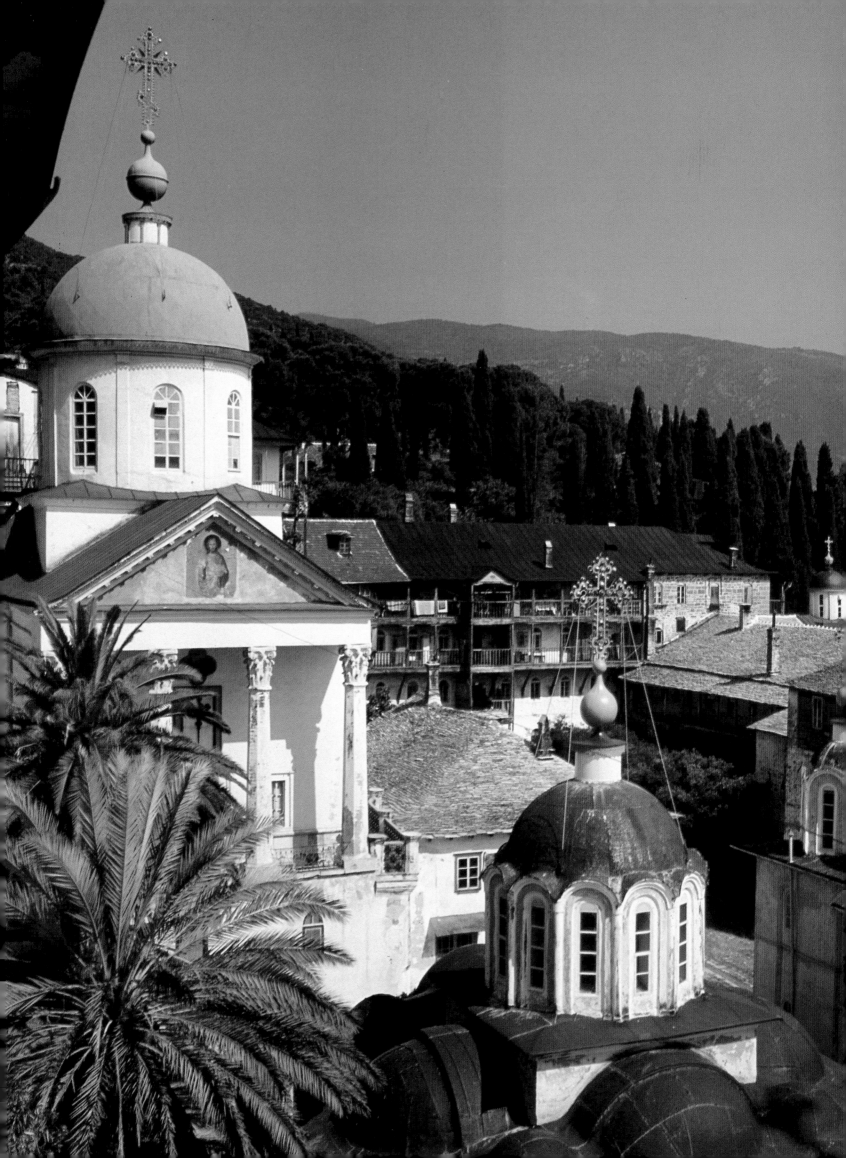

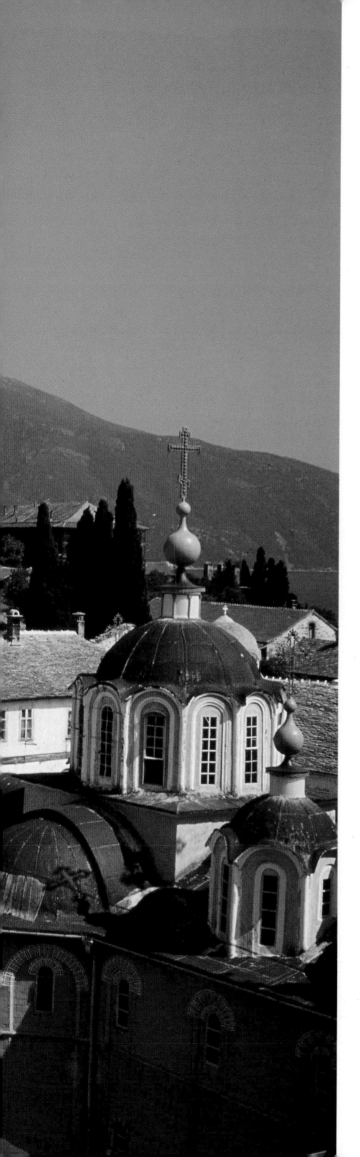

Mount Athos has always been pan-
Orthodox, with resident monks of
many different nationalities. The
Russian Panteleimon Monastery was
built on its present site in the early
nineteenth century and within eighty
years housed more than a thousand
Russian monks. All services in the
monastery are held in Greek and
Russian.

monasteries were founded in the fourteenth century as successive emperors once again sought to encourage monastic life. Pious donations arrived from distant benefactors: from the Grand Komnenoi of Trebizond; from Bulgaria and the rulers of Serbia who supported the reinvigorated Serbian monastery of Hilandar. Athos became a more active centre for religious discussion, though its isolation from the intellectual life of Constantinople had its drawbacks. Its libraries, where pious copyists worked on sacred and secular texts, were well used and well kept. But many of the monks had no more than elementary education and there remained an under-lying suspicion of secular learning.

As Athos revived, some of the Mountain's monks began to embrace the mystical methods of hesychasm, a doctrine which caused further murmerings among church leaders. Other developments, notably a new form of monasticism, known as idiorrhythmy, pitted conservatives against those opting for change. The system, which accepted private wealth, inevitably subverted the communal principles of Athanasius adopted 400 years earlier. Where Athanasius had once clashed with the hermits, coenobites now clashed with those favouring the idiorrhythmic system. In 1394, Patriarch Nicias, in a strongly worded protest, condemned private property, the running of personal kitchens, and prolonged absences from the Mountain, all of which were tolerated by the new form of monasticism. The only time idiorrhythmic monks came together was for church services and large feasts. They had no abbot, although they elected a superior for a limited term to represent them on the Holy Synod. Idiorrhythmy appealed to contemplatives, but there was much room for misuse; it also attracted less strict monks who wished to retain their material wealth, and discipline inevitably slackened. On Athos the two approaches developed side by side, but for many the incursion of private wealth into monastic life was never acceptable. The conflict surfaced again recently, the last idiorrhythmic monastery, the Pantocrator, converting to the coenobitic system in 1992.

† Monks, Turks and Russians

As the idiorrhythmic way of life gained a foothold on Athos the golden days of Byzantium were rapidly drawing to an end. In the East the Turks were growing increasingly powerful. Turkish pirates attacked the holy peninsula during the mid-fourteenth century, causing some monks to seek refuge at Meteora or Paroria, and warning others of the impending Islamic threat. As the Ottomans swept westwards, the Byzantine government restricted further growth of monastic properties and, following the Turkish victory at Marica in 1371, confiscated some Athonite estates which were transferred to the imperial army. But the Byzantine troops were unable to hold back the Turkish tide. The Ottomans briefly occupied Athos in 1387 and again from 1393 to 1403, before establishing permanent control in 1430, following the fall of Thessalonika to Sultan Murat II.

Life for the monks under Turkish control was much better than many of them had perhaps feared. After agreeing to pay tax to the sultan they retained their autonomy but lost their immunities and estates in Macedonia and Thrace. During the sixteenth century, while the still young Ottoman Empire grew increasingly wealthy, Athos also enjoyed a measure of prosperity. A new monastery, Stavronikita, was founded towards the middle of the century: it was the last of the twenty ruling monasteries to be built. And in 1578 the Athonite monasteries co-operated to buy the

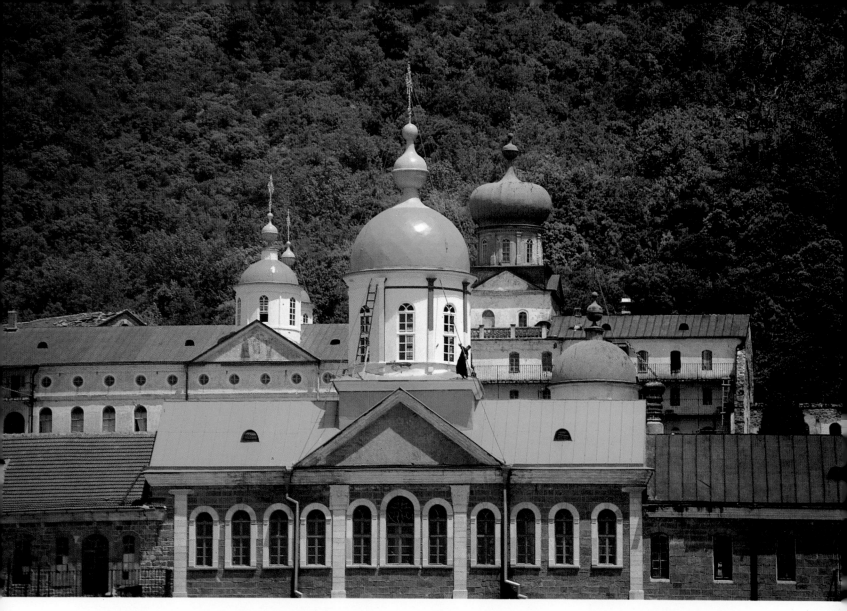

splendid library of Michael Cantacuzene, one of the wealthiest men of the period. But the taxation burden soon provoked an economic crisis and Patriarch Jeremias II was forced to call on the Constantinople Trade Union of Furriers to audit their accounts, and a long and painful period of decline set in.

From the seventeenth century onwards, the libraries of Mount Athos were increasingly neglected through lack of funds, though substantial bequests continued to be received. The following century was a period of general decline in both intellectual and cultural life; Athos monks became increasingly reactionary and a gulf developed between them and the cultured élite in Constantinople. Hesychasm still had its supporters at Athos, and Gregory Palamas was still read, even if little known elsewhere. Towards the end of the century arose a reactionary movement for spiritual renewal. Known as the 'Kollyvades', their wrath was directed against the influence of the western Enlightenment on Orthodoxy rather than the Turks. A regeneration of the Greek nation could only come, the Kollyvades believed, by returning to the roots of Orthodox Christianity. Secular ideas from the West were to be rejected in favour of frequent communion.

One of the leading members of the Kollyvades, Saint Nicodemus of the Holy Mountain (1748–1809), known as 'The Hagiorite' and 'an encyclopedia of Athonite learning', made a significant contribution to this era of spiritual awakening. Along with his contemporary Saint Macarius, Metropolitan of Corinth, he edited the *Philokalia*. a weighty anthology of mystical and ascetic texts written between the fourth and fifteenth centuries. This tome, devoted to the practice of inner prayer and particularly the Jesus Prayer, was intended for lay people as well as monks, and continues to be read and used today.

Panteleimon Monastery from the sea with, in the foreground, part of the wing used as guest quarters. The monastery has been neglected since the First World War though the main entrance wing is now being restored.

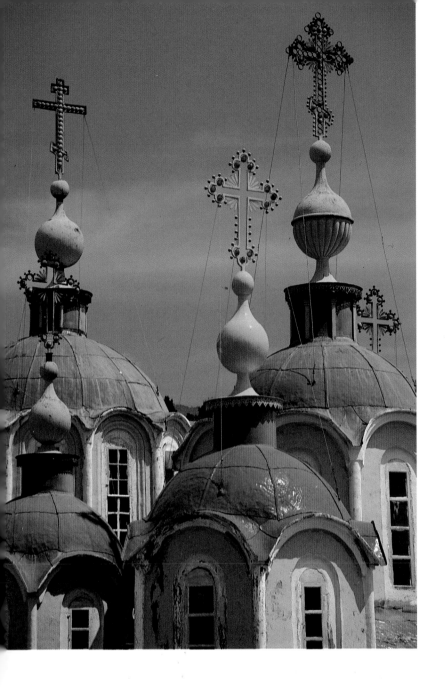
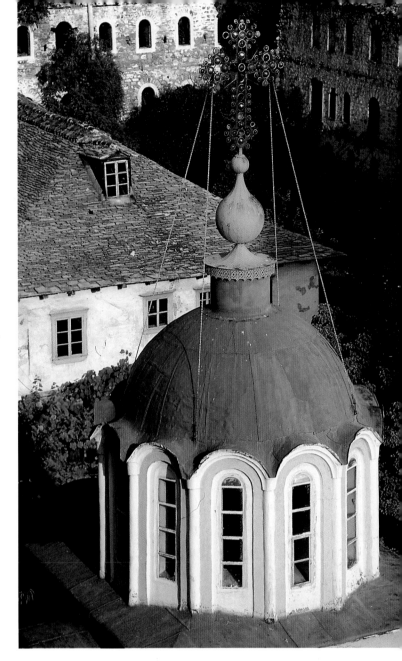

ABOVE AND PAGES 122–123: *Onion-top domes, typical of Russian churches, crown the catholicon.*

ABOVE RIGHT: *The monastery includes more than a dozen small chapels dedicated to Saints Constantine and Helena, Vladimir and Olga, several bishops of Moscow and other Russian saints.*

Other monks found their strengths in missionary work. Among them was Saint Kosmas the Aetolian (1714–79), who journeyed widely on mainland Greece and the islands attracting huge crowds wherever he went. In an effort to counteract general despondency, he founded new schools to promote the Greek language as well as the Orthodox faith. His apostolic journeys must have been a considerable success; the Turks were so perturbed by his teachings that they eventually had him executed, and in so doing created another 'New Martyr'.

If Saint Kosmas felt it necessary to leave Athos to spread the word, other monks stayed behind to help found the Athonite Academy, near Vatopedi Monastery, in 1753. The academy was an attempt by Patriarch Cyril V to restore the Holy Mountain as a centre of religious culture, though he may not have expected quite such a cool reception from the monks. Cyril appointed the Corfiot Eugenius Vulgaris, one of the leading philosophers of the time, as the centre's professor, but Vulgaris' modernist ideas so appalled the monks that he was forced to leave the Mountain for another post in Constantinople. As the monks became hostile to culture, Athos and the Greeks of Constantinople grew increasingly apart, and the Mountain lost its appeal for educated men.

The Athos monks' anti-intellectualism and suspicion of western values was, in many ways, a confirmation of their faith, an effort to conserve the essence of what

they believed in, unburdened by the latest scientific theories. To propagate the true Orthodox tradition monks installed a printing press in the Great Lavra which helped to spread their ideas of Greek cultural awareness until the eve of independence. The Mountain also remained an important destination for Orthodox pilgrims. An English medical man, Hunt, who visited Athos in 1817, has left an entertaining account of such a festive occasion:

> ...on Easter-day there were above fifteen hundred people who dined in the court-yard of the convent, principally Albanian, Bulgarian and Wallachian Greeks. It appears, as soon as the oppressed Christian peasants in the neighbouring Turkish provinces have saved a little money, or when pirates and freebooters have made a successful sally, they set out on a pilgrimage to this Holy Mountain, where they not only get a plenary absolution by giving up part of their gains, but enjoy the luxury of hearing a perpetual din of bells, and the sight of splendid churches, pictures of saints, and wonder-working reliques.

Life on Athos, however, was soon to be disturbed again as the spirit of revolt blew across the peninsula. The Mountain's monks were divided in their attitudes to the War of Independence. The abbots, in particular, were cautious of active involvement. But many lower ranked Greek monks had great sympathy for their compatriots' cause and for their fellow monks' actions in the Peloponnese. In the early days of the revolution 2000 monks plotted a local uprising, but it was quickly crushed by the Turks who installed a garrison of 3000 soldiers and demanded a hefty indemnity. Many monks subsequently abandoned the Holy Mountain and only returned when the struggle for Greek independence was finally won.

For those that remained behind life really hit rock-bottom if the accounts of western travellers are to be believed. Few had a good word for the Mountain's inhabitants. They were accused of ignorance and worthlessness, though standards were maintained at the Great Lavra. By now the average monk had forgotten how to read and simply chanted the liturgies that he had learned by rote. In 1856, Edward Lear, in his inimitable manner, described them as those 'muttering, miserable, mutton-hating, man-avoiding, Misogynic, morose and merriment-marring, mono-toning, many-mule-making, mocking, mournful, minced fish and marmalade-masticating Monx'.

Athos, it seems, had few friends. Despised by western travellers, at odds with the sultan and Catholicism, Greek monks were also soon at loggerheads with the monastery of Saint Panteleimon. A monastery ascribed to the Russians had existed on the site since the eleventh century, but after it was abandoned during the revolution, Greek monks took sole control. By 1834, faced with heavy debts, it accepted fifteen paying Russian novices who attracted others to the traditional retreat. The Russians were soon a majority and demanded the right to hold services on alternate days in Russian and to elect their own abbot. The Greek monks, supported by the Holy Synod at Karyes, were strongly opposed to the second of these demands, but they were overruled by the Patriarch Joachim II, whose support of the Russians was ensured by substantial presents from St Petersburg.

Unwittingly, Athos was becoming a small pawn in the bigger game of *Realpolitik*. At the 1878 Treaty of San Stefano, concluding the brief Turco-Russian War, the sultan explicitly recognized the existence of exclusively Russian communities on Athos. According to the Treaty: 'The monks of Mount Athos of Russian origin shall continue to enjoy ... the same rights and prerogatives as those assured to other religious establishments and convents on Athos.' The suspicions of the Great Powers

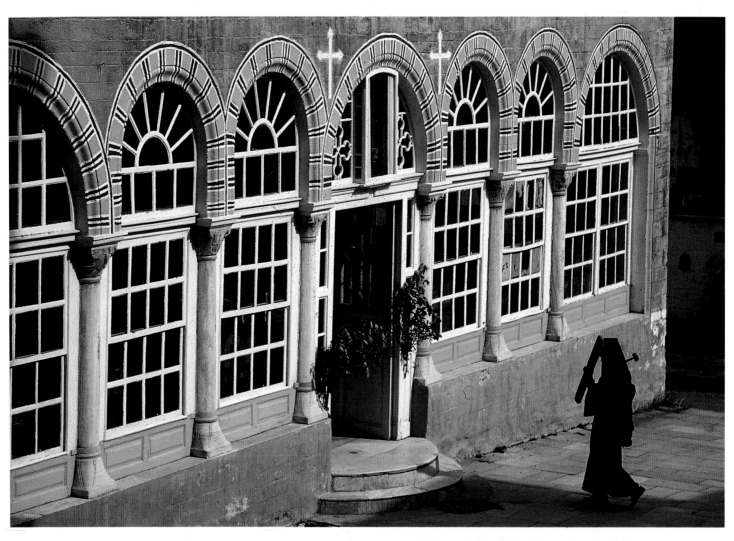

ABOVE: *A monk beats a wooden semantron, calling the faithful to prayer, outside the Church of St. Pantemelion.*

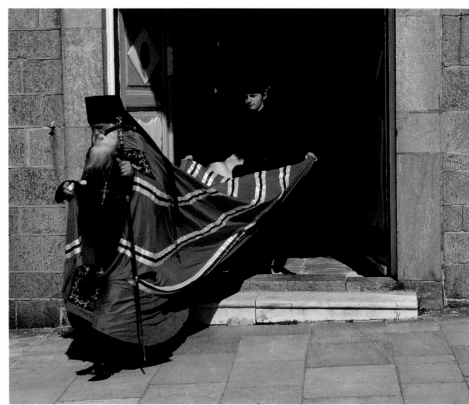

The abbot of St. Pantemelion, dressed in ceremonial robes, on the morning after Pentecost.

had been aroused and at the Treaty of Berlin in 1878 articles relating to Athos were renegotiated to guarantee the rights of all Orthodox monks whatever their origin. More importantly, the Treaty recognised the autonomy of the entire peninsula as an independent theocracy in an increasingly volatile region.

Russia now had a foothold in what amounted to a separate Aegean state. It moved quickly to consolidate its position, buying the leases of two sketes and twenty kellia which were enlarged to such an extent that they competed in size with the ruling monasteries. Of the 548 monks attached to the Greek monastery of Panto-crator at the turn of the century, 80 per cent, most living at the dependent skete of Prophet Elias, were Russian. By force of numbers, the Russians now planned to raise the status of the enlarged dependencies to that of Ruling Monasteries, and con-sequently to enhance their representation in the Holy Synod at Karyes. But the pliable Patriarch Joachim II, was succeeded by a far more astute character, Joachim III, 'the Magnificent', who set himself the task of combating the foreign threat. The new leader resisted further Russian advances, reorganized the unwritten and confus-ing tradition of Athonite law, and helped to draw up the Mountain's first consti-tution. Significantly, the draft document stated that any addition to the existing twenty monasteries, seventeen Greek and three non-Greek, was categorically forbidden.

The constitution had only been operating for two years when far more dramatic events enveloped the peninsula. The First Balkan War broke out, the Greeks quickly gained the upper hand, and after almost half a millennium the Turks were finally driven out of Macedonia. On 2 November 1912 the Holy Mountain came under Christian governance once again. As four Greek battleships moored offshore, Ottoman officials employed on the mountain sought refuge at the Monastery of Saint Panteleimon. After some hesitation the abbot surrendered the Turks, while the arriving Greeks hoisted the blue and white flag over the post office and customs house. Athos was about to begin a new era in its long history, but old troubles and deep-rooted disputes would continue to plague the mountain.

After the war, the Greek monasteries demanded that Athos be reunited with Greece. The Slavs pushed for independence under the control of all Orthodox churches. Russia, fearing that Greece would attempt to replace existing arrange-ments with Hellenic authorities, proposed governance by international commission. Should such a body be created, the Patriarch of Alexandria insisted that Britain be represented, since it had jurisdiction over the autocephalous Church of Cyprus. Even Austria-Hungary, which ruled over the Serbian Orthodox Patriarchate of Carlovitz, claimed a stake in future administrations. The 1913 Treaty of London failed to come up with a workable agreement, simply stating that the five Powers would decide Athos' fate. But little was immediately achieved. Frightful rumours encircled the mountain. The Greeks suspected the motives of the Russian monks. Indeed, were they really monks? Didn't the enlarged sketes and kellia command the most strategic positions on the Mountain? Arms and ammunition were surely hidden there.

While paranoia reigned, four years passed before Greek sovereignty over Athos was recognized by a clause in the Treaty of Sèvres, later ratified at Lausanne in 1923. Assurances guaranteed the inviolability of all non-Greek monasteries, while Greece agreed to maintain their traditional rights and liberties based on a 900-year tradition. The status quo, the autonomy of the Holy Mountain and inviolability of the twenty ruling monasteries is further reiterated in the Hellenic constitution. As well as equal rights, all monks, irrespective of their nationality, were to be granted Greek citizenship. Indeed, when Romanians sought to upgrade their skete to the

status of a ruling monastery, the Greek government simply replied that they were prevented from modifying the situation by ancient custom, treaty obligations, and their own legislation. That, officially, is how things remains today. But some quarters on the mountain, Greek monks as well as non-Greeks, have never been entirely happy with the Treaty of Lausanne. In recent years new political ambitions and old resentments have risen their ugly heads to haunt the Mountain once again.

✝ Athonite Style

From a distance, monolithic, grandly picturesque, the coastal monasteries of Athos appear as elaborate medieval stage sets, waiting for the actors' cue, rather than living spiritual communities. Indeed their effect, rather like the perched monasteries of Tibet, depends on their extraordinary siting as much as the architecture itself: the complete ensembles are far more impressive than their component parts. Like small fortified hill towns, the larger monasteries stand protected by formidable walls reinforced by watch towers, a reminder that pirates and foreign fleets were once a frequent threat. Within the walls lie the monks' cells, tiers of balconied rooms or large timber-clad wings; and in the central courtyard stand canopied fountains and clock towers, the catholicon or principal church, subsidiary chapels and the occasional refectory.

Little survives from the early days of the tenth to twelfth centuries except for sections of wall and the principal churches of several monasteries. What we see today is a curious mix of buildings of various date that were adapted and added to incrementally as the fortunes of Athos waxed and waned. There was never any grand master plan, nor indeed any grand master, in the sense of a Palladio or Wren, to design individually great buildings.

Athos churches are, nevertheless, attractive enough examples of Byzantine architecture. Nearly all are based on the plan instituted at the Great Lavra by Athanasius in 963. Here, an inscribed-cross plan or cross-in-square is covered by a central dome supported on four columns. The sanctuary was entered via a double narthex, flanked by two side chapels. The plan, with its triple apse to the east, was later adopted at Iviron and Vatopedi, but was largely unchanged until the double narthex was replaced at Hilandar by a single rectangular area for singers, often known as a lite. Not surprisingly, Athos' builders, essentially conservative in outlook, had minimal influence on Byzantine architecture beyond the peninsula. Although the layout of the monastic buildings was later adapted in Bulgaria, Athos had inherited the overall principles from southern Greece, Syria, and the Sinai.

To administer its scattered monasteries, and to provide essential supplies, Athos has its own capital at Karyes, a picturesque village in the centre of the peninsula. Here stands the Church of the Protaton, the only basilica on the Mountain. From outside it is an unassuming stone building but within it contains some of the earliest and finest frescoes of the Macedonian school which flourished during the reign of Emperor Andronicus Palaiologus (1282–1328). Probably painted by Manuel Panselinos, their unusual arrangement arises from the difficulties of adopting a system evolved for domed, inscribed-cross churches to that of a straightforward basilican plan. The frescoes, aged to an overall dull pink tone, are presented as four bands. The bottom rung represents a veritable portrait gallery of Church Fathers, hermits and saints. Above that, on the west wall, is the Dormition of the Virgin; on the other three sides, portrayals of the four Evangelists. The third zone is filled with

A wall painting of Noah in the tenth-century Church of the Protaton, the only basilica on the peninsula, in the capital of Karyes. The church was painted by Manuel Panselinos, a leading light of the Macedonian School, at the beginning of the fourteenth century.

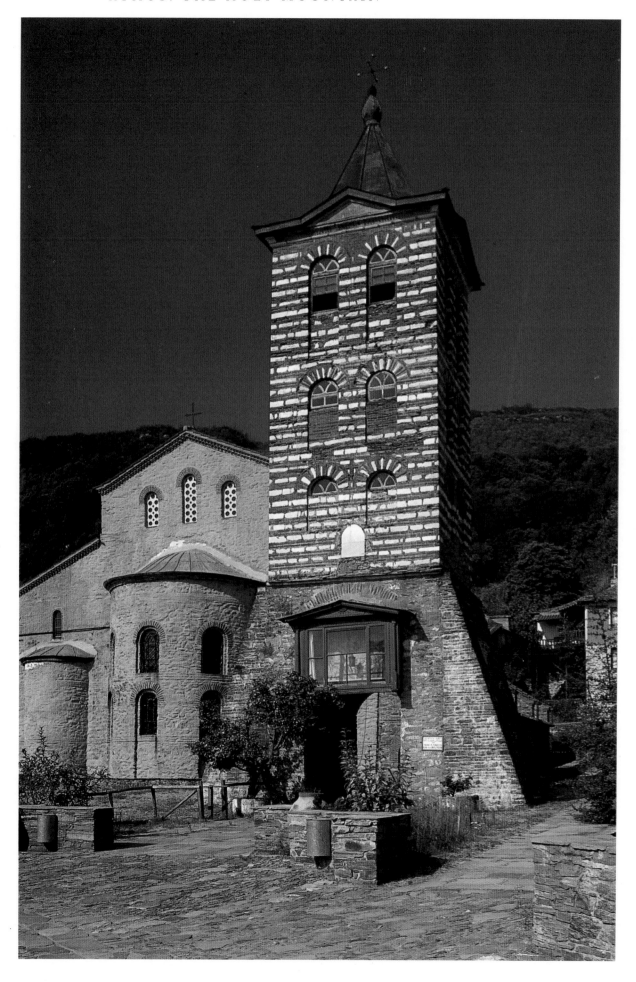

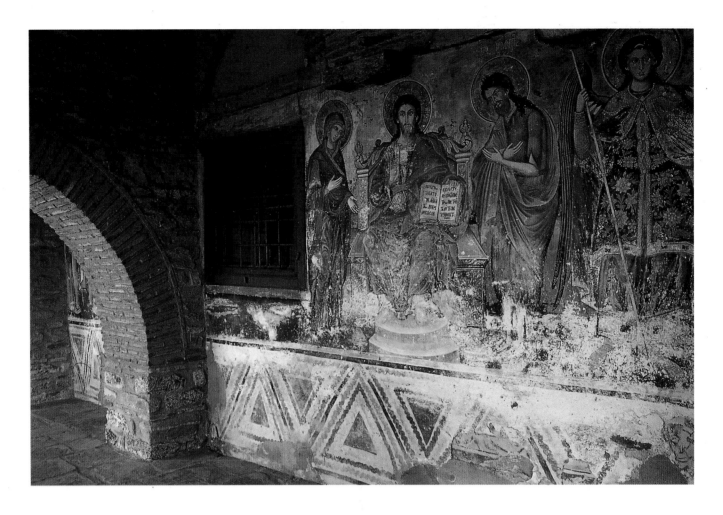

Wall paintings inside the open vestibule of the Protaton.

scenes from the life of Christ; the uppermost with Christ's ancestors, including Adam.

Early frescoes, dating from 1312, also survive in the church of Vatopedi Monastery, but are much overpainted. Here, unlike the Protaton, an inky blue predominates, offset by touches of ultramarine, red and ochre, giving a cool feeling to the whole church. The dominant paintings, leading works of the Macedonian school, are two life-size scenes of the Crucifixion and the Entry into Jerusalem. In the latter, Christ, robed in dark blue, is seated sideways on the ass. The Jewish crowd, waving palm leaves, waits expectantly. The city looms, a cluster of roofs and red domes, beneath an indigo sky scattered with stars.

Foreign attitudes towards Byzantine painting have changed radically since the days of the grand tours of the eighteenth and nineteenth centuries. Early travellers and art critics frequently dismissed it as a crude and static art. During his visit to Athos in search of medieval manuscripts in the 1830s, Robert Curzon was far from enthusiastic, reserving his most dismissive comments for the frescoes in the Great Lavra. 'In these pictures,' he wrote, 'which are often of immense size, the artists evidently took much pains to represent the uncouthness of the devils than the beauty of the angels, who, in all these ancient frescoes, are a very hard-favoured set.' A century later, Robert Byron described the same paintings in the Great Lavra's catholicon as 'three of the most important cycles of frescoes on the Mountain', a view still widely held today.

The restored Lavra paintings which led to such divergent opinions were executed in a rather sombre style by the celebrated Cretan painter Theophanes in 1535. Painters of the Cretan school, who subsequently worked throughout the

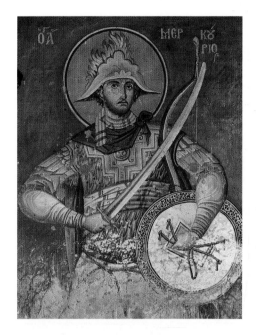

St. Mercurius, one of several warrior saints, including St. George and St. Demetrius, revered by the Orthodox Church. They were also invoked by the Crusaders to assist their troops in battle.

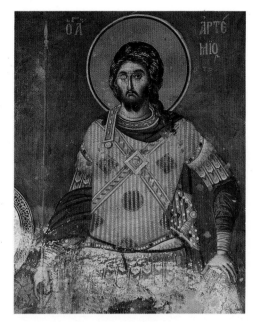

St. Artemius, martyred around AD363, was a veteran of Constantine the Great's army and imperial prefect of Egypt.

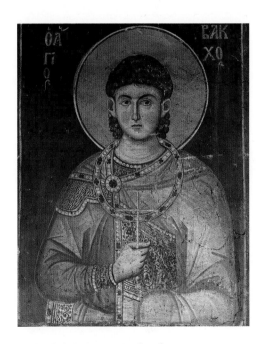

A detail depicting St. Bacchus from a wall painting in the Church of Protaton.

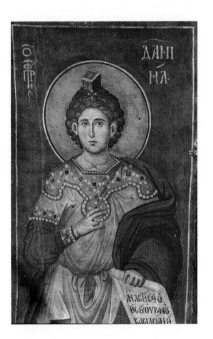

The Prophet Daniel. The prophetic book of Daniel, a fictitious work written around 167 to 164 BC, foresaw the collapse of the Greek Empire and the triumph of a Messiah who establishes a government on earth by the holy ones who had kept their faith.

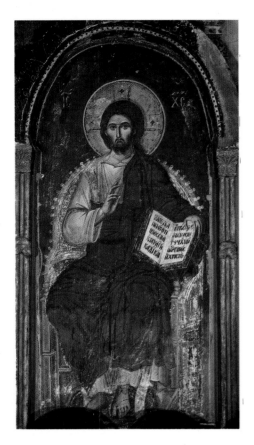

A detail depicting Christ from a wall painting in the Church of Protaton.

OPPOSITE: *Christ washing Peter's feet to teach the disciples humility in the Church of the Protaton.*

OVERLEAF: *The sun rises over the Bulgarian skete of Bogoroditsa, a dependency of St Panteleimon Monastery.*

Levant, followed predetermined formulas laid down in painting guides. One was written by a monk known as Denys, from the Fourna Monastery at Agrapha, who explained that hands and feet and faces should first be outlined in deep black, and the flesh colour added sparingly. Only facial highlights were to be coloured. At Athos, a few fragments of Cretan school paintings have survived, with their original colouring, in the Saint George's Chapel in the Monastery of Saint Paul.

The history of the Cretan school is poorly documented though something is known of the principal artists. Both Theophanes and his contemporary Zorzi, who decorated the catholicon of Dionysiou Monastery in 1547, were natives of the island. Theophanes' teacher, Manuel Panselinos, however, was probably from Thessalonika, suggesting that the Cretan style had even displaced the Macedonian school on its home ground. If fresco painting declined in Macedonia, it thrived in Crete simply because the island, unlike much of the rest of Greece, remained free of the Turkish yoke until 1669.

The Cretan influence on Athos is also apparent from the thousands of icons hanging on monastery walls and decorating the iconostases. Icon artists may have worked on Athos as early as the tenth century and a workshop making icon frames possibly existed in the fourteenth. At the Great Lavra, the oldest icon dates back to the early eleventh century, when Kosmos, a former monk at the monastery, commissioned Pantoleon, a leading Constantinopolitan artist, to paint a portrait of Saint Athanasius. The most revered icons are believed to harbour miraculous attributes. Some weep, others give off faint whiffs of myrrh, while the most famous on Athos, a thirteenth-century portrait of Saint Nicholas in Stavronikita Monastery, once gushed blood. This icon, as legend has it, was stolen by pirates in the sixteenth century. Years later it was washed ashore with an oyster embedded in the saint's forehead. As the shell was removed blood gushed from the scar. Half the oyster was kept; the other was sent as a gift to the first Patriarch of Moscow.

Despite its large icon collection no discernible school ever developed on Athos. Like the fresco artists, most icon painters in the last centuries of Byzantine rule came from Thessalonika or Constantinople, later to be usurped by the Cretans with their strong colour sense and less formal compositions than those typical of the Macedonian school. Growing trade in icons proved a boost for the island's painters, whose work is found in Saint Catherine's Monastery on Mount Sinai, in Venice and Alexandria, as well as nearly all the monasteries on Mount Athos.

✝ Manuscripts and Miniatures

While nineteenth-century travellers often failed to appreciate Byzantine painting, they were more easily impressed by the monasteries' other treasures. From the foundation of the Great Lavra in 963, Athonite communities received frequent gifts of crosses and textiles, liturgical silver, handsomely bound and decorated books, as well as thousands of Orthodox icons. Among the most astonishing treasures is an incomparable reliquary, housed in a small crypt at Dionysiou Monastery, containing the bones of Saint Niphon, one of the first ecumenical patriarchs after the fall of Constantinople. Before his term of office had run its course he retired to Athos where he worked as a woodcutter and muleteer. Following his death in 1515, his true identity was discovered, and his remains placed in this coffer, a gift from his confessor and godfather, Voivode Neagnoe of Wallachia. The superbly crafted reliquary is modelled on a cruciform church and crowned by five golden domes. On all four

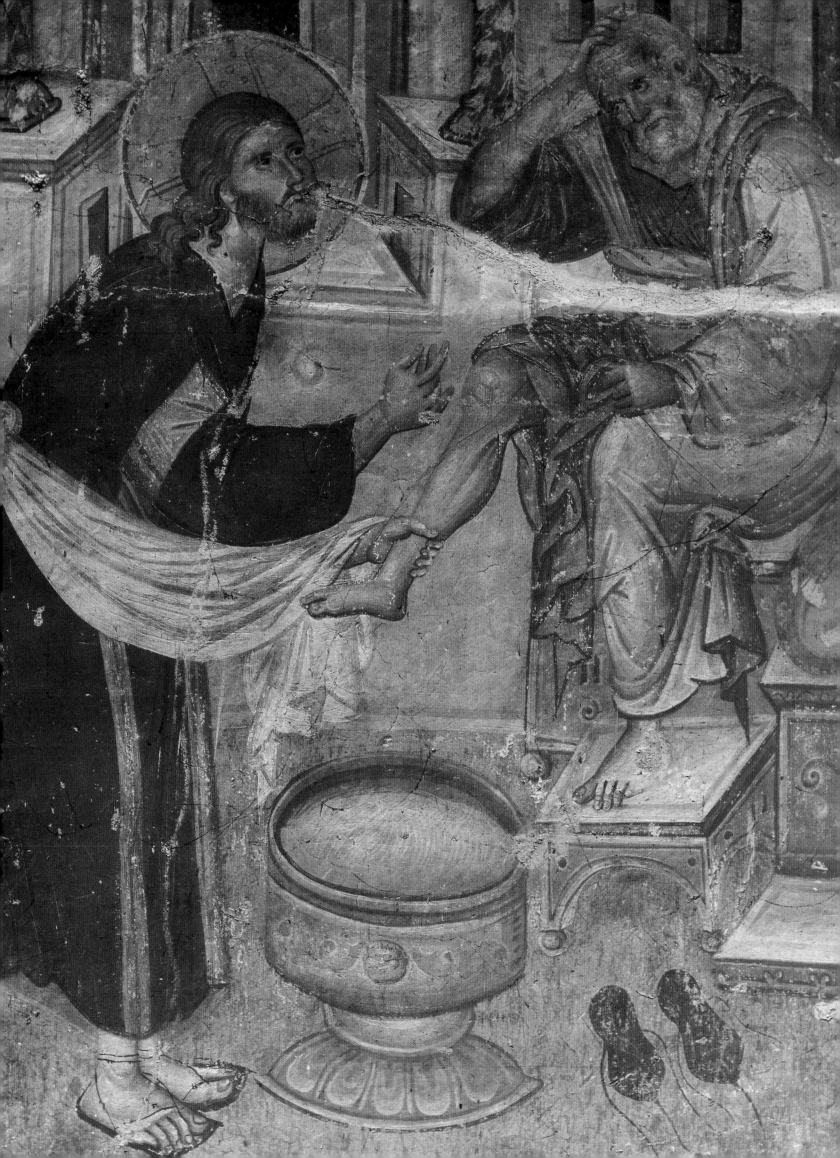

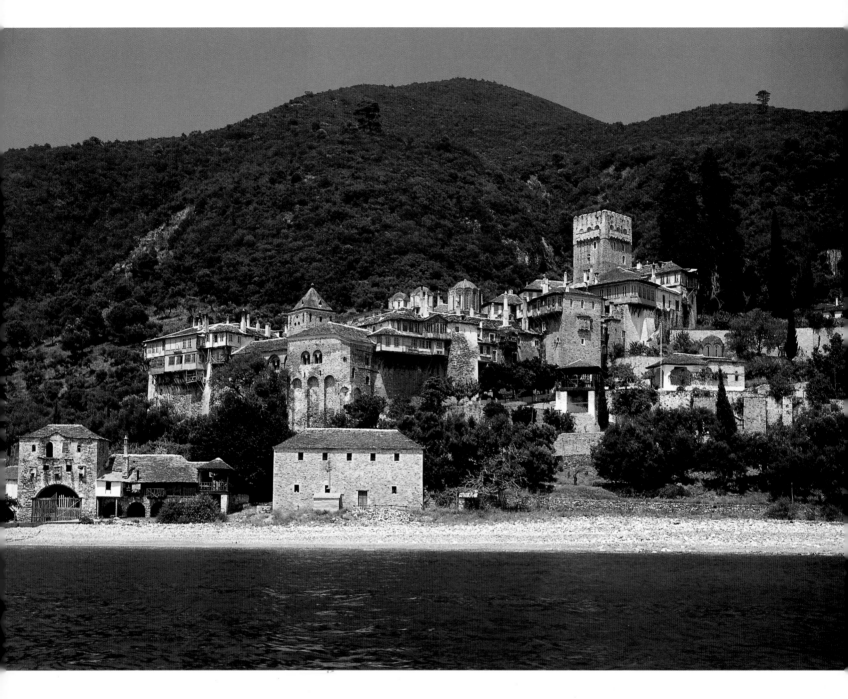

ABOVE: *According to tradition, Xenophontos Monastery was established in the tenth century, although the first references to the community date from the reign of Emperor Nicephorus III Botaneiates (1078–81) a century later. In retirement, the emperor's admiral, Stephen, took monastic vows, adopted the name Symeon, and finally became the monastery's abbot.*

Monks' cells at Xenophontos Monastery. In 1784, Xenophontos was the first community to revert to the coenobitic way of life after it had been forced, like other monasteries, to adopt the idiorrhythmic system in the face of economic difficulties.

sides, just below the eaves, runs a double frieze of saints in enamel. Delicate wrought tracery decorates the walls.

Less ornate, but equally well worked, is the lectionary cover of the Bible donated by Nicephorus Phocas in the treasury of the Great Lavra. An exquisite piece of workmanship, the golden metal cover is inset with precious and semi-precious stones: amethyst and garnet, lapis lazuli, beryl and cornelian. In each of the four corners huge crystals cover the sacred monograms of Christ and the Virgin. Christ himself stands barefoot on a cushion, the open pages of a Bible in his left hand. Other stones form crosses to his right and left; a double row of grey pearls creates a halo.

Among the most fascinating of the peninsula's treasures, however, carefully preserved at Dionysiou Monastery, is a tusk which once belonged to the strangest of all Orthodox saints, Saint Cristophoros Cynocephalos, the dog-headed Saint Christopher. Several stories explain this man-beast's alarming appearance. According to one, the saint was born with a dog's face which only became human after he embraced Christianity. Another tale suggests that Saint Christopher, an exceptionally handsome young man, prayed for this radical transformation lest he prove an irresistible attraction to either sex.

Astonishingly, Robert Curzon made little mention of the treasuries at Athos. But then, his real interest, like others before him, lay in the Mountain's libraries. They contain one of the richest collections of religious documents in the world: more than 12,000 manuscripts, written on parchment and paper and silk. More than 800 are illuminated, and many have recently been reproduced as one volume in the weighty three-volume tome *The Treasures of Mount Athos*, published in Athens. The earliest illustrated manuscripts date from the ninth and tenth centuries, though most are of later date, and comprise Old and New Testaments; menologies, or calendars with biographies of saints; Gospel books and various homiliaries. Like the icons few were produced on the Mountain, many arriving from other libraries in Constantinople, particularly during the last dark days of Byzantine rule.

The leading Athos monasteries all boast substantial libraries but the richest of all, with 10,000 printed volumes and more than 2000 manuscripts, belongs to the Great Lavra. In 1837, Robert Curzon found the library rather neglected. The books, he wrote, 'are disposed on shelves in tolerable order, but the dust on their venerable heads had not been disturbed for many years, and it took me some time to make out what they were, for in old Greek libraries few volumes have any title written on the back.' Curzon was looking to purchase old books and he visited the library several times to inspect all the vellum manuscripts. He concluded that none were particularly valuable and that, 'in so large a community', the monks were unlikely to part with their valuables anyway. So he moved on to the libraries of other Athos monasteries.

At Karakalou Monastery, to the north of the Lavra, the monks were all too willing to part with some of their book collection. The abbot accompanying Curzon round the dark closet of a library allowed the bibliophile to pocket a loose leaf of an ancient Gospel of Saint Matthew written in uncial Greek. Then he cut a thick wad from an eleventh-century Acts of the Apostles and handed it to Curzon thinking that he needed the pages to cover jam jars. Further books changed hands at a moderate price; and the proceeds helped to rebuild part of the courtyard damaged during the Greek rebellion.

Not all monks were as helpful as Karakalou's abbot. At Philotheou, Curzon was dismissed by curt monks who denied they even had a library. At the important

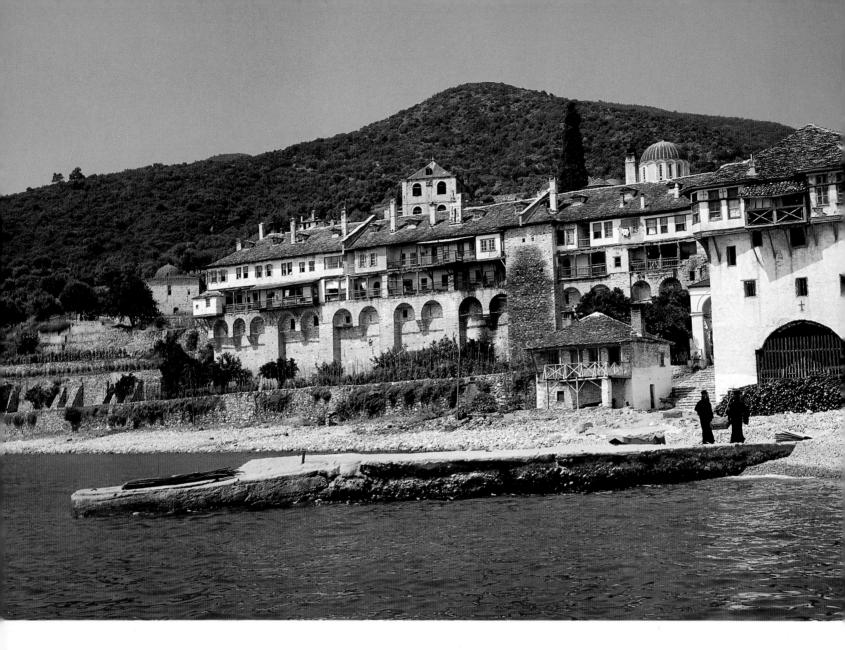

Tenth in the Athos hierarchy, Dochiariou was named after the former occupation of its founder, Euthymius. Before moving to Dochiariou, he had been a docheiares, *a storeman in charge of the oil and other foodstuffs at the Great Lavra.*

OPPOSITE: *The late eighteenth-century clock tower at Xeropotamou Monastery. The monastery, dedicated to the Forty Martyrs, was one of the richest foundations in Athos during the eleventh century. It still holds extensive tracts of land and is undergoing substantial restoration.*

monastery of Iviron he found a well-preserved book collection including a magnificent illuminated evangelistarium bound in red velvet; a copy of the four Gospels, illustrated with fine miniatures of the evangelists, which Curzon described as resembling a book of the Epistles in Oxford's Bodleian Library; and a fine eleventh-century manuscript of the Psalms. But nothing would persuade the monks to part with their precious books and Curzon had to be content with a history of the monastery, hand-written by the institution's secretary. He had no more luck at Stavronikita; and was deeply distressed when he arrived at Pantocrator to discover that its library had recently been destroyed during the Greek revolution.

Things started to look up at Dochiariou where the fathers gave him three leaves of a ninth-century evangelistarium. But it was at Xenophontos, where Curzon discovered parchment rolls and three important manuscripts on vellum, that he met the most astute monks. For five hours they discussed the price over coffee and sherbet and ouzo, before Curzon finally walked away with a work signed by Emperor Alexius Comnenus and a set of Gospels, originally a royal present to the monastery. A few days later, at Saint Paul's, he was given several books as a memorial of his visit. While at Simonos Petras he was just negotiating the purchase of three further works when an anathema was discovered on a copy of the Gospels, written by the book's imperial donor, against anyone who should sell or part with the book. Curzon, nevertheless, bought the other two which were added to his now substantial collection for shipping to Constantinople, and then London, where they now form part of the British Museum collection to which they were bequeathed in 1917.

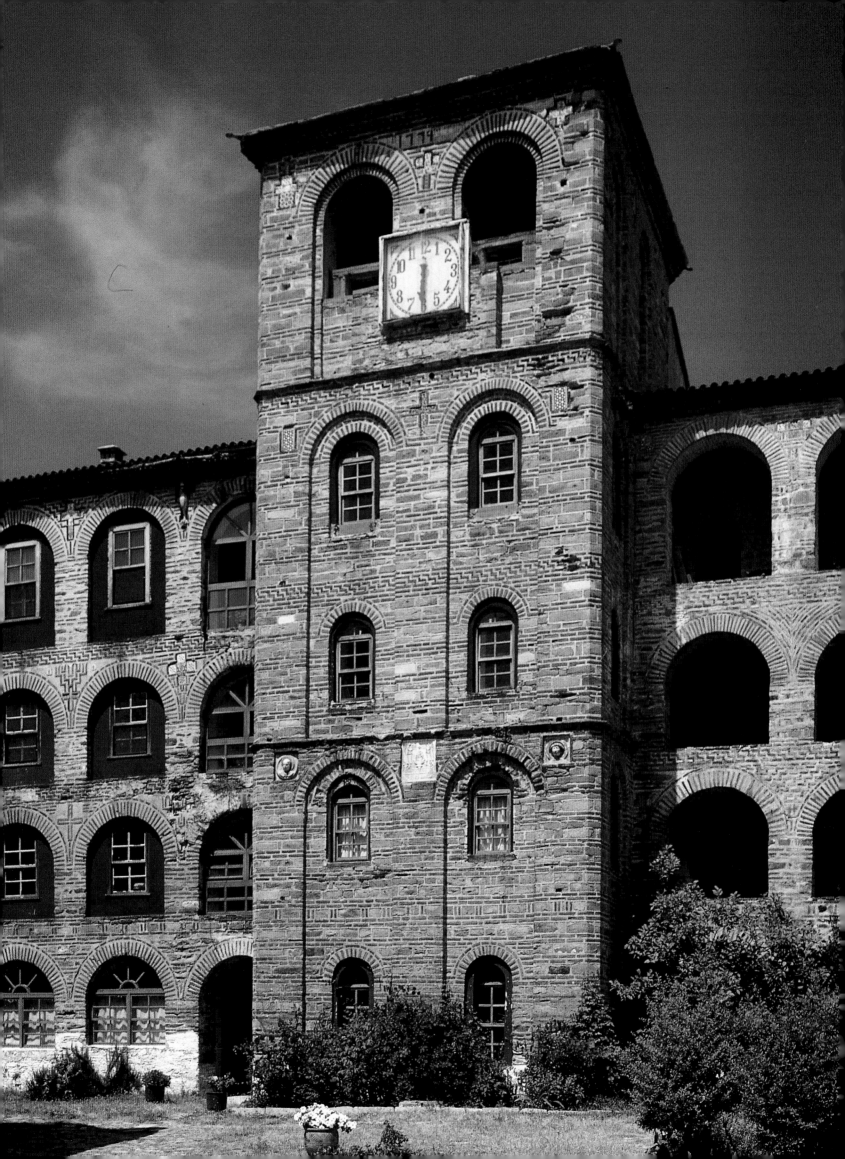

In Orthodox art St. Demetrius of Thessaloniki is frequently depicted in the company of his fellow military saint, George. Often the only way to tell them apart is by the colour of their mounts: Demetrius' horse is invariably dun, George's almost always white.

OPPOSITE: *Brickwork details with an inlaid cross made of broken tiles, probably Turkish in origin, in the monastery's eastern wing.*

St. Paul in the Church of the Forty Martyrs, painted in 1783, twenty years after the church was restored with funds raised by Kaisarius Daponte, a resident monk. The forty martyrs were fourth-century Armenians whom the Roman Emperor Licinius, who loathed Christianity, tried to freeze to death in a lake.

St. Onuphrius, a fourth-century Egyptian anchorite, in the exonarthex of the catholicon. Onuphrius lived alone; a long white beard reached to his knees and a palm-tree provided him with one fruit a month. Like other Egyptian saints his cultus spread throughout the Near East and was particularly popular in monasteries.

OVERLEAF: *Monastic dependencies and vegetable gardens near Xeropotamou Monastery.*

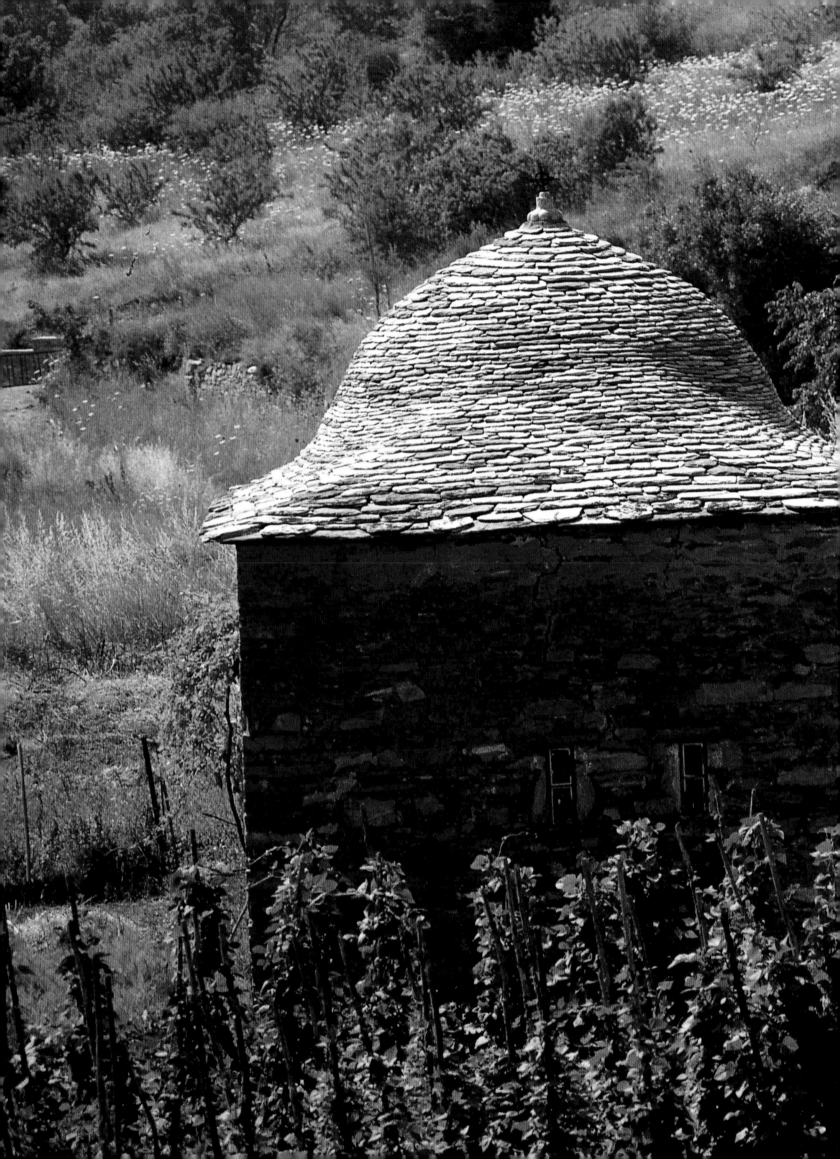

The Bulgarian monastery of Zographou. In the principal courtyard stands a monument commemorating twenty-six anti-Unionist monks who were burnt alive in the monastery tower in October 1276 for opposing the proposed union of the Orthodox and Catholic churches.

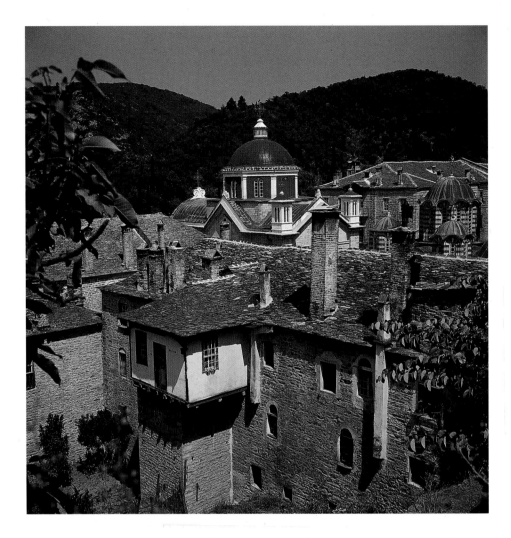

The days of Curzon and other nineteenth-century manuscript collectors have now long passed. Today, the Athos libraries are safely under lock and key and their contents can only be studied by Byzantine scholars. Curzon collected important works, and may have saved some from further deterioration, but his collecting mania had little overall effect on the richness of the Athos libraries. They are better organized now than they ever have been, though, as former visitors attest, attitudes towards books and learning have always varied between monasteries. Attempts to systematize the archives date back as far as the eighteenth century when one Cyril of the Great Lavra listed the acts in his monastery's records. Then came the wandering bibliophiles like Curzon and Dr Hunt, who at least gave the outside world a glimpse of what the libraries contained. The systematic publication of the acts of Athos was initiated by the Russians. In 1873, the acts of Panteleimon Monastery were published in Kiev; followed by those of Vatopedi fifteen years later. Greek scholars have recently published weighty tomes on the Mountain's treasures, but the most extensive publishing programme, *Archives de l'Athos*, begun in Paris in 1937, is still far from complete.

Other material, of immense historical importance, has yet to receive much attention. Thousands of photographs dating from the late nineteenth century lay scattered in monks' cells, the libraries, and abandoned storerooms. They include images of monastic life at the turn of the century, pictures of the buildings, portraits of abbots, and records of formal occasions; in short, essential information for architects restoring historic façades, as well as religious historians. A wealth of popular

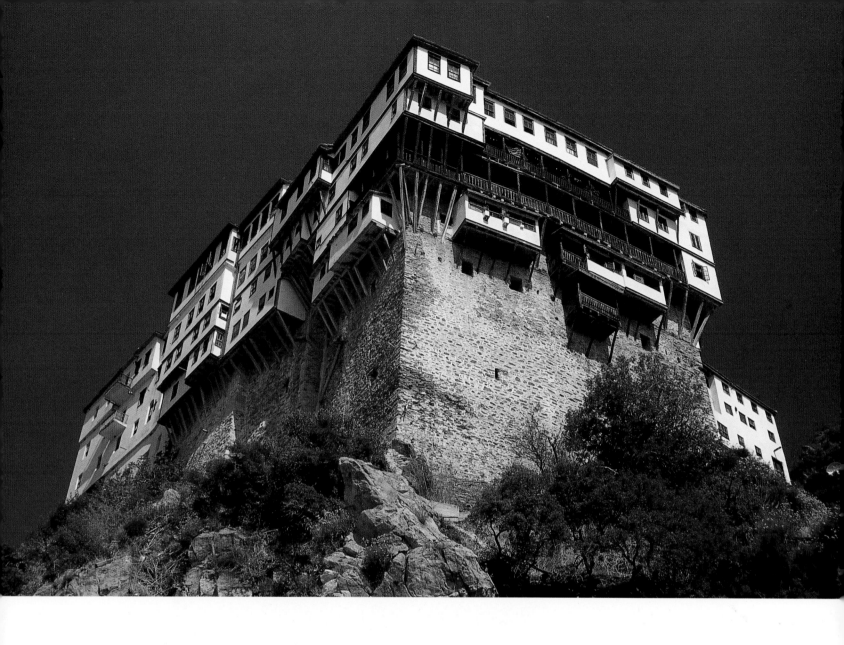

ABOVE: *Dionysiou Monastery from the harbour below.*

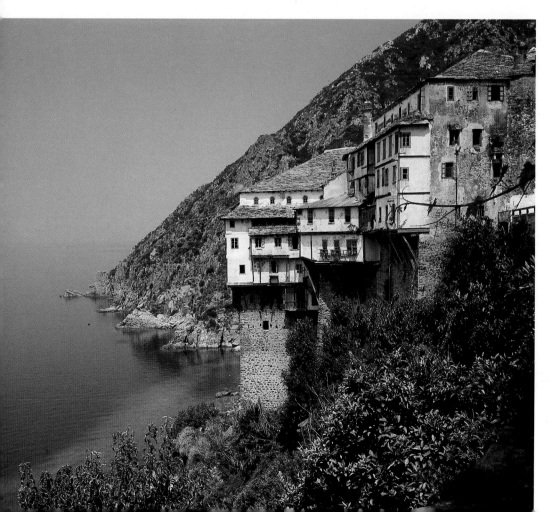

Founded in the second half of the fourteenth century, the building of Dionysiou Monastery was financed by the Emperor of Trebizond, Alexius III Comnenus, and by later Byzantine emperors, particularly members of the Palaeologan dynasty. After the fall of Constantinople in 1453, financial support shifted to the orthodox rulers of Moldavia and Wallachia.

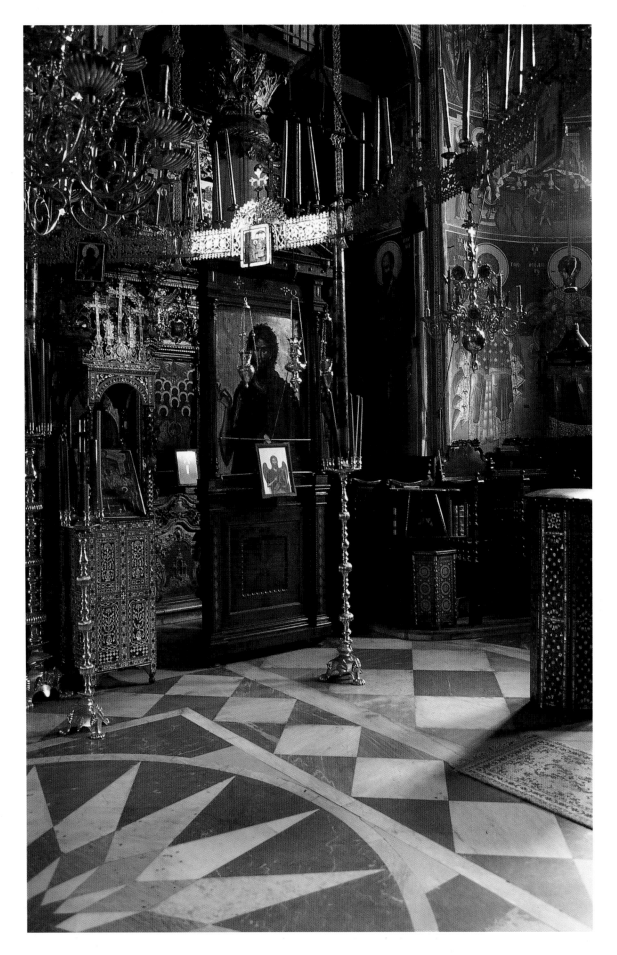

The catholicon at Dionysiou is decorated with remarkable frescoes, probably painted by Zorzi of the famous Cretan school, whose members migrated to Mount Athos and Meteora in the sixteenth century. The church was restored at the expense of Peter, Voivode of Moldavia, whose portrait, together with those of his children, appears in the right-hand aisle.

Old stalls in a corner of the refectory narthex at Dionysiou Monastery. Traditionally, the central part of an orthodox church is free of chairs or pews, although there are usually benches or stalls along the walls. The high, crutch-like armrests provide welcome support for elderly monks standing during long services.

The low cloister, outside the refectory at Dionysiou, decorated with dark and disturbing, sometimes amusing, scenes from the Apocalypse.

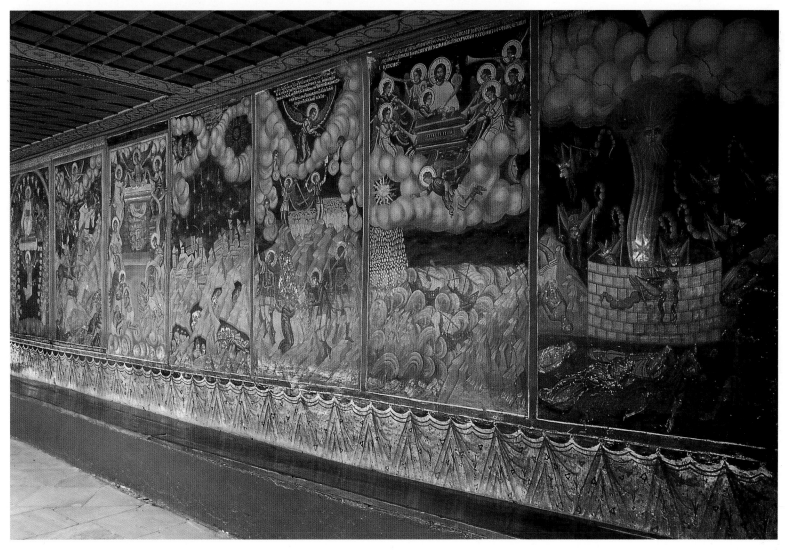

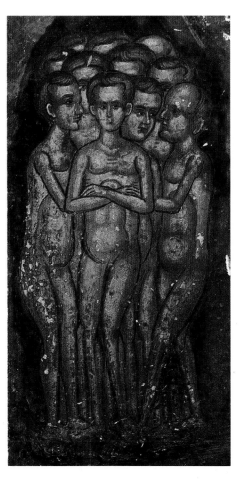

A detail from the sixteenth-century paintings of the Apocalypse at Dionysiou Monastery.

religious memorabilia also lies within Athos' hallowed walls. These include woodcuts and engravings of the monasteries, Orthodox saints, and major ceremonies, which were once printed in Mount Athos and elsewhere. They were a form of inexpensive souvenir, a substitute for traditional icons, bought by pilgrims to the Holy Mountain and hung on their walls back home. Fortunately, some of the original woodblocks and metal plates still survive, though well-preserved prints are becoming increasingly rare.

Cataloguing Athos' enormous manuscript wealth is a mammoth task, but that is only the first step towards an urgently needed conservation programme. And as yet little has been done to protect the libraries for future generations. Books and manuscripts continue to decay in draughty, wooden rooms that were never built with the needs of modern conservation in mind. In recent decades several monasteries, among them the Great Lavra, Iviron and Hilandar, have rehoused and ordered their collections, but little thought has been given to environmental control. Awareness of the need for a conservation programme is growing, however, most importantly among some of the more progressive monks themselves.

The monastery buildings, too, need urgent repairs and a long-term commitment to their conservation; and here more progress has recently been made. Work, funded by the European Union, the Greek government and private donors, is under way on several leading monasteries. In some, such as Stavronikita, restoration is almost complete. Xeropotamou boasts clean sand-blasted walls and new visitors' quarters, although the buildings near the main entrance are still in ruins. The Russian monastery of Saint Panteleimon is undergoing major reconstruction, but the architectural authenticity of the new works is highly questionable. In other monasteries, certain buildings, such as the catholicon at Vatopedi, need major work to restore them to their original conception. Overall, however, there is more building taking place on Athos today, and more awareness of its cultural necessity, than there has been for centuries.

✝ Holy Smoke: Athos Today

Most monasteries in Greece have experienced a marked drop in numbers or finally closed their doors in the last twenty-five years. In contrast, Athos has enjoyed a modest recovery. The recent increase, however, needs to be seen in the light of an enormous decline from the turn of the century until the end of the 1960s. In 1903, Athos had about 7500 monks, of whom nearly half were Russian. Saint Panteleimon had almost 2000 residents alone. But following the October Revolution and the introduction of an atheistic state, few novices arrived from the Soviet Union after the First World War and the number of Russian monks slowly shrunk. By the 1960s fewer than sixty monks lived at Saint Panteleimon.

The loss of Russian monks is only part of the picture. Fewer monks also arrived from Romania or Serbia, and the Mountain lost its attraction for young Greeks. From almost 7500 monks in 1903, the number of Athonites dropped dramatically to 1560 by the 1963 millennium, and again to 1145 by 1971. Alarm bells began to ring. Predictions were made of Athos' imminent extinction. How, indeed, could a medieval-based community, its foundations built for many thousands of monks, survive with little more than a thousand old men? Few of the monks were well educated and Athos no longer had any discernible influence over the religious life of Greece. In short, it had become a spiritual backwater.

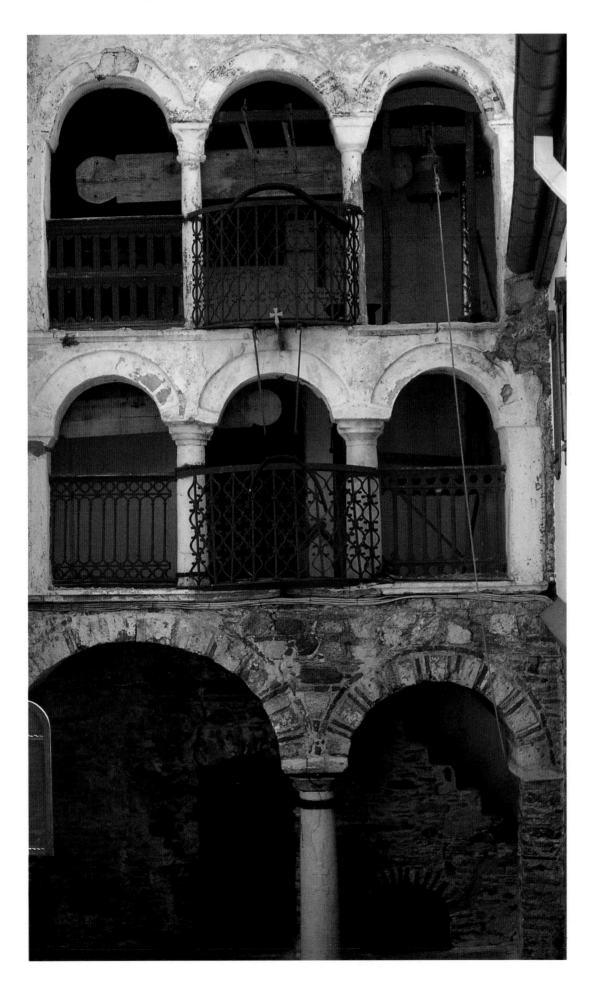

A grisly scene, by an unknown Romanian artist, of Roman soldiers torturing a Christian martyr, in the narthex of the catholicon, Dionysiou. Martyrdom scenes are recurring themes in Byzantine and post-Byzantine art and a graphic reminder of the suffering of the early Christians.

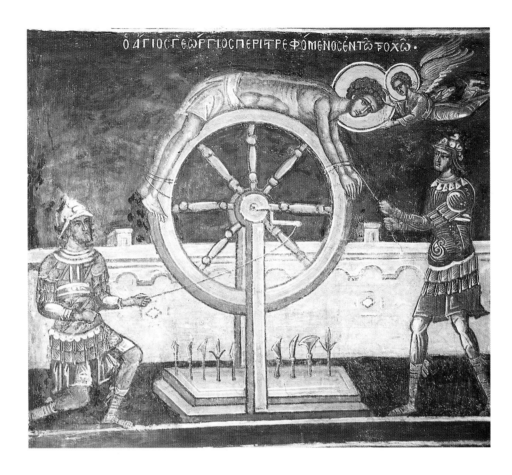

OPPOSITE: *Dramatically sited atop a rocky cliff-face, the seven-storey Simonos Petras Monastery is dedicated to the Nativity of Christ and was originally known as 'New Bethlehem'. One of the most renowned communities on the Mountain, it has long attracted foreign monks. Of about sixty residents today, fifteen are non-Greek.*

A brass tap in the form of a lion or other large cat at the entrance to Dionysiou Monastery.

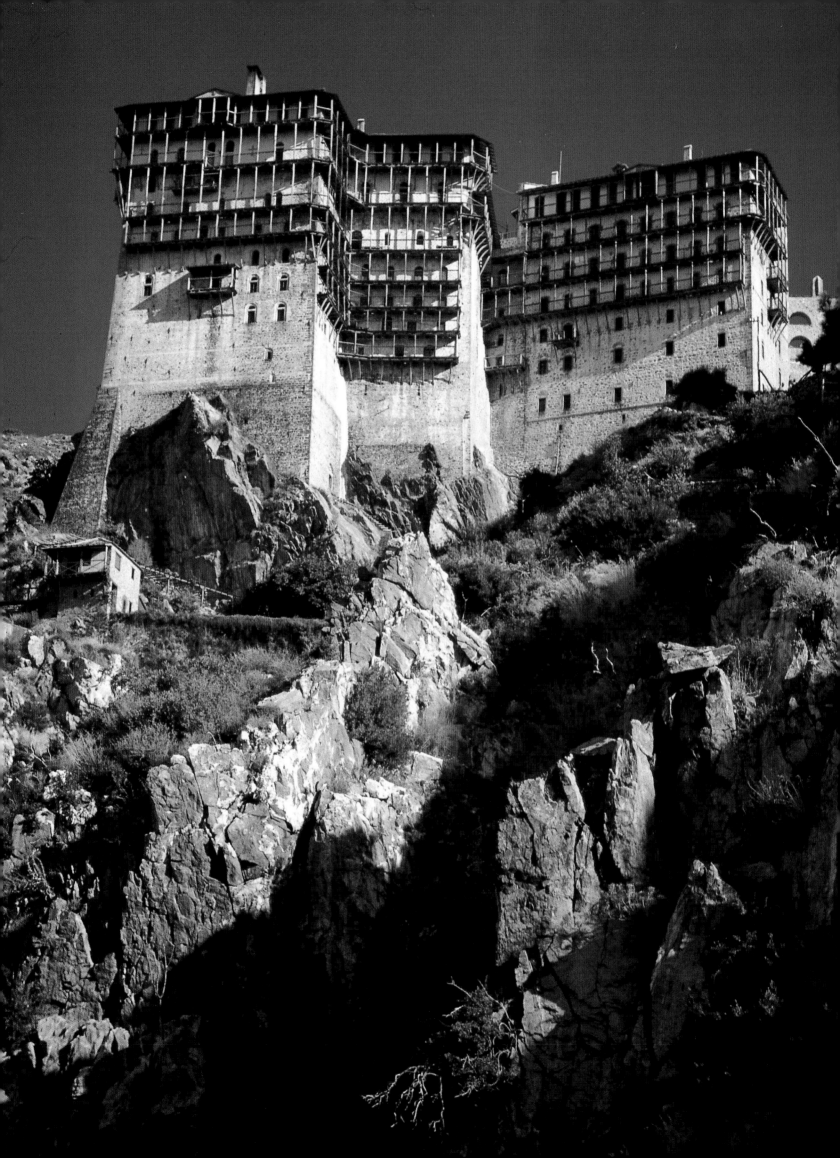

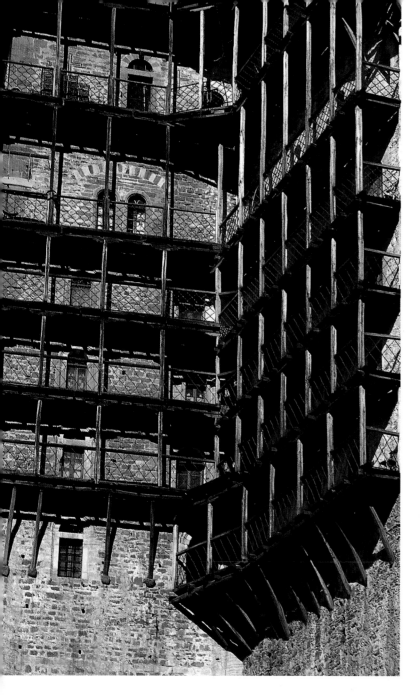

Tiered balconies at Simonos Petras. According to tradition the first builders to work at the monastery were so frightened by the vertiginous height that they abandoned the work half way through.

ABOVE RIGHT: *A bell hangs from the wooden balconies at Simonos Petras.*

Several important figures, however, continued to keep the spirit of the Mountain alive during this decadent period. Athos still produced its saints and ascetics schooled in the traditions of Orthodox monasticism. In 1988, a Russian monk from the monastery of Saint Panteleimon, Father Silouan, was proclaimed a saint in the fiftieth year of his death. A humble monk of peasant stock, Saint Silouan wrote a series of poetic meditations which were well received for their theological vision and translated into several languages. In the semi-eremitic settlement of the New Skete, the late Father Joseph attracted a group of disciples dedicated to the practice of the inner prayer. And several monasteries, notably Dionysiou under Father Gabriel (1886–1983), abbot for almost fifty years, maintained high standards in their efforts to nurture the monastic life.

Despite such souls in the wilderness little, it seemed, would ultimately stop the sounding of the death-knell. But then, unexpectedly, the population of Athos began to rise, albeit slowly, so that by the early 1990s the total population had risen by a third since 1971, to over 1500 monks and is now approaching 2000. A modest increase, perhaps, which only restores the numbers to their level forty years ago, but an increase nevertheless. More importantly, there has been a change in the Mountain's age profile and the monks' standard of education. Instead of pious peasants, once the Mountain's mainstay, educated young men, often with professional or

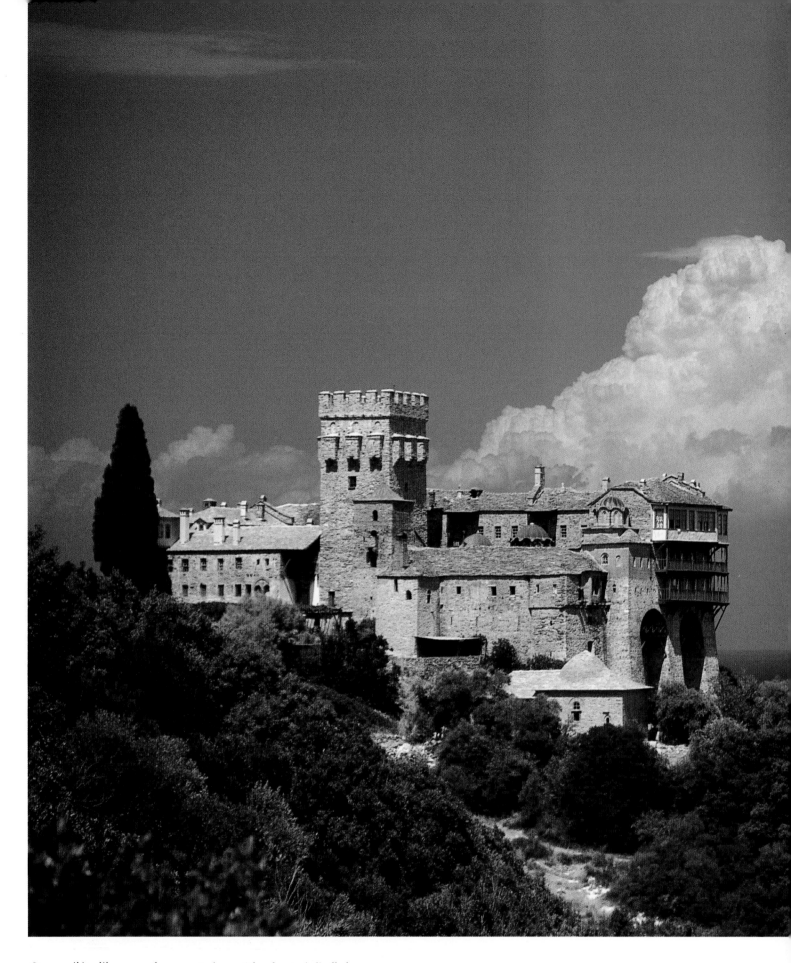

Stravronikita, like many other monasteries on Athos, has periodically been ravaged by fire. All but its stone walls were destroyed in 1607, although its records were saved. The monastery was rebuilt and enlarged but repeatedly damaged by lesser fires in 1741, 1864, and 1879. It has recently been restored again. Modern cooking and heating systems now reduce the risk of fire.

Monks outside Stavronikita, one of the most active, outward-looking monasteries on Athos. Under Father Vasileios, now abbot at Iviron, Stavronikita became coenobitic in 1968, and set a trend for the conversion of former idiorrhythmic monasteries to the coenobitic system.

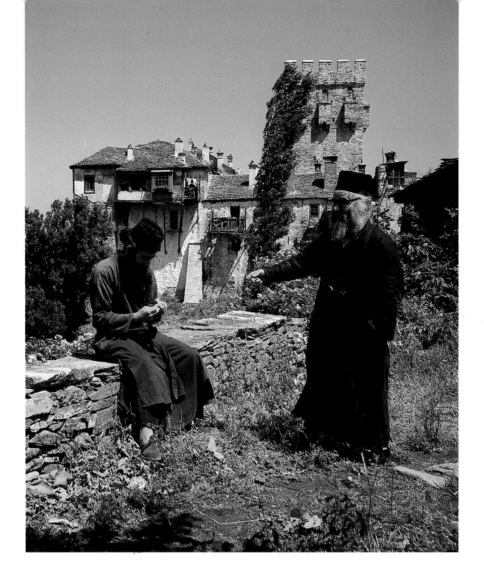

OPPOSITE: *Although the smallest of the Athonite monasteries, Stavonikita is noted for its aqueduct and a striking look-out tower which dominates the monastery from all sides.*

A monk climbs the steps of Esphigmenou Monastery's nineteenth-century catholicon, dedicated to the Ascension of Christ.

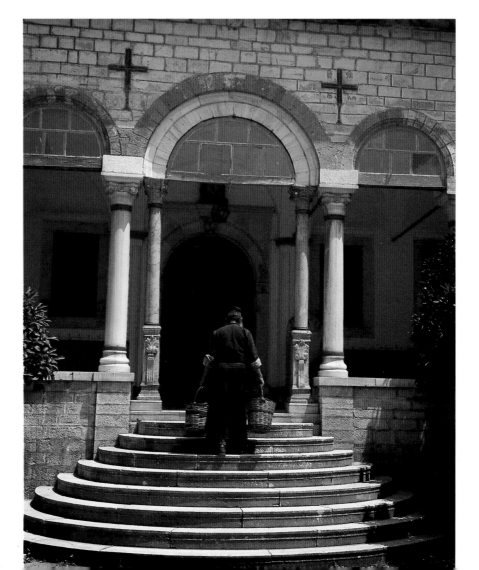

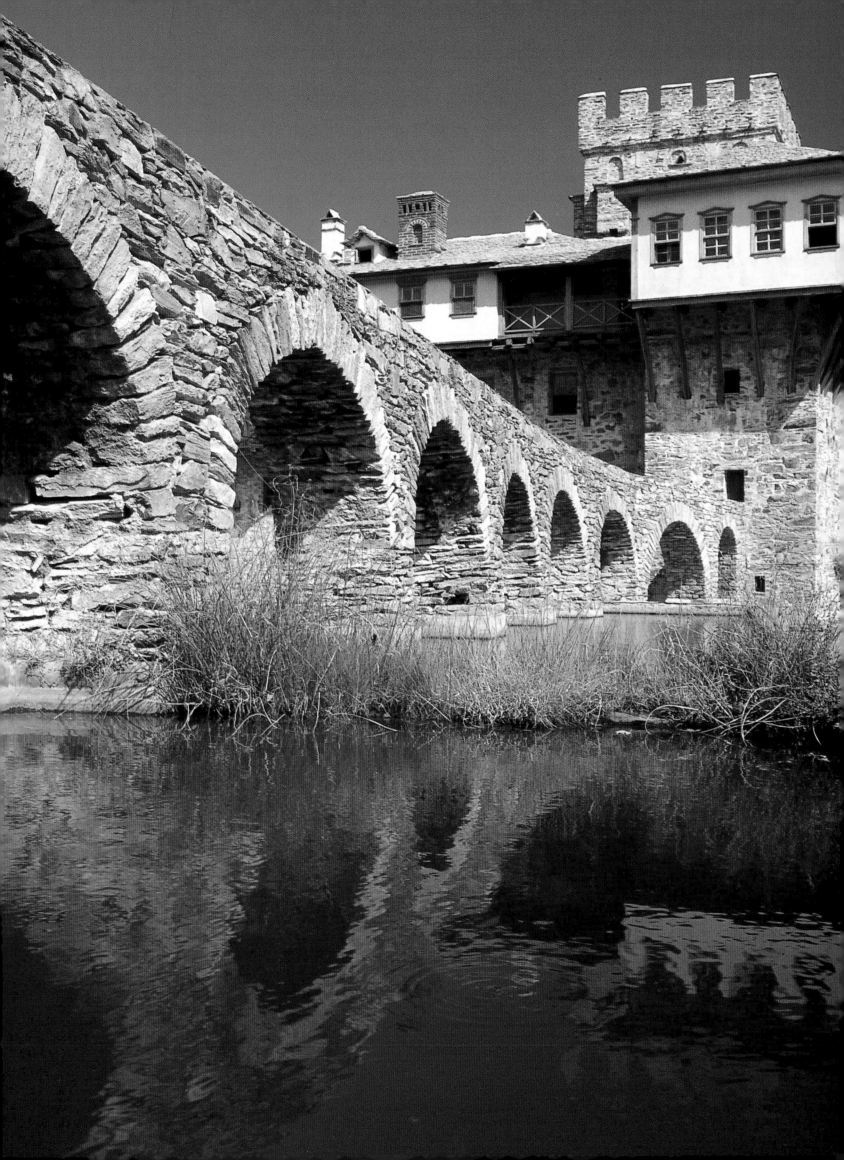

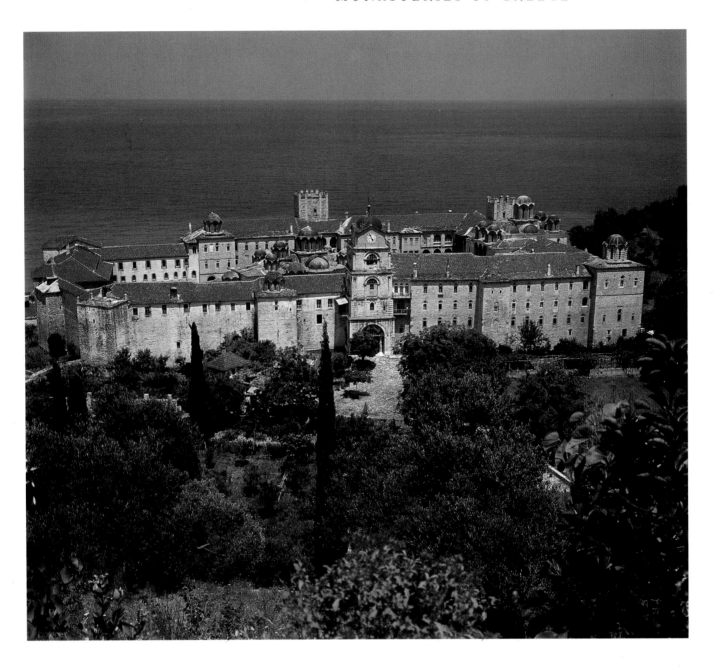

Esphigmenou Monastery, the most northerly of the Athos communities. The origin of the name Esphigmenou has led to widely different interpretations. The most curious suggests that the founder or restorer of the monastery was a monk whose habit was 'tied with a very tight cord'!

academic backgrounds, are now being attracted by the monastic life. Among the recent recruits are a former oil prospector and nuclear physicist, military officers, social workers, doctors and dentists, all attracted by the peace and spiritual calling of the Mountain.

Mount Athos also has its colourful characters such as Father Ioannikios of the Ravdouchou kellion which, he claims, has been lived in continually since the seventh century. The polyglot monk had an eventful life before deciding to retreat to Athos. During the Greek civil strife which succeeded the German occupation in the Second World War, Ioannikios, born Eustrakios Papakonstantinou, was imprisoned for his leftist views. On his release in 1953 he joined the Young Communist League and was politically active until the Soviets crushed the Hungarian uprising in 1956. Disillusioned by communism, he turned to making movies. After a period directing films for Bulgarian television, Ioannikios went to Africa and then to Copenhagen, where he worked as a researcher at the Royal Library. But he soon felt a greater need to save souls and, although a former communist, he was readily accepted as a novice on Mount Athos. Other recruits, with equally varied stories,

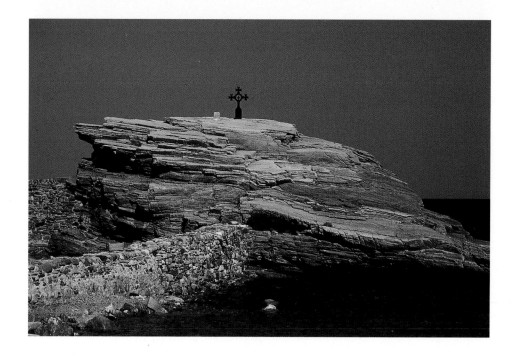

The fourteenth-century Pantocrator Monastery was founded by two nobles, Alexius Stratopedarch and John the Primikerios. Their remains lie in a mausoleum dated 1363 in the narthex of the principal church.

An iron cross marks the entrance to the small harbour at Pantocrator Monastery.

Hilandar Monastery has been variously referred to as 'the monastery of a thousand mists' or 'a thousand men'. According to one legend a thousand pirates planned to attack the monastery but, unable to distinguish friend from foe in the thick mist that rolled down the hillsides, they slaughtered each other rather than the monks.

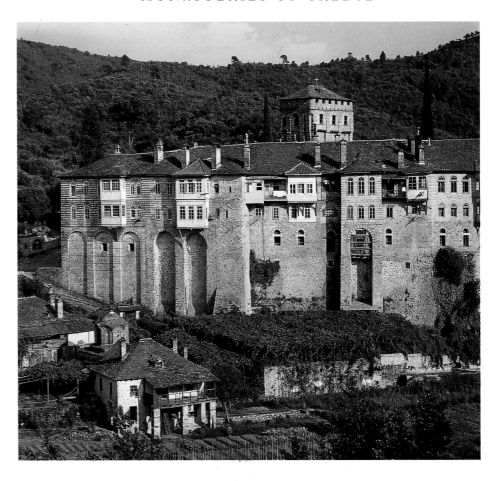

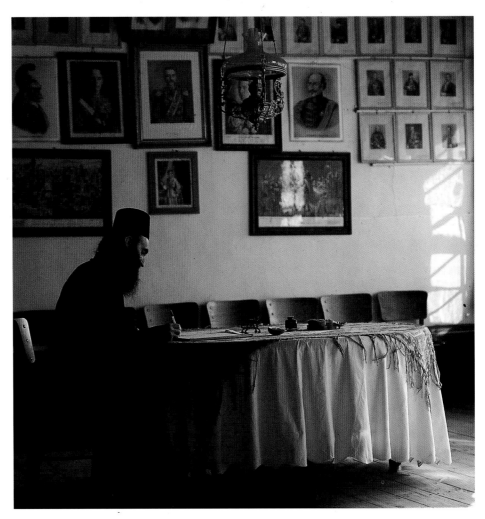

A monk writing in the archontariki, or reception room for pilgrims and visitors, at Hilandar Monastery.

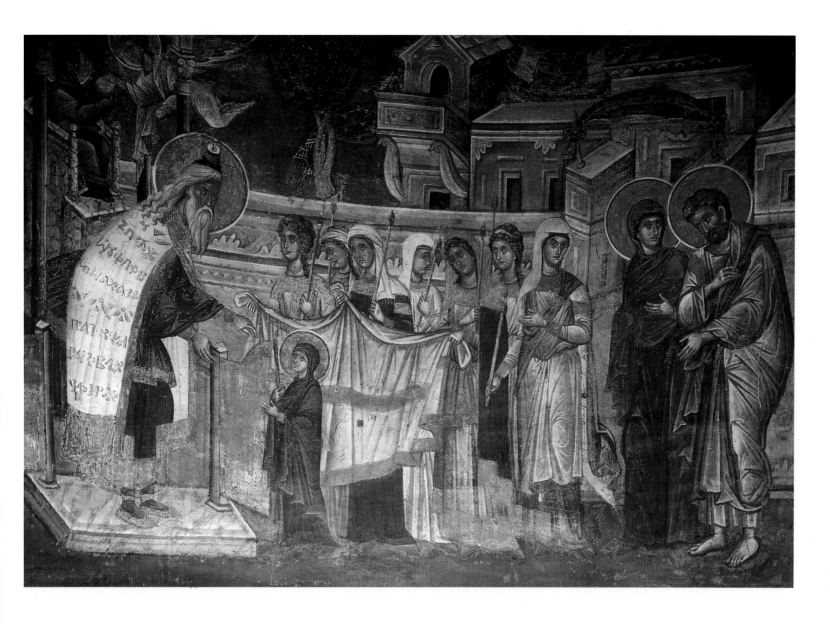

have arrived from outside Greece, from other Balkan countries, from western Europe, Australia and the United States.

Why is Athos bucking the trend? Is recent growth a real renaissance or simply a minor blip in a downward spiral? Athos has benefited from its uniqueness and at the expense of other ancient communities. Centres such as Meteora are now so overrun by tourists each summer that normal monastic life is difficult there and monks are drawn to Athos instead. In response to the increasing secularization of the national life young Greek Christians have chosen Athos as a radical alternative, while others, formerly attracted to fringe 'religious movements' are now choosing monasticism. Some of Athos' leading figures today once had strong contacts with the Zoe brotherhood, a semi-monastic organization widely criticized for its secrecy, authoritarianism and links with the military junta in the 1970s. Several dominant personalities have emerged from this background and have become known, even beyond the mountain, for their work as abbots at leading Athos monasteries. Strong personal direction has become as important to monasticism today as it was in the early Christian era.

A growing, vigorous population and strong leadership is clearly crucial to the future of Athos, but this growth has been accompanied by division and dissent. Among the chief critics of recent changes on Athos is an outspoken Greek monk, Father Maximos, formerly of the Great Lavra and now living in England. In a recent book, *Human Rights on Mount Athos*, he catalogued a whole series of alleged infringements of human rights by Holy Mountain administrators. Many of his

Hilander catholicon, dedicated to the Presentation of the Mother of God, is painted with a fourteenth-century mural depicting the important scene from the Book of James in which Mary's parents, Joachim and Anne, accompanied by seven attendants, lead the Virgin into church.

criticisms have historical precedent; others reflect recent changes in the Greek body politic.

Chief among the historical confrontations to re-emerge is renewed conflict between coenobites and the idiorrhythmic system. This time some of the antagonism towards idiorrhythmy, according to Father Maximos, came from outside as well as within. Present difficulties date back to the military coup in the late 1960s when monks were considered politically unsound and the regime tried to force the younger ones into military service. In 1968, Greek gendarmerie raided the then idiorrhythmic monastery of Stavronikita, forcing out the monks who were accused of immorality. The following day the civil governor appointed a new abbot, Father Vasileios, deemed acceptable to the new regime, and declared that henceforth Stavronikita was to be coenobitic.

Other idiorrhythmic communities subsequently converted to the coenobitic system, as their practices, based partly on private property, were widely attacked for undermining the stability of the traditional Athonite way of life. Coenobites charged that the idiorrhythmic monasteries had become little more than old men's homes; and that the only way forward, the only way for Athos to survive, was to rediscover the communal spirit. Indeed, it is hardly surprising, given the history of Athonite monasticism, that the coenobites should get the upper-hand during a period of relative prosperity. Originally, idiorrhythmy was only accepted during periods of crisis when the Mountain's administrators were able to accept a nominal amount of private property in order to attract much needed funds. Now, with numbers growing again, coenobitism has reasserted itself as the Orthodox monastic ideal.

Gregoriou Monastery, built on its present site in the fourteenth century, is dedicated to St. Nicholas whose portrait, a piece of fresco saved from an earlier church and converted into a silver-encased icon, is one of the monastery's most important treasures.

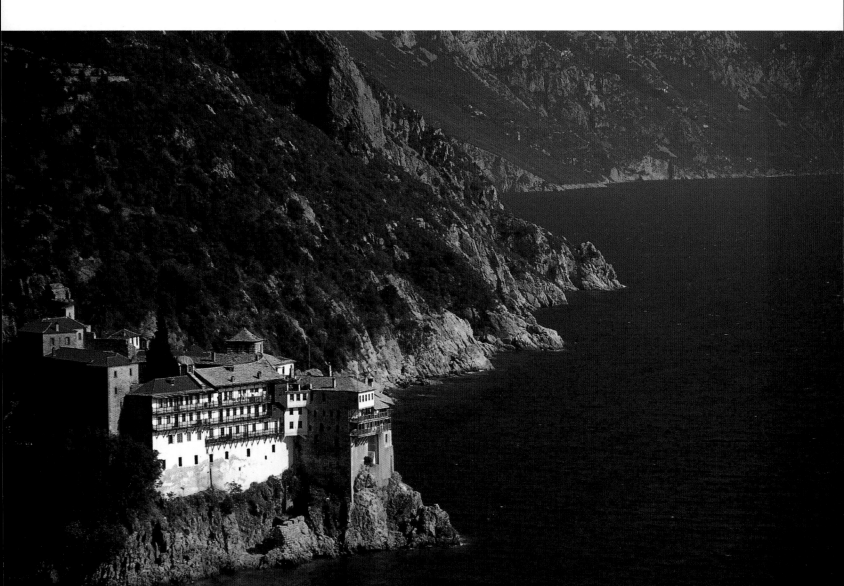

Whatever the pros and cons of the two systems, the coenobites have won the day, control almost all the Mountain, and have led the Athos revival. In the vanguard of the new evangelism, Patriarch Demetrios at Philotheou Monastery, which became coenobitic in 1973, runs one of the Mountain's toughest regimes. Here, more than eighty monks are trained to spread the Orthodox faith; they are sent to reform monasteries on Athos, on mainland Greece, and elsewhere in the Orthodox world. Visitors get a cool reception here: monks and guests are kept apart, forbidden to speak or dine together, and non-residents are confined to the rear of the chapel during worship.

Father Maximos claims that resurgent coenobitism has led to strong personality cults growing up around leading superiors, some of whom believe that Athos has a responsibility to promote Hellenism as well as world Orthodoxy. By the mid-1970s such attitudes had led to the founding of the Neo-Orthodox Movement, a form of religious nationalism expounded by Father Vasileios of Iviron, formerly of Stavronikita, in his book *Mount Athos and the Education of the Nation*. Beyond Athos the movement had wide popular appeal, attracting the attention of socialist politicians as well as right-wing intellectuals. But not all the monks on Athos were happy. Traditional pan-Orthodox monks, those who continued to uphold Athos as a spiritual centre for all Orthodox peoples, suffered for their beliefs. According to Father Maximos, the Neo-Orthodox authorities of Athos have kept their hold on power through

A corner of the principal reception room at Gregoriou.

ABOVE LEFT: *Skeletons in the cupboard. The ossuary at St. Andrew's skete, a Russian community now almost deserted, holds the skulls of local saints and former monks.*

OVERLEAF: *During the eighteenth century the cash-strapped Philotheou monastery sought financial help from the ruler of Moldavia and Wallachia, Gregory Ghika. The prince agreed to pay an annual stipend on condition that each year the right hand of St. John Chrysostom be sent to his kingdom to be blessed.*

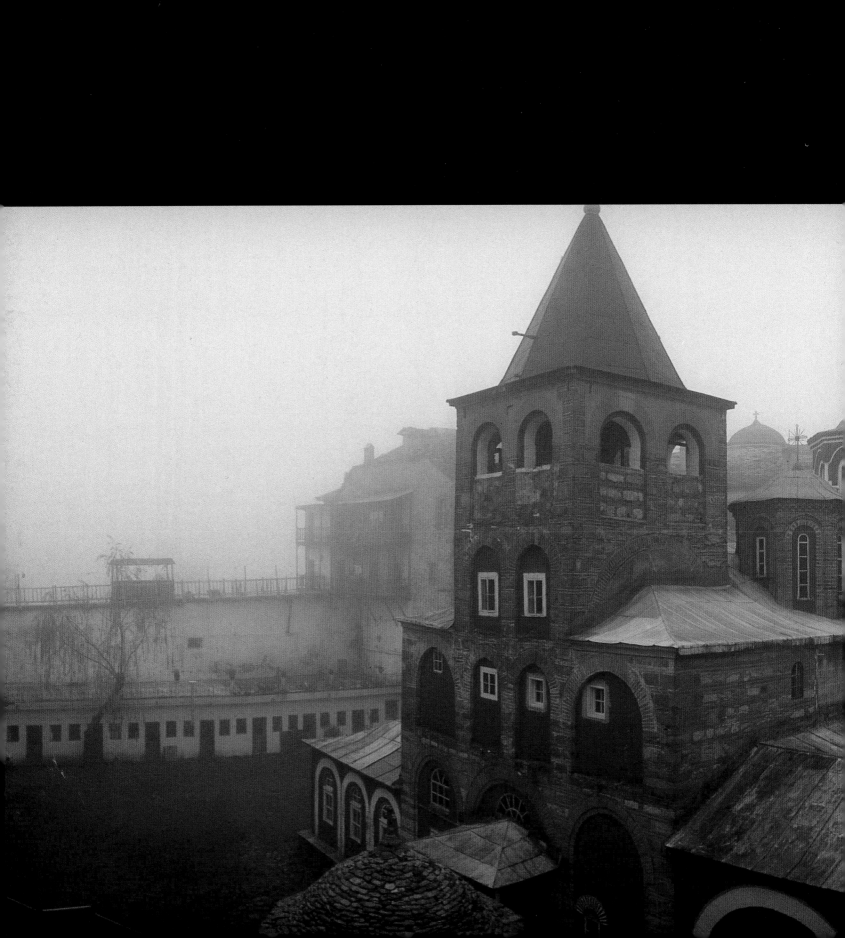

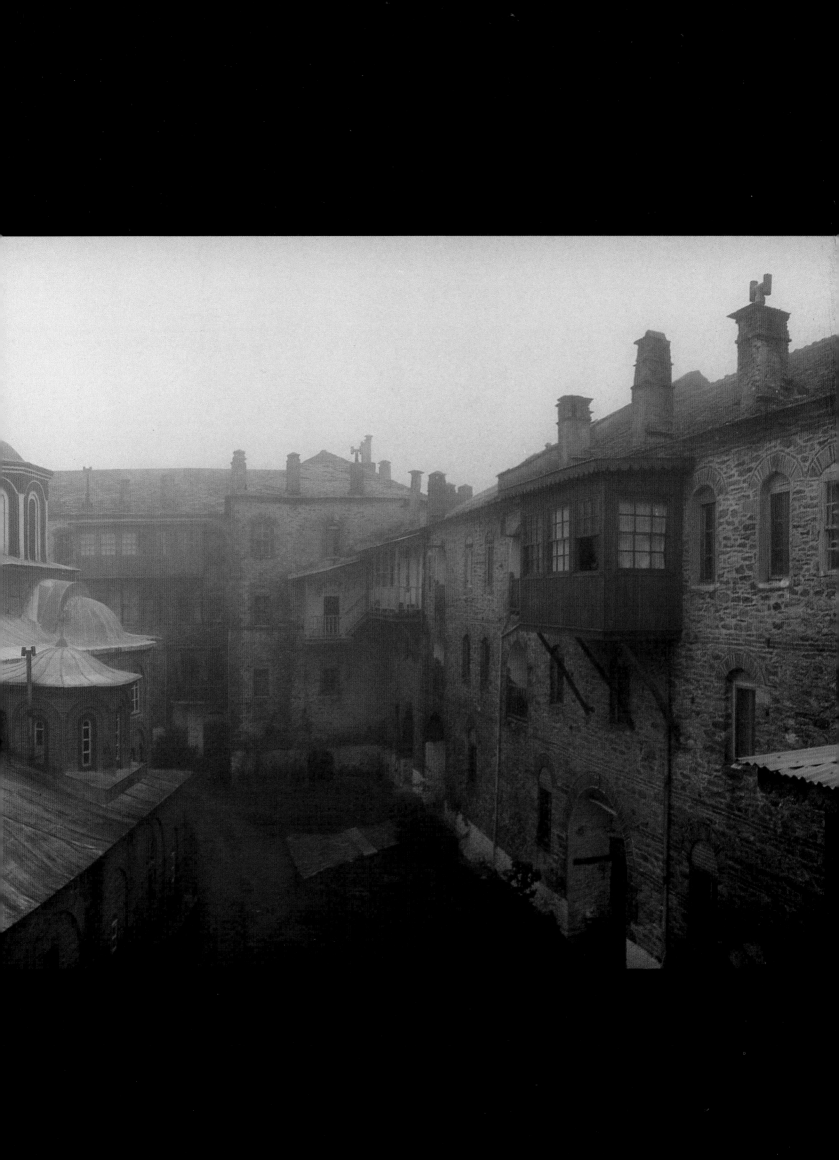

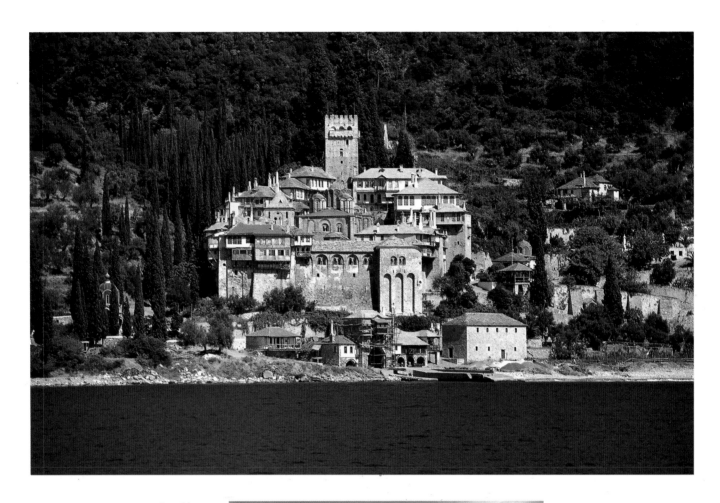

Dochiariou Monastery was found in the late tenth century by Euthymius, a former storekeeper at the Great Lavra, who may have been a disciple of St. Athanasius, originator of coenobitic monasticism on Athos.

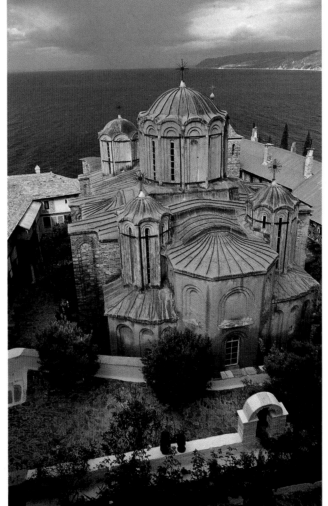

The catholicon at Dochiariou is dedicated to the Archangels Michael and Gabriel. According to the 'Worshippers Guide to Dochiariou' written by a resident monk, Cyril, in 1843, the monastery was originally dedicated to St. Nicholas but later changed to commemorate a miracle of the Archangels.

Tall chimney stacks give Dochiariou much of its characteristic profile.

Dome and cross crown the principal church at Dochiariou.

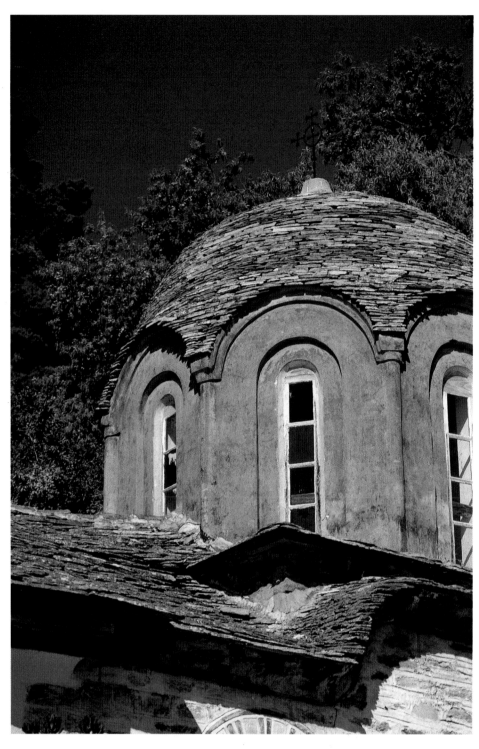

One of nine subsidiary chapels at Dochiariou.

coercion and the denial of basic human rights. Maximos accuses the Sacred Community of limiting dissenting monks' freedom of speech; mail and telephone calls have been vetted; newspapers and radio broadcasts are forbidden for spiritual reasons, but enjoyed in private by those in authority.

Other long-standing disputes continue to haunt the Mountain. The 'Old Calendarists' or 'Zealots', who still constitute about a quarter of the monks on Athos, refuse to communicate with other monks as a protest against the change of calendar – which dates back to 1924 – ecumenism, and what they see as the heresy of the Neo-Orthodox. The Ecumenical Patriarchate in Istanbul is bluntly snubbed for its half-hearted efforts towards reunion. In response, says Maximos, the authorities have restricted the zealots' access to public funds, necessary to carry out essential monastic repairs, and refused them new cells and hermitages. Zealots also have no representation on the Sacred Community.

OPPOSITE: *Daniel in the lion's den, possibly by the Cretan painter Zorzi, at Dochiariou.*

· 164 ·

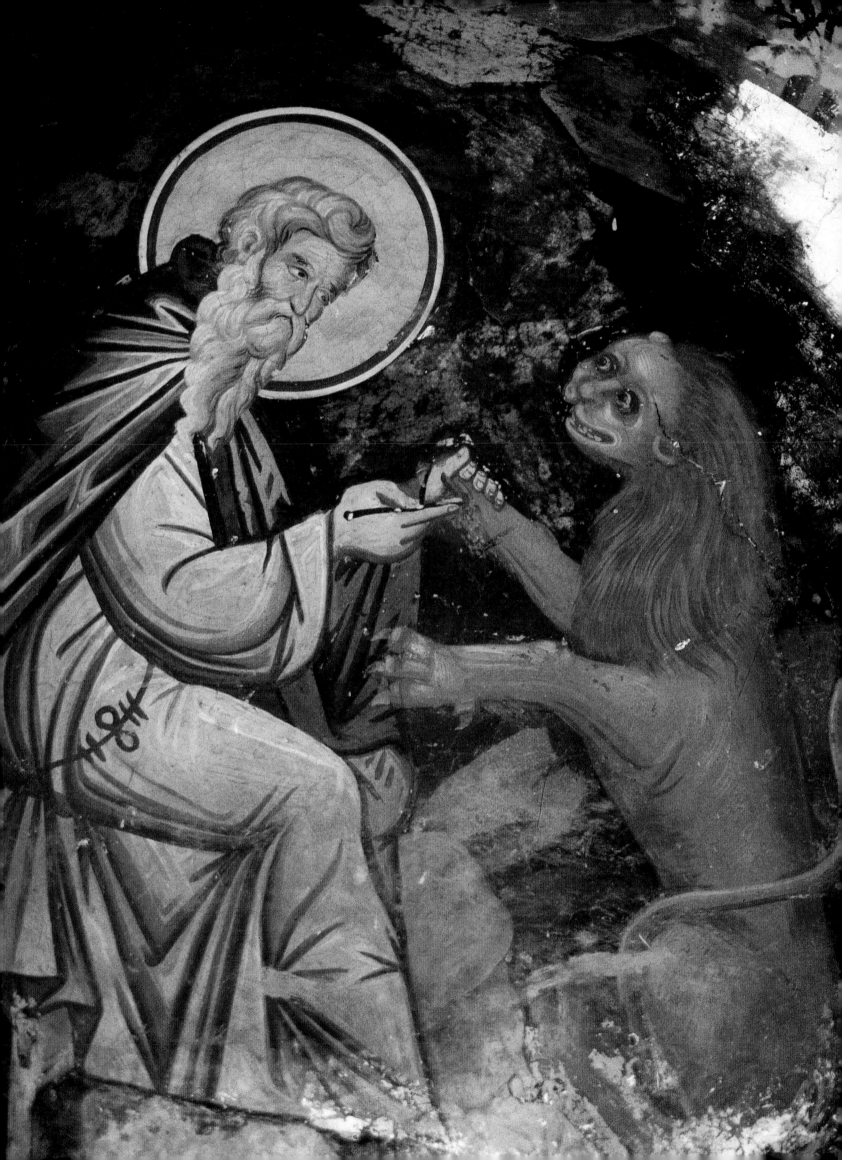

*A monk paints a large icon in one of
Athos' many workshops.*

*Turning the wooden vases which are
sold as souvenirs to orthodox
pilgrims.*

OVERLEAF AND PAGE 170: *Mount Athos, rising 2033 metres above
the Aegean Sea, is the culmination of the forty-five kilometre long peninsula
where monks follow a way of life little changed since the days of
Byzantium. In pagan mythology Athos, a Thracian giant, threw the
mountain at Poseidon in a clash between gods and giants.*

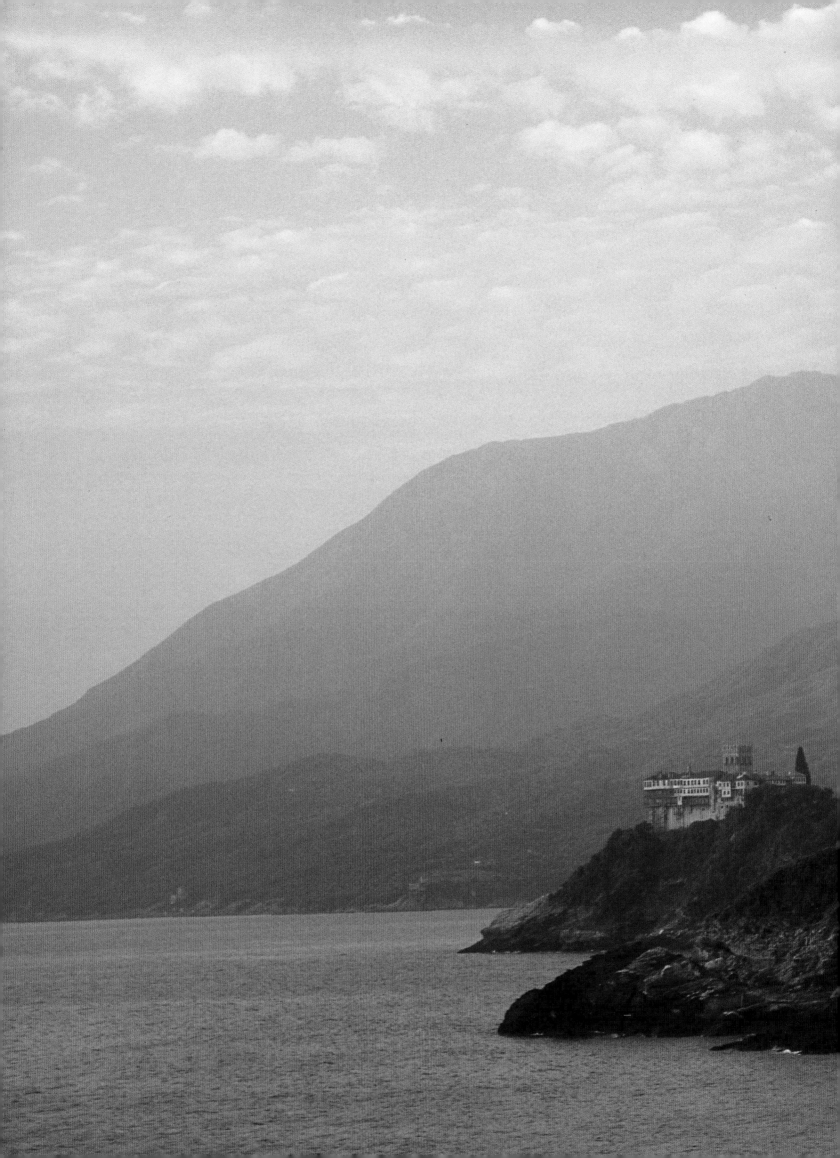

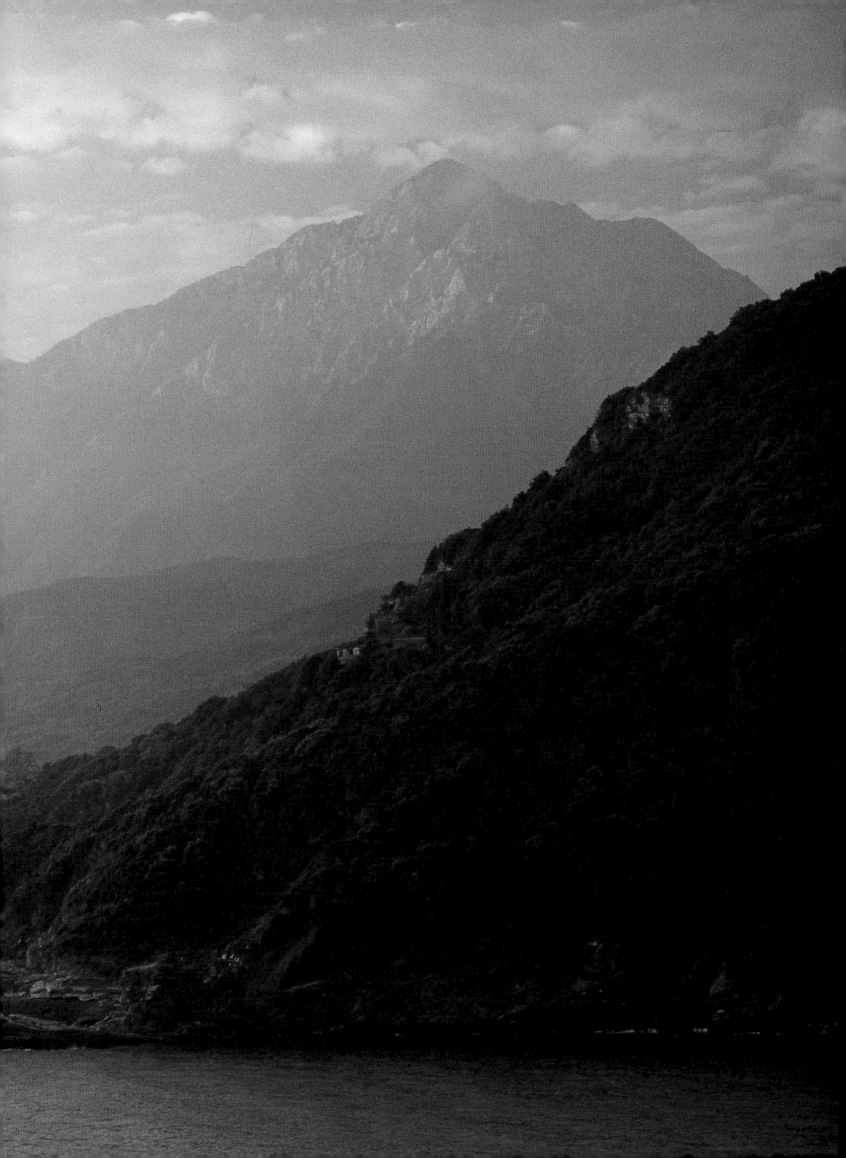

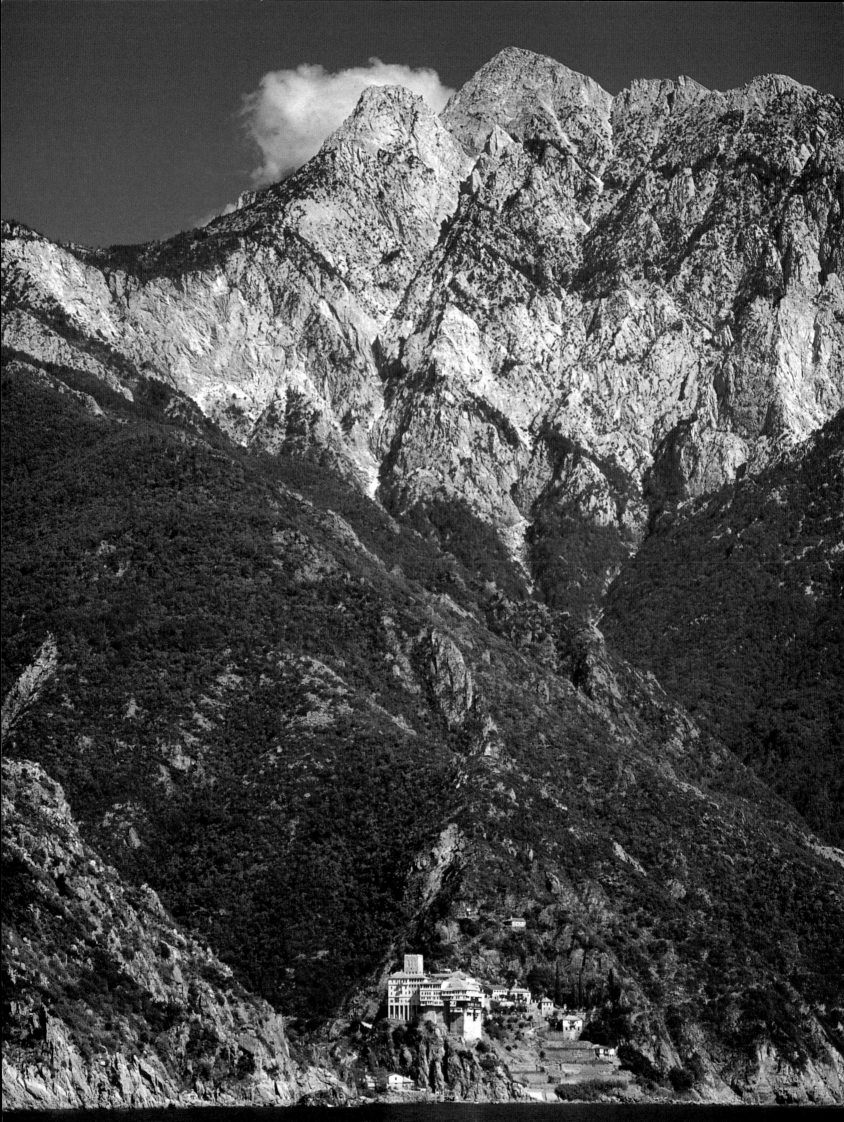

Perhaps, though, the most far-reaching concern on the mountain continues to be the thorny issue of the non-Greek monks. Although their rights are guaranteed by international treaty and the Greek constitution, during the 1967–74 military dictatorship strong anti-communist elements in the government, suspicious of the monks from the then Warsaw Pact countries, put pressure on them to leave. With the collapse of the eastern bloc and Greece's return to democracy the pressure has eased. But, asserts Father Maximos, the Greek Foreign Ministry's long-term policy 'is to abolish the self-government and autonomy of the Holy Mountain, and to transform it into a Greek prefecture.'

The government refutes such accusations, pointing to the fact that Athos' semi-autonomous status was further recognized when Greece became a member of the European Community in 1981. Under the terms of Greece's accession, the European Union accepts Athos' unique status on spiritual and religious grounds, notably on the right of settlement. Thus, while European Union citizens have the right to free movement, work and residence in all member states, Athos is an exception to the rule. For the present, the ancient traditions of Athos remain inviolate. Indeed, if they were not Athos would, almost overnight, lose its uniqueness.

Maximos may have overstated his case, but it does serve to underline Athos' ambiguous relationship with the Greek state. Misunderstandings between the Athos authorities and government agencies are mirrored by distrust between the monasteries themselves. While forward-looking monasteries, notably Stavronikita, Philotheou and Simonos Petras, run by well-educated abbots, often welcome outside help to restore their monasteries and conserve their libraries, more traditional communities staunchly resist change. For them, their spiritual calling overshadows the problems of conservation and decay; for them the inevitability of ageing lies in the hands of God. They have always controlled their monastic holdings and any seeming intrusion in their lives is clearly unwelcome.

As Athos revives, the materialistic ways of the outside world have, nevertheless, begun to make inroads there. When the Greek government nationalized Athonite land and holdings outside the peninsula after the Second World War, the monasteries were forced to exploit the Mountain's riches in order to survive. The forests were leased to a toilet paper company and, as a result, the peninsula was soon riddled with a network of dirt roads. The roads soon served the monks as well. In the mid-1980s a daily bus service was started between Karyes, the port at Daphni and Iviron Monastery on the east coast. And monks are now more likely to be seen driving four-wheel-drive vehicles than pack mules.

The opening of Athos to tourism, however, is strongly resisted by the monks and many grumble about the apparent infringement of the daily pilgrim quota. 'If the authorities in Karyes continue to liberalize entry we might have to do something radical', said one monk at Iviron. He did not specify what that might mean, but I had visions of monks marching in downtown Athens as their forebears once demonstrated in Constantinople against the policies of the iconoclasts.

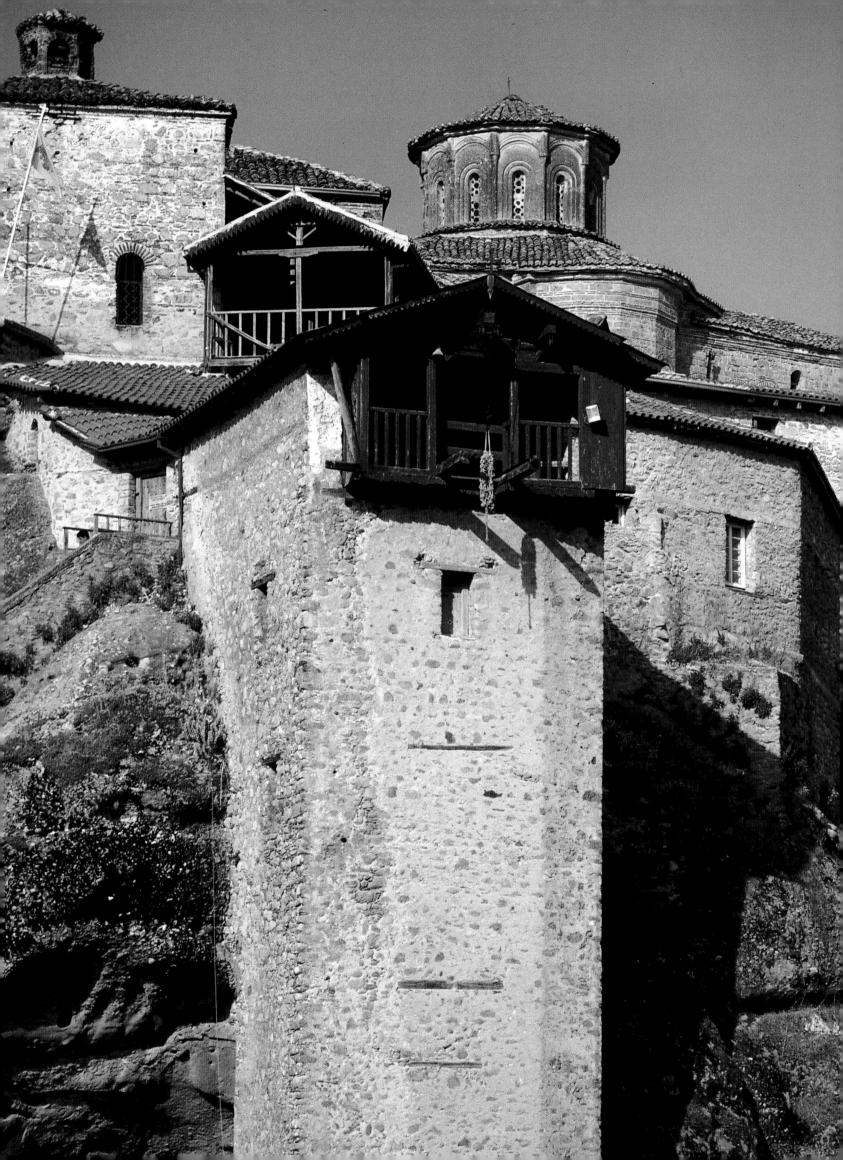

·6·
Monasteries in the Air

Looking up we could only see the end of the rope, by which we were to ascend, hanging from a block, with a great iron hook attached to it; but shortly after this was let down, accompanied by a strong and capacious net . . . I immediately seated myself in the middle of it, with my legs crossed under me à la Turque; but the monks called out that two should get in together . . . a shout from below, a pull from above, and we found ourselves swinging in mid-air . . . like a joint of meat suspended from a bottle-jack.

Revd Henry Fanshawe Tozer, Varlaam Monastery, 1853

Mount Athos was already well-established as the leading centre of Orthodox monasticism when bands of monks and hermits, some from Athos itself, began arriving in the extraordinary pinnacled landscape of Meteora in Thessaly, northern Greece. Here they founded a similar, though smaller, centre to that of the Holy Mountain, which grew from a loose collection of sketes and hermit cells to twenty-four substantial monasteries at its height in the sixteenth century. By virtue of their outlandish location, perched upon tall spires of rock, the monasteries are one of the strangest group of buildings to be found anywhere.

According to monastic tradition, the first ascetic at the Meteora was probably a hermit known as Barnabas who founded the small Skete of the Holy Ghost in the cliffs above Kastraki in 985. Others followed in his footsteps during the eleventh century, and by 1162 (according to some scholars, others say later) had founded the Theotokos of Doupiani, a dependency of the Stagi bishopric. Doupiani is one of the lesser rocks of the Meteora but, isolated at the western approaches of the Meteora, it was an appropriate location for the valley's first monks. Its almost vertical rock-face is riddled with caves and crevices like a mammoth Gruyère cheese: indeed its name, derived from Serbian or Bulgarian, means a cavity or hollow. And it was in these hollows that early anchorites created Meteora's first semi-organized community.

The monks called their community the 'Thebaid of Stagi', though it was not a monastery in the coenobitic sense of the word. In many ways it resembled the

OPPOSITE: *The winch tower of the Great Meteoron. Before the steps were cut into the rock face in the 1920s the only access was in a basket or net suspended on ropes from a winch or by rickety wooden ladders attached to the rock face.*

semi-eremitic communities that existed on Athos before the foundation of the Great Lavra. At Doupiani, the monks, living in caves and perched on narrow ledges, retained their independence, but scampered down the rock-face once a week to congregate for Mass on Sundays in a small church known as the Protaton. Their lives were supervised by a protos, rather than an abbot, who was ultimately answerable to the Bishopric of Stagi which, by the fourteenth century, received an annual tribute from the hermits, payable in wax. For the bishop, the monks were a manageable bunch of ascetics who helped draw attention to his small diocese. But before long, as the number of monks grew and monasteries replaced the sketes, the bishop found his importance diminishing as Meteora's abbots developed more useful contacts with the Archbishop of Larissa and the patriarch in Constantinople.

† The Blessed Father Athanasius

The Meteora's first notable father was Athanasius (not to be confused with the earlier Athanasius of Athos), who founded the Great Meteoron, the largest and highest of the valley's monasteries. Details of his life are contained in several documents in the archives of the monasteries themselves, principally a hagiography, the 'Life of our blessed father Athanasius who practised the ascetic life in Stagi on the rock called by him the Meteoron', written by an anonymous Meteora monk. Two versions of the story exist: the original, written in literary Greek soon after Athanasius' death, and a second, popular version, transcribed into colloquial Greek around 1700. Although they emphasize different points they agree on the essential aspects of the saint's life.

Athanasius was born to a noble and prosperous family in Neopatras in 1305 and baptized Andronicus. His parents died, so he was brought up and educated by his paternal uncle who later became a monk. As a young man Athanasius proved an enthusiastic scholar and studied Greek philosophy at Thessalonika, but soon, perhaps influenced by his uncle or by the vicinity of Mount Athos, he felt the calling of a monastic life. He was still too young, however, to be received as a novice, so he left Macedonia for Constantinople to pursue his religious studies there. In the Byzantine capital he met the men who were to change his life; among them was Isidore Boucheiras, later to succeed John Calecas as patriarch, and Gregory of Sinai, one of the leading proponents of hesychasm. Gregory had left his first monastery on Mount Sinai, had spent some time on Crete, and, when he met Athanasius, was passing through Constantinople on his way to instruct a group of anchorites on Mount Athos. Athanasius followed him, hoping that he could find an experienced monk to adopt him as an apprentice and handyman.

Mount Athos proved a more appealing retreat for Athanasius than for Gregory. Piratical raids made it an uncomfortable place in the fourteenth century and, although the eremitic life was enjoying something of a revival on the Mountain, Gregory's extremism made him unpopular with the monks. He thus sought refuge in Thessalonika before moving to Bulgaria in about 1325. Athanasius remained behind and moved to one of the remotest parts of the peninsula where two monks, Moses and another Gregory, had reputedly reached the limit of spiritual perfection. Although Athanasius was still too young to become a monk, Moses and Gregory agreed to act as his spiritual guides in return for domestic chores. He carried food and cut firewood and repaired their ramshackle huts. It was a tough life but Athanasius accepted it willingly as a necessary trial in reaching his ultimate goal as a

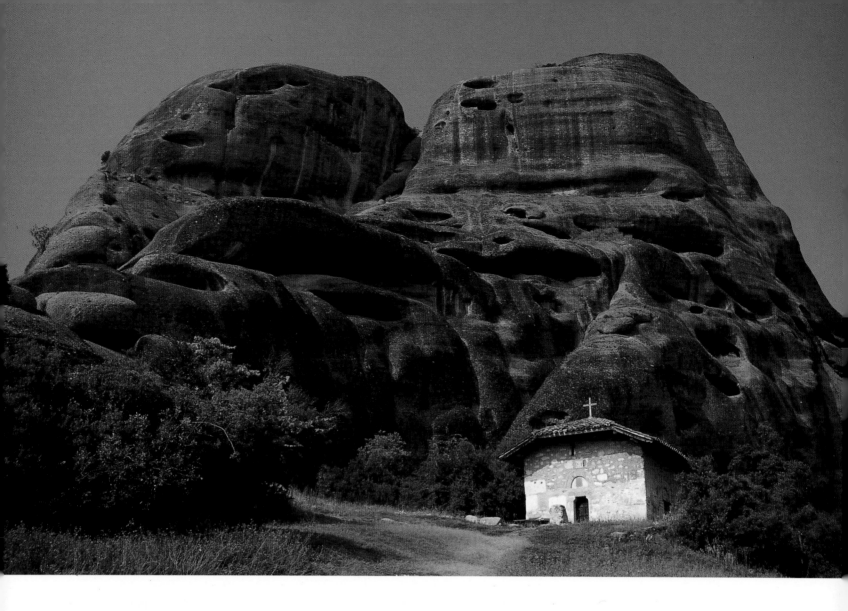

monk. Finally, at the age of thirty, he was accepted as a novice by Father Gregory, who shaved his crown and invested him with a black habit and his monk's name.

Even in their distant hideaway the three ascetics were still vulnerable to piratical raids. One day Moses was surprised and captured by a Muslim brigand who must have been equally surprised by Moses' miraculous powers. Apparently, he converted his captor to Christianity, but, just in case other pirates should prove less compliant, he sought refuge behind Iviron's substantial walls. Gregory and Athanasius, though unmolested, had had their peace disturbed and, discouraged by continuing raids, left Athos in search of a new spiritual home. After wandering around Macedonia, they heard of a remote hillside in Thessaly where enormous rocks had been thrown up on their ends at the beginnings of creation. It sounded a perfect place to continue their ascetic lifestyle and, shouldering their few belongings, they headed south to Thessaly. No one lived in these wild rocky wastes, and birds were the only creatures to reach the higher peaks and caves. Athanasius' biographer insists that his hero was the first to found a monastic community at Meteora, ignoring the fact that the skete known as the Thebaid of Stagi was already established among the rocks.

Athanasius and Gregory settled in a nearby cave in a rock they called Stylos or the Pillar. Their reputations, particularly that of Gregory, now known as the Stylite, spread far and wide and multitudes of lay and religious people made their way to his hallowed cave in search of spiritual enlightenment and his blessing. Before long, Athanasius, with the due approval of his teacher, sought a cave of his own to pursue his prayers in isolation; but his fame followed him to his new retreat and hopeful disciples continued to disturb his peace. He thus scaled a hitherto unclimbed

The 'Column of Doupiani' where Meteora's first anchorites lived in the hollows of the rock-face. In the foreground stands the Chapel of the Virgin, built on the site of the first church, the twelfth-century Protaton, where monks congregated for Mass on Sundays.

peak where he built a hesychasterion, or small wooden hut, where he could continue with his meditations undisturbed.

Perching on the rock pinnacle did much to enhance Athanasius' desired sense of calm, or hesychia. But towering above his retreat loomed the highest peak of all, the awe-inspiring Platylithos or Broad Rock, with its smooth grey flanks plunging almost vertically to the ground below. Surely a hesychast could approach even greater spiritual perfection at such a giddy height. Gregory gave Athanasius his consent for an assault on the pinnacle as long as he took a couple of other monks with him. Oral tradition sometimes claims that Athanasius reached the peak of Broad Rock on the back of an eagle. The monk's biographer is more prosaic. Athanasius and his climbing companions began their ascent at a point where the peak is about sixty metres from the ground. Slowly they inched their way upwards, attaching rope ladders to the rock face as they went, until they reached a cave near the summit: this became the site of their first settlement. Nearby, in a crevice above the cave, Athanasius also decided to construct a small chapel, dedicated to Theotokos Meteoritissa, where his relics now lie, so that he would not have to leave the Broad Rock each week to hear Mass. But Athanasius had no priest. He himself was, and remained, a layman. So he ordered one of his monks to visit the nearest bishop for a pressing ordination.

While Athanasius was building the Theotokos chapel, the rigours of an ascetic life began to tell on an already frail Gregory. Around 1350 he left the mountain, accompanied by his disciple, for refuge in Thessalonika. After bidding his spiritual father farewell, the younger monk returned over the mountains to Meteora,

The kitchen of the Great Meteoron Monastery, unchanged for centuries.

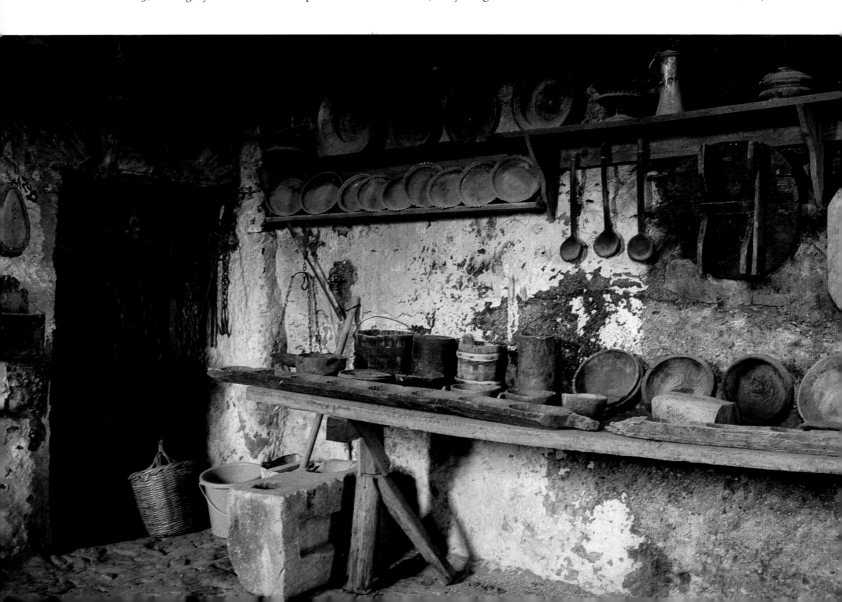

while Gregory continued his journey to Constantinople where he ended his days. When Athanasius arrived back in Meteora he found the elder who had replaced Gregory on the Stylos had also died. So scornful was the late monk of his earthly body that he had asked for it to be left on a ledge to be devoured by the vultures. This unchristian funeral disturbed Athanasius and, after a scavenger flew by with a thumb in its beak, he took the elder's remains and buried them himself.

Athanasius never intended to found a monastery at Meteora, preferring the more solitary life offered by a loose group of anchorites or a skete. But after the deaths of Gregory and his successor, Athanasius returned to the Broad Rock where he continued to draw the attentions of other monks. Eventually he allowed fourteen of them to join him in his other-worldly pursuits. More monks meant more building and the summit of Broad Rock soon boasted cells and cloisters, a kitchen and a new church dedicated to the Metamorphosis or Transfiguration. Though small, it was a more substantial building than the rudimentary chapel just below the summit and Athanasius needed funds from elsewhere. Even pious monks cannot conjure churches out of thin air. He turned to the Serbs who, under king Stephen Dushan, controlled most of Thessaly by 1345. Who exactly supported the project is unclear, though it was probably Dushan's general, Presloumbos, who had recently been appointed viceroy of Trikkala.

The monks' retreat subsequently became known as the Monastery of the Great Meteoron. It had its own typicon, a straightforward but strict set of rules which regulated the lives of all who chose to live there. Its members were limited to the original fourteen and everything – food, drink and clothing – was shared equally. The valley at the base of the Broad Rock was reasonably fertile and here the monks cultivated grapes and corn and potatoes. At harvest time the crops were hoisted up the rock-face in large nets or baskets. But nothing else was allowed into the monastery from the outside world; no secular books and certainly no women whom Athanasius referred to as the 'affliction' or 'the sling' which hurled sin into men's souls. To his followers Athanasius' virtue lay in his total renunciation of the world. None of the hesychasts whom he had known on Athos, claims his biographer, had reached such great spiritual heights. He had founded the first aerial monastery and there he died on 20 April 1383, aged seventy-eight, after an illness lasting forty days.

✝ The Monk King

Athanasius' successor as Father of the Meteoron was a Serbian emperor, John Ourosh Ducas Palaiologus, who renounced the world to join the community of the Broad Rock. Better known as Father Joasaph, he had accepted monastic vows long before his accession to the throne in 1381. Empire building was not for him and while living as a monk he delegated the running of his Thessalian kingdom to Caesar Alexis Angelos. Although he rejected worldly ways, the emperor's wealth gave the Monastery of the Meteoron a secure financial base. Indeed, it is as much to Joasaph as Athanasius that the monastery owes its pre-eminence.

Another monk, Agathon, had at first been designated to succeed Athanasius as Father of the Meteoron but when he died Athanasius, with the unanimous support of the monks, offered his authority to Joasaph. The emperor-monk was a popular choice, but he only remained at Meteora with Athanasius for a short while before leaving the towering spires for Thessalonika. Meanwhile Athanasius passed away and the monks of the Broad Rock were left leaderless for almost two years. After

OVERLEAF: The Great Meteoron, or Monastery of the Transfiguration, founded in 1356 (to the left) and Varlaam Monastery, built on the site of a fourteenth-century hermitage established by the monk Barlaam.

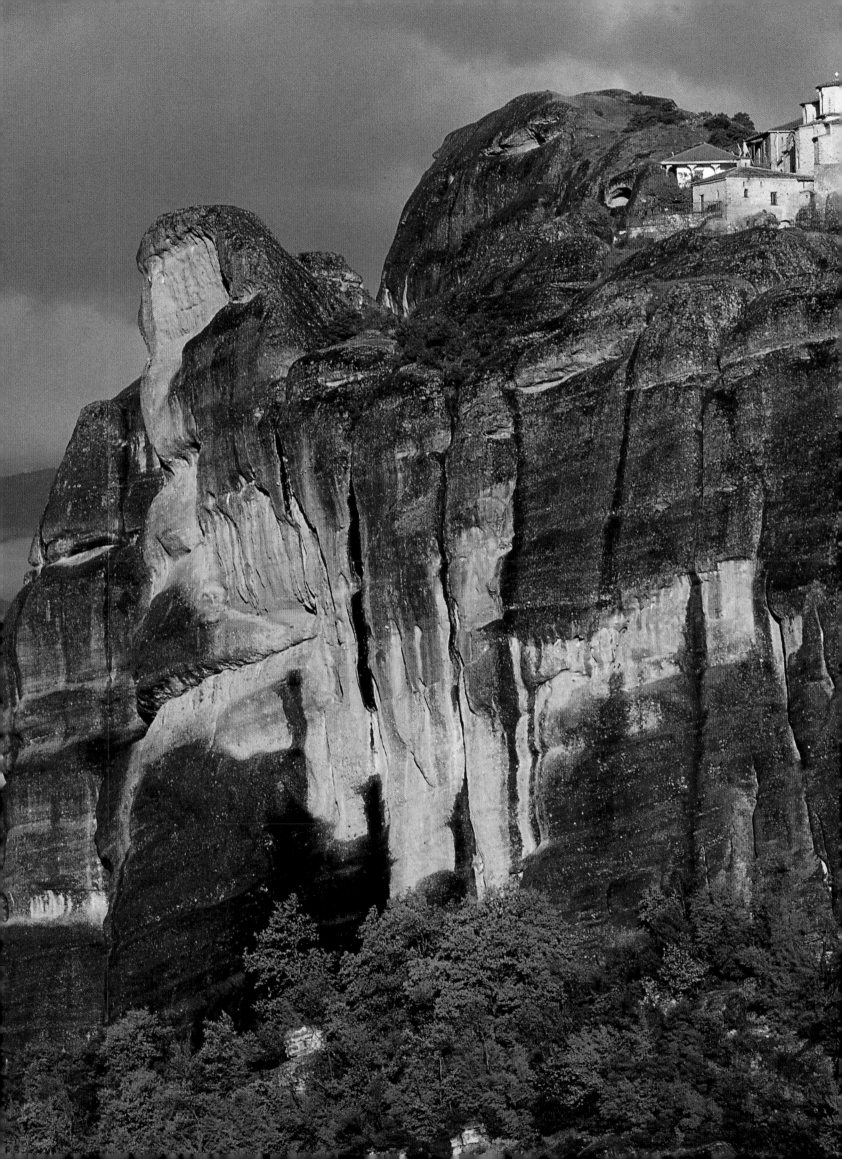

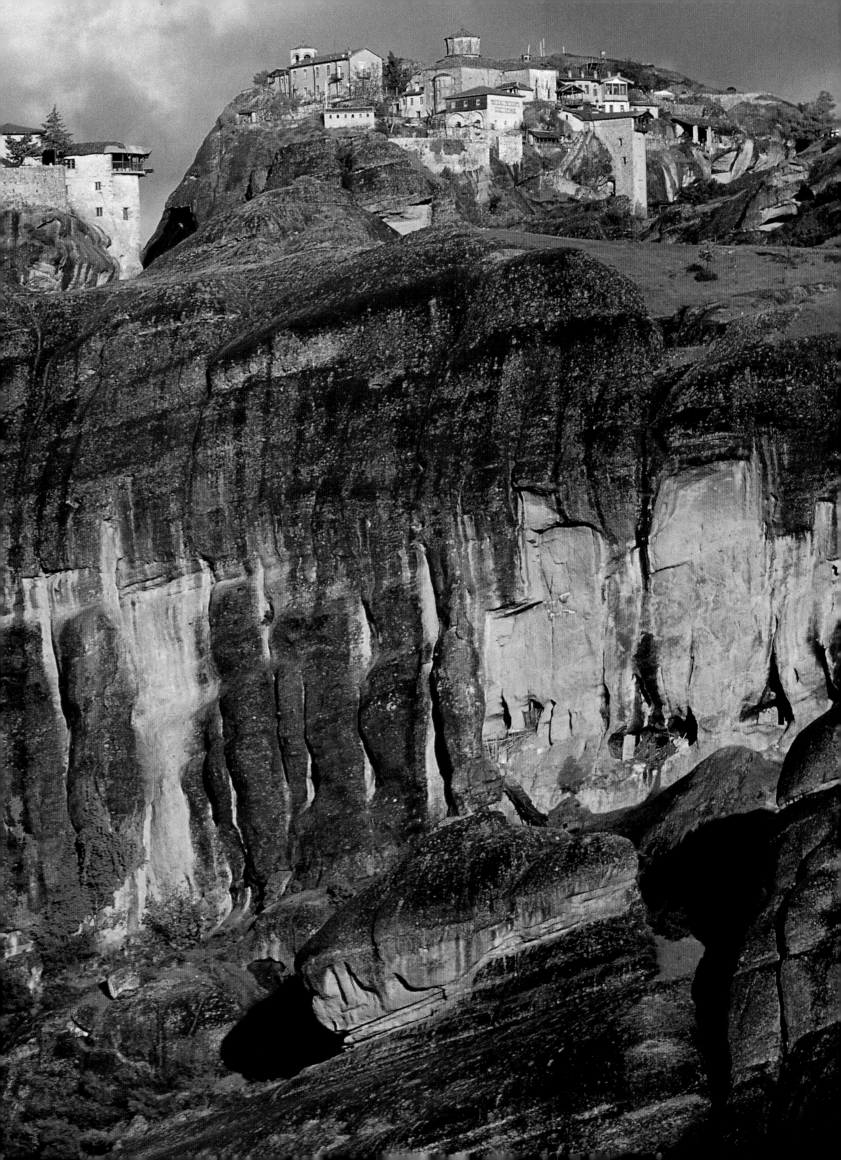

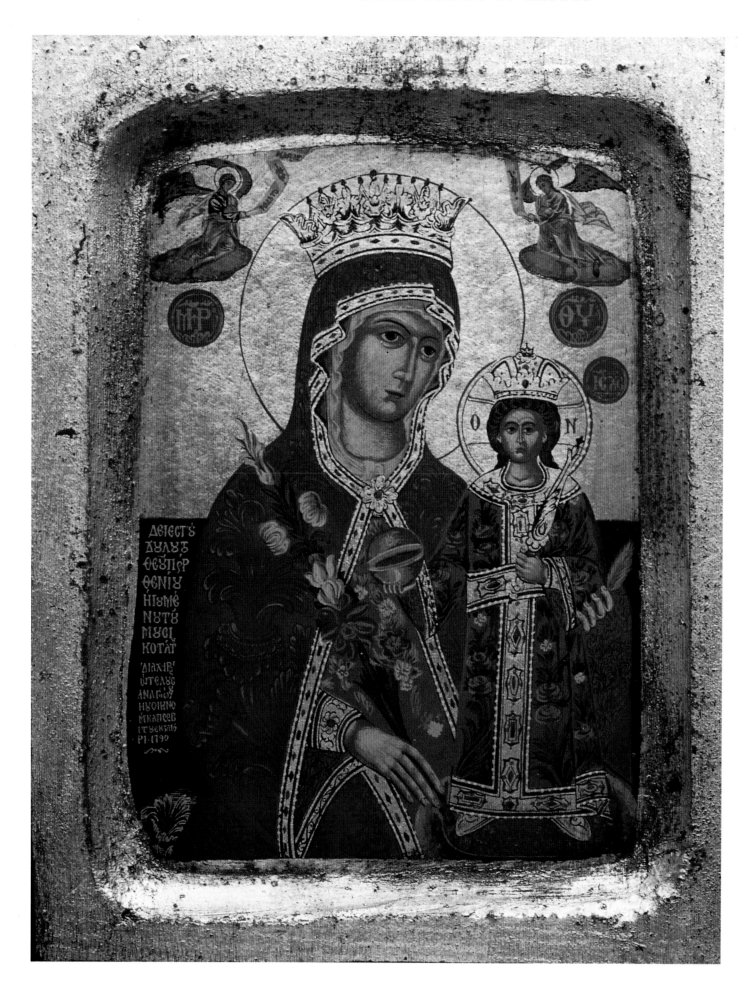

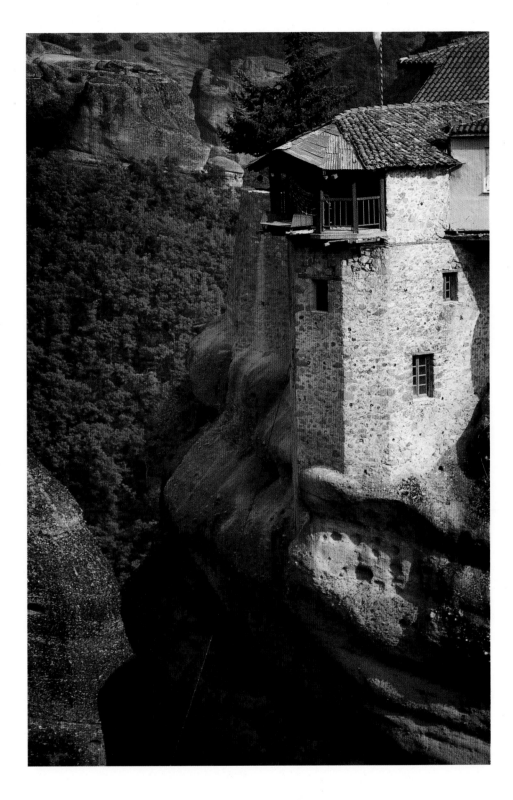

άνοιξης. Το εξήγησαν δε σαν σημάδι ότι ο Ιωάσαφ επρόκειτο να επιστρέψει.

Πραγματικά το 1384, ο Ιωάσαφ γύρισε πίσω στον Πλατύλιθο και η μοναστική κοινότη αμέσως άρχισε να αναπτύσσεται και να ευημερεί πάλι. Η αδελφή του Ιωάσαφ, η Μαρία Αγγ λίνα, πρόσφερε θησαυρούς στην εκκλησία, περιλαμβανομένου ενός ωραίου σταυρού που αν κε σε ένα πρώην Δεσπότη της Ηπείρου. Ο ίδιος ο Ιωάσαφ κατέβαλε τα κεφάλαια για την αν κοδόμηση και τη διεύρυνση της εκκλησίας των Μετεώρων· το ανατολικό άκρο του καθολικι η αψίδα και το ιερό χρονολογούνται σ' αυτή την περίοδο. Και ο βασιλιάς-μοναχός ανέλαβε διοίκηση των πιο επίγειων υποθέσεων της κοινότητας. Ήλθε επίσης σε διαπραγματεύσεις

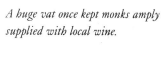

A huge vat once kept monks amply supplied with local wine.

church of the Meteoron; the eastern end of the catholicon, the apse and the sanctuary date from this period. And the emperor-monk took a lead in the more earthly affairs of the community, negotiating with the bishop over the ownership of property and renting buildings from other communities nearby.

Joasaph's work at the Meteora was temporarily halted, however, after the Turks invaded Thessaly in 1386. Fearing the worst, he fled with three other monks to Mount Athos where he toyed with the idea of moving into a kellion near Vatopedi Monastery. But his heart was in Thessaly and since the Turks had shown little interest in the stylites of Stagi he soon returned there as Father of the Meteoron. Before long Joasaph's monastery became known as the Great Meteoron, the leading monastery of the Meteora, and it was further enriched with landed estates, flocks of sheep, cattle and dependencies of its own. The Meteoron's growing status and the reputation of its charismatic leader soon attracted attention elsewhere.

In 1401 the Archbishop of Larissa climbed or was hauled up to the top of the Broad Rock where he praised Joasaph's 'men of sanctity, their faces turned to God, accomplished in deed and word and wisdom'. Joasaph even managed to earn the patronage of the Patriarch of Constantinople, who seemed equally impressed by the idea of an emperor as abbot. Patriarch Euthymius, who held the patriarchal post

from 1410 to 1416, granted the Great Meteoron a charter of freedom, making it independent of the local bishops, and in so doing recognized its importance as a protector of the soul of Byzantium.

According to tradition, Joasaph died on the same day and in the same month as Athanasius sometime after 1422, and the feast of the founders is still celebrated on 20 April each year. The historical record is mute on this point. But whether true or not the coincidence helps to reinforce the importance of their joint achievements in the eyes of the faithful. Joasaph's standing is further enshrined in three frescoes on the walls of the monastery church. In the earliest painting, executed on the centenary of Athanasius' death in 1483, Joasaph is shown praying. He also holds a scroll with the message 'Strive to love all men so far as you are able; if you are not yet able then at least bear hatred to no man.' Another depicts him as the Meteoron's founder, holding a model of the church in his right hand. The third, on the wall of the sanctuary, probably painted when the church was extended in 1555, shows Joasaph and Athanasius as joint founders. Between them they hold another model of the church and around them, as if to emphasize the radical changes brought to the Meteora peaks, stylite saints perch atop Corinthian columns.

† Decadence and Disorder

After Joasaph's death the Meteora seems to have been plunged into a period of disorder and decay. No worthy successors rose to fill the vacuum left by Joasaph's passing and the monks' lives were soon upset due largely to their own intrigues and infighting. The story is told in the 'Historical Discourse' in terms which waver between farce and tragicomedy. Some years after Joasaph's death the monastery was controlled by a fraudulent monk named Galaktaion, the first of many to appropriate the title of abbot by bribing the Turkish authorities to recognize him as the monastery's new leader. But Galaktaion did not last long. The Archbishops of Thessalonika and Larissa excommunicated him and sent him into exile near Arta. There his corpse suffered the same fate as those of heretics and apostates. For years it lay unburied, its black, shrivelled skin stretched across his skeleton like a drum, as a fearsome reminder of the destiny that was sure to befall other corrupt and fraudulent souls.

Other Meteora communities also fell into evil hands during the course of the fifteenth century. Michael Mouchtouris, a half-Turkish landowner with two children, seized the kellion of the Presentation and pocketed its small income for the best part of forty years, though he was careful to remain on good terms with the Great Meteoron with donations of new kitchenware. Vlach squatters took over the abandoned monasteries of Holy Trinity and Kallistratos. And the Monastery of the Pantocrator was briefly inhabited by a squint-eyed and crooked monk called Theodore, who lived there with two women who dressed themselves as monks.

According to the 'Historical Discourse' the valley of the rocks degenerated to the point where acts of inter-monastic violence were commonplace. When the monks of the Pantocrator began to construct a new watermill they were set upon by a group of angry Meteorites, wielding sticks and knives, who claimed that the land on which the mill was being built belonged to them. It was hardly Christian behaviour, but the Meteoron eventually won the day. The Pantocrator monks, hauled before the courts and accused of trespassing, were subsequently deprived of their land, vineyards, and water-supply. Only the strange *ménage à trois*, squint-eyed Theodore and his cross-dressing female friends, were left.

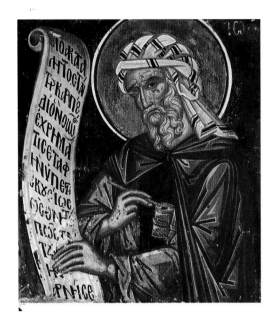 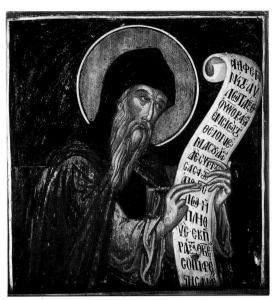

All Saints' Church, incorporating the original fouteenth-century chapel dedicated to the Three Hierarchs, was completed in 1544. It contains two remarkable series of frescoes. In the narthex the walls are covered with various ascetics and were painted in 1566. The slightly earlier paintings in the naos, dated 1548, are the work of Frango Catellano of Thebes and show clear western influences in their colours and realistic poses.

(ON THIS PAGE, RIGHT) *St. John Damascene, one of the greatest poets of the Eastern church, the last of the Greek fathers and the first in a long line of Christian Aristotelians.* (FAR RIGHT) *St. Cosmas (shown here) and Damian, Arabian-born twins, were widely venerated in the East for practising medicine unpaid.*

OPPOSITE PAGE: *St. John the Baptist, whose life is portrayed in the narthex of All Saints' Church.*

The monks of the Meteoron were involved in other, equally violent and unneighbourly acts. In the early sixteenth century two brothers, Nektarios and Theophanes, founded the new Monastery of Varlaam on a tall rock not far from and slightly below the Great Meteoron. On a hillside nearby they established a vegetable and flower garden which they lovingly cultivated and tended. For three years the narrow-minded monks of the Meteoron looked down on their neighbours with increasing pangs of jealousy. Then, one Holy Week, they began to plot the destruction of the Varlaam garden. On Easter Monday, the day after the Resurrection, they finally descended the Meteoron in their nets or by their rickety ladders, armed to the teeth with forty axes. Following their abbot they charged into their neighbours' garden 'and hacked it remorselessly to pieces'.

The version of events recounted in the 'Historical Discourse' may well be exaggerated, but the greed and pride of the largest monastery undoubtedly contributed to a general air of decadence among the rocks. In the half-century before the compilation of the Discourse, the Great Meteoron held a progressively dictatorial sway over its neighbours. It was a cavalier attitude which, combined with mediocre if not incompetent leaders, coloured community attitudes. But during the sixteenth century, under two new fathers, Anthimos and Bessarion, things at last began to look up.

✝ Bessarion and After

The monks Bessarion and, to a lesser extent, Anthimos were largely responsible for the rebirth of monasticism in the Meteora. Little is known about Anthimos except that he was instrumental in restoring some of the abandoned monasteries, notably Holy Trinity which had been squatted by Vlach shepherds. His efforts were, predictably, resisted by the monks of the Great Meteoron, who dismissed him as a meddler and succeeded in having many of his supporters excommunicated. Anthimos, nevertheless, had started the ball rolling. The climate of opinion was beginning to change for the better, the Meteoron monks were softening in their attitudes, and the reforms of Anthimos' successors, notably Bessarion, would prove more durable.

Between 1520 and 1540, Bessarion presided over one of the most active

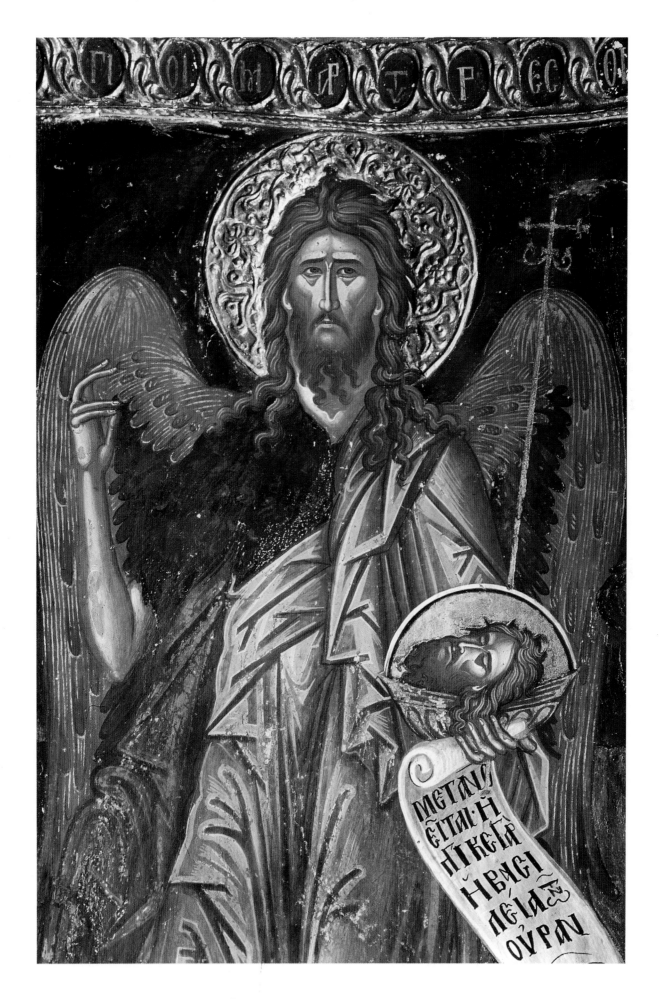

periods in the history of the Meteora. Early on a commission of inquiry confirmed the community's coenobitic status with the Great Meteoron or Monastery of the Metamorphosis having pride of place among them. Monasticism at Meteora became increasingly organized and communications, broken during the days of anarchy were re-established with the patriarchs of Constantinople. As at Mount Athos, the coenobitic system was universally accepted with a number of ruling monasteries to which all monks, even the hermits, officially belonged. New monasteries at Varlaam and Roussanou were founded during Bessarion's regime and further growth continued under his successor, his nephew Neophytos, who was Archbishop of Larissa from 1541 to 1565.

The Meteora renaissance was not, however, solely dependent on energetic and able leaders. External political factors were also crucial to the monastic revival. During the liberal reign of the Ottoman sultan Suleiman the Magnificent, earlier bans on the building and restoration of Christian churches were relaxed. The monks quickly took advantage of the reprieve and in 1544 began a ten-year programme to enlarge the Church of the Metamorphosis, which was consciously modelled on the monastery churches at Mount Athos. The frescoes, too, follow a common pattern with a symbolic arrangement of painted panels descending from the bearded Pantocrator, surrounded by angels, apostles and prophets, on the dome. As was usual, the Virgin Mary is portrayed in the circular recess of the apse, while below her church fathers assist in the liturgy. Some of the first scenes to greet the churchgoer, however, are the rather grisly paintings in the narthex representing the Last Judgement, with disturbing scenes of torment, torture and the deaths of the martyrs.

When the main church and its frescoes had been finished work began on a new refectory, now the museum, which was completed under Abbot Symeon in 1557. Here, because of the nature of the site, the monks were forced to abandon Athonite convention. On the Holy Mountain, monastery refectories are usually situated to the west of the church narthex. But on the Meteoron rock there was no space to conform to tradition, so the monks placed their refectory to the north, separated from the church by a small courtyard. For the monks' humble fare it is a rather grand pillared hall, twenty metres long, more appropriate perhaps for a medieval manor house than a monastic retreat. The abbot sat at the eastern end and presided over mealtimes while a monk read passages from the Gospels, the Life of Saint Athanasius, or other religious texts, as they still do in the Athonite monasteries today.

Near the refectory stands the kitchen, which remains as it was centuries ago with its stone flags, rickety shelves and copper cauldrons, an open hearth and encrusted layers of dirt and grime. Water was supplied from four huge cisterns which are cut deep into the rock. The reservoirs filled up during the winter and provided the monks with ample supplies except in the driest of summers. But even if they did run dry the Meteoron always had fully stocked cellars where wine, produced from their own grapes, was stored in giant wooden barrels.

The Meteoron buildings were largely complete by the end of the sixteenth century, but minor changes and additions continued to be made. A residence for the abbot was built to the west of the church and a small chapel, dedicated to Saint John the Forerunner, was added to the south of the catholicon. In 1789 another chapel, dedicated to Saints Constantine and Helena, was built in the Byzantine style nearby. But overall life on the Broad Rock stagnated and, although later patriarchs of Constantinople reconfirmed the Meteoron's privileged status, one nineteenth-century patriarch, Constantine II, felt obliged to remind the abbot that his name should be commemorated in the liturgy.

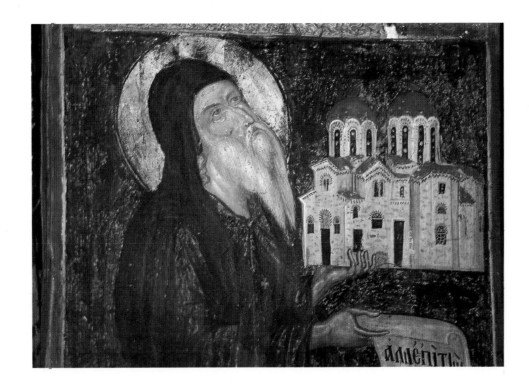

The monk Barlaam, founder of a hermitage on the site of Varlaam Monastery, presents a church to God in this sixteenth-century fresco painted by the Cretan artist Frango Catellano.

Varlaam Monastery was founded in 1518 by two wealthy brothers, Nectarios and Theopanis Aparas of Ioannina, on the site of a fourteenth-century hermitage.

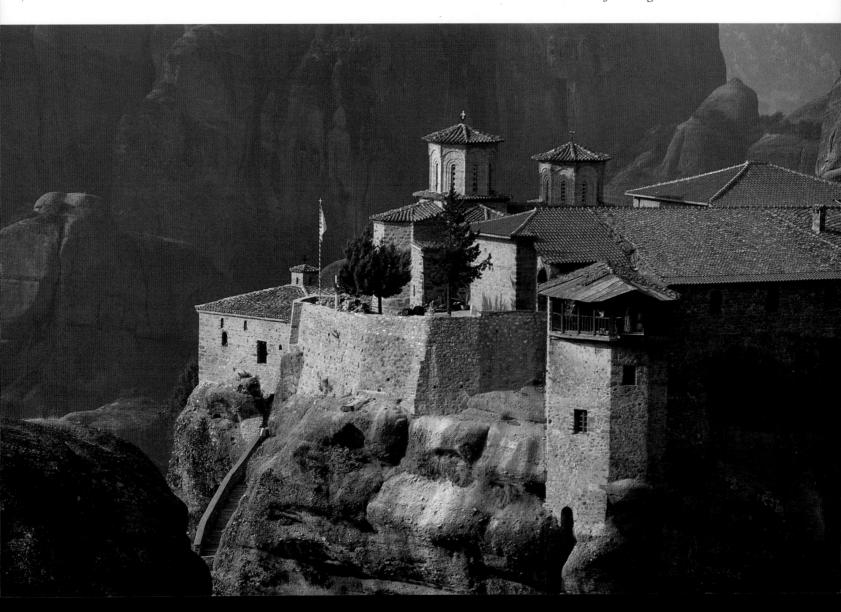

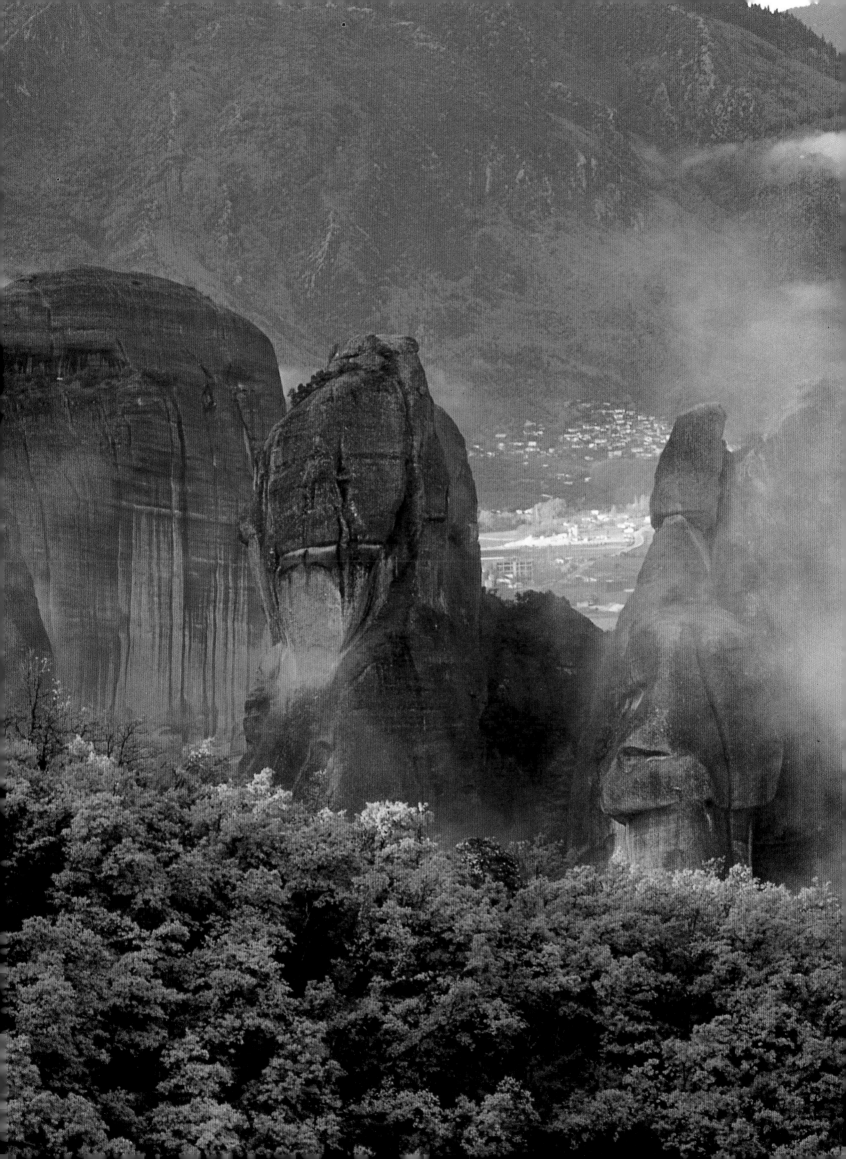

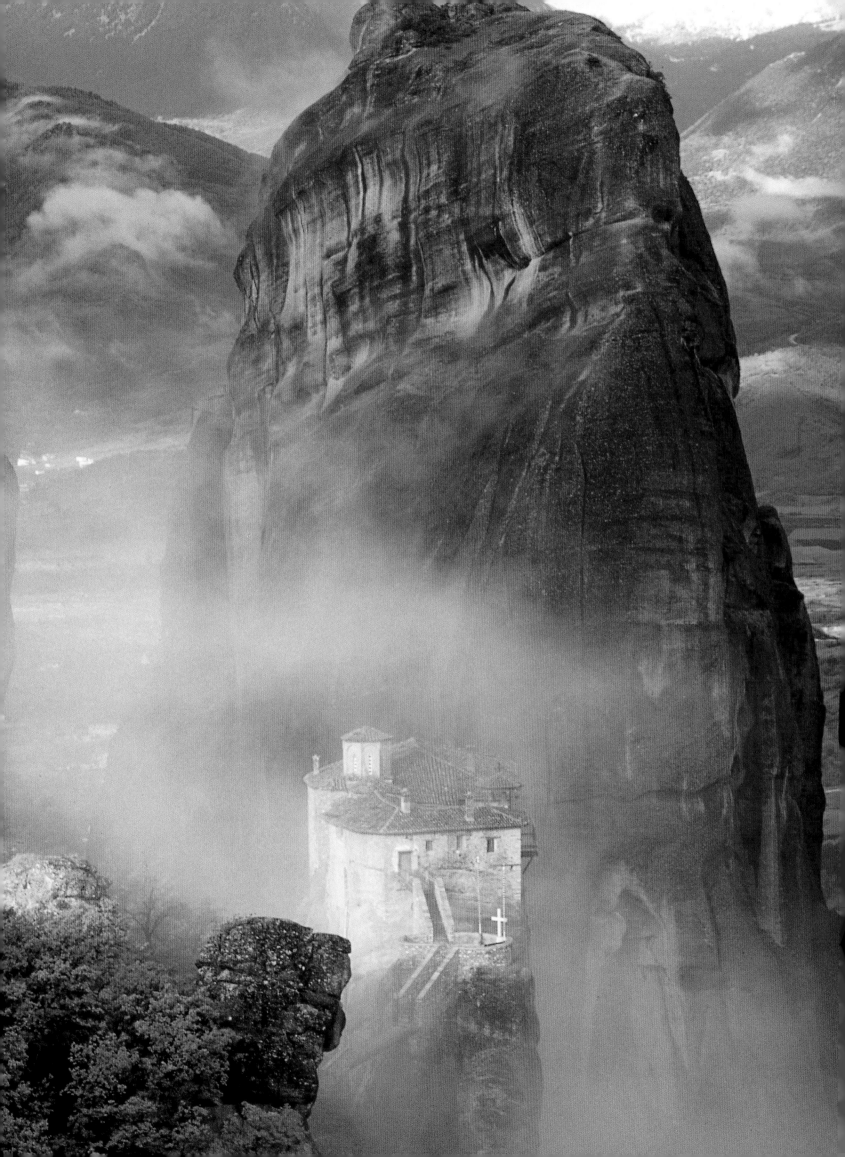

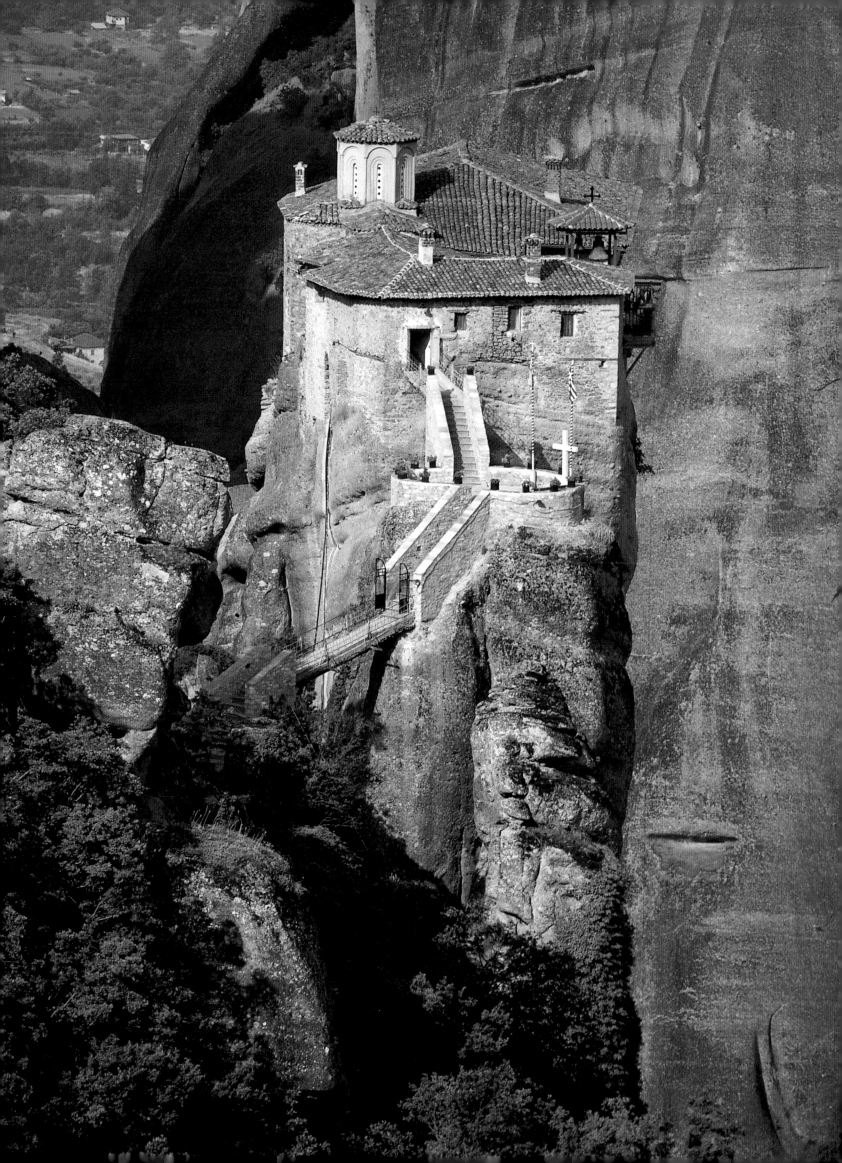

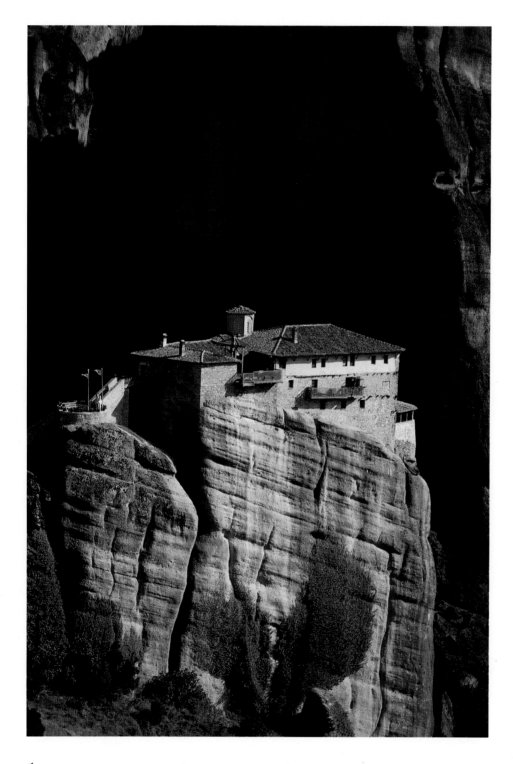

PAGES 188–191: *Perched atop a narrow pinnacle of rock in the astonishing landscape at Meteora, Thessaly, the small Roussanou Monastery, was rebuilt in the sixteenth century by the monks Joasaph and Maximus on the site of an earlier foundation.*

† Foreign Aid

Of the other extant monasteries at Meteora only one, the Monastery of Saint Stephen, dates back as far as the fourteenth century. There were others: the Monastery of Hypselotera built in 1390 and the Hypapanti founded in 1367, but of these little remains. Like the Great Meteoron, Saint Stephen's has impeccable regal connections. Its founder was Antonios Cantacuzene, a relative of the monk-king Joasaph and grandson of the Emperor John VI who had championed the hesychast cause. Like the Meteoron, it was granted the privileged status of a stavropegion, a monastery answerable to the patriarch alone, by Patriarch Jeremias I in 1545. And its independence was reaffirmed sixty years later by another patriarch, Raphael, who recognized that it had always been outside the jurisdiction of the Meteora's first skete.

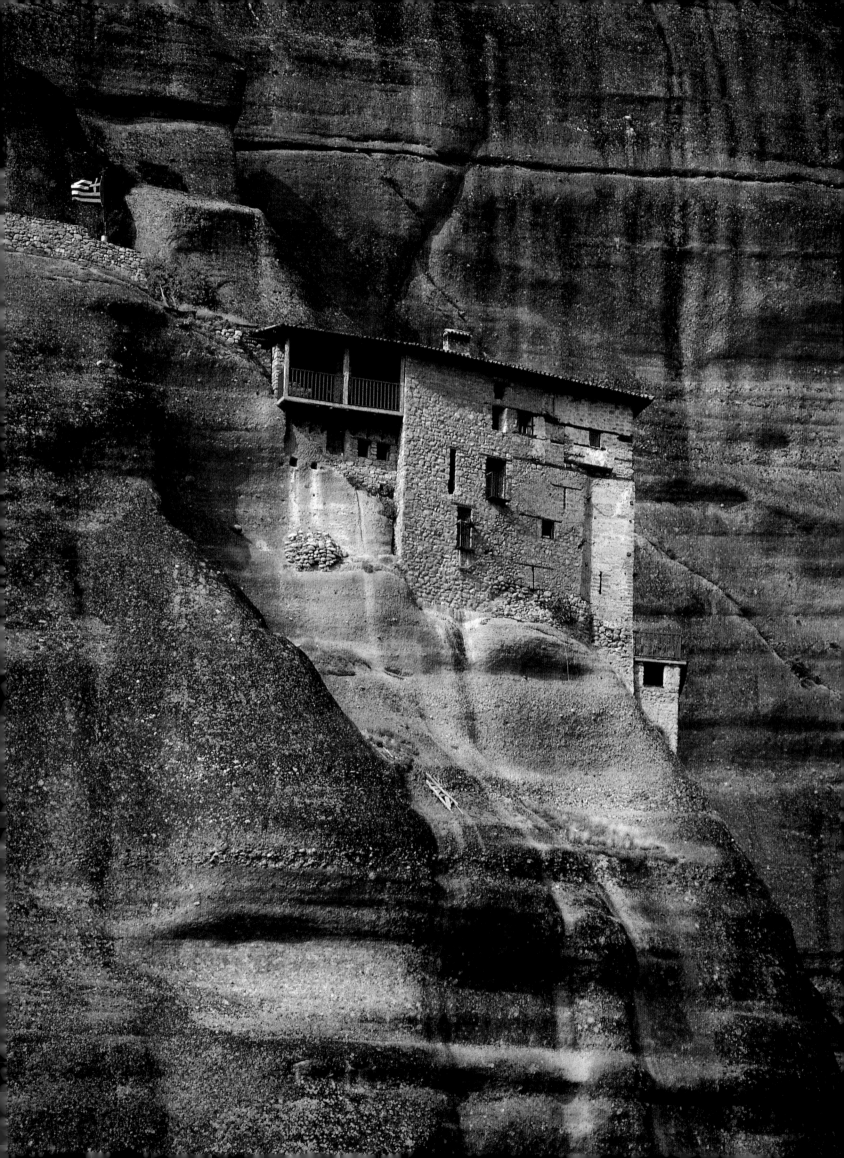

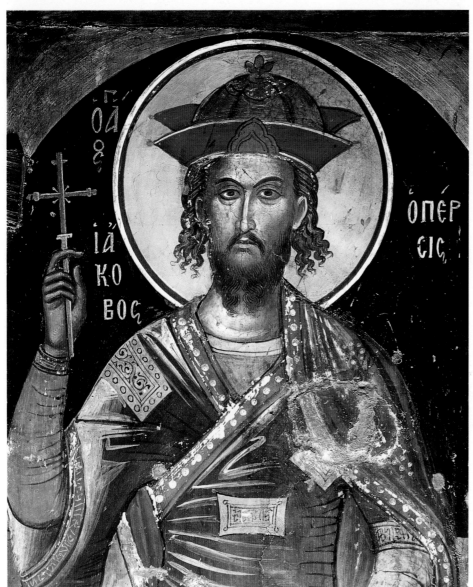

Adam names the animals in a 1527 mural in the catholicon of St. Nicholas' Monastery. The scene was painted by Theopahanes the Cretan, the chief representative of the Cretan school, whose work is found in Macedonia and Thrace as well as on Mount Athos and at Meteora.

OPPOSITE: St. Nicholas' Monastery probably dates back to the fourteenth century, although the present church was not begun until 1510. The constricted site has limited its growth and led to an unusual two-storey layout with the monk's cells placed above the church.

This painting from St. Nicholas depicts St. James the Persian, a fourth-century ascetic and member of a monastic community.

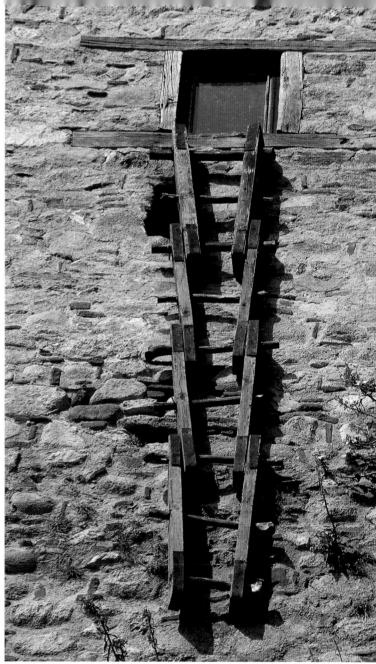

To the monks and the laity, however, Saint Stephen's renown was based on
its most hallowed possession: the head of the martyr Saint Charalambos, enclosed in
a silver reliquary, after whom the catholicon is named. This holy relic earned great
prestige for the monastery as it was believed that Charalambos had the power to cure
or ward off plague which frequently ravaged the people of the Thessaly plains.

Saint Stephen's Monastery prospered during the sixteenth century, a period
of relative stability under the still young Ottoman Empire. Imperial patronage may
have disappeared with the fall of Constantinople but the monastery successfully
acquired and exploited distant estates in Greece and elsewhere. With other Meteora
monasteries, Saint Stephen's also enjoyed the patronage of new benefactors beyond
the Danube in Wallachia and Moldavia. From here the Romanian voivodes, or
princes, self-appointed defenders of Orthodoxy, showered gifts and money on
Meteora, Athos and other worthy monasteries. The Monastery of Saint Stephen
claimed to have been among the first to benefit from their generosity at Meteora and,
according to one story, it was a Romanian voivode, John Vladislav, who gave the
monastery Saint Charalambos' head and other miraculous relics. Romanian patron-
age weakened during the seventeenth and eighteenth centuries although a depen-
dency beyond the Danube continued to provide some revenue and probably
contributed to the construction of a new church in 1798.

Wallachian and Moldavian charity also found its way to the Great Meteoron. One of the ablest of the Wallachian voivodes, Neagoe Bassarab (1512–21), paid for the delivery tower and for crucial repairs to the ladders clinging to the rock-face. Another prince and philhellene, Radu Mihnea, granted the Meteoron Wallachian estates including the dependent Monastery of Golgotha, near Tirgoviste. This beneficial arrangement was reconfirmed in the mid-eighteenth century by Gregory II and Matthew Ghika, and a hundred years later the Golgotha estate was still providing a considerable part of the Meteora's annual income.

By the seventeenth century, however, the Romanian princes appear to have been suffering from compassion fatigue or at least had reduced their formerly generous donations. Daily life had become such a struggle at the Meteora that the abbots of the twelve ruling monasteries then existing made a collective appeal to John Basil Lupu, Voivode of Moldavia from 1634 to 1654. The appeal flattered Lupu as 'the most powerful defender of our Orthodox faith' and listed a whole series of problems then confronting the Meteora: how the monks were beaten and imprisoned by their Turkish oppressors, and how difficult it was becoming to maintain the faith. The abbots invited the prince to become the Meteora's second founder and the saviour of Orthodox monasticism in Turkish Thessaly. Basil Lupu may have responded to their plea for help by donating enough money to cover daily overheads and expenses, but there is little physical evidence of major contributions as before.

Local revenues were also declining and the monks found it increasingly difficult to raise enough money to pay their taxes to the Turks. A revival of Greek national sentiment and its concomitant, the tightening of the Turkish yoke, made things even worse. A rebellion in 1611 led by a former Bishop of Trikkala, Dionysios, was quickly suppressed by the Turks, who responded by evicting all the Christians

Jonah and an unusual looking whale in the sanctuary at St. Nicholas' Monastery.

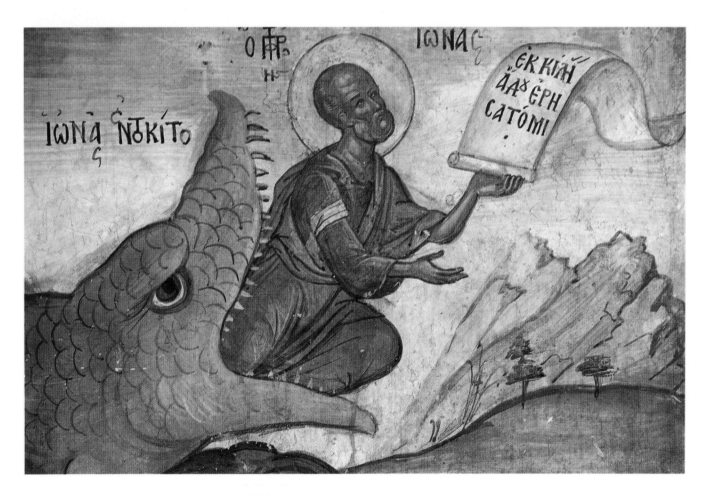

living within the walls of Ioannina and by plundering and destroying a number of monasteries. A dependency of the Great Meteoron, the Monastery of the Virgin at Lykousada, founded in the thirteenth century, was almost reduced to ruins. At Meteora, the monks were usually able to control access to their rocky spires by refusing to haul up the net. But they were known to be taken in by confidence tricksters. In 1616, soldiers in the pay of Arslan Bey, the Pasha of Ioannina, entered the Meteoron by posing as innocent and pious visitors. Once inside the monastery they ran amok and murdered four of the monks.

Even without the pillaging and tax burdens, the Meteora was becoming increasingly short of funds. Some money could be made by selling off books and manuscripts though the monks would never part with their holy relics. It was about this time that monks began selling sections of their libraries to passing strangers. The chief buyer of the period, who did much to despoil the Meteora libraries, was a Greek Cypriot priest, another Athanasius, who converted to Roman Catholicism and moved to Paris in 1639. There he caught the attention of leading church dignitaries, Cardinal Mazarin and Chancellor Séguier, who employed him to tour the Greek monasteries collecting manuscripts for Parisian libraries. At the Meteora, Athanasius posed as a Greek priest and thus gained the confidence of the unworldly monks. He then offered to buy the books at their equivalent weight in small change, an offer that, in the dire circumstances of the time, proved irresistible. In ten years, between 1643 and 1653, Athanasius sent more than 200 manuscripts back to Paris; and when he left Greece he brought another hundred with him, some of which he sold in Rome and Venice. Unfortunately, much of his haul has now disappeared without trace or record.

Selling off books and manuscripts, however, could do little to keep the wolf from the door and political changes in Wallachia and Moldavia in the early eighteenth century meant the monks could no longer look north for financial support. In desperation the abbots sent out their monks with the begging bowl. In 1776, for instance, the Abbot of the Meteoron, Damaskenos, ordered one of his monks to do the rounds with several of the monasteries' most venerated relics, including a hand of Saint Parakevi and the head of Saint Panteleimon.

While the monks sought alms the local political climate continued to deteriorate. In 1788, Ali Pasha became governor of Ioannina and so began a long and feared reign by a ruler who governed much of northern Greece as a semi-independent province of the waning Ottoman Empire. The Thessaly Christians complained that they were subjected to even greater persecution under Ali, particularly by the Turks of Larissa, and the Meteora monasteries took on a new role as refugee centres. At one point it was claimed that 500 women and children had sought safety with the monks.

The monks were also suspected of complicity with rebel forces. Some monasteries, notably Haghia Moni and Saint Demetrius, were used as hideouts by klepts resisting Ali's authority, though few of the monks were actively involved in plotting against the pasha. Ali's son, Veli Pasha, took the opportunity to impose even heavier taxes on monastic lands and to supplement the pasha's already considerable fortune as and when he pleased. Extortion and ransom demands became a fact of life. In 1810 an English traveller, Colonel Leake, visited the Meteora and found the Abbot of the Meteoron, two of his monks, and one or two monks from the other monasteries languishing in Ioannina prison for having unwillingly fed a band of rebels. The Turks were waiting for a ransom from their monasteries before ordering their release.

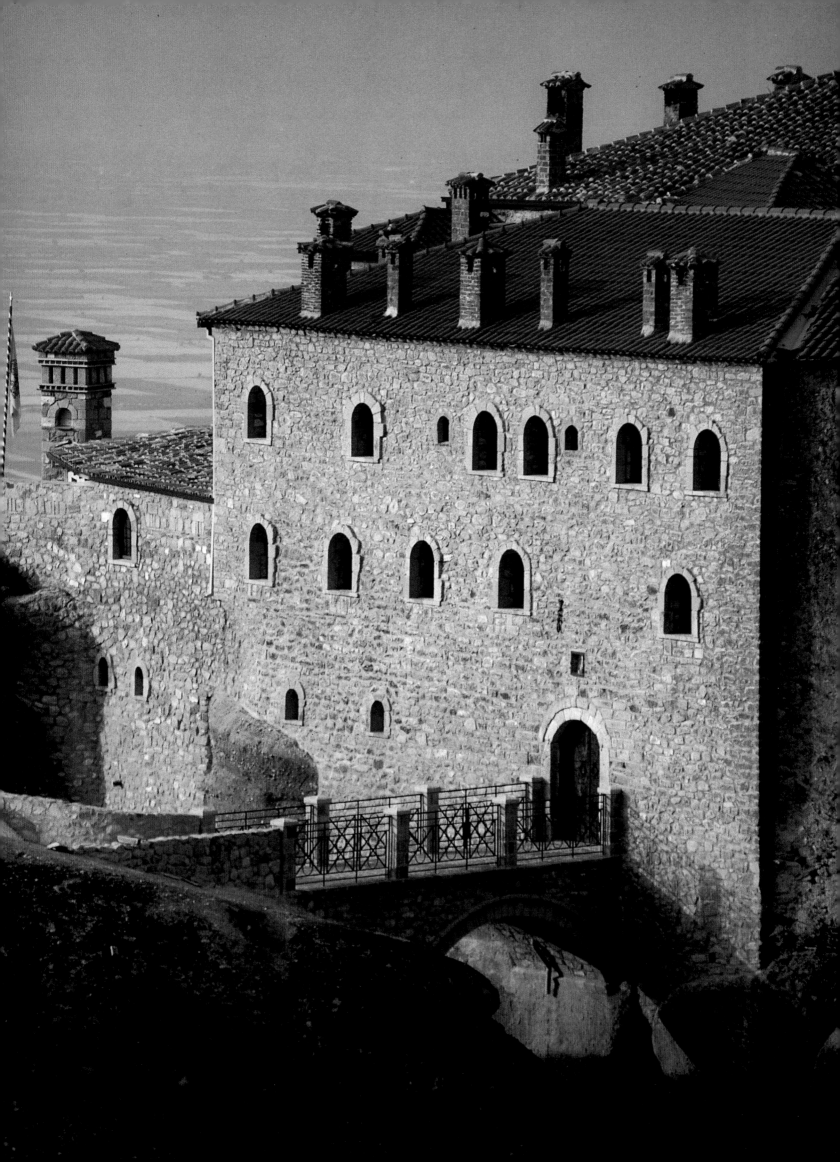

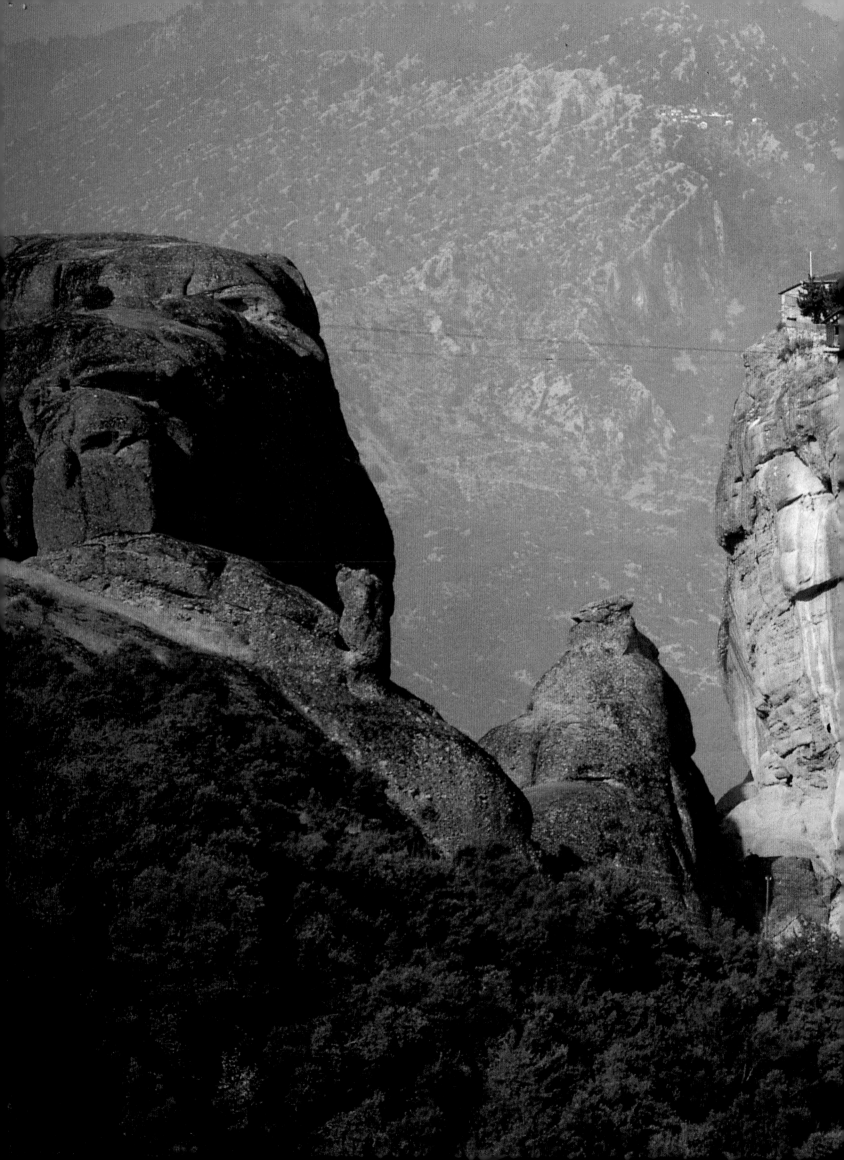

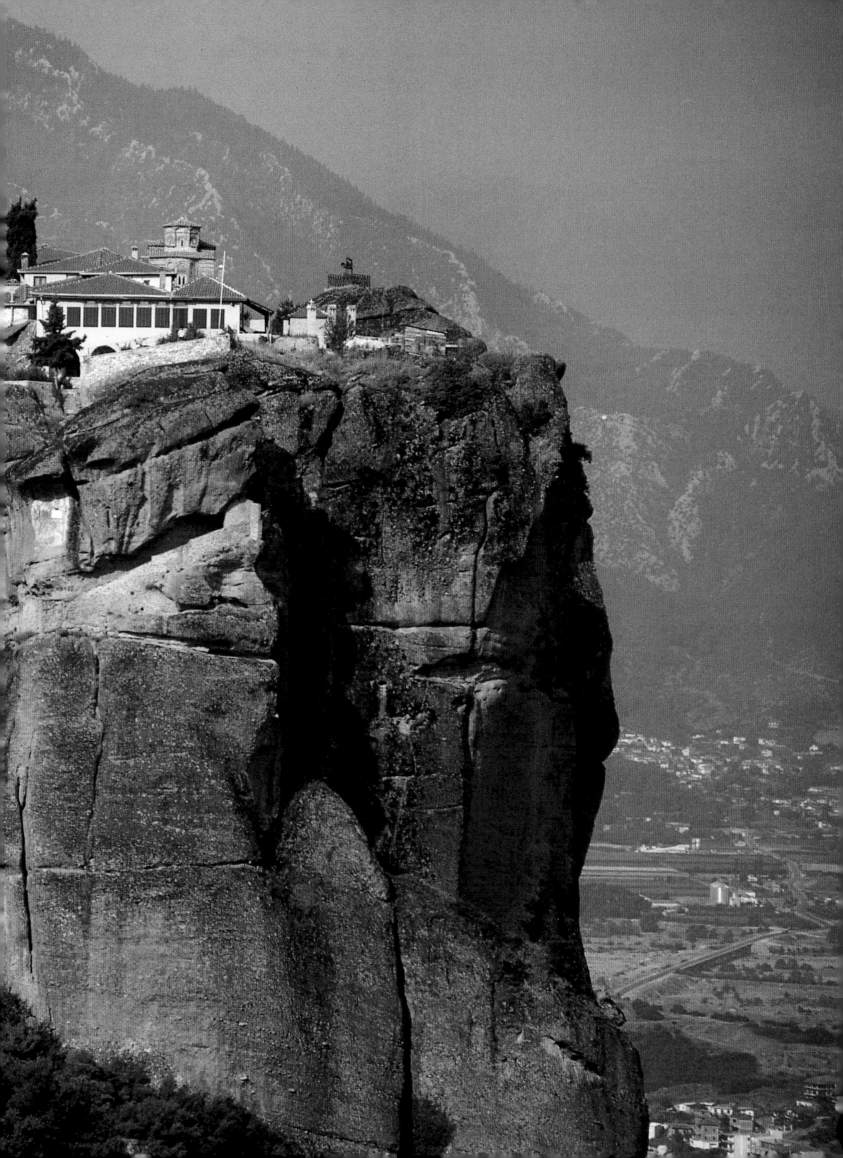

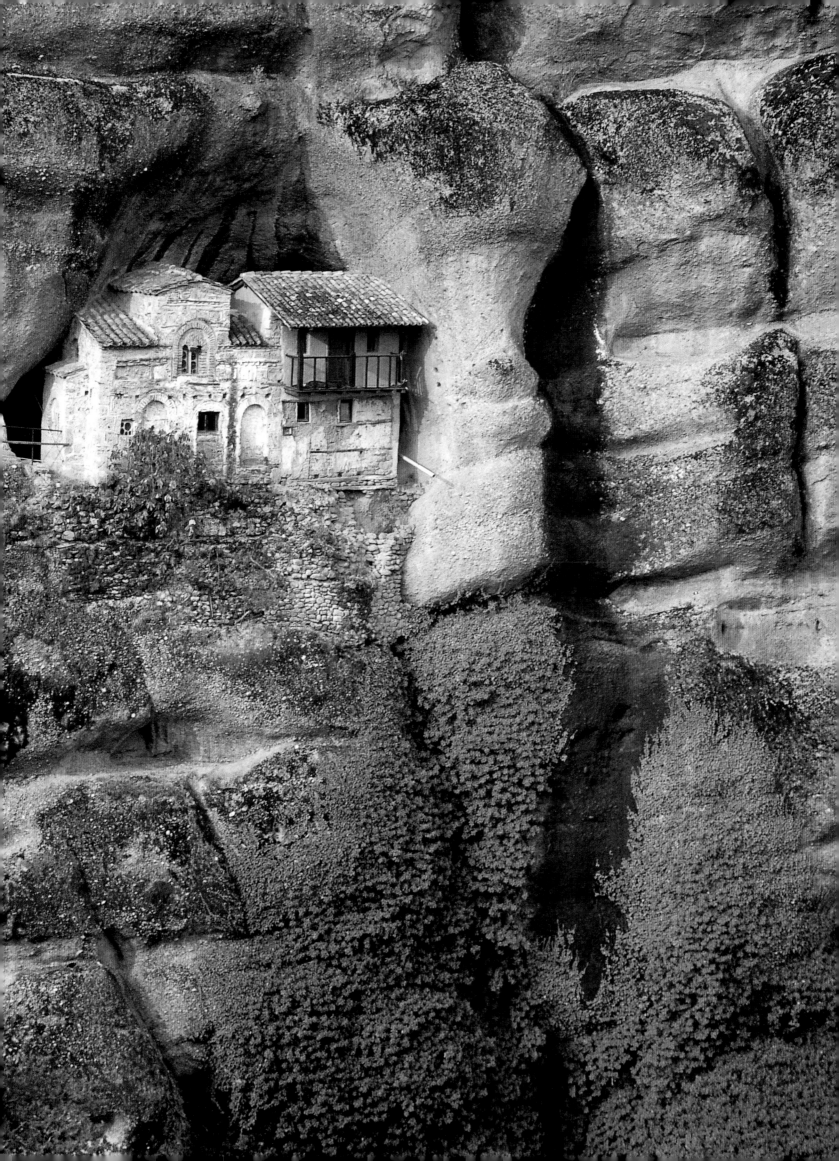

✝ Shell Shock

The days of Turkish rule were, however, numbered. After the Greek War of Independence the first peace treaty drew the Turco-Greek boundary south of Thessaly, leaving the Meteora within the Ottoman Empire. Attempts to liberate Thessaly in 1854 were quickly suppressed, but in 1881, following the Turco-Russian War, the international boundary was redrawn giving most of Thessaly to Greece. Even then the monks could hardly return to a semblance of normality. Sixteen years later Thessaly became the focal point of the brief Greco-Turkish War. In the fray thousands of refugees fled south to Athens, and the Meteora was pillaged by retreating Turkish troops. Finally, in June 1898, the last of the sultan's soldiers, the Turkish landlords, and most Muslim civilians left Thessaly for the East. The Meteora had thrown off the Turkish yoke at last.

Throughout the years of hardship the monasteries had lost much of their former wealth. During the eighteenth and nineteenth centuries, following Anathasius' book-buying trips in the 1640s, more foreign bibliophiles, notably Lord Curzon, had arrived to relieve the monasteries of valuable manuscripts. The Great Meteoron, however, still had more than 600 manuscripts in 1859, according to the Russian traveller Archimandrite Uspensky, and the Monasteries of Varlaam, Rousanou and Saint Stephen still held important works. Indeed, they were considered important enough for the new Greek government to set up a commission in 1882 with the intent of removing all the existing manuscripts to Athens. But the monks, supported by the local population, refused to part with their libraries and the commissioners, frustrated by 'the senseless opposition of the senseless inhabitants', returned to Athens with only a handful of manuscripts for the new National Library.

The pulley mechanism inside Holy Trinity Monastery at Meteora. The system has long been the monks' lifeline to the world outside.

OPPOSITE: *Wedged into a narrow crevice, the Hypapanti Monastery is one of the lesser-known monasteries at Meteora. Although abandoned and largely ruined, the church is still decorated with frescoes and retains its iconostasis.*

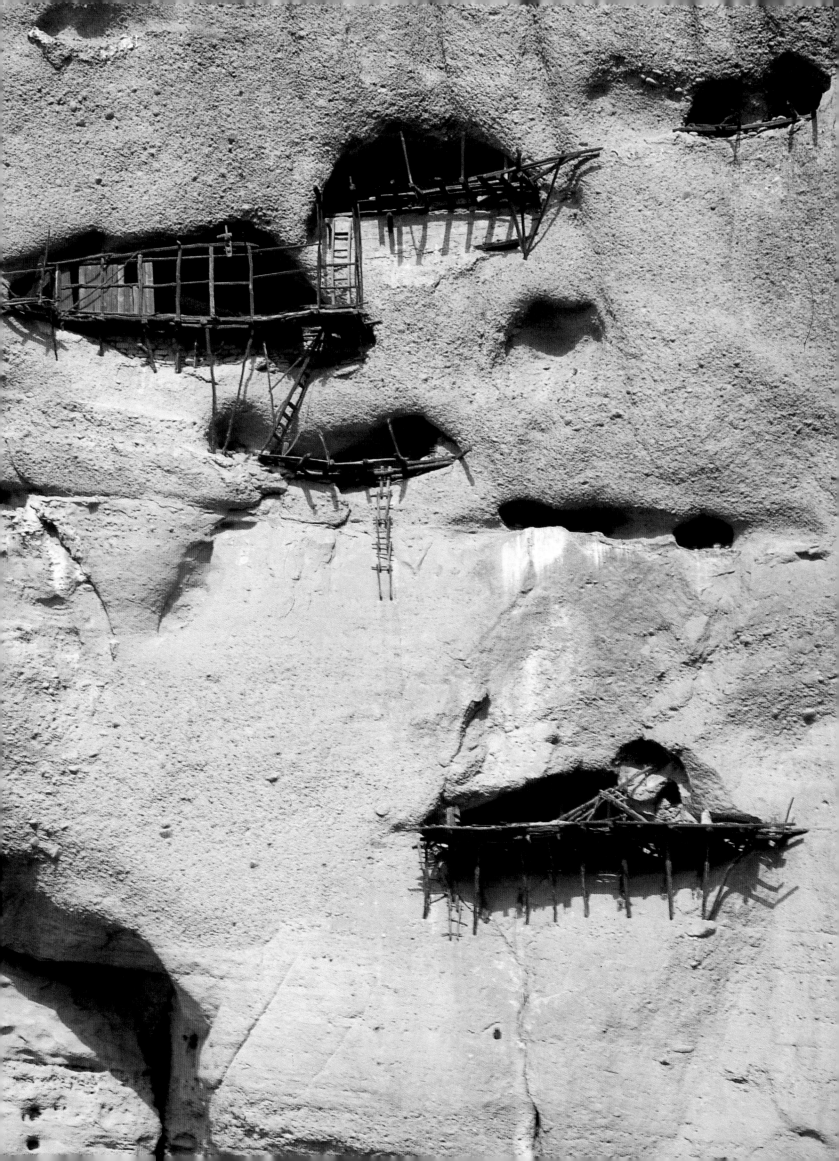

With the Turks gone the monks, perhaps, could have expected to concentrate their efforts on their spiritual calling. But the twentieth century has been no kinder to the Meteora than preceding centuries. During the disastrous German and Italian occupation of Greece in the Second World War the Meteora suffered considerable damage and the monks were mercilessly harassed. At the Great Meteoron, the principal treasures were safely hidden away at the outbreak of hostilities, but Italian soldiers captured the abbot in 1943 and sent him packing to Larissa. The two remaining monks at the Holy Trinity Monastery were also exiled by the Italians who subsequently ransacked the church, seizing the main candelabra and wrenching silver halos from the icons. A panel of the iconostasis was smashed, most of the stalls broken, and liturgical books scattered across the floor. Venerated relics, including the skulls of Saints Gregory and Barbara, disappeared.

The most badly damaged of all was Saint Stephen's Monastery which the Germans suspected of harbouring guerrillas. In October 1943, they shelled the monastery from the Thessaly plain below, hitting the dome of the catholicon dedicated to Saint Charalambos and the older chapel of Saint Stephen, which lost much of its wooden roof and valuable frescoes. German and Italian soldiers later occupied the complex, broke up doors for firewood and fled with candelabra and other church treasures. Following the German occupation it was the turn of the communists whose troops commandeered Saint Stephen's for its strategic position during the bitter civil war.

In the aftermath of war the monks slowly began the painful process of recovery, although pressing monastic repairs had to wait while the rebuilding of towns and villages took priority. Restoration of the monasteries only really began in the 1960s when the government undertook to repair the damage wrought on one of the country's most curious and important national monuments. The work was motivated by cultural rather than spiritual reasons and by the fact that tourism could contribute significantly to monastic and government coffers. The Meteora, unlike Athos, is now a tourist honeypot attracting coachloads of package and independent travellers each year. Not all have welcomed this new, if peaceful, invasion. Few monks or nuns now live on the Meteora. Those that do have accepted their summertime role as ticket sellers and monastic guides. Others wanting a quieter spiritual life have been forced to move to other monasteries which have less to interest tourists, such as Dousiko near Trikkala, or to closed centres such as Mount Athos.

OPPOSITE: *Abandoned hermits' cells built on the narrow ledges of the Meteora cliffs. Some of the cave dwellings are still venerated by local people who, following a long tradition, tie coloured flags at each entrance.*

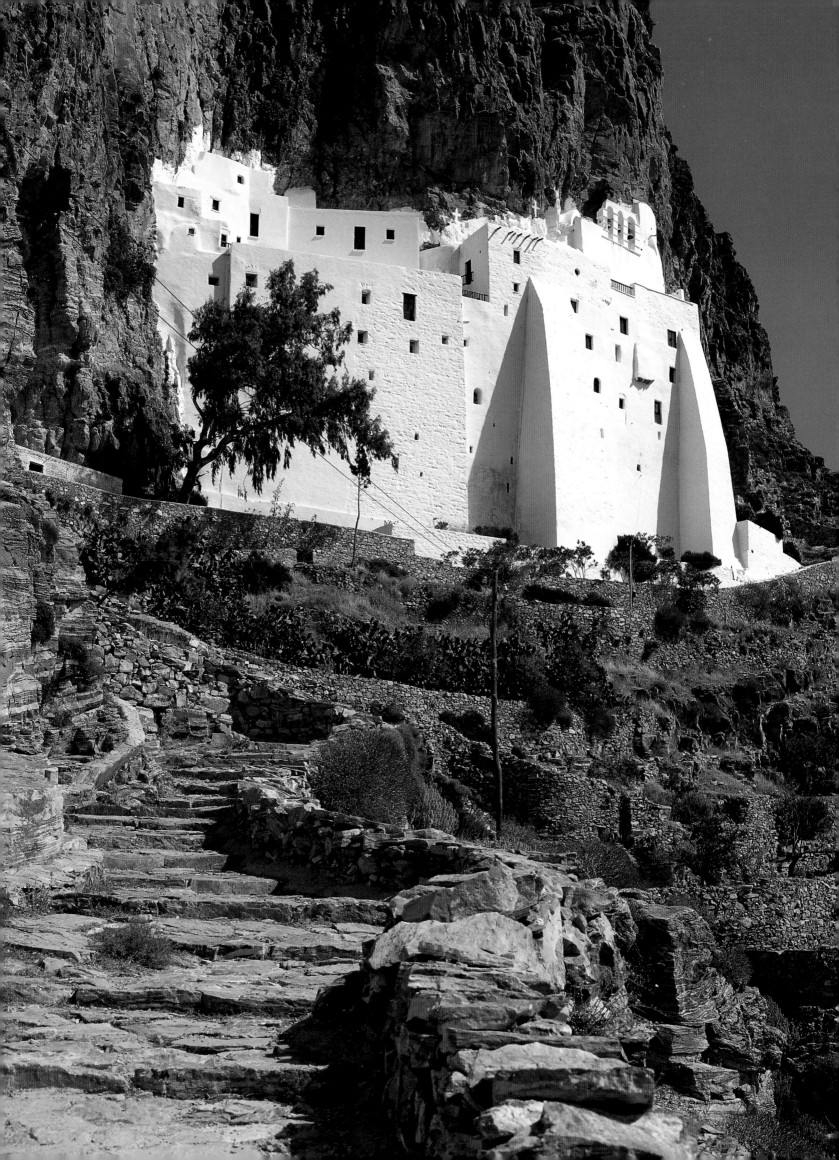

·7·

More Nuns
Than Monks

. . . the Sisters . . . became ever more obsessed with my status viv-à-vis God. The cherry-lipped Sister Magdalini cornered me in the rose garden one day and said, brandishing a trowel. 'Heretics don't go to paradise, you know. Please convert, for the sake of your own soul.'

Sara Wheeler at the Nunnery of Saint Nicholas, Euboia,
An Island Apart, 1992

The modest rise in the number of Athonite monks since the early 1970s has had little significant effect beyond the Holy Mountain. Several centres have, however, grown slightly and there has been a surprisingly large rise in the number of nuns. Some churchmen have interpreted this as a sign of optimism for, however small the increase, it would seem that at least in a few leading monasteries the tide has begun to turn after centuries of decline; a decline that began under the later Byzantine emperors, continued under the Turks, and accelerated in independent Greece.

At the dawn of independence one could, perhaps, have expected a certain amount of state sympathy, if not firm support, for monasticism. The monasteries and the Church, after all, had long been credited with harbouring the Hellenistic spirit and providing centres from which to launch the revolution in 1821. But it was not to be. Less than ten years after Greek independence the Earl of Caernarvon, passing through Greece, concluded that: 'The power of the Church over the minds of men is slowly but certainly declining in Greece.' Church influence, particularly monastic influence, is still on the wane, but it is far from being written off. Orthodoxy remains an integral aspect of the Greek character even if the traditional links between Church and State have, to a large extent, been eroded.

The administration of today's Church is complex. Owing to the history of the eastern Mediterranean, church responsibilities within Greece are still divided between the ancient patriarchate of Constantinople and the independent Church of Greece. Though enormously reduced in size since its tenth century heyday the patriarchate's jurisdiction continues to include Mount Athos, Crete and the Dodecanese, as well as Turkey, Finland, and the Greek diaspora. Patriarch Bartholomew's situation in Istanbul is an unusual one, as diplomatically sensitive as it was during the Ottoman Empire. In all, his patriarchate includes six million people,

OPPOSITE: *The Monastery of the Presentation of the Virgin clings to a precipitous limestone cliff on the island of Amorgos in the central Cyclades. The monastery was founded in 1088, about the same time as the celebrated St. John's Monastery on Patmos, by the Byzantine Emperor, Alexius I Comnenus.*

☦

Easter celebrations at St. John's Monastery, Patmos.

but there are few Orthodox in the city in which he resides. Until 1971 the patriarchate ran a celebrated theological school on the island of Halki, near Istanbul, but under the Turkish generals it was forced to close. Since then it has been dependent on other seminaries in Patmos, Crete, and Athos. In Greece the patriarchate also maintains two monastic-based foundations; both founded in 1968: the Orthodox Academy at the monastery of Our Lady Gonia, Crete, which promotes ecological and social studies, and the Patriarchal Institute for Patristic Studies at Vlátadon Monastery, Thessalonika.

The rest of Greece is under the jurisdiction of the Church of Greece which maintains a network of parishes, monasteries and philanthropic foundations. In organizational terms the Church has expanded slightly in the last twenty years, but the monastic revival on Athos has had little real influence elsewhere. Even in the monasteries where the number of fathers looks reasonable on paper, there are often few actual residents. And in many of the more important Byzantine monasteries monks have become little more than museum caretakers.

OPPOSITE: *A doorway at Panagia Monastery on the Pelion peninsula, adorned with the universal symbol of Christianity.*

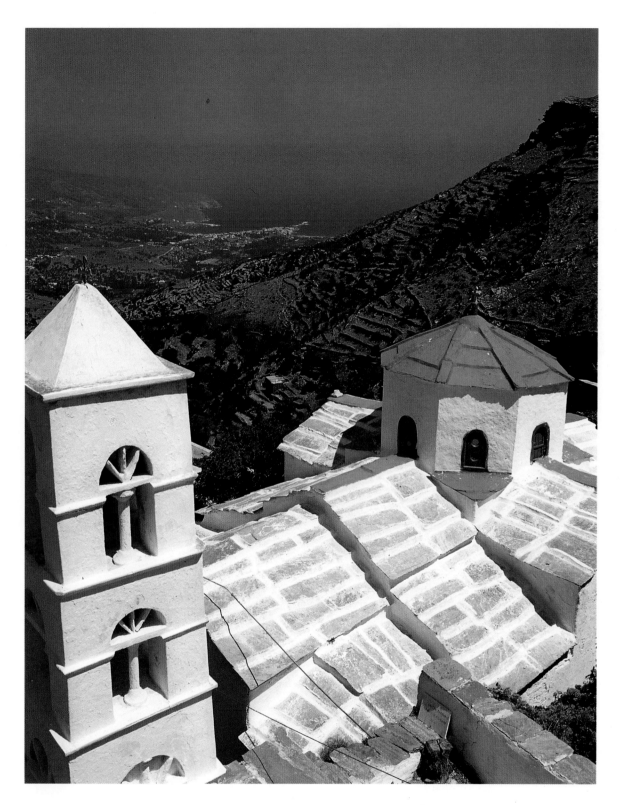

The Monastery of Panachrantou on Andros from the southwest and (OPPOSITE) *inside the dining room. The monastery was founded in 961 by the Byzantine emperor Nicephorus II Phocas, who also funded the first monastery, the Great Lavra, on Mount Athos.*

Some of the 336 cells in the important sixteenth-century Monastery of the Great Gates or Dousiko, in the hills west of Trikkala in Thessaly. It was founded about 1515 by St. Bessarion, Archbishop of Larissa, who later presided over one of the most active and prosperous periods in the history of Meteora.

ABOVE RIGHT: *A wing of the deserted Monastery of Agia Paraskevi, high above the Vikos Gorge in Zagoria, 'the land beyond the mountains', near the Albanian border.*

If most houses outside Athos are depleted in numbers, there are exceptions to the overall view. Two monasteries of relatively recent origin in Attica, the old calendarist Monastery of the Transfiguration at Kouvara and the Monastery of the Paraclete at Oropos, follow strict coenobitic traditions and house a healthy number of youngish monks. There are also efforts to revive some of the older houses such as Ossios Loukas where extensive restoration, much of it paid by tourist receipts, is under way. Figures for the Church of Greece show that the number of monks edged up from 776 in 1971 to 927 in 1992; a 20 per cent increase, but insufficient to predict a significant monastic revival. Indeed, the number of monks within the Church's jurisdiction is far lower than the number of monks on Athos alone.

If most monasteries are in an advanced state of decadence, there are signs that nunneries are expanding steadily. In a trend that strangely seems to mirror the growth of large convents in the early centuries of the Turcokratia, nuns increased from a few hundred in the 1920s to almost 2500 today. Newly established women's houses have often, as at Saint Nicholas' Nunnery on Euboia, taken over earlier buildings abandoned by men. Among the larger houses is the convent of the Annunciation, on the Chalcidice peninsula, a dependency of the monastery of Simonos Petras on Athos; and the unusual Kechrovouni convent on the island of Tenos. The latter, renowned in the Greek world for pilgrimages to the shrine to the Mother of God, resembles a small village and houses about sixty nuns.

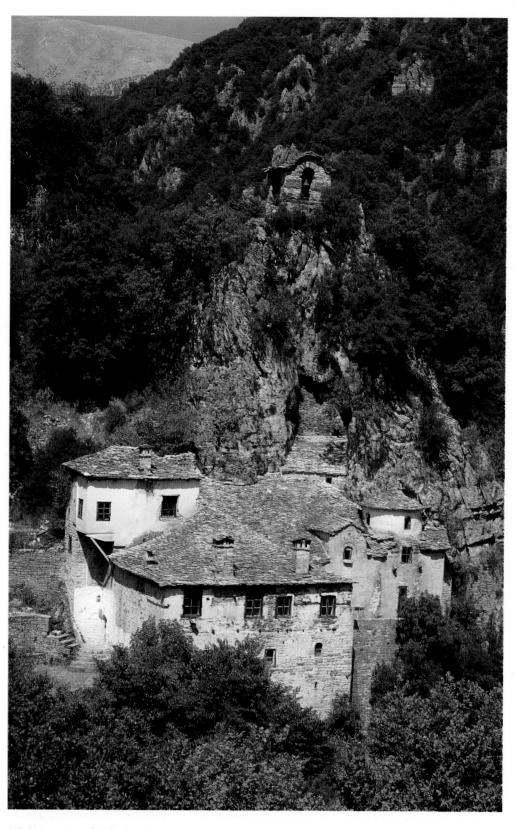

*The Monastery of Spiliotissasi, one
of many small monasteries, now
deserted, hidden away in the Zagoria
mountains, near the Albanian border.*

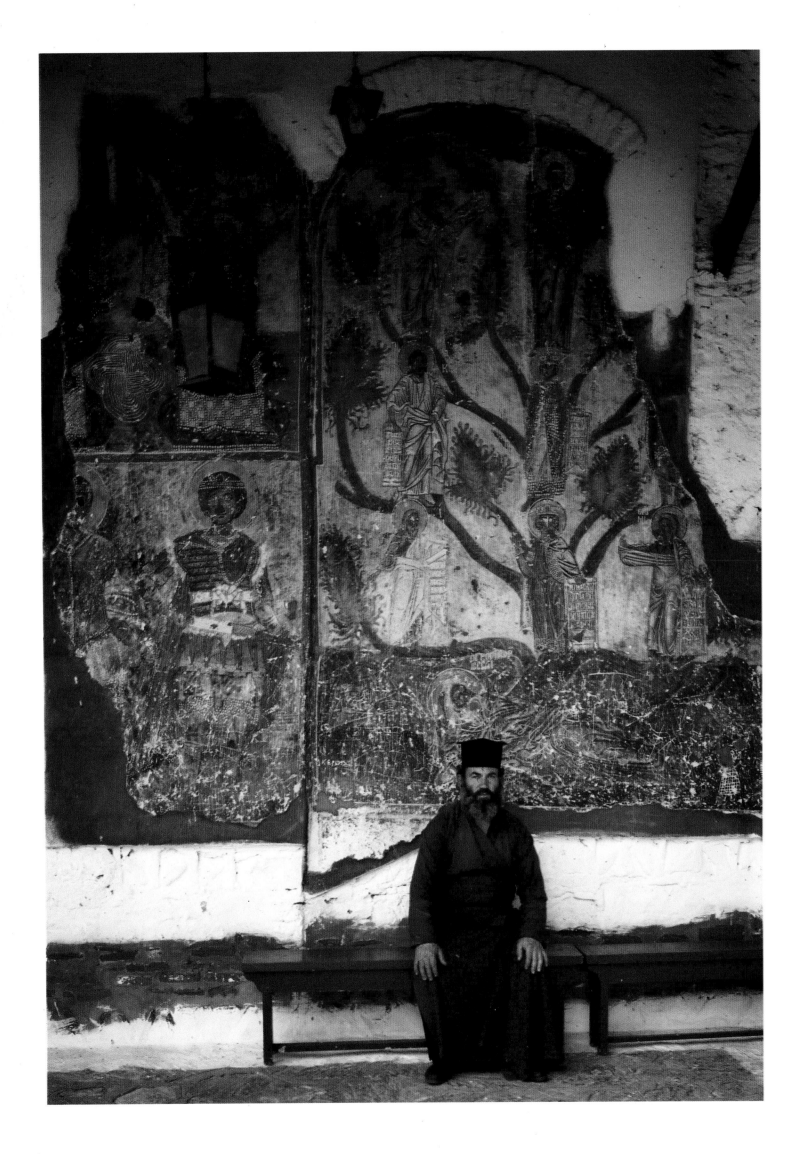

The bell-tower of the Monastery of Spiliotissasi.

New or revived houses are, however, isolated examples. It may be inappropriate to talk of a true monastic revival, but the numbers of monks and nuns is at least holding to the extent that some ancient foundations, particularly on Athos, can look forward to a secure future as living centres of religion. The rise in cultural awareness, the benefits of tourism and a wealthier Greek state also mean that important Byzantine monasteries, long abandoned by their monks, are now being preserved as museums.

The restoration of Byzantine monasteries happily extends beyond the boundaries of modern Greece. One of the most successful American-sponsored programmes involved the cleaning of the frescoes and mosaics in the former monastic Church of Saint Saviour in Chora, in Istanbul, undertaken by the Byzantine Institute. Meanwhile, the monastery churches in Cappadocia, once an outlying Byzantine province, are being restored under a UNESCO sponsored programme that began in the 1970s.

These and other monastery museums in Greece are, of course, unlikely ever to be living communities again. They will never again echo with the sound of the semantron or be inhabited by black-clad figures from another age. For a glimpse of how things once were we need to return to the curious communities of Athos where increasing numbers of monks still follow rites little changed since the days of Byzantium. Here there is a guarded optimism about the future. But whether recent recruits, some from non-Orthodox backgrounds outside Greece, will settle on the Mountain long-term still remains to be seen. Indeed, as one monk at Iviron monastery told me: 'Our numbers are growing slowly. But we musn't expand too quickly, otherwise the spiritual life will be left behind.'

OPPOSITE: *The eleventh-century Monastery of Panagia Mavriatissa near Kastoria, an important provincial centre of Byzantine art. The monastery has twin churches of which the oldest, the Church of the Virgin, is decorated in thirteenth-century frescoes showing the Tree of Jesse with the Virgin framed by the apostles on the branches.*

The universal symbol of Christianity
the 'precious and life-giving Cross'.
In Byzantium, trade contracts
invoked the Trinity and were
marked with the sign of the Cross,
while today most Orthodox
Christians wear a small cross, hung
on a chain round their neck, to
remind them of their baptism.

Glossary

Anastasis the Resurrection. In Orthodox iconography the Anastasis is often represented by Christ breaking the gates of Hell, and the rescue of Adam, Eve and the Old Testament kings.

archimandrite the superior of a large monastery in the Orthodox Church, also given as an honorary title to a monastic priest.

Arian a believer in the doctrine of Arius of Alexandria (4th cent.) who denied the full divinity of Christ.

Arsenites a conservative group of dissident monks, supporters of Patriarch Arsenius Autorianus.

askesis or ascesis self-discipline or the training required to live life as a hermit.

bema the sanctuary of an Orthodox church, where the liturgy is performed.

bibliophylax a librarian.

brevion a monastery's foundation deed listing all endowments and the founder's wishes regarding the litany.

catechumen a Christian convert under instruction before being baptized.

catholicon the principal or main church in a monastery.

chalice a goblet or wine-cup used in the Eucharist.

charisticum monastic foundations whose business transactions were handled by a professional property manager.

charisticarius the manager of a charisticum.

chartophylax a monastery's clerk or registrar.

chrysobul an imperial decree written on a parchment scroll. The document was fastened with a gold ('chryso') seal, from which it gets its name.

cloisonné walling decorative masonry in which stone blocks are framed by slender bricks.

coenobitic monastery a monastery governed by a strict set of community rules. All possessions are held in common and private property is forbidden.

Deesis a representation of Christ flanked by the Virgin Mary and John the Baptist.

dendrite an early ascetic who lived, often chained, in the branches of trees.

distyle a style of church midway between a domed basilica and a Greek cross plan.

Dodekaorton literally the 'twelve feasts'. The twelve scenes which illustrate the most important episodes in the life and death of Christ and his Mother: the Annunciation, the Nativity, the Presentation in the Temple, the Baptism, the Raising of Lazarus, the Entry into Jerusalem, the Crucifixion, the Resurrection, Ascension, Pentecost, the Transfiguration, and the Dormition of the Virgin.

dragoman a dated term for a guide and/or interpreter in the Levant and Middle Eastern countries.

economus a monastery's bookkeeper or accountant.

epistemonarchoi a senior monk designated to arbitrate between disputing monks.

epitaktoi a monk responsible for house discipline.

eremiticism a reclusive lifestyle, especially Christian. From the Greek for solitary – *eremos* – and desert – *eremia*.

evangelistarium a codex, or manuscript volume, containing miniature paintings of the evangelists.

exarch a patriarch's representative or a bishop ranking between the patriarch and the metropolitan. Also the governor of a Byzantine province.

exo-narthex the outer porch in a church with two narthexes.

hagiography the biography of a saint.

hegoumenos the leader or abbot of a coenobitic monastery.

hesychast a mystic or monk seeking divine peace and tranquillity in his search for God. They claimed to receive the light of Divine Vision by adopting particular exercises and postures.

hesychasterion a small hut, cave or other dwelling used by a hesychast.

iconodule or **iconophile** a supporter of the use of icons in Orthodox worship (as opposed to the iconoclasts, or icon-smashers, who opposed the representation of God or the

human form in art).

iconostasis a screen, hung with icons, which separates the nave from the sanctuary.

idiorrhythmy a monastic system which allows monks to retain private property.

kellion a hermitage or lavra affiliated to a nearby monastery.

kelliot a recluse or solitary living in a kellion.

klepts Greek outlaws or brigands.

Kollyvodes a conservative group within the Orthodox church which opposed western influence on Orthodoxy towards the end of the eighteenth century.

lavra or laura originally a group of hermits' cells, but the term was later applied to the leading monastery, the Great Lavra, on Athos.

lite a unified rectangular porch which replaces the double narthex.

menology a calendar which includes the biographies of a number of saints.

narthex railed-off western porch in a church usually reserved for women and penitents. In monastery churches, however, it is used by trainee monks.

naos the inner part of a temple or church.

nave the main body of a basilica church usually separated by pillars from the aisles.

omphalopsychi a derogatory term for a hesychast, literally meaning those who keep their souls in their navels.

palikares Cretan insurgents during the Greek War of Independence.

Pantocrator Christ, 'Ruler of All', usually painted on the dome of an Orthodox church.

paten a shallow dish used for bread at the Eucharist.

patriarch a bishop in the Othodox Church, or head of an autocephalous church.

patriarchate the residence of the ecclesiastical patriarch.

patristics the study of the writings of the Fathers of the Church.

Phanariot resident of the Greek Phanar district of Constantinople.

phiale a canopied fountain or reservoir for holy water.

prothesis part of the church where the credence table, used for Eucharistic elements, is placed.

protos head of the Holy Synod on Mount Athos until the office was abolished in the mid-seventeenth century.

sacellarius an official of the patriarch's court responsible for patriarchal foundations.

saloi an early ascetic who thought he served God by acting the fool.

scriptorium room set aside for writing in a monastery.

semantron a wooden beam beaten with a mallet to summon the monks to prayer.

skete a monastic dependency.

solemnion an annual stipend granted as a gift by the emperor and paid from the state treasury.

stavropegion a monastery answerable to the patriarch alone.

stylite an ascetic who lived on top of a pillar or column.

taxiarch a monastery official responsible for organizing processions and church rituals.

transept the extension of the nave of a church with bays to north and south.

typicon a foundation deed listing the monks' rights and duties in a monastery.

Vlach Romanian-speaking people from south east Europe.

voivode princes or rulers of Wallachia.

Bibliography

ALLATIOS, LEO, *The Newer Temples of the Greeks*, trans. and intro. Anthony Cutler, Philadelphia, 1969.

ARNOTT, PETER, *The Byzantines and their World*, London, 1973.

ATHANASIUS, SAINT, *The Life of Antony*, trans. R. C. Gregg, New York, 1980.

ATTWATER, DONALD, *The Christian Churches of the East*: Volume II: *Churches not in Communion with Rome*, Geoffrey Chapman, London, 1961.

BAKER, DEREK, 'Theodore of Sykeon and the Historians', *Studies in Church History* 13, 1976.

BARROIS, GEORGES A (trans. and intro.), *The Fathers Speak*, New York, 1986.

BARSKY, V. G., 'Travels of Vasili Gorgorivitch Barsky to the Holy Places of the Orient', St Petersburg, 1885–7 (in Russian).

BENEDICTA WARD, SISTER (trans.), *The Sayings of the Desert Fathers. The Alphabetical Collection*, London/Oxford, 1981.

BENT, J.T., *Early Voyages and Travel in the Levant*, Hakluyt Society, Series I, LXXXVII, London, 1893.

BINON, S., *Les origines légendaires et l'histoire de Xeropotamou et de Saint-Paul de l'Athos*, Louvain, 1942.

BREHIER, LOUIS, *Les Eglises Byzantines*, Paris, 1912.

BREHIER, LOUIS, *Les Institutions de l'Empire Byzantin*, Paris, 1949.

BREWSTER, RALPH H., 'Athos: the holy mountain' in *The Geographical Magazine* 2(4), February 1936.

BROWNING, ROBERT, *The Byzantine Empire*, London, 1980.

BRYER, ANTHONY, 'The Later Byzantine Monastery in Town and Countryside', *Studies in Church History*, 16 (1979), 234–41.

BRYER, ANTHONY and LOWRY, HEATH, *Continuity and Change in Late Byzantine and Early Ottoman Society*, Birmingham/Washington, 1986.

BUDGE, ERNEST A. WALLIS (trans.), *The Paradise, or Garden of the Holy Fathers: Being Histories of the Anchorites, Recluses, Monks, Coenobites and Ascetic Fathers of the Deserts of Egypt between AD CCL and AD CCCC Circiter, compiled by Athanasius, Archbishop of Alexandria, Palladius, Bishop of Helenopolis et al.*, London, 1907.

BUCHON, JEAN-ALEXANDRE, *La Grèce continentale et la Morée. Voyage, séjour et études historiques en 1840 et 1841'*, Paris, 1843.

BULGAKOV, S., *The Orthodox Church*, London, 1935.

BYRON, ROBERT, *The Station, Athos: Treasures and Men*, London, 1928.

BYRON, ROBERT, *The Byzantine Achievement*, London, 1929.

BYRON, ROBERT, and RICE, DAVID TALBOT, *The Birth of Western Painting: A History of Colour, Form and Iconography, illustrated from Paintings of MISTRA and MOUNT ATHOS, of Giotto and Duccio, and El Greco*, London, 1930.

CAVARNOS, CONSTANTINE, *Anchored in God: An Inside Account of life, art and thought on the Holy Mountain of Athos*, Athens, 1959.

CAVARNOS, CONSTANTINE, *The Holy Mountain*, Belmont, Mass., 1973.

CHANDLER, RICHARD, *Travels in Greece or An Account of a Tour Made at the Expense of the Society of Dilettante*, Oxford, 1776.

CHARANIS, PETER, 'The monastic properties and the state in the Byzantine Empire', *Dumbarton Oaks Papers* 4, 1948.

CHARANIS, PETER, 'The Monk as an Element in Byzantine Society', *Dumbarton Oaks Papers* 25, 1971.

CHATZIDAKIS, MANOLIS, *Icons of Patmos*, Athens, 1986.

CHATZIDAKIS, MANOLIS, and SOFIANOS, DIMITRIOS, *The Great Meteoron: History and Art*, Athens, 1990.

CHITTY, DERWAS J., *The Desert a City*, Oxford, 1966.

CHOISEUL-GOUFFIER, COMTE de, *Voyage Pittoresque de la Grèce*, 2 vols. Paris, 1782–1822.

CHOUKAS, MICHAEL, *Black Angels of Athos*, London, 1935.

CLARKE, W. K. LOWTHER (trans.), *The Ascetic Writings of St Basil*, London, 1925.

CLÉMENT, OLIVIER, *Byzance et le Christianisme*, Paris, 1964.

CLIMACUS, SAINT JOHN, *The Ladder of Divine Ascent*, trans. Colm Luibheid and Norman Russell, New York, 1982.

CLOGG, RICHARD (ed. and trans.), *The Movement for Greek Independence 1770–1821. A Collection of Documents*, London, 1976.

COCKERELL, C.R., *Travels in Southern Europe and the Levant*, London, 1903.

COLBECK, ALFRED, *A Summer's Cruise in the Waters of Greece, Turkey, and Russia*, London, 1887.

CORMACK, ROBIN, *Writing in Gold: Byzantine Society and its Icons*, London, 1985.

COVEL, Dr. John, *Some Account of the present Greek Church, with Reflections on their present Doctrine and Discipline, particularly on the Eucharist and the rest of the seven Pretended Sacraments*, Cambridge, 1722.

CROSSLAND, JOHN and CONSTANCE, DIANA, *Macedonian Greece*, London, 1982.

CURZON, R., *Visits to Monasteries in the Levant*, London, 1849.

DAWKINS, R. M., *The Monks of Athos*, London, 1936.

De Paris à Athènes, La Turquie, le Mont Athos, la Grèce. Souvenirs d'une excursion de vacances. Recueillis par un des directeurs de la Caravane, Lille, 1894.

de VOGUE, EUGENE-MELCHOIR, *Syrie, Palestine, Mont Athos. Voyage aux Pays du Passé*, Paris, 1876.

DIEZ, ERNST, and DEMUS, OTTO, *Byzantine Mosaics in Greece: Daphni and Hosios Lucas*, Cambridge, Mass., 1931.

DODWELL, EDWARD, *A Classical and Topographical Tour Through Greece, during the Years 1801, 1805, and 1806*, London, 1819.

DREUX, R.P. ROBERT de, *Voyage en Turquie et en Grèce du R. P. Robert de Dreux, aumonier de l'ambassadeur de France (1665–1669)*, Paris, 1925.

FAILLER, A., 'Le monachisme byzantin aux XIe-XIIe siecles: Aspects sociaux et economiques', *Cahiers d'Histoires* 20, 1975, 279–302.

FARMER, D.H. (ed.), *Oxford Dictionary of Saints*, Oxford, 1987.

FERMOR, PATRICK LEIGH, *Roumeli: Travels in Northern Greece*, London, 1966.

FERRADON, A., *Des biens des monastères à Byzance*, Bordeaux, 1896.

FERSTER, EDWARD S., *A Short History of Modern Greece*, London, 1958.

FESTUGIÈRE, A.J. (ed.), *La Vie de Théodore de Sykeon*, Brussels, 1970.

FORSYTH, G. H., and WEITZMANN, K., *The Monastery of St. Catherine at Mount Sinai. The Church and Fortress of Justinian*, Ann Arbor, Mich., 1973.

FORTESCUE, ADRIAN, *The Orthodox Eastern Church*, London, 1913.

FRAZEE, CHARLES A., *The Orthodox Church and Independent Greece 1821–1852*, Cambridge, 1969.

GAMBA, PIETRO, COUNT, *A Narrative of Lord Byron's last journey to Greece. Extracted from the journal of Count Pietro Gamba, who attended his Lordship on that expedition*, London, 1825.

GARDNER, ALICE, *Theodore of Studium: His Life and Times*, London, 1905.

GRABAR, A., *L'Art Religieux et l'Empire Byzantin à l'Epoque des Macedoines*, Paris, 1939.

GRABAR, A., *L'Art Byzantine du Moyen Age*, Paris, 1963.

GRASSI, E., *Mont Athos, Presqu'île Sacrée*, Paris, 1981.

H.M.S.O., *Works of Art in Greece, the Greek Islands and the Dodecanese: Losses and Survivals in the War*, London, 1946.

HAMMOND, PETER, *The Waters of Marah: the present State of the Greek Church*, London, 1956.

HANNAY, J.O., *The Spirit and Origin of Christian Monasticism*, London, 1903.

HASLUCK, F.W., 'The First English Traveller's Account of Athos', *The Annual of the British School at Athens*, No. XVII, 1910–11.

HASLUCK, F.W., *Athos and Its Monasteries*, London, 1924.

HASLUCK, F.W., *Christianity and Islam Under the Sultans*, 2 vols, Oxford, 1929.

HAUSHERR, IRENEE, Spiritual Direction in the Early Christian East', *Cistercian Studies* 116, Kalamazoo, 1990.

HAUSSIG, HANS-WILHELM, *A History of Byzantine Civilisation*, London, 1971.

HOME, D., 'Monasteries in Cyprus', *Eastern Churches Review*, iv, 1972.

HOPKINS, ADAM, *Crete: Its Past, Present and People*, London, 1977.

HUNT, DR, 'Mount Athos: An Account of the Monastic Institutions and Libraries, in Walpole, Robert *Memoirs relating to European and Asiatic Turkey*, London, 1817–18.

HUSSEY, JOAN M., *Church and Learning in the Byzantine Empire*, Oxford, 1937.

HUSSEY, JOAN M., *The Orthodox Church in the Byzantine Empire*, Oxford, 1986.

JANIN, RAYMOND, *Les Eglises Orientales et les Rites Orientaux*, Paris, 1925.

JANIN, RAYMOND, 'Les Eglises et Monastères de Constantinople Byzantine', *Revue des Etudes Byzantines*, 1951.

JANIN, RAYMOND, *Constantinople Byzantine. La Géographie Ecclesiastique de l'Empire Byzantine*, Pt i, iii, *Les Eglises et les Monastères*, Paris, 1953.

JANIN, RAYMOND, *Le Siège de Constantinople et le Patriarch Oecumeniques: Les Eglises et Les Monastères*, Paris, 1969.

JANIN, RAYMOND, *Les Eglises et les Monastères des Grands Centres Byzantins (Bithynie, Hellespont, Latros, Galesios, Trebizonde, Athènes, Théssalonique)*, Paris, 1975.

KADAS, SOTIRIS, *Mount Athos*, Athens, 1991.

KARLIN-HAYTER, PATRICIA, 'Preparing the Data from Mount Athos for use with Modern Demographic Techniques', *Byzantion*, 48, 1978.

KAZHDAN, ALEXANDER P. (ed.), *Oxford Dictionary of Byzantium*, 3 vols, Oxford, 1991.

KOLLIAS, ELIAS, *Patmos: Mosaics – Wall Paintings*, Athens, 1990.

KOMINIS, ATHANASIOS D. (ed.), *Patmos, Treasures of the Monastery*, Athens, 1988.

KIDD, B.J., *The Churches of Eastern Christiandom*, London, 1927.

LACARRIÈRE, JACQUES, *L'Eté Grec*, Paris, 1975.

LAKE, KIRSOPP, *Early Days of Monasticism on Mount Athos*, Oxford, 1909.

LANCASTER, OSBERT, *Sailing to Byzantium, an architectural companion*, London, 1969.

LANGLOIS, VICTOR, *Le Mont Athos et ses monastères*, Paris, 1867.

LEAKE, W. M., *Travels in Northern Greece*, London, 1835.

LOCH, SYDNEY, *Athos: The Holy Mountain*, London, 1957.

LONGFORD, ELIZABETH, *Byron's Greece*, London, 1975.

LOVERDO, C. de, *J'ai été Moine au Mont Athos*, Paris, 1956.

McGANN, JEROME J. (ed.), *Lord Byron: The Complete Poetical Works*. Vol. I., Oxford, 1980.

McGREW, WILLIAM W., *Land and Revolution in Modern Greece, 1800–1881: The Transition in the Tenure and Exploitation of the Land from Ottoman Rule to Independence*, Kent State University Press, Ohio, 1985.

McMANNERS, JOHN (ed.), *The Oxford Illustrated History of Christianity*, Oxford, 1990.

MANTZARIDIS, G., 'New Statistical Data Concerning the Monks of Mount Athos', *Social Compass*, xxii, 1975; and *Eastern Churches Review*, v, 1973, vii, 1975.

MARIN, L'ABBÉ, *Les Moines de Constantinople Depuis la Fondation de la Ville Jusqu'à la Mort de Photius (330–898)*, Paris, 1897.

MATHEWS, T.F., *The Early Churches of Constantinople: Architecture and Liturgy*, Philadelphia, 1971.

MAXIMOS, FATHER, *Human Rights on Mount Athos: An Appeal to the Civilised World*, Welshpool, 1991.

de MENDIETA, EMMANUEL AMAND, *Mount Athos: The Garden of the Panaghia*, Berlin, 1972.

BIBLIOGRAPHY

MILLET, GABRIEL, *Le Monastère de Daphni, histoire, architecture, mosaiques*, Paris, 1899.

MILLET, GABRIEL, *Monuments byzantins de Mistra*, Paris, 1910.

MILLET, GABRIEL, *Les Monuments de l'Athos*, Paris, 1927.

MYLONAS, P.M., 'Le plan initial du catholicon de la Grande-Lavra au Mont-Athos et la genèse du type du catholicon athonite', *Cahiers Archéologiques* 32 (1984), 89–112.

MYLONAS, P.M. 'La trapeza de la Grand Laura au Mont Athos', *Cahiers Archéologiques* 35 (1987), 143–57.

NEALE, Revd JOHN MASON, *A History of the Holy Eastern Church*, 1850.

NICOL, DONALD M., *Meteora, The Rock Monasteries of Thessaly*, London, 1963.

NICOL, DONALD M., 'A Layman's Ministry in the Byzantine Church: The Life of Athanasios of the Great Meteoron', *Studies in Church History* 26 (1989), 141–54.

NICOL, DONALD M., *The Last Centuries of Byzantium, 1261–1453*, London, 1972.

NORET, JACQUES, 'La Vie la plus ancienne d'Athanase l'Athonite Confrontée à d'Autres Vies de Saints', *Analecta Bollandiana*, Tome 103, 1985.

NORTH, RICHARD, 'Highly Unorthodox Behaviour', *World Magazine*, January 1991.

NORWICH, JOHN JULIUS, *Byzantium: The Early Centuries*, London, 1988.

NORWICH, JOHN JULIUS, *Byzantium: The Apogee*, London, 1991.

NORWICH, JOHN JULIUS and SITWELL, RERESBY, *Mount Athos*, London, 1966.

OBOLENSKY, DIMITRI, *The Byzantine Commonwealth: Eastern Europe 500–1453*, London, 1971.

OSTROGORSKY, GEORGE, *History of the Byzantine State*, 2nd edn, Oxford, 1986.

PAPACHRYSSANTHOU, DENISE, 'La Vie Monastique dans les Campagnes Byzantins du VIIIe au XIe siècle. Ermitages, groupes, communautés', *Byzantion* 43 (1973), 158–80.

PAPACHRYSSANTHOU, DENISE, 'La Vie Ancienne de Saint Pierre L'Athonite', *Analecta Bollandiana* 92 (1974), 19–61.

PAPACHRYSSANTHOU, DENISE, *Actes du Protaton, Archives de l'Athos*, Paris, 1975.

PAPADAKIS, A., 'Byzantine Monasticism Reconsidered,' *Byzantine Studies* 47, 1986, 34–46.

PAPADOPOULOS, STELIOS A., *Stavronikita Monastery: History, Icons, Embroideries*, Athens, 1974.

PAPADOPOULOS, STELIOS A., *The Monastery of Saint John the Theologian*, Patmos, 1987.

PAPADOPOULOS, T.H., *Studies and Documents relating to the History of the Greek Church and People under Turkish Domination*, Brussels, 1952.

PARGOIRE, J., 'Les monastères doubles chez les Byzantins', *Echos D'Orient*, Vol. 9, 1906, 21–5.

PELEKANIDES, S.M. *et al.*, *The Treasures of Mount Athos: Illuminated Manuscripts*, 3 Vols., Athens, 1973–9.

PERILLA, F., *Le Mont-Athos*, Paris, 1928.

PETIT, L., 'La grande controverse des colyves', *Echos D'Orient*, Vol. II, 1898–99.

PREVITE-ORTON, C.W., *Shorter Cambridge Medieval History*, Vol. I: *The Later Roman Empire to the Twelfth Century'*, Cambridge, 1962.

QUINET, EDGAR, *La Grèce Moderne*, Paris, 1830.

RICE, DAVID TALBOT, *Byzantine Art*, Oxford, 1935.

RICE, DAVID TALBOT, *The Appreciation of Byzantine Art*, Oxford, 1972.

RILEY, ATHELSTAN, *Athos, or the Mountain of the Monks*, London, 1887.

RINGROSE, KATHRYN M., 'Monks and Society in Iconoclastic Byzantium', *Byzantine Studies*, Vol.6, 1979.

RINVOLUCRI, MARIO, *Anatomy of a Church: Greek Orthodoxy Today*, London, 1966.

ROBERTSON, RONALD G. *The Eastern Christian Churches: A Brief Survey*, 3rd edn., Rome, 1990.

ROBINSON, N.F., *Monasticism in the Orthodox Churches*, London, 1916.

RUNCIMAN, STEVEN, *Byzantine Civilisation*, London, 1933.

RUNICMAN, STEVEN, *The Fall of Constantinople 1453*, Cambridge, 1965.

RUNCIMAN, STEVEN, *The Great Church in Captivity. A Study of the Patriarchate of Constantinople from the Eve of the Turkish Conquest to the Greek War of Independence*, Cambridge, 1968.

RUNCIMAN, STEVEN, *Mistra: Byzantine Capital of the Peloponnese*, London, 1980.

RYCANT, Sir PAUL, *The Present State of the Greek and Armenian Churches, Anno Christo 1678*, London, 1679.

SALAVILLE, S., 'La vie monastique grecque au debut du XIVème siècle d'après un discours inédit de Théolepte de Philadelphia', *Etudes Byzantines*, II (1944), 119–25.

SCHULTZ, ROBERT WEIR and BARNSLEY, SIDNEY HOWARD, *The Monastery of Saint Luke of Stiris, in Phocis, and the Dependent Monastery of Saint Nicolas in the Fields, near Skripou, in Boetia*, London, 1901.

SEVCENKO, I., 'Nicolas Cabasilas "Anti-Zealot" discourse: a reinterpretation', *Dumbarton Oaks Papers* 11, 1957.

SHERRARD, PHILIP, *The Greek East and the Latin West*, London, 1959.

SHERRARD, PHILIP. *Athos: The Holy Mountain*, London, 1960.

SHERRARD, PHILIP, 'The Paths of Athos', *Eastern Churches Review*, ix, 1977, and viii, 1976.

SOPHRONY, ARCHIMANDRITE, *St Silouan the Athonite*, Tolleshunt Knights, 1991.

SOTIRIOU, GEORGE, 'Les Météores, "qui planent entre ciel et terre"', *UNESCO Courrier*, Vol. VIII, No. 5, 1955. 4–8, illus.

STANLEY, ARTHUR PENRHYN, *Lectures on the History of the Eastern Church*, London, 1924.

STONE, TOM, *Patmos*, Athens, 1981.

TACHIAOS, ANTHONY-EMIL N. (ed.), *Mount Athos and the European Community*, Thessaloniki, 1993.

TAFRALI, O., *Thessalonique au quatorzième siècle'*, Paris, 1913.

TALBOT, A.M., 'An Introduction to Byzantine Monasticism,' *Illinois Classical Studies* 12, 1987, 229–41.

THEOCHARIDES, PLOUTARCHOS, FOUNDAS, PANDELIS, and STEFANOU, STERGIOS, *Mount Athos: Greek Traditional Architecture*, Athens, 1992.

TOUGARD, A., 'La persecution iconoclaste d'après la correspondance de saint Théodore Studite', *Revue des Questions Historiques*, Paris, July 1891.

TOZER, Revd HENRY FANSHAWE, *Researches in the Highlands of Turkey including Visits to Mounts Ida, Athos, Olympus and Pelion, to the Mirdite Albanians, and other Remote Tribes; with Notes on the Ballads, Tales and Classical Superstitions of the Modern Greek*, London, 1869.

TRONE, ROBERT H., 'A Constantinopolitan Double Monastery of

the Fourteenth Century: The Philanthropic Saviour', *Byzantine Studies* 10, 1983.

TURNER, WILLIAM, *Journal of a Tour in the Levant*, 3 vols., London, 1820.

VRYONIS, SPOROS, *Byzantium and Europe*, London, 1967.

WADDINGTON, GEORGE (Dean of Durham), *A Visit to Greece in 1823 and 1824*, John Murray, London, 1825.

WADDINGTON, GEORGE (Dean of Durham), *The Present Condition of the Greek or Oriental Church: With some Letters written from the Convent of the Strophades*, London, 1829.

WADDINGTON, GEORGE (Dean of Durham), *The Condition and Prospects of the Greek or Oriental Church*, London, 1854.

WALPOLE, ROBERT, *Memoirs Relating to European and Asiatic Turkey*, London, 1817.

WARE, KALLISTOS, 'The Church: A Time of Transition', in CLOGG, RICHARD (ed.), *Greece in the 1980s*, London, 1983.

WARE, TIMOTHY, *The Orthodox Church*, London, 1963.

WARE, TIMOTHY, *Eustratios Argenti: A Study of the Greek Church under Turkish Rule*, Oxford, 1964.

WHEELER, Sir GEORGE, *An Account of the Churches ... of the Primitive Christians, from the churches of Tyre, Jerusalem and Constantinople described by Eusebius, and ocular observations of several ... ancient edifices of churches ... in those parts, etc.*, London, 1689.

WHEELER, SARA, *An Island Apart*, London, 1992.

WILBERG, R.G., *A Handbook for Travellers in Greece*, London, 1872.

WILLIAMS, G., *The Orthodox Church of the East in the Eighteenth Century*, London, 1868.

WOODHOUSE, C.M., *The Greek War of Independence, its historical setting*, London, 1952.

WYRWOLL, NIKOLAUS (ed.), *Orthodoxia 1992–1993*, Regensburg, 1992.

ZAKYTHINOS, D.A., *Le despotat grec de Morée. Vie et Institutions'*, Athens 1953, pp. 295–309.

ZERNOV, NICOLAS, *Eastern Christendom: A Study of the Origin and Development of the Eastern Orthodox Church*, London, 1961.

Index

Page numbers in *italic* refer to captions to illustrations.
Page numbers in **bold** indicate the main reference to a subject.
Continuous page references ignore intervening illustration pages.
Unless otherwise stated Patriarchs are of Constantinople.